ANATOMY ACTS

ANATOMY ACTS

HOW WE COME TO KNOW OURSELVES

ANATOMY ACTS

ACTS

HOW WE COME TO KNOW OURSELVES

EDITED BY

ANDREW PATRIZIO

AND

DAWN KEMP

BIRLINN

First published in 2006 by
Birlinn Limited
West Newington House
10 Newington Road
Edinburgh EH91QS

www.birlinn.co.uk

ISBN10: 1 84158 471 1
ISBN13: 978 1 84158 471 3

British Library Cataloguing-in-Publication Data
A catalogue record for this book is available
from the British Library

Design and layout James Hutcheson and Mark Blackadder

Scotland & Medicine: Collections & Connections is supported through the
Regional Development Challenge Fund, funded by the Scottish Executive
and administered by the Scottish Museums Council on its behalf.

Supported by the Strathmartine Trust

Printed and bound by Scotprint, Haddington

Contents

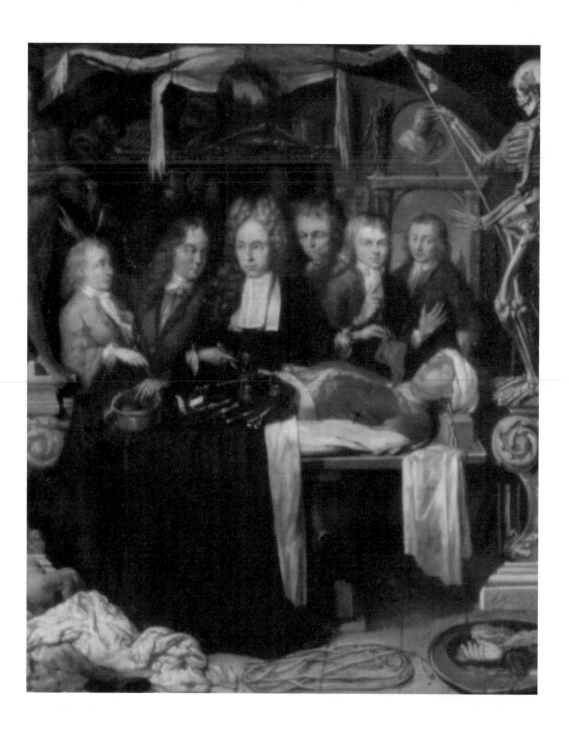

ANDREW PATRIZIO AND DAWN KEMP

Anatomy Acts:
INTRODUCTION

Anatomy Acts seeks to explore the social, cultural and scientific significance of anatomy in Scotland over the past 500 years. How we have come to know ourselves through anatomical study. How the study of anatomy has changed over the centuries. What contribution Scotland has made to the 'culture of anatomy'. How the arts responded to the work of anatomists and surgeons.

Working on this project has reminded us of just how resilient the subject of anatomy is in our culture. Such has been the enthusiasm from colleagues and partners to engage with the topic – whether to promote, to critique, to create or to speculate – we feel sure that *Anatomy Acts* is timely within a national and international context.

Since the eighteenth century, Scotland has been amongst the most important countries for medical teaching, training, and practice in the world. It has continued to be at the forefront of developments in new technologies for medical imaging (for example, microscopy, ultrasound, magnetic resonance imaging and virtual technology), and dissemination of medical and historical research through publication, educational activities and museum exhibition. There has been a move over the centuries from the 'macro' to the 'micro'. We see an ever-deepening interest that starts with surface structure, the large-scale, public and 'gross anatomy' towards the near invisible, hidden, abstracted and subtle way the body works. All are included in *Anatomy Acts*.

Anatomy Acts draws entirely on Scottish collections and there is no comparable visual history of anatomical material from Scotland. Some works

presented date from the fifteenth and sixteenth centuries, whilst others are contemporary – a matter of months old. They are of various media and types ranging from anatomical atlases, paintings, prints and drawings, models and casts in metal, wax and papier-mâché, specimens, photographs, X-rays, scans and new media technologies, medical instrumentation, text-based work, and film. A modest representation comes from non-Western traditions too. Most were created for practical educational purposes, but not all. Some have entirely benign intentions whilst others are the products of a darker story.

Anatomy Acts offers a new focus, building on the more general overviews of the relationship between art and anatomy that have appeared in recent years. The essays included here have been commissioned from authors selected for their specialist knowledge of visual, cultural and medical history, as well as their original and provocative perspectives. The essays put Scotland's contribution to anatomical understanding in a broader context. *Anatomy Acts* is intended to be of interest to a wide audience, including professionals and students of medical, cultural, and historical studies, but also the more general reader.

Our rationale has been to explore new models for public engagement with anatomy through both a book and exhibition. We have sought to innovate in terms of exhibition presentation not just for its own sake, but to develop and deepen audience engagement beyond cynical spectacle and controversy. The book is a fusion of accessible though learned texts, discussions with contemporary artists, high-quality photographs of anatomy-related material, and information on where to explore the subject further. Naturally the educational component

Opposite. A. van der Groes. *A Surgical Demonstration, c.1700. Courtesy of the Royal College of Surgeons of Edinburgh.*

of the exhibition is crucial, but is aimed not merely at imparting information on the subject (of which there are volumes), but of creating a space in which the public can develop personal meanings for themselves based both on what they know already and what they see in *Anatomy Acts*. All are united, of course, in encouraging us to learn about the body, and Scotland's fascinating medical collections, through reflection on our own bodies. The interest of many readers will be stirred by their own personal experiences of surgery, childbirth, injury and ill-health or by the current media focus on anatomy and surgery.

It is particularly important that the book and exhibition are interspersed with in-depth commissions created specially by contemporary practitioners: three visual artists – Christine Borland (Scotland), Claude Heath (England) and Joel Fisher (USA), and one poet – Kathleen Jamie (Scotland), all of whom have distinguished reputations. Collectively they illuminate anatomy's continuing significance and fascination from different positions.

The impetus for *Anatomy Acts* has come through the partnership, Scotland & Medicine:

Collections & Connections. The many partners in this new enterprise are listed in the acknowledgements, but we must make special mention of our learned and enthusiastic Scotland & Medicine colleagues without whom this project would have been impossible. We are also particularly pleased that the exhibition element of *Anatomy Acts* will tour in 2006-7 to both art- and science-related venues, where it will adjust and evolve to suit the varying contexts it encounters. This, we believe, is a fitting way to tour an exhibition of this nature.

This book we hope has some significance within Scottish cultural publishing in bringing together existing expertise, objects and information in an easily available form on the important relationship that has existed between anatomy and its visual representations over time. Even more welcome would be that it becomes a bridgehead for further critical and creative discovery in this interdisciplinary field, at generalist and specialist levels. As contemporary art and science in Scotland testify, the subject is a dynamic and expanding domain.

Foreword

The Scottish Museums Council is delighted to support *Anatomy Acts*, an initiative of the Scotland & Medicine: Collections & Connections partnership, which is one of ten projects funded by the Scottish Executive's Regional Development Challenge Fund. The aim of this fund is to build capacity and improve the sustainability of Scotland's non-national museums sector by stimulating and supporting the development of new strategic and creative partnerships across local authority boundaries, between local authority and independent museums and with national museums. The fund was established in the wake of the National Audit of Scotland's museum collections, published by the Scottish Museums Council in 2001, which demonstrated for the first time the full extent of Scotland's health-related collections: over 46,000 items, 99% of them held by no fewer than 76 non-national organisations, most of them independent or University museums.

The Scotland & Medicine partnership, whose 27 founding members include university, local authority and independent museums as well as the National Library of Scotland and the National Galleries of Scotland, is unique in being led by an independent museum: Surgeons' Hall Museum is part of the Royal College of Surgeons of Edinburgh, one of Scotland's most distinguished professional bodies and the oldest medical incorporation of its kind in the world. The project is also special because of the sheer range and number of partners it has recruited across the length and breadth of Scotland, making it a truly national project. This is as it should be, of course, since it celebrates the pioneering contribution that Scotland has made – and continues to make – to the development of medical science and health care since the days of the Scottish Enlightenment, a contribution that is well documented in the archives and collections of material objects held by the project's partners.

One of the aims of Scotland & Medicine is to promote these important historic collections to local, national and international audiences. The *Anatomy Acts* exhibition and this accompanying book do just that. It is an appropriate choice of subject, not only because of the important contribution that Scottish anatomists have made to our understanding of the body, but also because of the fascination that this topic still exercises over the public imagination. Our thanks and congratulations are due to all involved in putting together this creative partnership.

Dr Graeme Roberts
Chairman, Scottish Museums Council

Acknowledgements

The goodwill, support and expertise of literally hundreds of people has gone into the production of this book and the touring exhibition Anatomy Acts. It is a true partnership of many of Scotland's leading museums, galleries, libraries, archives and institutes of higher education. It is difficult to thank everyone by name, our apologies to those we have missed, our gratitude is no less.

Very special thanks are due: to Sara Barnes who is as much the creator of Anatomy Acts as the editors, her research and editorial piloting have shaped the project from the beginning; to Siobhan McConnachie, Scotland & Medicine's Project Manager who has created the administrative hub, orchestrating everything from budgets and fund-raising to print design and events; to Isobel McDonald and Colin Lindsay who laid solid foundations for the practical delivery of the exhibition and Andrew Hunter who completed the project; and to Max Mackenzie for his photographs which have done great justice to truly amazing objects.

At Surgeons' Hall, Andrew Connell and Caroline Smith have given tremendous support and advice and the RCSEd Fellows and staff who were members of the Anatomy Acts Specialist Advisory Group: Jim Foster, Paul Geissler and Tony Watson provided invaluable subject perspectives.

Grateful thanks to everyone at Birlinn especially Laura Esslemont, James Hutcheson and Liz Short for keeping us on track. For exhibition production design special thanks are due to David Campbell and the staff of Campbell & Co. and for hosting the exhibition the City Art Centre, Edinburgh; Collins Gallery, University of Strathclyde; Gateway Centre, University of St. Andrews; Inverness Museum & Art Gallery; Iona Gallery, Kingussie; Lamb Gallery, Dundee University; St. Fergus Gallery, Wick, and Swanston Gallery, Thurso.

Thanks to the writers and visual artists who have, through their contributions, helped all of us broaden our minds, senses and imaginations in approaching the vast subject of anatomy: Iain Bamforth, Sara Barnes, Christine Borland, Joel Fisher, John Fleming, Elizabeth Hallam, Claude Heath, Kathleen Jamie, Roberta McGrath, Duncan Macmillan, Malcolm Nicolson, George Rousseau, Jonathan Sawday and Steve Sturdy.

The Scotland & Medicine Management Group have guided and supported the development of this publication and the Anatomy Acts exhibition: Jane Coutts, Rosemary Hannay, David Hopes, Brian Hillyard, Nicola Ireland, Mathew Jarron, Jacky MacBeath, Jane McKinlay, Carol Parry, David Paterson, Helen Rawson, Maggie Reilly, Claire Smith and Sarah Vince.

For advice and help with research, loans, editing and an array of other tasks:

Ulrike Al-Khamis, Ken Arnold, James Bradburne, Caroline Brown, David Campbell, Annie Cattrell, Corrie Cheyne, Emilios Christodoulidis, Shona Connachan, John Dallas, Helen Dingwall, Tony Doherty, Ian Donaldson, Siân Ede, Marianne Eigenheer, Gordon Findlater, Maureen Finn, David Gauldie, Imogen Gibbon, Martin Gorman, Laura Hamilton, David Hardwick, James Holloway, Elizabeth Henderson, John Isaacs, Matthew Kaufman, Steve Kerr, Tanya Leighton, Nicola Lepp, Frank Little, Stephen Lloyd, Helen Luckett, Stuart McDonald, James Mcdowell, Iain Macintyre, Ishbel Mackinnon, Murdo Macleod, David Mitchell, Alison Morrison-Low,

ACKNOWLEDGEMENTS

Jennifer Melville, Andrew Morgan, Iain Milne, Rory Morrison, Sheila Noble, Ian O'Riordan, Iain Patterson, Tony Payne, Niki Pollock, Ruth Pollitt, John Reid, John Scally, Thomas Schnalke, Peter Sharp, Ann Marie Shillito, Marianne Smith, Joanna Soden, Ian Stewart, Andy Sproul, Paula Summerly, Alison Taubman, Jane Taubman, Alistair Tough, Susie Whiten, David Weston, Michael Wolchover and Margo Wright.

Scotland & Medicine Partners: City of Edinburgh Council; Collins Gallery, Strathclyde University; Edinburgh College of Art; Fetlar Museum Trust; Fife Council; Highland Council; Hunterian Museum and Art Gallery; Lothian Health Services Archive; NHS Health Scotland; National Galleries of Scotland; National Library of Scotland; Royal College of Physicians of Edinburgh; Royal College of Physicians and Surgeons of Glasgow; Royal College of Surgeons of Edinburgh; Royal Scottish Academy; Scottish Borders Council; Scottish Enterprise Edinburgh & Lothian; University of Aberdeen (Marischal Museum); University of Dundee; University of Edinburgh; University of Glasgow; University of St. Andrews; VisitScotland Edinburgh; West Lothian Council.

Anatomy Acts has been made possible by the generosity of our major funders, sponsors and supporters. Our special thanks go to the Scottish Executive and the Scottish Museums Council (Regional Development Challenge Fund); the Esmée Fairbairn Foundation; the Arts and Humanities Research Council; the Calouste Gulbenkian Foundation; the Scottish Arts Council; Edinburgh College of Art; the Strathmartine Trust, Elsevier PLC; the City of Edinburgh Council; the Royal College of Surgeons of Edinburgh and AXA ART.

Dawn Kemp and Andrew Patrizio, May 2006

EMERGING BODIES

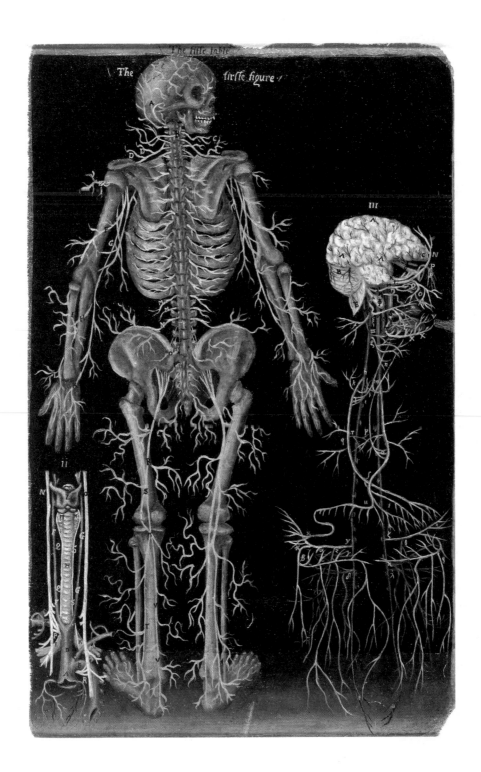

The firste figure

JONATHAN SAWDAY

The Paradoxes of Interiority:
ANATOMY AND ANATOMICAL RITUALS IN EARLY MODERN CULTURE

I INTERIORITY AND DISCOVERY

The paintings, models, drawings, diagrams, instruments, engravings, and tables assembled for *Anatomy Acts* recount the story of how, in the West, the geography of the human body was mapped over the course of nearly five hundred years. They tell us, too, how a new prospect of the human interior emerged in the mid-sixteenth century, which was associated, in the first instance, with the images and ideas to be found in the monumental *De humani corporis fabrica* (1543) (*Of the structure of the human body*) of Andreas Vesalius. The body which was thus fashioned by the anatomists and artists of the period was one that possessed both surface and depth, replacing earlier, more schematic views of the human interior. It was not, then, simply that Vesalius and his heirs *knew* more about the body – its morphology, its dynamic structures – than their predecessors. Rather, they imported new artistic and aesthetic conventions – most notably the deployment of perspective – into the process by which the interior of the human frame was represented. The creation of this new 'body' was the product of a commitment to verisimilitude, or naturalism, which can, in turn, be traced to the rise of the so-called 'New Philosophy' (a term which would later come to embrace what we think of as 'science') of the sixteenth and seventeenth centuries (Smith 2004: 18).

In the English context we could compare this engagement with naturalism and to a new

Opposite. *Anon. Skeleton, brain, nerves from John Banister: Anatomical tables. Table 5 & 6, c.1580 oil on paper; 40.5 x 56 Ms Hunter 364 (v. 1. 1) Glasgow University Library, Special Collections*

science of seeing or looking, to what might (at first) appear to be the rather different realm of the Elizabethan or Jacobean playhouse. The dramatists of the 1590s and later – Christopher Marlowe, William Shakespeare, Ben Jonson and their contemporaries – found themselves exploring the ways in which the *illusion* of psychological realism might be convincingly portrayed on the stage. Hamlet in soliloquy, for example, offers us a convincing *autopsy* (literally, seeing for oneself) of such an interior mental landscape. Hamlet's 'inwardness,' his reminder that he has 'that within which passes show' (*Hamlet* 1. 2. 85) reminds us that interiority was not only a physical, but also a psychological state in early modern culture (Maus 1991: 29). We watch and listen, as Hamlet sets about the dissection both of himself and the gangrenous body politic in which he is enmeshed, deploying the scalpel of an emerging language of self-reflection (Sawday 1997: 38). Lest this analogy seem historically far-fetched, we perhaps need to remind ourselves of the congruency of the theatres of anatomy and the theatres of drama in the early modern period, both intellectually and geographically. The civic dignitary who, in London, might have been invited to watch a three-day anatomical dissection at the Barber-Surgeons' Hall in Monkwell Street in the 1590s, when *Hamlet* was produced on the London stage for the first time, would have witnessed a complex, multi-layered performance, governed by ritual as much as by the dictates of science (see below, p. 000). This same space (if the permission of the Court of the Company had been obtained) might also be used for the

performance of 'plays or daucing or for... other like entente' (Dobson 1979: 78). From the theatre of anatomy it was a short walk over London Bridge to the playhouses where a different kind of performance, equally spectacular, was enacted.

Comparing the natural or organic body to the body politic, as well as to the larger 'body' of the world was a habit of mind that came almost unbidden to the sixteenth or seventeenth century anatomist, poet, or playwright. The human microcosm and the macrocosm existed in creative tension with one another. 'O my America! My new-found-land/My kingdome, safeliest when with one man mann'd' was the English poet, John Donne's, exultant yell of feverish sexual possession, as he laid his hand on the body of his mistress, and thus 'opened' her to erotic, if not anatomic, discovery (Donne 1937: 107). To 'open' a body, or a continent, was not only to know it, but also to own it in some way. Hence, Donne's proprietorial gesture was to be repeated by the anatomists who, like the heroic voyagers into the newly encountered (and darkly mysterious) interior of the Americas, scattered their names promiscuously across the human body, as they opened it to discovery. The early eighteenth-century Italian anatomist, Giovanni Domenico Santorini, for example, was responsible for naming no fewer than twelve eponymous features of the body – Santorini's Duct, Santorini's vein, and so on. In this, he was emulating not only his famous anatomical predecessors – Fallopius or Eustachius – but the post-Columbian explorers and (later) colonialists, who were busily opening the New World to

trade, commerce, the Christian Bible, disease, and the armed adventurers of Portugal, Spain, and (later) Britain. If 'America' was itself, an eponym as well as a place, why should not the new world of the human body similarly commemorate its new discoverers?

Planting their own names on the body's interior, in much the same way that the explorers and discoverers claimed whole continents in the name of their respective sovereigns, or commemorated their friends and patrons by submitting geography to European systems of nomenclature, the anatomists were participating in that great enlightenment project by which the world, and all that it contained, was systematized and regulated. This was, however, very far from a disinterested collegial undertaking. Rather, these early voyages into the human interior were often the occasion of intense rivalry – bravura displays of Renaissance intellectual machismo. In Bologna, for example, notices of a forthcoming dissection would be posted around the city, in much the same way that a play might be advertised. The record of a medical student, Baldasar Heseler, who witnessed Vesalius conduct a series of anatomical 'demonstrations' in the church of San Francesco in Bologna in the winter of 1540 hints at the ways in which such public demonstrations must often have seemed more like gladiatorial combats, rather than disinterested 'scientific' enquiries or instructive lessons on the composition of the human interior. The dramatic entrance of Vesalius into the crowded auditorium – five hundred students were said to have attended the 1540 cycle of lectures – would initiate

the demonstration (Carlino 1999: 46-7). The performance might be punctuated by applause as Vesalius demolished the opinions of anatomical rivals – both ancient and modern– with the help of his scalpel and the opened cadaver.

However, such stories of heroic discovery – or heroic squabbling – just as in the case of the subsequent histories of the newly 'discovered' indigenous peoples of the Americas, also conceal a more disturbing history. This story is rooted, unambiguously, in human cruelty and misery. To this history we must now turn if we are properly to understand the creation of these new visions of human interiority.

II 'MONUMENTS OF SHAME'

One of the elements that a visitor to an anatomy museum might find striking, even disturbing, is the sheer *corporeality* of the items on display. We might think of ourselves as being relatively inured to the topography of our own interior, given the vast range of media – film, ultrasound, TV, X-rays, MRI scans, CT scans, photography, and so on – now available to the medical technologist. But all such images are, in the end, mediated by the very technology that allows them to be reproduced. For all that they represent the living human interior in astonishing detail, they may often seem strangely anodyne in comparison to these earlier images which were mediated by artistic skill, rather than the computer screen or the TV monitor.

The visceral 'corpo-reality' of these earlier scenes (as opposed to the digital reality of our own technology) is a function of the circumstances that brought these images into existence. This history is not, however, a comfortable one. Many of these images were designed to serve a dual purpose. If they reflect the growing 'medicalisation' of the body, they also emerge from a world in which they were held to serve a wider moral purpose. Moral didacticism was as important (sometimes, indeed, far more important) than any commitment to a rational understanding of the body's functions. So these images are, on the one hand, monuments which commemorate the ever more skilful anatomists who, in the period before the advent of William Harvey, believed themselves to be, at first, 'resurrecting' or emulating the ancient anatomical project of classical antiquity, to be discovered in the writings of Galen, Hippocrates and the Arabic medical tradition (Cunningham 1997: 7). As time went by, however, this sense of the body being *re-discovered* by Renaissance learning was jettisoned as the anatomists began to sense that they, rather than their classical predecessors, were in possession of a more complete understanding of the body's interior structures and processes. But, at the same time, the earlier images and artefacts gathered together in this exhibition are also monuments to a much more disturbing reality. This was the reality in which a man's or a woman's body was transported, amidst a howling mob, from the gaol to the executioner's scaffold, and thence to the anatomy theatre.

Thus, many of the Scottish and English specimens in pathology and anatomy collections if they were produced before 1832 (the date of the passing of the Anatomy Act which regulated dissection throughout the British Isles until well

3

into the late twentieth century), are rooted not just in medical history, but also in the closely allied histories of punishment and poverty. The same is also true, of much of the earlier material derived from continental origins. What we are contemplating, in other words, is another type of memorial – a memorial to the often-nameless individuals whose bodies were either unclaimed by their friends and relatives, or else who had died at the hands of the executioner. In Scotland in 1505, Edinburgh Town Council granted the new Incorporation of Surgeons and Barbers the right to one executed criminal a year for anatomical dissection. This was ratified by James IV in the following year. England was to follow suit when, in 1540, similar provision was made by Henry VIII for the newly united companies of Barbers and Surgeons in London (Richardson 1989: 32). Generations of anatomists, dissectors, and their students and assistants, throughout the sixteenth, seventeenth, and eighteenth centuries, may have proclaimed that their discipline was a disinterested exploration of the hidden secrets of the human interior. In the eyes of the legal authorities however (as well as in the popular mind), the dissection of the corpse was more commonly perceived as the final act in a drama of retribution and punishment. In this drama, the body of the condemned felon was first hauled from the gallows and delivered into the hands of the anatomists and their servants, sometimes amidst scenes of near riot as relatives and friends of the condemned man or woman struggled to retrieve the corpse. From the gallows, the body would be conveyed to the public arena of the anatomy theatre. Writing in 1725, the poet, political philosopher, pamphleteer, and physician, Bernard Mandeville, has left us something of the flavour of the spectacle which acted as a grisly prelude to the reception of the corpse by the medical men:

> 'The Tragedy being ended, the next Entertainment is a squabble between the surgeons and the Mob, about the bodies of the Malefactors that are not to be hanged in chains. "They have suffered the Law" (cries the Rabble,) "and shall have no other barbarities put upon them:" "We know what you are, and will not leave them before we see them buried… a Fray ensues." ' (Mandeville 1725: 26)

Anatomy was a 'barbarity' considered worse than gibbeting – the exposure of the criminal corpse to gradual (and public) decay. Mandeville's language ('tragedy', 'entertainment') reminds us, once more of theatricality. Theatricality – the sense of anatomy being a performance – similarly informed the last of William Hogarth's engravings of the *Four Stages of Cruelty* (1751) [fig. 1]. In Hogarth's famously satirical image, which is itself a parody of the title-page of the *De humani corporis fabrica* of Vesalius [fig. 2], we can see how eighteenth-century observers had already begun to shrink from the ghastly quasi-legal ritual to which the bodies of the poor, the outcast, and the condemned were subjected. Hogarth's sequence of images recounts the history of the pauper boy, Tom Nero (in whose name, of course, there is a reminder of the classical epitome of cruelty). Convicted of

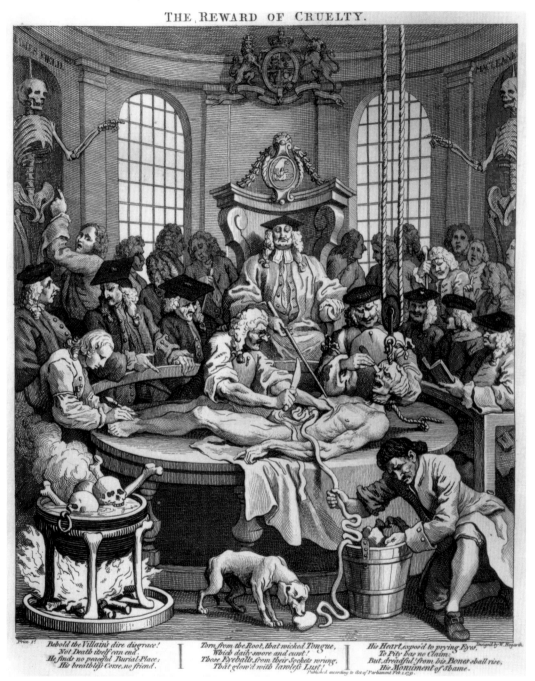

Fig. 1 *William Hogarth,* The Four Stages of Cruelty: The Reward of Cruelty. *1751.*
Photo © Hunterian Museum and Art Gallery, University of Glasgow.

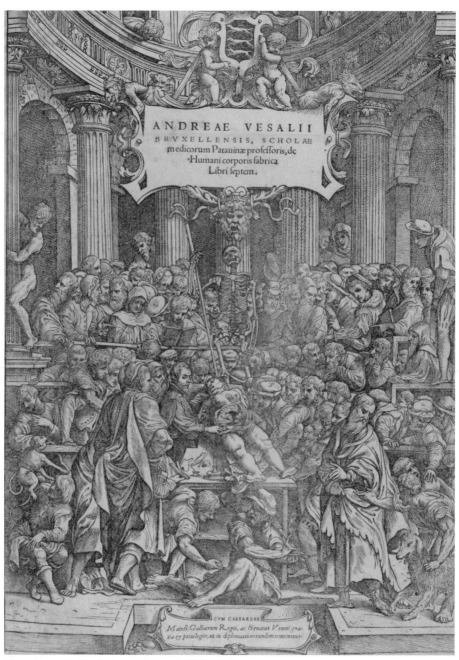

Fig. 2 *Andreas Vesalius, De humani corporis fabrica Basle, 1543.*
Glasgow University Library, Dept. of Special Collections.

robbery, and executed, he lies now on the anatomist's table. The verses appended to the image point the moral for us:

> 'Behold the Villain's dire Disgrace!
> Not Death itself can end.
> He finds no peaceful Burial-place
> His breathless, Corse, no friend.'
>
>
>
> 'His Heart, exposed to prying Eyes
> To pity has no claim:
> But dreadful! From his Bones shall rise
> His Monument of Shame.'

Increasingly, dissection was considered to be 'brutality writ large and given an official blessing' (Porter 2003: 224). Hogarth's image is replete with ideas of disgrace, shame, and disgust, culminating in the exposure to 'prying eyes' (and canine jaws) of the intensely private kernel of the body – the human heart. The dog which gnaws at Tom Nero's discarded heart is revenging himself on the former inhumanity of the victim of dissection, whilst in the guts and viscera which are being casually emptied into a pale, Tom is being emptied of his human core. Nearly one hundred years after the publication of Harvey's researches into the operation of the heart, lungs, and circulatory system of the blood, to be found in his *De motu cordis* ('Of the Motion of the Heart') of 1628, the heart was still believed, at least in the popular mind, to be the 'seat' of the affections and passions – joy, sorrow, hope (Erickson 1997: 12). It was, in other words, a vital part of what made us human.

The *Four Stages of Cruelty* culminate, then, in a scene of abjection. Abjection, too, can be glimpsed in the rather more coolly detached image of Rembrandt's famous dissection scene, *The anatomy lesson of Dr Nicolaes Tulp* [fig. 3]. Commissioned by the Amsterdam surgeons in 1631, the painting commemorates an emerging Cartesian understanding of the human form, in which the body is analysed in terms of a machine. As Tulp, the anatomist, pulls delicately on the sinews of the dissected arm of the corpse, so its fingers curl, in echo of the gesture which he, too, is making with his own (living) hand. But this 'machine', the body of the executed felon, also had a name. So, more properly, the painting ought to be entitled 'The Anatomy of Adriaen Adrianenszoon', for that was the name (or at least one of the names) of the subject of Tulp's anatomy. Adriaenenszoon, a citizen of Leiden, was executed on 31 January 1631 for the crime of stealing a coat (Sawday 1995: 148). So, as well as proclaiming the skill and dexterity of the anatomist, Tulp, Rembrandt's image memorialises 'an act of penal and sovereign domination, exemplary and substantive, symbolic and material at one and the same time' (Barker 1984: 74).

Hogarth's Tom Nero (as much as Rembrandt's Adriaenenszoon) is dead, and he is hence (we might assume) beyond any sensible appreciation of what has happened to his body. Yet, Hogarth, in keeping with the conventions of 'living dissection' handed down from Vesalius [fig. 4], in which the body is presented (impossibly) as if it were still alive to the world around it, suggests that there is still a remnant of feeling within the eviscerated corpse, and this may well have reflected a wider, popular view in the early-modern period: that death was, in some measure, a liminal state. Life and death were then perceived (far more than now) as a continuum rather than states of absolute

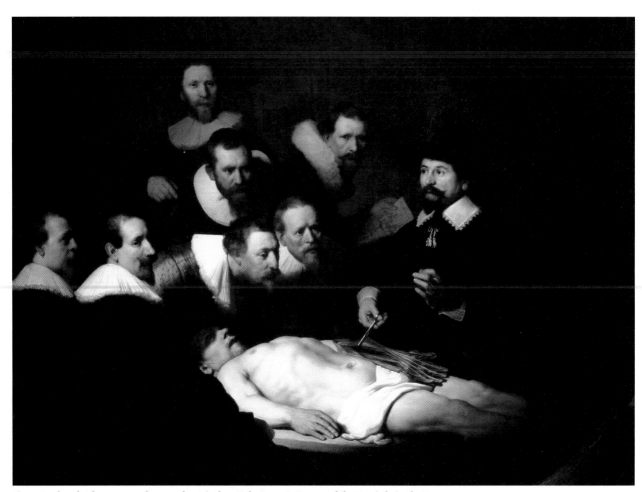

Fig. 3 *Rembrandt*, The anatomy lesson of Dr Nicolaes Tulp *(c. 1632). Courtesy of The Mauritshuis, The Hague.*

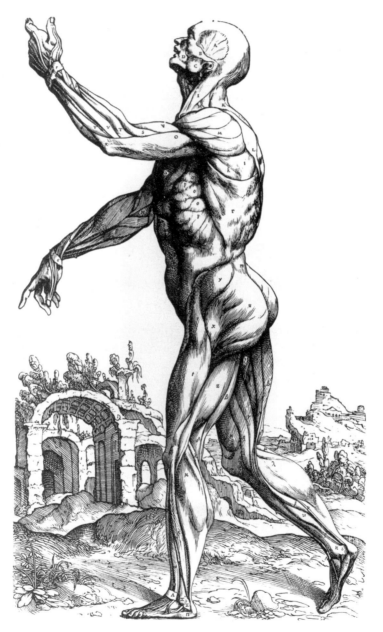

Fig. 4 *Andreas Vesalius, Secunda Musculorum Tabulae*. De humani corporis fabrica, *Basle, 1543.*
Liber II, page 174. Glasgow University Library, Dept. of Special Collections.

difference (Gittings 1988: 13). After life, one joined the transitional community of the dead, there (so it was believed) to await the general resurrection. But, turned over to the anatomists, a secular resurrection might come about rather sooner than one might have hoped. There is no account, in the historical record, of any anatomist *consciously* dissecting the living. But anatomists were always keen to garner freshly killed corpses which thus had a much higher intellectual and monetary value. In the seventeenth century, too, the search for the Cartesian 'seat' of the soul had begun to stir the ambitions of the anatomists, who believed, at one stage, that dissecting the pineal gland (which, it was also thought, decayed rapidly after death) might deliver this ultimate prize of human interiority. So the demand for corpses which had barely ceased to breathe became all the more pressing. Undoubtedly, 'mistakes' were made. There are numerous accounts of men and women (a freshly executed young woman, because of her rarity, was a valuable commodity) hurried from the scaffold only to revive on the dissector's table. The antiquarian, John Stowe, recorded such a horrifyingly Lazarus-like moment which took place in London in the February of 1587, the barber-surgeons having 'begged' the body of a recently executed criminal:

> '…after hee was dead to all mens thinking, cut downe, stripped of his apparel, laide naked in a chest, throwne into a carre, and so brought… to the Chirurgeons's Hall nere unto Cripplegate: the chest being there opened, and the weather extreeme cold hee was found to be alive….' (Stowe 1594: 1261)

Popular fear of the anatomists ran deep, and it

was a fear that the authorities, particularly in England, sought to exploit in the mid eighteenth century through the passage of the so-called Murder Act of 1752. Passed the year after Hogarth had produced his disturbing exploration of the cruelty perpetuated by, and on, Tom Nero, this act (25 Geo. II. c. 37) was promulgated to 'better prevent the horrible crime of murder', and codified the full, ferocious practice of 'penal anatomy'. Anatomical dissection was now understood as a means of impressing on the populace 'some further terror and peculiar mark of infamy… added to the punishment of death' (Sawday 1995: 54). The goddess *Anatomia*, whose attributes were the mirror of self-knowledge and the dissecting scalpel, was a voracious deity, consuming the bodies of men and women at rates which the scaffold, was barely able to match [fig. 5].

III REDEMPTION

So, *Anatomy Acts* is, at least in part, a monument to infamy, shame, and misery. We should not neglect to tell this story, even if we are also celebrating the skills and curiosity of those earlier explorers, from whom we have derived incalculable benefit in the emergence of modern medicine. But an exhibition about anatomy is also, paradoxically, a monument to redemptive, even sacramental, structures of thought. It is on this note that I should like to conclude this account of the search for interiority in the early-modern period.

In 1662, the diarist Samuel Pepys (who had a lively interest in surgical matters, having survived the dangerous operation of being 'cut for the stone' four years previously) witnessed a dissection

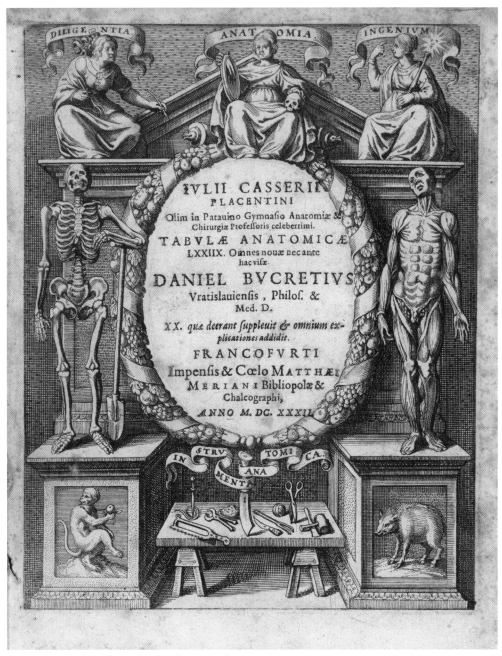

Fig. 5 *Julius Casserius, title page from Tabulae anatomicae, 1627.*
Courtesy of the Department of Special Collections, University of St Andrews Library.

in the new anatomy theatre, designed in 1636 by Inigo Jones at Barber-Surgeons' Hall, in London. The subject of the dissection (wrote Pepys) was 'a lusty fellow, a seaman that was hanged for a robbery'. After the day's work was over, and having had a fine dinner, Pepys returned to the theatre in the company of the famous physician Dr Scarburgh 'to see the body alone'. 'I did touch the dead body with my bare hand' Pepys recorded in his diary, later that evening: 'it felt cold, but methought it was a very unpleasant sight' (Pepys 1938: 54). Reaching out to touch the executed criminal's body, Pepys was not merely hungry for new sensation or indulging a certain degree of morbid curiosity. For, in England, as elsewhere in Europe in the seventeenth century, the body of an executed criminal was held to be therapeutic – the conduit of a semi-magical curative power (Linebaugh 1975: 109). We can understand this belief as a mirror of older patterns of belief (recently revived, in Pepys's time, with the restoration of Charles II) that the King's touch possessed similar power to cure disease. This story alerts us to the larger patterns of belief within which we need to understand the search for interiority in the early-modern period. For the body – even the body of the most criminally outcast – was still considered to be the handiwork of the creative power of God. More than this, it was the shell or vessel within which had once been contained the precious substance of the soul. It had to be approached, therefore, by the anatomist with some degree of caution, even reverence, at least in theory. This redemptive view of the body may strike us as odd, given the chaotic scenes of disorder from which it had been so recently conveyed. Redemption, too, is

conspicuously absent from Hogarth's image, which might have made the cruelty on display even more shocking to an eighteenth-century observer. Nevertheless, the sense of the body as a divine structure helps to account for the fantastic rituals that came to surround the corpse once it had been unveiled within the anatomy theatres. In Italy, public dissections would normally take place (appropriately enough) during the carnival period of late January and February, which was also, of course, the coldest time of the year (Ferrari 1987: 104). This tradition, along with others, was preserved in Northern Europe, where we read of the processional entries into the anatomy theatre, the playing of music during dissections to amuse the spectators (some of whom might have paid for their seats), and the elaborate costumes of the assembled physicians.

Similarly, the ornate decoration of Jones's now vanished theatre (it was demolished in 1784) told a complex story, uniting this new science with scriptural tradition, the corresponding histories of the microcosm and the macrocosm, and political power. Thus, when Pepys reached out to touch the dismembered corpse of the 'lusty' seaman, he stood beneath the elaborately carved figures of the liberal sciences, the signs of the zodiac, representations of Adam and Eve, and the image of the slaughtered Charles I (Hatton 1708: 597). In this respect, the anatomy theatre was much more than an auditorium. It was also a temple of mortality, in which the human form – itself understood as a 'temple' fashioned by God – was gradually dismembered. We can see these ideas at work, too, in the decoration of the great anatomy theatre at the protestant University of Leiden, where many English and Scottish students

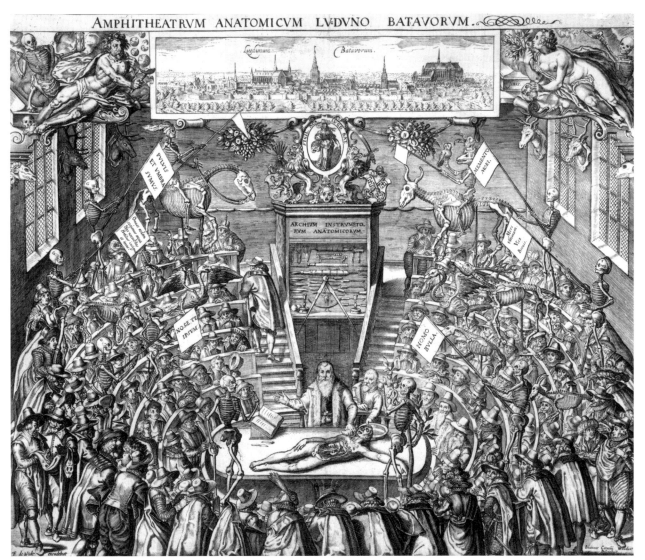

Fig. 6 View of the Leiden Anatomy Theatre, 1644, *after an earlier print, c. 1609. Leiden University Library. Port. 315-III, no. 19.*

of medicine were trained in the late sixteenth and seventeenth centuries, and which was originally constructed inside a church, parts of which were still consecrated [fig. 6]. On the title-page of Vesalius's work, published in the same year (1543) in which the astronomer, Copernicus, produced his *De revolutionibus orbium coelestium* ('On the Revolutions of the Celestial Spheres'), a similar network of theological and philosophical ideas surrounds the body. Copernicus had suggested a new image of the relationship of the earth and the heavenly bodies, revolving heliocentrically rather than geocentrically. So, we can think of the artist responsible for the image that prefaced Vesalius's exploration of the interior microcosm of the human form as offering a kind of riposte to Copernican mathematics. Surrounded by an audience, in an imaginary theatre of anatomy, Vesalius, with one hand opens the womb of the cadaver, whilst with the other hand he makes the familiar deictical gesture of the Renaissance orator, pointing upwards towards the heavens and towards the skeleton which stands in the midst of the crowded room. The womb signifies our point of entry into the world, and around it the entire image revolves, concentrically, as though this were some anatomical version of the Copernican universe, whilst the skeleton is a *memento mori* – a reminder of our mortality. That gesture of Vesalius's hand, however, also reminds us of the flight of the soul, upwards towards heaven, abandoning the empty shell of the newly eviscerated cadaver.

The exploration of the structure of the human body in the early modern period, out of which emerged our own, modern, understanding of the body's inner recesses and processes, was *never* a disinterested undertaking. Rather, it was compounded out of jarringly discordant, even contradictory, elements. In the late sixteenth century, John Donne – in whose poetry the anatomical is never far from the surface – explains something of the nature of these contradictions. What did interiority amount to? Donne's poem 'The Extasie' struggles to find an answer. The body is not simply 'drosse', but then neither does it represent the entire human being: bodies, he continues, are 'ours, though they are not wee'. The body is, rather, a 'subtle knot' – a union of the material and the immaterial – in which we can learn some larger lesson in human experience:

> 'To'our bodies turne wee then, that so
> Weake men on love reveal'd may looke;
> Loves mysteries in soules doe grow,
> But yet the body is his booke.'
> (Donne 1937: 48)

To read and interpret this 'book' of the body, in which 'love' (in both the sacred and the profane sense) was made incarnate, was the whole endeavour of the anatomists who have left us these fragments. That these same fragments were fashioned out of a curious mixture of the poetic, the scientific, the spectacular, the pious, and the cruel, makes them all the more alluring.

REFERENCES AND FURTHER READING

Barker, F. 1984. *The Tremulous Private Body: Essays on Subjection*. London and New York: Methuen.

Carlino, A. 1999. *Books of the Body: Anatomical Ritual and Renaissance Learning*. Trans. John Tedeschi and Anne C. Tedeschi. Chicago and London: The University of Chicago Press.

Cresswell, C. H. *The Royal College of Surgeons of Edinburgh: Historical Notes 1505 – 1905*. Edinburgh: Oliver and Boyd.

Cunningham, A. 1997. *The Anatomical Renaissance: The Resurrection of the Anatomical Projects of the Ancients*. Aldershot: Scolar Press.

Dobson, J. 1979. *Barbers and Barber Surgeons of London: A History of the Barber-Surgeons' Companies*. Oxford: Alden Press.

Donne, J. 1937. *Poetical Works*. Ed. Sir Herbert Grierson. London: Oxford University Press.

Erickson, R. A. 1997. *The Language of the Heart 1600 – 1750*. Philadelphia: University of Pennsylvania Press.

Ferrari, G. 1987. 'Public Anatomy Lessons and the Carnival: The Anatomy Theatre of Bologna', in *Past and Present* 117: 50 – 106.

Gittings, C. 1984. *Death, Burial and the Individual in Early Modern England*. London: Routledge.

Hatton, E. 1708. *A New View of London*. Vol. 2. London.

Linebaugh, P. 1975. 'The Tyburn Riot against the Surgeons' in Hay, D., Linebaugh, P., Rule, J., Thomson, E. P. *Albion's Fatal Tree: Crime and Society in Eighteenth-century England*. Harmondsworth: Penguin Books.

Mandeville, B. 1725. *An Enquiry into the Causes of the Frequent Executions at Tyburn*. London.

Maus, K. Eisaman. 1991. 'Proof and Consequences: Inwardness and Its Exposure in the English Renaissance' *Representations* 34: 29 – 52.

Pepys, S. 1938. *The Diary*. Ed. Henry B. Wheatley. Vol. 3. London. G. Bell and Sons Ltd.

Porter, R. 2003. *Flesh in the Age of Reason*. New York and London: W. W. Norton & Company.

Richardson, R. 1988. *Death, Dissection and the Destitute*. London: Penguin Books.

Sawday, J. 1995. *The Body Emblazoned: Dissection and the Human Body in Renaissance Culture*. London and New York: Routledge.

Sawday, J. 1997. 'Self and Selfhood in the Seventeenth Century' in Porter, R. (Ed.) *Rewriting the Self: Histories from the Renaissance to the Present*, London and New York: Routledge.

Smith, P. H. 2004. *The Body of the Artisan: Art and Experience in the Scientific Revolution*. Chicago and London: The University of Chicago Press.

Stowe, J. 1594. *The Annals of England*. London.

GEORGE ROUSSEAU

A Sympathy of Parts:
NERVOUS SCIENCE AND SCOTTISH SOCIETY

The durability of nerves had been loosely classified according to social class and gender by the 1730s in England: the higher your social echelon the more gradated your nerves, especially if you were female. Men then were also 'nervous', but apparently with fewer variations – from 'weak to strong' – than women. It was unclear precisely what the anatomists meant by 'weak nerves' and 'strong nerves', except that these concepts were widely disseminated and routinely invoked. When, for example, one of Dr Thomas Dover's adversaries lost no opportunity to trash the efficacy of 'Dover's Powders' – an alleged panacea for all ailments – his diatribe included this account:

> 'At first, the Spleen was said to be the entire Property of the Court Ladies; here and there indeed a fine Gentleman was pleas'd to catch it, purely in Complaisance to them. Soon after, Dr. Ratcliffe [sic] out of his well-known Picque to the Court Physicians, persuaded an Ironmonger's Wife in the City into it, and prescribed to her the Crying Remedy of carrying Brick-dust; the City Physicians took the Hint; and the Country Doctors remov'd it into the Hundreds of Essex, whence a learned Academick brought it with him to Cambridge: Soon after it was heard of in the Fenns of Lincolnshire, and it crossed the Humber in 1720. The Contagion [of spleen] has at last extended itself into Northumberland.'

A preposterous history of the nerves by any measure, yet infectiously vivid. But there had also been other versions of this 'nervous sweep' over

Opposite. *Jan Wandelaar (1697-1759). Plates for Bernard Siegfried Albinus,* Tabulae Ossium Humanorum, *Leiden 1753. Royal College of Physicians of Edinburgh*

Britain, here portrayed as miasma in the air. Even so, 'Spleen' could not have existed without the anatomical nerves, especially 'delicate nerves', a fact anatomists since the Renaissance had noticed. The attribution to John Radcliffe, Queen Anne's Physician after whom the Radcliffe Camera in Oxford University was named, remains fiction: there is no evidence he cajoled an ironmonger's wife to stop her tears by carrying brick-dust through the city (a superstitious remedy for hysterical grief). The flames the author recounts, ripping across the burnt English plain, is colourful but simply fanciful.

A year after the publication of this risible passage another more extended pronouncement appeared. This was Doctor George Cheyne's *English Malady* (1733), a best-selling book that explained why the English were so melancholic, even suicidal [figs. 1 & 2]. Cheyne's theory was more convincing than Dover's, while also embedding a vitalist physiology that the mind stirs the body towards diverse 'motions' and renders it 'nervous'. The basic tenet was that increased affluence and luxury under the Hanoverians had produced a 'soft life' that was weakening bodily constitution. People grew obese, eating themselves into the grave, not exercising, and keeping late hours, producing broken sleep or no sleep. The new lifestyle shattered their nerves by weakening (what we would call) their immune system: turning them into depressives, and driving them to 'self-harm'. Cheyne's account seems commonplace now, but in the 1730s its novelty burned off the page – with this difference: today people of most socio-economic classes can indulge in the 'soft life' but then – in the early eighteenth century – only the upper classes could. A Scottish physician based in Bath at the end of the eighteenth century remembered Cheyne's generation this way:

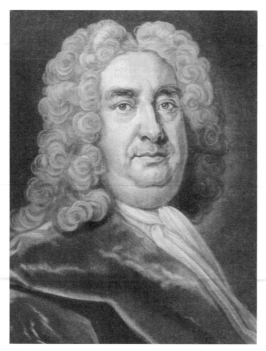

Fig. 1 *Johannes Faber Junior after Johan Van Diest. George Cheyne. 1732. Scottish National Portrait Gallery.*

'Upwards of thirty years ago [i.e. *c*.1760], a treatise of nervous diseases was published by my quondam and ingenious preceptor DR. WHYTT, professor of physick, at Edinburgh. Before the publication of this book [i.e. Whytt's *Treatise on the Nerves*, 1764] people of fashion had not the least idea that they had nerves; but a fashionable apothecary of my acquaintance, having cast his eye over the book, and having often been puzzled by the enquiries of his patients concerning the nature and causes of their complaints, derived from thence a hint, by which he readily cut the

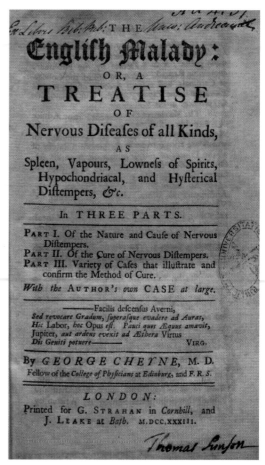

Fig. 2 *Title-page. George Cheyne. 1733. The English Malady. Courtesy of the Department of Special Collections, University of St. Andrews Library.*

Gordian knot – 'Madam, you are nervous'; the solution was quite satisfactory, the term [nervous] became quite fashionable, and spleen, vapours, and hyp, were forgotten.'

Fig. 3 *Title-page. 1680. Thomas Willis, facsimile copy.* The anatomy of the brain. *National Library of Scotland*

FIVE TREATISES,

VIZ.

1. Of Urines.
2. Of the Accension of the Blood.
3. Of Muscular Motion.
4. The Anatomy of the Brain.
5. The Description and use of the Nerves.

BY

THOMAS WILLIS, M.D.

LONDON:

Printed for *T. Dring, C. Harper, J. Leigh,* and *S. Martin,*
MDCLXXXI.

This was Doctor James Makittrick, who later took the name 'Adair' and whose version of the new vocabulary is as preposterous as Dover's geographical miasma, but it demonstrates the perception then of swift contagion. We shall return to these Scottish doctors, Whytt and Adair, both based in Edinburgh. To understand the transition, however, we must first flash back three generations to the England of neuroanatomist Thomas Willis in the Restoration [fig. 3]. He was the most innovative brain theorist of his century and published the first comprehensive books on the brain and nervous system in Europe. He improved on his Renaissance predecessors, especially Leonardo da Vinci, by suggesting that specific parts of the brain (i.e. the cerebrum) are localized for specific functions, and

elevated the nervous system – especially the cranial, spinal, and autonomic nerves – in the body's system of health and disease, as well as the brain's role in attention and awareness in realms we call cognitive. His master plan was nothing less than 'to unlock the secret places of Mans [sic] Mind'.

It was a tall order. Both anatomically educated persons and lay folk in Willis' epoch learned about the nerves from sources other than anatomical books [fig. 4]. Still, there was no doubt that the anatomists disseminated their knowledge to the medical professions – including apothecaries, barbers, surgeons, midwives – and further afield to quacks and mountebanks. Popular lore also played a role in the dissemination, as did poetry, such as Flemying's *Neuropathia*, but as philosophers – especially Willis' own student, John Locke – began to comment about 'Man's Nature' their explanations increasingly centred on 'an Anatomical consideration of the Brain and Nerves' [fig. 5].

Locke, Shaftesbury, and Addison were especially vocal. Locke had studied medicine and was particularly alert to Willis' revolutionary 'nervous science'; even after he became a philosopher in the 1680s and wrote about the way human beings acquire and structure ideas in his famous *Essay concerning humane understanding* (1690), Locke acknowledged that nervous anatomy played a part in these processes. He was particularly eager to understand the relation of sensations to systems of associated higher thoughts, especially the acquisition of abstract ideas and formation of a 'science of mankind'. His student, Shaftesbury, developed the aesthetic dimension: beginning with the postulate that human beings are passionate as well as rational creatures, and aroused to do

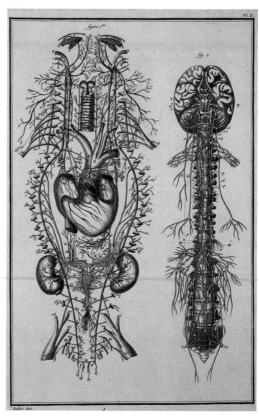

Fig. 4 Brain and spinal cord after Eustachius. *Wellcome Library London.*

good – benevolence – when responding to aesthetic beauty, he demonstrated that 'virtue' was a moral act also implicated in the new physiology. Addison, the foremost literary critic of his day, extemporised these ideas, claiming that the 'body of man' plays an important role in the performance of good thoughts and deeds.

The philosophical contribution was powerful but rarely explicit about the body's interventions in thought processes, this despite Newton's magisterial influence then. The philosophers pursued awareness and moral consciousness as cognitive processes, but always stopped short of explaining how human anatomy conducted signals to the mind, which presumably acted on the pulsations. Newton, as we saw in the discussion of Cheyne, had implied a mechanistic physiology. But it was left to Scottish philosophers, rather than English, to supply the missing links.

Chief among these were David Hume and Adam Smith, although Frances Hutcheson had also paved the way. Hutcheson extended Shaftesbury's enquiry to try to understand the source of our 'ideas of beauty and virtue'. Yet 'body and mind' never lay far from his imagination: he read the medico-anatomical literature, kept abreast of its debates, imported it to his moral philosophy. Adam Ferguson, another of these philosophers, also harboured a sense of the 'nervous body' as the foundation for his thought about the way nations advance 'morally and materially' towards the mature state of commerce, refinement, and liberty. But it was Hume and Smith who showed the full force of philosophical input.

Hume, however sceptical about hypotheses and theories, and however doubtful that everything can be known, transported his caution to the realms of physiology and medicine. He was especially vigilant to distinguish between 'the conjunction of events' (A and B) and the attribution of one event (A) to another (B) as its root cause. He saw deeply into the 'nervous body' as the 'engine enabling all motion', cognition and

Fig. 5 *Title-page. Malcom Flemying. 1740. Neuropathia. Courtesy of the Department of Special Collections, University of St Andrews Library.*

abstract thought. Smith, for his part, also maintained friendships with leading Edinburgh anatomists and doctors, and with them conjured ways to establish *laissez-faire* medical care. His fame rests on the genesis of a 'science of wealth',

yet often by reasoning upward from 'the body of man.' It strains the biographical record to believe he could have accomplished this pioneering work without anatomico-medical liaisons. We shall see that William Cullen – the pre-eminent 'nerve man' of Edinburgh – was his lifelong friend.

'Feeling' – not merely the broad emotional state but in its full range from initial sensory impressions to higher associated ideas – drove whole segments of these systems of belief. In Hume, especially in his *Treatise of Human Nature* (1739), feeling is the force driving the body forward. In Smith, feeling and pleasure are inextricably tied: both fundamental to his 'science of wealth'. In others, feeling was being viewed as intrinsic to the rational faculties. The older view – inherited by Alexander Pope and the poets – that 'reason and passion' were antitheses had given way. As they did, an emphasis on sentiment gathered: in religion, morals, and daily life, as well as in the biological sciences; not so differently from the way the 'nervous body' was seen to be steering the mind, as its vassals commandeered the brain without which all human beings would be rendered ineffective. No wonder the Age of Hume and Smith was loosely being referred to as the 'Age of Sentiment'.

These thinkers distinguished between feeling and sympathy. If 'feeling' held sway over all the domains of human activity, 'sympathy' was the coordination of its (i.e., feelings') components. That is, sympathy was a 'correspondence of parts': a yielding to, and bending from, emotional states. A century earlier, the doctors (for example, Kenelm Digby) had explained the precise mechanisms of these 'correspondences': how one anatomical

region bends to another, in health and illness. Diseased organs 'correspond' with 'healthy' ones geographically 'far away'; the 'sympathetic correspondence' transforms the 'body's regimen'. The philosophers and 'system builders' imported such physiological theories, and by the time Cheyne and Hutcheson, Hume and Smith wrote, 'sympathy' was fundamental to the physiological body of man [fig. 6]. These philosophers also

Fig. 6 *Drawn by Ego, Engraved by F. C. Hunt.* Oh! There's something in my eye! I wish you'd take it out, there's always something the matter with me! *Wellcome Library London.*

analogised from the 'body of man' to the 'civic body'. What remained to be explained were the interstices: how one domain of thought, one 'part of society', affected another. Even the 'sympathy of nations', as Smith construed it, was a category of explanation for developing nation-states in the eighteenth century – so central was physiology to the dominant cultural discourse of the time.

Anatomical 'sympathy' did not leave 'sensibility' behind. It was only a small step from 'sympathy of parts' to a generalized 'sensibility' that magnified the role of feelings within one person. The logic was straightforward: body parts 'corresponded' through processes of anatomical sympathy; such 'correspondence' proved that no part of man's body existed in isolation; similar 'sympathetic correspondences' also existed between human beings. We are 'sympathetically aroused' when we see a fellow creature in distress. Poverty, such as is found among beggars and street urchins, 'sympathetically' elicits feeling within us and drives us to 'do good'.

This physiological 'sensibility' underlay all theories of benevolence. And the philosophers grasped that 'doing good' was not merely an act committed because the Samaritan had been told to do so in Sunday church, but because his body was especially enabled through its nervous physiology. Still, some folk are more disposed than others: this was the point where the cults of civic sympathy and social sensibility were contested. Women and the upper classes were alleged to be more predisposed than men, especially rustics and workers. When asked why, the reply was that 'their nerves were more delicate'; hence their bodies more finely attuned to comply – consciously or

unconsciously – with these 'processes of correspondence and sympathy'. The deduction was that the 'nerves' of individuals reflected their race, class, gender, or age. We have returned full-circle to the curious pronouncements above when 'the term nervous became quite fashionable'.

Such benevolent 'sensibility', or 'doing good', was not limited to persons but extended to countries – indeed entire civilizations. The view was that primitive societies had historically given way to more civilized ones in proportion to the numbers of 'civilized members' within its population. By a process of extension, the whole world was 'sympathetically linked'. But how could these 'sensible citizens' be distinguished from the rest? By the delicacy of their nerves, went the explanation. Willis and Cheyne had laid the basics; now the Scottish philosophers supplied the missing links. Kames may have focused on agricultural progress and legal advancement, but the bedrock of his belief assumed a progressively 'nervous man'. The same for Lord Monboddo, his comrade in the 'Select Society' of fifteen eminent Scots: Monboddo studied the historical progress of language in different civilizations, only to conclude that neuroanatomy – the brain – had determined the gradations from ape to man, from primitive to civilized man. Even Bernard Mandeville, the Anglo-Dutch economist-physician who lived at the turn of the eighteenth century, spent many years expounding how conditions such as hysteria – the malady of 'weak nerves' – always indicated a civilized society.

The social milieu of these anatomists and philosophers was more optimistic than ours. Despite Smith's caution and Hume's sceptical

debunking, a pervasive sense existed that everything that could be known, eventually would be, and that even 'the Mystery of Man's Mind', as Willis had written, would reveal its secrets. Still, mankind possessed a murderously savage inner self – a 'stranger within' – which could explode at any moment. This was the ultimate fragility of civilization: the more primitive a society, the cruder its anatomy; for anatomy, like all else, was 'evolving', even if in no systematic way, as was clear in other spheres of social progress.

Perhaps this is why the physiological debates between Albrecht von Haller and Robert Whytt created such a stir throughout Europe. Swiss-based Haller believed that anatomical 'irritability and sensibility' account for the whole secret of man's movements: these 'involuntary actions' occur when the muscle fibres contract. That is, body parts are 'irritated' and excited to 'correspond' and – again the old doctrine – to 'sympathise' with other parts of the central nervous system by conducting stimuli along the nerve-fibres. The process, in turn, produces the anatomical equilibrium at any single moment of time and demonstrates that the body conforms to mechanical laws. But Haller never abandoned the view of his predecessor, Stahl, that the soul also played a part in these involuntary actions. Whytt countered by discarding soul altogether and recasting the meaning of involuntary actions. For him, irritability exists to remove anything that irritates, or hurts, the body. His new idea was the 'involuntary reflex action', such as breathing, or the contraction of the pupil. The point is not adjudication between Haller or Whytt, but recognition of the big bang physiological theories made in their world.

Whytt sparred with Haller early in the 1750s,

after his (Whytt's) book on the involuntary motions of animals was translated into German. A few years earlier he had been appointed professor of the theory of medicine in Edinburgh, where he continued to offer clinical lectures on the nerves, bound as his magnum opus: *On Nervous, Hypochondriac, or Hysteric Diseases* (1764). A year later Whytt was dead. William Cullen moved into his Chair and followed in his predecessor's nervous footsteps, so to speak, soon becoming Edinburgh's most stunning lecturer [fig. 7]. Cullen was as steeped in Enlightenment values – practical as well as theoretical – as Scotland's philosophers, and also partook of the scientific penchant to collect and classify. Indeed he made the classification of diseases (then called nosology) the centrepiece of his pedagogical reform. But the nervous system consumed his greatest fascination. Everything he touched, even chemical and mechanical, devolved back to the human nervous system, nor did he delimit his view of nerves to the human body. He extended it geographically to different cultures, and invoked social and environmental explanations for the nervous systems of different populations, inquiring why, for example, such nervous conditions as hysteria were more prevalent in certain places. And he invoked climate, as well, in the discussion of nervous conditions, thus turning himself into an early medical anthropologist.

The more entrenched Cullen became, the less dogmatic he seemed: in the lecture theatre, in learned societies, personally as teacher and friend. He was thoroughly sociable and clubbable – further evidence, perhaps, of the 'civilized state' of his own nerves. Not all his magnification was original: some part was in the air at the time, especially the

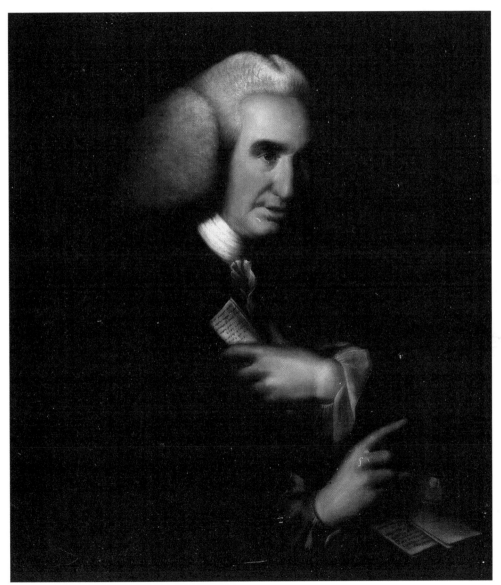

Fig. 7 *William Cochrane. Portrait of Willian Cullen. c.1768. Scottish National Portrait Gallery.*

doctrine's relation to 'sense and sensibility': the idea that 'sensation' drove culture while 'sensibility' tested the true mettle of individuals. But Cullen also gazed deeply into the utilitarian components: the idea that his new nosology would advance medical diagnosis and therapy. If new therapies were to improve the lot of man, its theoretical underpinnings had to become more secure. In this practical turn endowed to nerves, he was thoroughly hewn of Enlightenment fibre: the wedding of the two – theoretical and practical – a sure test of the part each would play.

By the time Cullen died in 1790 'nervous science' had been placed on its firmest footing since the Ancients. This was not merely owing to Cullen's achievement but to widely disseminated popular interest in 'nervous science', even when electrically applied. In France, diverse 'mesmerists' held séances 'electrifying' themselves. [fig. 9]. In Britain, doctors and quacks both peddled 'magnetic therapy' to their patients, as in these cartoons [figs. 8 & 10] illustrating 'patients undergoing magnetic therapy' and – more cunningly – 'a quack doctor assisting a voluptuous

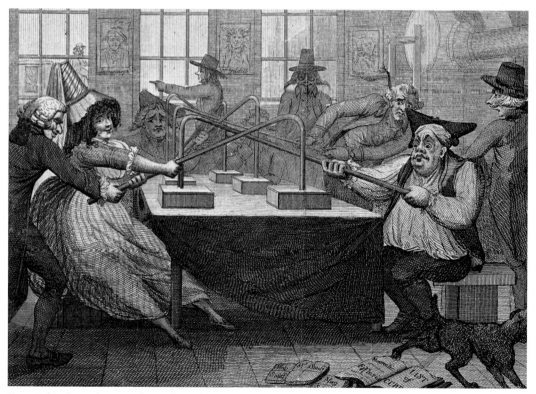

Fig. 8 *Etching by J. Barlow, 1792, after J. Collings.* Patients under-going magnetic therapy. *Wellcome Library London.*

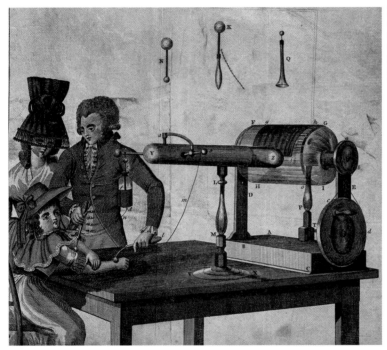

Fig. 9 George Adams demonstrates his electrotherapy machine to a woman and her daughter. *Frontispiece to:* An essay on electricity. *1799. 5th ed. London. Wellcome Library London.*

female patient', showing the means to an end: the ruddy, fashionable lady rather than stimulation of her 'nerves' for therapeutic purposes.

Cullen's contribution was undertaken apart from self-interest or gain: progress had demanded it – the Scots responded. Any charge that 'nervous nosology' was merely a pedagogical device, calculated to ensure successful teaching, was refuted. Besides, Cullen could have claimed that Scottish Enlightenment values demanded it: so central had the analogy between the healthy nervous body and healthy nervous society become: more than a metaphor or mirror copy. It was not fortuitous that the Edinburgh of Cullen's professorship for a quarter of a century (1765–90)

had also grown into the hub of the intellectual universe – Enlightenment civilization writ large, nervous civilization with Cullen's example was living proof. What contrast this formed with another Scottish doctor who also made the nerves his centrepiece.

We promised to return to Adair [fig. 11]. He had studied medicine under Whytt, as we saw. Later he went out to Antigua and practised there, but when he returned to Britain he set up a lucrative practice in Bath, publishing books about 'fashionable diseases' aimed at general audiences to validate himself further, and translated into foreign languages. But he also harboured ulterior motives: to persuade his well-heeled patients

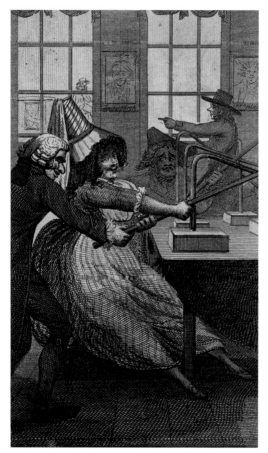

Fig. 10 *Etching by J. Barlow, c. 1792, after J. Collings.* A quack doctor assisting a voluptuous female patient with group magnetic therapy. *Wellcome Library London.*

of their own superiority. Nerves were of paramount interest to them not merely because they played a central role in understanding disease, but because they were also the guarantors of privilege. Small wonder then that Adair's *Essays on fashionable diseases* (1787) became a classic in the field. And if

primed about his philosophical foundations, Adair might have claimed that he too, like Whytt and Cullen, had infused his thought with Enlightenment principles about the homology of 'nervous body' equalling 'nervous society'. But his exclusive practice, in Bath, was so specifically limited to rich patients that his celebration of nerves is ultimately suspect.

Adair died in 1801, a decade after the far more luminous Cullen. Soon an entire generation educated in the belief that 'nervous societies' are healthiest because they are, analogously, more energized and sympathetic than others – polities of sensibility – would be gone and Cullen discredited. The decline of his 'nervous science' constitutes a chapter in part of the waning of Enlightenment culture.

So too would Thomas Trotter be dead, another 'Cullenite' who remained faithful to his teacher's beliefs. Trotter emphasized nervous physiology and its role in disease, especially among drunks, but minimized gender and class. Like Cullen he was quick to grasp the inherited facets of many nervous diseases, but less impressed by his patients' social niche. The notion, for example, that female nerves were inherently weaker than male, or that the nerves of the rich were more 'exquisitely delicate' and therefore more easily capable of derangement, made little impact. As a naval doctor of distinction, Trotter knew the difference between men and women, but did not exploit it to enhance his gain or enlarge his clientele.

None of these figures – Willis and Cheyne to Cullen and Trotter – viewed the 'nervous system' as a signifier for something else, let alone as Kantian transcendental signifiers. The literal nerves, they thought, were crucial for evolving theories of society

MEDICAL CAUTIONS;

CHIEFLY FOR THE

CONSIDERATION

OF

INVALIDS.

CONTAINING

ESSAYS

ON

Fashionable Diseases	On Quacks,
The dangerous Effects of	Quack Medicines,
Hot and Crouded Rooms.	and Lady Doctors.
An Enquiry into the Use of	AND
Medicine during a Course	An Essay on REGIMEN,
of Mineral Waters.	very much enlarged.

THE SECOND EDITION.

TO WHICH ARE NOW ADDED,

APPENDIX I. Containing farther Animadversions on a cele-
brated Quack Medicine, and Remarks on the Medical
Powers and Use of the DULCIFIED ACIDS.

APPENDIX II. An Essay on THERAPEUTICS.

PUBLISHED FOR THE BENEFIT OF

THE GENERAL HOSPITAL AT BATH.

By JAMES MAKITTRICK ADAIR, M.D.

Member of the Royal Medical Society,
And Fellow of the Royal College of Physicians, Edinburgh.

Nullius addictus jurare in verba magistri.

HOR. Lib. I. Ep. 1.

BATH, PRINTED BY R. CRUTTWELL;
AND SOLD BY
C. DILLY, POULTRY, LONDON; AND BY ALL THE
BOOKSELLERS IN BATH,
MDCCLXXXVII.

Fig. 11 *Title-page. James Adair. 1787.* Fashionable diseases. *Wellcome Library London.*

and civilization more generally, including the aesthetic and ethical realms. Later books about the 'nervous bases of civilization', of the type the Victorians and Edwardians produced, would not have seemed alien to them. But by then the *caché* of rank and class in 'nervous science' was paramount. Nervous science had to await its twentieth-century heritage before becoming democratized.

REFERENCES AND FURTHER READING

Adair, J. M. 1787. *Essays on fashionable diseases.* London: T.P. Bateman.

Adair, J. M. 1787. *A philosophical and medical sketch of the natural history of the human body and mind.* Bath: R. Cruttwell.

Cheyne, G. 1733. *The English malady: or, A treatise of nervous diseases of all Kinds.* London.

Cullen, 1773. *Lectures on the materia medica.* London: T. Lowndes.

Cullen, W. 1810. *Nosology: or, a systematic arrangement of diseases, by classes, orders, genera, and species.* Edinburgh: Bell & Bradfute.

Cullen, W. *The works of William Cullen: containing his physiology, nosology, and first lines of the practice of physic; with numerous extracts from his manuscript papers, and from his treatise of the materia medica.* Edited by Thomson J. 1827. Edinburgh: Blackwood.

Digby, K. 1658. *A late discourse made in a solemne [sic] assembly of nobles and learned men at Montpellier in France: touching the cure of wounds by the powder of sympathy.* London: R. Lownes and T. Davies.

Dover, T. 1732. *The ancient physician's legacy to his country.* London: Printed for the author.

Ferguson, A. 1805. *Essays on the intellectual powers, moral sentiment, happiness, and national felicity.* Paris: Parsons and Galignani.

Hume, D. 1757. *Four dissertations. I. The natural history of religion. II. Of the passions. III. Of tragedy. IV. Of the standard of taste.* London: A. Millar.

Hutcheson, F. 1728. *An essay on the nature and conduct of the passions and affections, by the author of the Inquiry into the original of our ideas of beauty and virtue.* Dublin. 1728.

Locke, J. 1975. *An essay concerning human understanding [by] John Locke; edited with an introduction, critical apparatus and glossary by Peter H. Nidditch.* Oxford: Clarendon Press.

Monboddo, J. B. Lord. 1797. *Antient [sic] metaphysics. Volume fifth. Containing the history of Man. In the civilized state.* Edinburgh: Bell & Bradfute.

Pope, A. 1751. *An essay on man, in four epistles.* Edinburgh.

Rousseau, G. 2005. *Nervous Acts: Essays on Literature, Culture and Sensibility.* Basinstoke: Palgrave.

Simpson, I. 1991. *Anatomy of humans: including works by Leonardo da Vinci, John Flaxman, Henry Gray and others.* London: Studio Editions.

Smith, A. 1776. *An inquiry into the nature and causes of the wealth of nations.* London.

Steinke, H. et al. 2005. *Irritating experiments: Haller's concept and the European controversy on irritability and sensibility, 1750-90.* Amsterdam: Rodopi.

Trotter, T. 1807. *A view of the nervous temperament.* London.

Whytt, R. 1751. *An essay on the vital and other involuntary motions of animals.* Edinburgh.

Willis, T. 1965. *Cerebri anatome: cui accessit nervorum descriptio et usus. English. The anatomy of the brain and nerves.* Translated by Samuel Pordage. William Feindel, (ed). Tercentenary edition 1664–1964. Montreal: McGill University Press.

DAWN KEMP

Ane condampnit man efter he be deid:

EDINBURGH AND THE ACT OF ANATOMY (1505-1832)

By the late eighteenth century Edinburgh was established as one of Europe's leading centres of medicine. (Conrad et al 1995: 453; Dingwall 2003:108; Kaufman 2004: 5). The city's pre-eminence came through the coalescence of many local, national and international factors, but a major contribution was the quality and extent of anatomy teaching. This mainly rested on the knowledge and teaching ability of the instructors (Struthers,1867: 81) and an adequate supply of bodies to give all students, direct individual experience of anatomical dissection.

Notoriously, Edinburgh also gained great prominence in the framing of Britain's first Anatomy Act in 1832 (George IV, 1832: 1) a result of being the place where the mass murderers, Burke and Hare, carried out their awful crimes in the late 1820s. Murders fuelled by the shortage of legal supply of human bodies for anatomical dissection (Porter, 2002: 121).

Stories of the supply of bodies have, understandably, become the stuff of gruesome folklore, and through time, embellishment, and myth have inevitably crept in. The Edinburgh situation exemplified the issues which the practice of anatomy raised in Scotland. It also indicated reasons why Scotland was thought to be more opposed to anatomical dissection than England, Wales or Ireland.

ANE CONDAMPNIT MAN EFTER HE BE DEID

The first authorised provision of bodies for anatomical study in Britain was made in Edinburgh in 1505. The surgeons' and barbers' charter (Seal of Cause) granted by the Town Council stated:

'That everie man... aucht to knaw the nature and substance of every thing that he wirkis or ellis he is negligent. And that we may have anis in the yeir ane condampnit man efter he be deid to mak anatomea of quhairthrow we may haif experience. Ilk ane to instruct utheris. And we sall do suffrage for the soule.' (Cresswell, 1926: 4)

'...every man ought to know the nature and substance of every thing with which he deals, or else he is negligent; and that we may have once a year a condemned man after death to perform anatomy on whereby we may have experience, each one to instruct others, and we shall do suffrage for the soul.' (Translation from Scots by Frances Shaw, 2004)

It seems that the teaching of anatomy in Renaissance Scotland could combine without conflict, exaltation of the work of God with new empirical scientific enquiry. That the body for anatomisation should be that of a condemned criminal's signaled that dissection was not viewed as a privilege; indeed it would not have been linked to criminality in this way if it was not so clearly a popular taboo (Richardson, 1989: 76), but with the addition of prayers 'and we shall do suffrage for the soule,' there is a suggestion that the act was some form of post-mortem penance for the deceased.

However by the mid-seventeenth century a body provided 'anis in the yeir 'was not enough to provide for a more structured approach to anatomical teaching that was proposed, or the extension of the geographical authority of the surgeons' incorporation to examine

(Cresswell, 1926: 192; Smith, 1905: 12). More bodies had to be found and a grotesque trade emerged to meet the demand: in 1678 the first recorded case of grave-robbing, directly associated with the supply of bodies for anatomical teaching, was reported. A body taken from a grave in Edinburgh's Greyfriars Church was thought most probably to have been:

> '...stolen away by some chirurgeon, or his servant, to make ane anatomicale dissection on; which was criminal to take at their owne hand, since the magistrates would not have refused it; and I hear the chirurgeons affirme, the towne of Edinburgh is obliged to give them a malefactor's body once a year for that effect... and its usual in Paris, Leyden and other places to give them; also some of them that dyes in hospitals.'(Lord Fountainhall ms: 1678 from Buchanan et al, 1828)

Fountainhall, although missing the point about the adequacy of one body a year, makes comparison with Paris and Leyden (now known as Leiden), Europe's two most successful centres of medicine at the time. This reference to practice on the continent chimed with the slightly later experience and ambitions of Archibald Pitcairne, one of Edinburgh's leading doctors who had been Professor of the Practice of Physic at Leyden University in 1693, and on returning to Scotland was keen to establish a medical school to an equally high standard (Struthers, 1867: 7). He encouraged and supported a request to the Town Council in1694 by the surgeon Alexander Monteith for bodies for anatomical dissection, of prisoners who had died in custody, having 'nane to owne them' and of foundlings who 'die upon the breast' (Armet, 1962: 160; Cresswell, 1926: 192; Dingwall 2005: 52). [fig.1]

Pitcairne wrote to a friend in London at the time, 'I do propose, if this be granted, to make better improvements in anatomy than have been made in Leyden these thirty years (Struthers, 1867: 8; Refs Chalmers, 1794: 30, Bower, 1817, Vol 2: 148)

The important proviso that dissection could only be undertaken if there was 'nane to owne them' recognised not only the ultimate ignominy to the wrongdoer but that such a fate also deeply affected family and friends. As Thomas Wakely, founder of *The Lancet* and one of the most prominent medical reformers of the early nineteenth century, commented during the Anatomy Act debate: 'Ties of kindred or friendship were grounds for a "natural horror" of dissection' (Richardson, 1989: 77).

The Incorporation of Surgeons, concerned for its monopoly over anatomy teaching because of Monteith's success, petitioned the Town Council for:

> 'the dead bodies of foundlings who die betwixt the time they are weaned and their being put to schools or trades... unless the friends of those concerned reimburse the Kirk Treasurer whatever they have cost the town. As also they allow the dead bodies of such as are *felo de se*, when it is found unquestionable self-murder and have none to own them... the petitioners always burying the dead bodies within ten free labouring days upon their own charges in what place that shall be appointed by the Council.' Burgh Records Nov 1694 (Cresswell, 1926: 192)

Fig. 1 Archibald Pitcairne (1652-1713). *John De Medina, c.1702. Courtesy of the Royal College of Surgeons of Edinburgh.*

Fig. 2 *Edinburgh's first Surgeons' Hall. The Hall was built in 1697 to accommodate an anatomical theatre where public dissections could be held once a year. P. Fourdrinier after Paul Sandby, Engraving. Courtesy of the Royal College of Surgeons of Edinburgh.*

It was highly unlikely any foundlings still in the care of the Kirk would have 'friends' prepared or able to reimburse all costs and pay for their funeral. The prayer for the subject, perhaps by now implicit, was overshadowed by the promise of financial benefit to the town in covering all burial costs. The new source of bodies, foundlings without means of self support, was effectively that of 'unclaimed poor'.

The provision of unclaimed poor for dissection in Edinburgh, although similar to Paris and Leyden where the bodies of those who died in hospitals were given over for dissection, created a marked difference in practice from the rest of the United Kingdom. It may have been that Pitcairne's hope of making Edinburgh comparable to the great medical centres on the Continent influenced the Town's decision and there is later evidence in 1705 that the magistrates were mindful of this consideration (Armet, 1967: 109). Nevertheless in allowing the petitions of Monteith and the Incorporation of Surgeons to be passed, Edinburgh created an early connection between poverty (as opposed to capital crime) and dissection that may have contributed to a greater public sensitivity and fear of dissection in Scotland in later years.

The Town offered the 'gift' of such bodies on condition that the surgeons' build 'ane anatomicall Theatre where they shall have once a year... ane publick anatomicall dissection... and if they failzie thir presents to be voyd and null'. The Incorporation agreed to the conditions, a new Surgeons' Hall was opened in December 1697 and a committee convened to arrange the public demonstrations [fig. 2]. The term 'public' did not mean the general public,

but was defined, by the Burgesses of the town, as the regular apprentices and pupils of freemen and others that the Burgesses may sometime wish to include (Gairdner, 1860: 17; Struthers, 1867: 11). That 'public' dissections then took place annually does not seem inconceivable; the Burgh Records don't appear to suggest any breach of conditions, but despite Struthers' claim that annual dissections took place between 1697 and 1825, there is no clear evidence for this. The first recorded dissection at Surgeons' Hall (1702) was presided over by Pitcairne. It was of David Mylles, executed for incest. (Cresswell, 1926: 194; Masson, 1995: Dingwall, 2005: 54). [fig. 3]

AND FOR TO PLEASE THEIR CURIOSITIES

Yet still the Town's new allowance was not enough to meet the growing demand; (Creswell, 1926: 195) body supply by grave robbing continued as did the association of the grave-robbers, or resurrectionists as they were also known, with the anatomists. Contemporary reports reflected popular detestation of the practice. A broadside account, in doggerel, from May 1711, tells of:

> '...the most horrid and unchristian actions of the Gravemakers in Edinburgh, their raising and selling of the Dead...
> When emptie graves unto this place is found,
> What kind of resurrection this may be.
> ...
> Since men do raise the dead at their own hand;
> And for to please their curiosities
> They them dissect and make anatomies
> ...

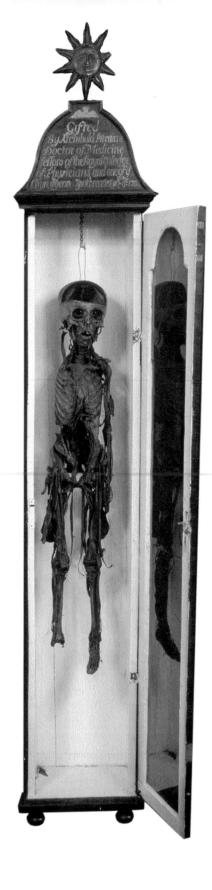

Schedule of Dissection:

Day 1
Anatomy in general, dissection and
demonstration of the common teguments
and muscles of the abdomen
(James Hamilton – current Deacon)

Day 2
The peritoneum, omentum, stomach,
intestines, mesentery and pancreas
(John Baillie)

Day 3
Liver, spleen, kidneys, ureters, bladder and
parts of generation (Alexander Monteith)

Day 4
Brain and its membranes with discourse of
the animal spirits (David Fyfe)

Day 5
Muscles of the extremeties (Hugh Paterson)

Day 6
Skeleton in general, with the head
(Robert Clerk)

Day 7
The articulations and the rest of the
skeleton (James Auchinleck)

Day 8
Epilogue (Archibald Pitcairne)

Courtesy the Royal College of Surgeons
of Edinburgh

Fig. 3 The remains of David Mylles,
whose body was used for the first
recorded anatomical dissection
conducted at Surgeons' Hall, presided
over by Archibald Pitcairne, November
1702. Courtesy of the Royal College of
Surgeons of Edinburgh.

Especially in Edinburgh doth abound.

…

As both the living and the dead do deer.
These monsters of mankind, who made the
graves,
To the chirurgeons became hyred slaves;

…

As I'm informed the chirurgeons did give
Fourty shillings for each one they receive:
And they their flesh and bones asunder part,
Which wounds their living friends unto
the heart'
(Buchanan et al, 1829: xi)

Compelled to distance itself from such accusations,
the Incorporation of Surgeons issued a 'Memorial
Act' (Cresswell, 1926: 196) dated 17 May 1711, to
the Town Council noting:

'… that which affects them [the surgeons] most
is a scandalous report… that some of their
number were accessory thereto… They doe
therefore hereby declare their abhorrence of all
such unnaturall and unchristian practices… that
if any of their number should be found accessory
to the violation of the sepulchers… shall be
expelled.' (Armet, 1967: 214).

The sentiment of the 'Memorial Act' was
reaffirmed in 1721 but further reports of violation
of the Greyfriars churchyard in 1722 led to the
Incorporation again tightening their regulations
and repudiating any involvement with grave
robbing. (Struthers, 1867: 21)

Such proclamations, though, did not put an end
to body snatching nor did they quell public
suspicion of the anatomists' collusion with the
resurrectionists. Matters came to a head in 1725,

when, following another report of violated graves,
an angry mob tried to burn down Surgeons' Hall
because it housed the anatomy theatre where
Edinburgh's Professor of Anatomy, Alexander Monro
(primus), taught (Struthers, 1867: 22) [fig. 4]. In
response, the Incorporation ordered: ' their officer
not to take in any Dead Bodie into their Hall or
Theatre till once there be ane order from the
Magistrates for that End and which Order shall be
shown to the deacon and in his absence to the
Thesaurer.' (Royal College of Surgeons of
Edinburgh, Council Minutes, 1725)

Monro, frustrated by the restrictions imposed
by the surgeons and fearful for his own safety,
asked for and was given protected rooms within
the University, thus beginning the long history of
anatomy at Edinburgh University. (Cresswell, 1926:
257; Struthers, 1867: 21).

The links between the teaching of anatomy and
the judicial process were reinforced in 1752 with
the introduction of *The Murder Act, An Act for
Better Preventing the Horrid Crime of Murder,*
which made anatomical dissection a compulsory
addition to all death sentences for murder. The
Act enshrined anatomisation in law as the ultimate
punishment, the prospect of which was deemed
so awful that it was hoped it might act as a
deterrent. (George III, 1752: 25 c 37)

Despite these additional provisions for a
regulated source of bodies, throughout the
eighteenth and early nineteenth centuries the
study of anatomy continued to be inextricably
linked to the unsavoury associations of the supply
of cadavers for dissection. Put simply, demand for
bodies continued to outstrip (legal) supply and
grave-robbing was becoming established as a trade
in itself (Richardson, 1989: 57). Even prominent

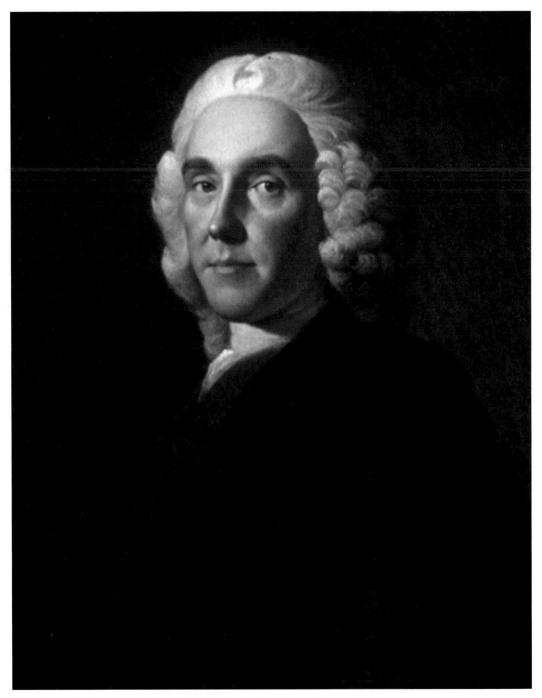

Fig. 4 Alexander Monro primus (1697–1767). *Allan Ramsay. In a private collection.*

anatomists and their students were likely involved, though difficult to prove, in resurrectionist activities: in 1742 the surgeon, Martin Eccles, was prosecuted for unlawful possession of a body, the case was 'not proven' (Dingwall, 2005: 87). By the early nineteenth century several leading surgeon/ anatomists were implicated: Robert Liston, the fastest surgical operator of his day was rumoured to have had a deft touch with a spade and hook (the grave-robbers' special tools (Richardson, 1989: 59; Comrie, 1932: 497 cites Lonsdale, 1870: 66); Sir Charles Bell's clinical notes from 1800 suggest that the body/skeleton of a deceased patient was obtained through Bell's own involvement in a grave-robbing, 'In procuring this skeleton I lost myself for two hours, and found myself at 2 o'clock in the morning in the court before Pennycuick House' (Kaufman,1994: 73), and in his memoirs Sir Robert Christison's precise detail of grave-robbing suggests he had 'been an eye witness/accomplice in his youth' (Richardson, 1989: 59).

In her key work on anatomy in Britain, *Death, Dissection and the Destitute* (1988), Ruth Richardson makes only too clear the vile nature of the body 'trade',

'Corpses were bought and sold, they were touted, priced, haggled over, negotiated for, discussed in terms of supply and demand, delivered, imported, exported, transported. Human bodies were compressed into boxes, packed in sawdust, packed in hay, trussed up in sacks, roped up like hams, sewn in canvas, packed in cases, casks, barrels, crates and hampers; salted, pickled or injected with preservative. They were stored in cellars and on quays. Human bodies were dismembered and

sold in pieces, or measured and sold by the inch.' (Richardson, 1989: 72)

Importation was especially important for supply in Scotland, and trade with London and Ireland was well established by the early nineteenth century (Comrie, 1932: 496).

Edinburgh's most popular anatomy lecturer, Dr Robert Knox, in the 1827/28 session taught over 500 students which Kaufman estimates would have required about 90 bodies (Kaufman, 2004: 91/92), [figs. 5 and 6]. Knox organised a supply of bodies from Ireland, which he openly discussed in a letter (dated 3rd November 1828 but never sent) to Sir Robert Peel, the British Home Secretary, responsible for framing the Anatomy Act: 'A short time ago I was anxious to import anatomical subjects via Liverpool – they were in the best condition having been selected by my assistants sent to Ireland for that express purpose' (Cresswell, 1926: 205). But Robert Knox's professional reputation was to be forever linked to the supply of cadavers from an even more sinister and unlawful source.

THE BURKE AND HARE SCANDAL

'Up the close and doon the stair, Ben the hoose wi' Burke and Hare. Burke's the butcher, Hare's the thief, Knox the boy who buys the beef.'

(Anon contemporary rhyme 1829; Bridie 1969: 52)

'The following trial is a dreadful proof of the deep depravity of human nature, and no criminal case, as far as we know, can make

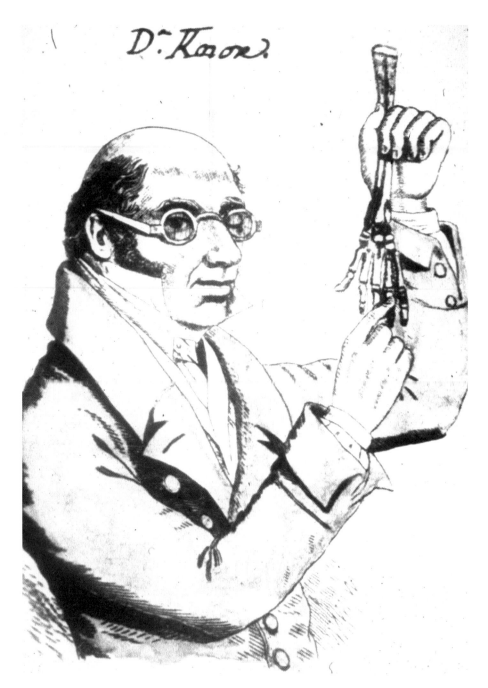

Fig. 5 *Dr Robert Knox, anatomist. Caracture, artist unknown. Courtesy of the Royal College of Surgeons of Edinburgh.*

ANATOMY
AND
Physiology.

DR KNOX, F.R.S.E. *(Successor to* DR BARCLAY, *Fellow of the Royal College of Surgeons and Conservator of its Museum,)* will commence his ANNUAL COURSE OF LECTURES ON THE **ANATOMY** AND **PHYSIOLOGY** of the Human Body, on Tuesday, the 4th November, at Eleven A. M. His Evening COURSE of LECTURES, on the same Subject, will commence on the 11th November, at Six P. M.

Each of these Courses will as usual comprise a full Demonstration on fresh Anatomical Subjects, of the Structure of the Human Body, and a History of the Uses of its various Parts; and the Organs and Structures generally, will be described with a constant reference to Practical Medicine and Surgery.

FEE for the First Course, £ 3, 5s.; Second Course, £ 2, 4s.; Perpetual, £ 5, 9s.

N. B.—*These Courses of Lectures qualify for Examination before the various Colleges and Boards.*

PRACTICAL ANATOMY
AND
OPERATIVE SURGERY.

DR KNOX'S ROOMS FOR **PRACTICAL ANATOMY** AND **OPERATIVE SURGERY,** will open on Monday, the 6th of October, and continue open until the End of July 1829.

Two DEMONSTRATIONS will be delivered daily to the Gentlemen attending the Rooms for PRACTICAL ANATOMY. These Demonstrations will be arranged so as to comprise complete Courses of the DESCRIPTIVE ANATOMY of the Human Body, with its application to PATHOLOGY and OPERATIVE SURGERY. The Dissections and Operations to be under the immediate superintendance of DR KNOX. Arrangements have been made to secure as usual an ample supply of Anatomical Subjects.

FEE for the First Course, £ 3, 5s.; Second Course, £ 2, 4s.; Perpetual, £ 5, 9s.

N. B.—*An Additional Fee of Three Guineas includes Subjects.*

₊ *Certificates of Attendance on these Courses qualify for Examination before the Royal Colleges of Surgeons, the Army and Navy Medical Boards, &c.*

EDINBURGH, 10. SURGEONS' SQUARE,
25th September 1828

Bill of Dr. Knox's Lectures, 1828.
From the Original in the University of Edinburgh.

Fig. 6 *Handbill advertising Dr. Knox's classes. The address given for Knox's anatomy classes is 10 Surgeons' Square. The correct name for the square is Surgeon Square but over time the error has been repeated so often it is more commomly referred to as Surgeons' Square.*
Courtesy of the Royal College of Surgeons of Edinburgh.

any parallel to it – it stands alone in the annals of murder.'
(*The Trial of William Burke and Helen M'Dougal*, Buchanan et al, 1829: v)
[figs. 7 and 8].

William Burke and William Hare committed at least 16 murders in Edinburgh during 1827 and 1828, selling the bodies of their victims for anatomical dissection to Robert Knox. They were the most prolific serial murderers known in British history until Dr Harold Shipman's conviction in 2000. Tellingly, Burke and Hare are often referred to as grave-robbers as if the term is as damning as murderers, yet there is no evidence that either of them took bodies from graves. The misapprehension appears to have originated in a report in the *New Scots Magazine* at the time of Burke's trial. (Edwards, 1993: ix)

Many accounts of Burke and Hare's murders have been produced, told and retold in almost every popular medium (see Further Reading below). The enduring fascination seems to rest not only in a compelling revulsion of 'the deep depravity of human nature' – in the act of murder itself, but also in the conundrum of ethical boundaries in the pursuit of scientific advance.

How much did Knox know about the source of the bodies? It is reported that he met Burke at least once and told him to call for him if he were ever detained by the police while he was delivering bodies (Anon, Echo of Surgeons' Square, 1829; Bailey, 2002: 138). If true it suggests that Knox believed he could persuade the police to drop or lessen charges for body-snatching (it seems unlikely he would have agreed to vouch for Burke to cover up murder). The anatomists'

dilemma in obtaining bodies was well appreciated and few were ever prosecuted for receiving bodies not officially sanctioned by local or national government (Richardson, 1989: 59). New legislation would seek to remove the medical profession from the criminal associations linked to supply altogether.

'In this affair there has been a clamour raised against medical men, we hope on no foundation, as subjects must be had to lecture upon, or the most useful of sciences must die; and, unfortunately, human prejudices as to sepulture are so strong, that great difficulties occur in procuring bodies for dissection.'
(Buchanan et al, 1829: v)

Burke and Hare's reign of murder coincided with parliamentary debate on the need for legislation to better regulate the supply of bodies to anatomy schools. Although the first Anatomy Bill put forward in 1829 was unsuccessful, the full implications of anatomical dissection being a catalyst for murder, once considered, meant legislation was inevitable. Many believed that the existing law had provided the incentive for the crimes, 'Woe is me! That mine should be the country where such deeds have been committed... in consequence of her own laws!' (A Royal Naval Surgeon, 1829: 25).

Many suggestions as to how to remedy the vexatious issue of legal supply of bodies were put forward (Richardson, 1989: 119, 163). Some thought the bodies of dead criminals (including those who had committed 'self-murder') the only proper subjects for such an ignominious end (A Royal Naval Surgeon, 1829: 36). Others proposed a new supply through voluntary donation:

Fig. 7 Anon. William Burke and Helen McDougal. *Courtesy of the Royal College of Surgeons of Edinburgh.*

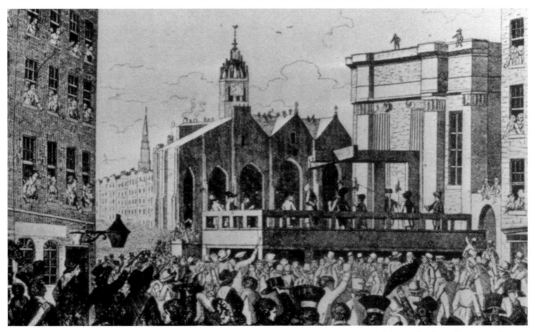

Fig. 8 Anon. Execution of William Burke January 1829. *From a contemporary print. Courtesy of the Royal College of Surgeons of Edinburgh.*

'If people… bequeath their bodies to the public for dissection they might have the merit of being for once useful to their fellow creatures… To the more refined of the female sex, however, this should be unpalatable doctrine… But the poor-house, and the gallows, from whence all who suffer should be dissected, may make up for this deficiency' (Buchanan et al,1829: vi).

The note that the 'deficiency' would be made up through the 'poor-house' was contentious. The Anatomy Bill had failed in 1829 in part because supply of bodies from those unclaimed from public institutions, especially workhouses and hospitals, was specifically detailed, effectively creating a division of law on class lines. This was viewed by many parliamentarians as an unacceptable shift in the supply of bodies for dissection from those of convicts to those of the innocent poor. (Richardson, 1989: 157) If a new Bill was to succeed, supply of bodies could not be solely from the poor-houses and the act of dissection would have to be distanced from its role as an instrument of punishment. Buchanan's suggestion is of note in the Edinburgh context because the city already permitted the supply of foundlings' bodies, the extension to others in the poor-house, as an idea, was obviously not without support.

THE ANATOMY ACT 1832 [fig. 9]

In August 1832, the Anatomy Act (an Act of Parliament to Regulate Schools of Anatomy in Britain) was passed. It marked a distinct shift in the British establishment's treatment of and relationship to the poor. As Ruth Richardson attests, it was indeed significant but its omission from histories of nineteenth century Britain is largely due to it being conflated with other radical social legislation that followed, especially the Poor Law of 1834 (Richardson, 1989: 270). Although specific mention of the institutions had been removed from the Bill (George IV, 1832: clause VIII) it was clear that workhouses were still intended as the main source for 'unclaimed' bodies (Richardson, 1989: 123). Between 1832 and 1932 nearly 57,000 bodies were used for anatomical dissection in London alone, with less than half a percent coming from places other than institutions which housed the poor (Richardson, 1989: 271). Although the Act did allow for individual donation of bodies (George IV, 1832: clause VII) there is little evidence to indicate this was actively encouraged, and the Act's new association with the poor made dissection a fate, which if no longer disgraceful, that was shameful and pitiful. Richardson's statistics show that individual donation did not supply any significant quantity of bodies before the twentieth century.

The Act also repealed the 1752 Murder Act's compulsory dissection of murderers (George IV, 1832: clause XV1) thereby removing the medical profession both from association with the illegal supply of bodies and the judicial system. In shifting the main source of bodies for anatomical dissection from executed convicts to the unclaimed poor, a fate, previously deemed appropriate as the ultimate punishment for those who had committed the most serious of criminal acts, became one to be feared by society's most vulnerable.

ANNO SECUNDO & TERTIO

GULIELMI IV. REGIS.

C A P. LXXV.

An Act for regulating Schools of Anatomy.
[1st *August* 1832.]

WHEREAS a Knowledge of the Causes and Nature of sundry Diseases which affect the Body, and of the best Methods of treating and curing such Diseases, and of healing and repairing divers Wounds and Injuries to which the Human Frame is liable, cannot be acquired without the Aid of Anatomical Examination: And whereas the legal Supply of Human Bodies for such Anatomical Examination is insufficient fully to provide the Means of such Knowledge: And whereas, in order further to supply Human Bodies for such Purposes, divers great and grievous Crimes have been committed, and lately Murder, for the single Object of selling for such Purposes the Bodies of the Persons so murdered: And whereas therefore it is highly expedient to give Protection, under certain Regulations, to the Study and Practice of Anatomy, and to prevent, as far as may be, such great and grievous Crimes and Murder as aforesaid; be it therefore enacted by the King's most Excellent Majesty, by and with the Advice and Consent of the Lords Spiritual and Temporal, and Commons, in this present Parliament assembled, and by the Authority of the same, That it shall be lawful for His Majesty's Principal Secretary of State for the Time being for the Home Department in that Part of the United Kingdom called *Great Britain*, and for the Chief Secretary for *Ireland* in that Part of the United Kingdom called *Ireland*, immediately on the passing of this Act, or so soon thereafter as may be required, to

Secretary of State to grant Licences to practise Anatomy;

8 S grant

Fig. 9 Anatomy Act 1832. *Courtesy of the Royal College of Surgeons of Edinburgh.*

Fig. 10 *Anon, lithographer R H Nimmo, Wretch's Illustrations of Shakespeare, no. 6 of series. Appears to show Dr Robert Knox pursued by angry ghosts. Hand coloured lithograph on paper. Scottish National Portrait Gallery.*

CONCLUSION

> 'I apprehend the public feeling against dissection is stronger in Scotland than it is in this country or in Ireland, and that it is much more difficult from local circumstances to find the means of supplying subjects than in almost any other part of the Empire.'

(Robert Peel in a letter to the President of the Royal College of Surgeons of Edinburgh, 9 April 1828 (RCSEd 1828/32: 9; Cresswell,1926: 202).

Anatomical dissection is an invasive, absolute act. Edinburgh Town's 'gift' of bodies of unclaimed foundlings for dissection in 1697 in consort with the Murder Act provision of 1752 classed the poor along with the most serious criminal wrongdoers, an association not even the authors of the Anatomy Act of 1832 thought acceptable to assert. The main injustice of the Anatomy Act was that the unclaimed poor not only had their rights forfeited but their very bodies commodified, increasing the fear and shame of poverty, especially amongst the most economically vulnerable. That the supply of bodies of foundlings for dissection was sanctioned by the Town of Edinburgh 138 years before the Anatomy Act was passed may well have contributed to a greater fear of dissection in Scotland, especially among the poorer classes. Religious and folk beliefs concerning death are also likely to have played a part alongside the sheer number of bodies required to supply the largest medical student population in Britain. Peel's letter was written before the murders committed by Burke and Hare came to light. If the public felt strongly against dissection in April 1828 they were absolutely outraged by the beginning of 1829 [fig. 10].

The causes of the difference in attitude in Scotland are complex and further research into them is needed, but it seems clear that events in Edinburgh played a very significant part in shaping the national response. In the final reading, the rights and anxieties of the poor were clearly viewed as of a lesser concern. 'Vulgar prejudice' against anatomical dissection was viewed as a form of ignorance and was condemned for holding back medical science while the 'educated' classes protected themselves and their families from an end most also felt uncomfortable with (RCSEd, 1828-32: Council Minutes; Richardson, 1989: 151). Had all the options for the adequate supply of bodies for teaching been properly considered then, a more socially equitable, consensual and humane system could have been introduced sooner.

POSTSCRIPT

The 1832 Anatomy Act in Britain was amended in 1871 and 1984.

In 2006 the Anatomy Act was amended again in Scotland but abolished in England, Wales and Northern Ireland, being absorbed into new human tissue legislation.

REFERENCES AND FURTHER READING:

Anon. (Possibly David Paterson), Pamphlet. 1829. *The Echo of Surgeons' Square*, Edinburgh

Anon. Broadside. 1830. *The Execution of John Thomson and David Dobie*. Edinburgh: Robertson and Thomson.

Armet, H. (ed). 1962. *Extracts from the Records of the Burgh of Edinburgh*. 1689–1701. Edinburgh and London: Oliver and Boyd.

Armet, H. (ed). 1967. *Extracts from the Records of the Burgh of Edinburgh 1701–1718.* Edinburgh and London: Olivor and Boyd.

Bailey, B. 2002. *Burke and Hare, The Year of the Gouls.* Edinburgh: Mainstream Publishing.

Bower, A. 1817. *The History of the University of Edinburgh.* Volumes 1 and 2. Edinburgh: Oliphant, Waugh and Innes.

Bridie, J. 1969. *The Anatomist.* Reprint of 2nd edition,1st edn 1931. London: Lowe and Brydone.

Buchanan, R. et al. 1829. *The Trial of William Burke and Helen M'Dougal.* 24 December 1828. Edinburgh.

Burke and Hare, Robert Knox literary and film references: *The Bodysnatchers,* Robert Louis Stevenson (1884); *The Anatomist,* James Bridie (1930); *The Body Snatcher,* Robert Wise (1945); *The Greed of William Hart,* Oswald Mitchell (1948); *The Flesh and the Fiends,* John Gilling (1959); *Burke and Hare,* Vernon Sewell (1971); *The Doctor and the Devils,* Freddie Francis (1985); *The Falls,* Ian Rankin (2002) and *Fleshmarket,* Nicola Morgan (2004).

Chalmers, G. 1794. *The Life of Thomas Ruddiman.* London: John Stockdale.

Comrie, J. 1932. *History of Scottish Medicine.* London: Wellcome Historical Museum/Baillière, Tindall and Cox.

Conrad, L.; Neve, M.; Nutton, V.; Porter, R.; Wear, A. 1995. *The Western Medical Tradition 800 BC to AD 180.* Cambridge: Cambridge University Press.

Cresswell, C. H. 1926. *The Royal College of Surgeons of Edinburgh, Historical Notes from 1505-1905.* Edinburgh & London: Oliver and Boyd.

Dingwall, H. 2003. *A History of Scottish Medicine.*Edinburgh: Edinburgh University Press.

Dingwall, H. 2005. *A Famous and Flourishing Society – The History of the Royal College of Surgeons of Edinburgh 1505-2005.* Edinburgh: Edinburgh University Press.

Edinburgh Town Council. 1505. *Surgeons and Barbers of Edinburgh 'Seal of Cause';* granted by Edinburgh Town Council, 1 July 1505. Translation from old Scots by Dr Frances Shaw.

Edwards, O. D. 1993. 2nd edn,1st edn, Polygon 1980. *Burke and Hare.* Edinburgh: Mercat Press.

Elizabeth II. 1961. *Human Tissue Act, 1961.* 9&10 Eliz. 2, Chapter 54. London: HMSO.

Elizabeth II. 1984. *Anatomy Act 1984.* Chapter 14. England: W.J. Sharp, HMSO and Queen's Printer of Acts of Parliament.

Fountainhall, Lord. 1678. *Fountainhall ms 6 February 1678.* Edinburgh: Faculty of Advocates.

Gairdner, J. 1860. *Historical Sketch of the Royal College of Surgeons of Edinburgh.* Edinburgh: Sutherland and Knox.

George IV. 1832. *An Act for Regulating Schools of Anatomy 1st August 1832* Printed by George Eyre and Andrew Spottiswoode, 1832.

Kaufman, M. 2004. *Medical teaching in Edinburgh during the18th and 19th centuries.* Edinburgh: Royal College of Surgeons of Edinburgh.

Kaufman, M. and Jaffe, S. M. 1994. 'An early Caesarean operation (1800) performed by John and Charles Bell'. *Journal of the Royal College of Surgeons of Edinburgh 39 (69–75).* Edinburgh: Royal College of Surgeons of Edinburgh.

Lonsdale, H. 1870. *A Sketch of the Life and Writings of Robert Knox, the Anatomist.* London, Macmillan and Co.

Masson, A. H. B. 1995. *Portraits, Paintings and Busts in the Royal College of Surgeons of Edinburgh.* Edinburgh: Royal College of Surgeons of Edinburgh.

A Medical Officer in the Royal Navy. 1829. *Reflections Suggested by the Murders Recently Committed at Edinburgh &c Being an Epistle to the Right Hon. Robert Peel. M.P.* Glasgow: W R M'Phun.

Porter, R. 2004. *Blood and Guts. A Short History of Medicine.* London: Penguin.

Richardson, R. 1989, 1st edn, Penguin, 1988. *Death, Dissection and the Destitute. London:* Pelican.

Rights of Personality, Property Rights and the Human Body. The Edinburgh Law Review, vol. 9, 2005.

Royal College of Surgeons of Edinburgh. 1725. *Royal College of Surgeons of Edinburgh Records 11 Feb 1725 – 2 March 1725.* MS Edinburgh.

Royal College of Surgeons of Edinburgh Council Minutes (1828–1832) Royal College of Surgeons of Edinburgh Minute Book 1828-1832, MS Edinburgh.

Sawday, J. 1996, 1st edn, 1995. *The Body Emblazoned.* London: Routledge.

Shaw, F. 2004. *Incorporation of Surgeon Barbers' Seal of Cause – Translation from Old Scots.* Edinburgh: Royal College of Surgeons of Edinburgh, limited print.

Smith, J. 1905. *Collections of Royal College of Surgeons of Edinburgh.* Edinburgh: George Robb and Co, printers.

Struthers, J. 1867. *Historical Sketch of the Edinburgh Anatomical School.* Edinburgh: Maclachlan and Stewart.

MALCOLM NICOLSON AND JOHN FLEMING

Scottish Innovations:

THE CASE STUDY OF ULTRASOUND

In the nineteen fifties, Ian Donald compared the maternal abdominal wall to 'an iron curtain' (Donald 1955: 167). He was expressing his frustration at the difficulty of understanding what was happening within the gravid uteri of his obstetric patients. Donald was appointed to the Regius Chair of Midwifery at the University of Glasgow in 1954 and his major textbook, *Practical Obstetric Problems*, was published a year later.

It is salutary to recall how imperfect an obstetrician's ability to diagnose fetal disorders, or even follow the course of a normal pregnancy, was at this time. From around 20 weeks' gestation, the fetal heartbeat could be heard with a stethoscope. Later in pregnancy, the skull, pelvis and major bones could be visualised by X-ray, which allowed the definite diagnosis of some gross abnormalities as well as recognition of the presence of twins. By the mid-fifties, however, X-ray imaging was being used less frequently as the dangers of exposing the fetus to radiation were becoming better understood (Stewart *et al*, 1956). In the third trimester, knowledge of the size and position of the fetus could be gained by palpation, visual inspection and other forms of physical examination. But these were uncertain means of gathering information, very dependent on the skill of the individual practitioner, and often problematic, for example in overweight or very anxious patients.

The mother could also supply valuable information. Her recollection of her last menstrual period was important in estimating gestational age and her perception of fetal movements could

offer reassurance that her baby was still alive. Blood and urine tests were available which could also confirm the presence of a living fetus. But these were often equivocal and, owing to the persistence of gonadotropin hormone in the blood, might be slow to confirm fetal death. This period of uncertainty as to the continuance of pregnancy could sometimes last as long as a fortnight and was a source of considerable emotional distress to the mother and anxiety to her medical attendants.

Thus, before the development of modern imaging techniques, many important clinical decisions had to be made on the basis of what was more or less educated guesswork. Often the obstetrician would be unaware of the possibility of serious problems until they expressed themselves during labour. For example, the presence of a second fetus was sometimes not recognised until late in pregnancy or even, on occasion, until after the first twin had been delivered. The survival chances of both babies, and especially the second born, could be compromised under these circumstances.

Placenta praevia was another condition that was difficult to identify in pregnancy but could cause serious problems during delivery. In this disorder the placenta lies across the internal opening of the cervix. Vaginal bleeding may result. Moreover, as the fetal head engages with the pelvic brim, it will press against the obstruction, resulting in severe haemorrhage. The lives of both fetus and mother may be at risk. By the mid-fifties, several methods of localising the placenta had been tried, but without much success (Hibbard, 1962). Thus, if a woman suffered vaginal bleeding after the first trimester, her medical attendants, ignorant of the exact position

Opposite. Anon. Model of the eye showing the cornea and lens, late 18th century. Courtesy of the University of Aberdeen

Fig. 1 *Ian Donald serving as a medical officer in the RAF where he became familiar with radar and sonar.*
Courtesy the British Medical Ultrasound Society Historical Collection.

of the placenta, could not responsibly ignore the possibility of placenta praevia. It was thus standard practice for such patients to be admitted to hospital and to be kept there, under surveillance, until their pregnancies were in the 38th week. At that time, when the fetus was deemed viable, a vaginal examination would be undertaken, under full anaesthesia with a surgical team standing by. If the disturbance to the cervix provoked a serious haemorrhage, an emergency Caesarean would be carried out. These elaborate precautions were extremely inconvenient for the women concerned and they took up beds and other hospital resources for long periods, often unnecessarily. It is understandable, therefore, that Donald would 'look forward to the day when a safe and certain method of diagnosing placenta praevia is possible without local examination and disturbance' (Donald 1955: 217).

Donald had served in the Royal Air Force during the Second World War [fig. 1] and knew of the military use of echolocation technologies such as radar and sonar (Willocks and Barr, 2004). The principle behind sonar is that a short pulse of ultrasound (sound of a frequency higher than humans can hear) is sent out from a transmitter and the time taken for an echo to return is measured. The presence of a reflective surface (a submarine, for instance) may thus be detected and its distance from the transmitter calculated. After the war a number of researchers endeavoured to adapt ultrasound echolocation for medical purposes. One of the most active researchers in this field was John Wild, an English surgeon based in Minneapolis. Wild had been able to locate cysts and tumours within breast tissue by means of an ultrasound probe

(Wild and Reid, 1954). In the summer of 1954, just before he took up his post in Glasgow, Donald had a chance encounter with Wild, who encouraged him to try to apply the technique to obstetrics and gynaecology. Donald read up about the technology and learned that ultrasound machines were used in industry to detect flaws in metals.

In the spring of 1956, Donald visited the Research Division of Babcock and Wilcox Ltd, a major user of industrial ultrasound, and had the ultrasonic flaw detector demonstrated to him (Donald, 1974) [fig. 2]. Donald was intrigued that the technicians calibrated their equipment by bouncing the sound beam off the bone in their thumbs. The echo from within the thumb produced a characteristic spike on the detector's oscilloscope screen. Donald realised that considerable biological information was being obtained about the tissues around the bone. He was sufficiently intrigued by what he saw to arrange a further visit. One afternoon, he and a colleague loaded the boots of their cars with fresh pathological specimens, including fibroids and a large ovarian cyst. Donald wanted to know whether the flaw detector could enable a differentiation to be made between a solid tumour, such as a fibroid, and a hollow, fluid-filled, cystic structure:

'All I wanted to know… was whether a metal flaw detector could show me… the difference between a cyst and a myoma [a solid tumour]… To my surprise and delight, the differences were exactly as my reading led me to expect, the cyst showing clear margins without intervening echoes because of its fluid content and the fibroid progressively attenuating the returning echoes.' (Donald 1980: 6).

53

Fig. 2 A Kelvin and Hughes Mk IV Ultrasonic Flaw Detector in use by the late Mr J. Davis in the Babcock and Wilcox's factory in Renfrew in the late 1950s. This type of instrument was demonstrated to Professor Donald in 1954.
Courtesy the British Medical Ultrasound Society Historical Collection.

Using the unmodified industrial equipment, Donald was able readily to distinguish between the two types of pathological specimen.

Distinguishing fibroids from ovarian cysts was an important issue within Donald's gynaecological practice in Glasgow at this time. The setting-up of the National Health Service had revealed an abundance of morbidity among the female working-class population of the city. Presented with a gross distension of the abdomen, the gynaecologist was often uncertain as to the nature of the underlying pathology, whether solid tumour, ovarian cyst, some other abdominal disorder, or even obesity. The NHS had responded to the unexpectedly high level of demand for treatment by imposing waiting lists. Whereas a patient with a large fibroid could be safely left for several months, ovarian cysts demanded more urgent attention since they were more likely to be associated with malignancy. It is understandable, therefore, that Donald responded with elation to the apparently clear-cut distinction between the echo pattern of a solid tumour and that of a cystic structure. He was immediately convinced that further investigations into the diagnostic potential of ultrasound would be worthwhile.

Donald enlisted the help of a junior clinical colleague, John MacVicar, and, crucially, that of Tom Brown, a brilliant young engineer. Brown was able to obtain a new, state-of-the-art flaw detector for Donald's exclusive use and research began in earnest. Brown also quickly managed to acquire an oscilloscope camera with which to record the results of their diagnostic investigations. Donald regarded the arrival of the camera as very significant. Images that could be shown to colleagues and reproduced in scientific publications were essential if the results of their ultrasound research were to be effectively disseminated within the academic community.

Gradually, Donald, MacVicar and Brown learned not only how to distinguish cysts from fibroids but also to recognise the ultrasonic characteristics of different types of cyst. They could also diagnose ascites, the presence of fluid in the abdominal cavity. Most of their early work was in gynaecology rather than obstetrics, although they noted that ultrasound could reveal the presence of hydramnios, an excess of amniotic fluid. Hydramnios is often associated with anencephaly, which could be confirmed by X-ray imaging. Another early demonstration of the utility of ultrasound in the monitoring of pregnancy was achieved, not by Donald and his colleagues, but by Marjorie Marr, a Sister at Glasgow's Royal Maternity Hospital. Donald became intrigued by Marr's ability to pronounce confidently on the position of the baby's head, even in obese patients or other complicated cases. It emerged that she had been making surreptitious use of the flaw detector in advance of the Professor's rounds, and had taught herself how to recognise the echoes of the fetal skull.

The real breakthroughs in diagnosis by ultrasound began in 1957, when Tom Brown realised the need for two-dimensional images and designed and built the first scanner [figs. 3, 4]. However, the challenge that Donald and his colleagues faced in interpreting the pictures from the new scanner can hardly be overstated. No one had ever looked at the human body in this way before. Each image was effectively a thin slice through the abdominal

Fig. 3 *Tom Brown in the laboratories of Kelvin and Hughes Ltd with the scanning mechanism of the first contact scanner that he designed. This machine produced the images for the paper published in 1958 by Donald, MacVicar and Brown. Courtesy the British Medical Ultrasound Society Historical Collection.*

cavity. The skills necessary to make sense of such images were quite different from those required to understand an X-ray plate, for instance. Ability to interpret two-dimensional ultrasound images was gained slowly, by trial and error and by systematic correlation with structures revealed at laparotomy, i.e., surgical investigation.

If it was not easy to learn to interpret the images; it was often still harder to explain them to outsiders. To try to convey the planar nature of the pictures, Donald devised a metaphor based on a sliced loaf of bread. The loaf represented the body of the patient. The ultrasound image was imagined to be constructed as if one lifted a single slice out of the loaf and saw the image on its cut surface. This was a useful pedagogic device. However, whereas a loaf of bread is always sliced transversely, ultrasound scanners could take images transversely, longitudinally or obliquely. It is hardly surprising that many of Donald's colleagues could not fully comprehend what was being visualised and thus remained sceptical about the value of the pictures.

Undeterred, Donald decided it was time to publish. In *The Lancet* of 7 June 1958

a paper appeared entitled 'Investigation of Abdominal Masses by Pulsed Ultrasound' (Donald, MacVicar and Brown 1958). The authors emphasised the contrasting ultrasonic appearances of cystic structures and solid tumours. Another image illustrated the deeper penetration of the ultrasound beam into the abdominal cavity that the team had identified as being characteristic of ascites. The most historically significant images in the 1958 paper were, however, undoubtedly those of the fetus and its associated structures. As the authors dryly observed, 'the pregnant uterus offers considerable scope for this kind of work because it is a cystic cavity containing a solid foetus' (Donald, MacVicar and Brown: 1192). A clear outline of a fetal skull, at 34 weeks' gestation, features in one image. Another picture displays twins at 37 weeks – two pairs of buttocks can be readily discerned. There is a crude but vivid visualisation of hydramnios.

The paper's most remarkable image shows a fetus, of only fourteen weeks' gestational age, that was detected in a woman who was not thought to be pregnant. She had been admitted to the Western Infirmary with irregular vaginal bleeding and a swelling of the abdomen. A fibroid was suspected. Her uterus was enlarged but she had no breast symptoms and did not think that she could have conceived. Surgical removal of the fibroid was decided upon.

Fig. 4 *The first image made using the machine shown in Fig 3. Courtesy the British Medical Ultrasound Society Historical Collection.*

Ultrasonic examination, however, revealed that the uterus was enlarged with fluid. Moreover, faint echoes could be discerned within the uterine cavity, which Donald was convinced were those of a very small fetus. A pregnancy test was ordered and its results eagerly awaited. The ultrasonic diagnosis was confirmed. In due course, a healthy baby was born. The happy outcome of this case gave Donald enormous satisfaction. It also represented a very considerable coup for the new diagnostic technology.

As ultrasound scanners began to be built and sold commercially, the quality of the images that they could produce greatly improved. More acute diagnostic discriminations became possible. Soon Donald and his colleagues could detect fetuses as early as nine weeks' gestation. They could also confidently diagnose the dangerous condition of hydatidiform mole. Early in 1963, a chance discovery was made that was to render the application of diagnostic ultrasound much more straightforward, at least as far as gynaecological cases, and obstetric patients in the first trimester, were concerned. A woman in the early weeks of pregnancy had been inadvertently kept waiting much longer than usual for her scan. She had been too nervous to ask to go to the toilet and presented herself for examination with a very full bladder. On viewing the images of her scan, the operators realised that her enlarged bladder had displaced the bowel from above the uterus and provided a clear 'sonic window' into the abdomen. This was a major breakthrough (Donald 1963).

Throughout this period of rapid technological development, localisation of the placenta remained a major research goal. Donald wrote:

> 'It was hoped from our work on the echoes from hydatidiform mole that a satisfactory method of locating the placenta might be developed, but we have to confess that, so far, we have been more often wrong than right. The technical possibilities are still, however, being explored' (Donald 1965: 912).

However, later that same year, a team of researchers working in Denver stole a march on their Scottish counterparts. The arrival of a pre-publication draft of a paper entitled 'Ultrasonic placentography', caused consternation in Glasgow. The Americans claimed that the key to the success of their technique was the exceptional sensitivity of their amplifier (Gottesfeld et al 1966).

However, Donald quickly realised that the amplifiers he had been using were, in fact, already sufficiently sensitive. A colleague recalls that Donald had decorated the walls of the corridor outside his office in the Queen Mother's Hospital with ultrasonograms. Having read the Denver paper, Donald was able to walk along the line of images, repeatedly pointing with his finger and exclaiming, 'There's the placenta! And there! And there! And there!' (B. Fraser, pers. com.). Now that he knew what to look for, Donald realised that the Glasgow team had, for some time, been producing images that showed the placenta [fig. 5]; but they had not been recognising what they saw. Developing an educated eye that could interpret ultrasound images correctly was indeed a long and arduous process.

Accurate location of the placenta transformed the diagnosis and management of placenta praevia.

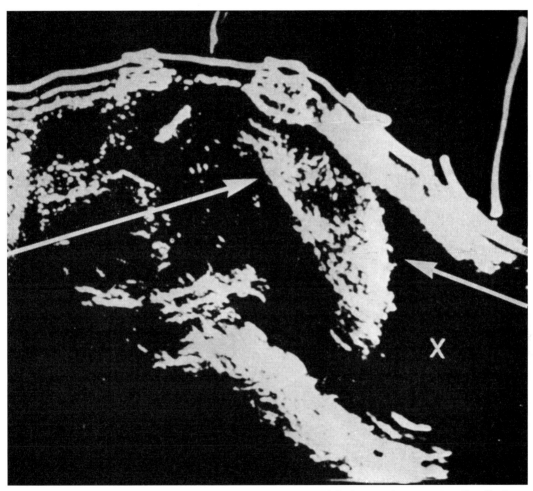

Fig. 5 An ultrasound image taken from a paper published in 1968 by Donald and Abdulla showing a placenta praevia, indicated by the two arrows. X indicates the bladder. A fetus, 33 weeks' gestation, is seen to the left. Courtesy the British Medical Ultrasound Society Historical Collection.

Fig. 6 *This advertisement from February 2001 indicates how ultrasound images have become part of common experience and are widely understood. With permission of Stagecoach Group.*

Throughout the sixties, Donald and his colleagues were also able to scrutinise the fetus in ever more detail. The size of the fetal skull and the length of its body were precisely measured, greatly assisting in the accurate estimation of gestational age (Willocks *et al* 1964; Robinson 1973). Techniques were devised to detect the fetal heartbeat, enabling much more immediate confirmation of fetal life than had previously been possible. The detection of major abnormalities, such as neural tube defects and microcephaly, was pioneered.

Donald was sanguine that the innovations he and his colleagues had introduced represented the bright, confident future of their specialty:

'I like doing obstetrics this way and removing as much of the traditional guesswork from our subject as possible. I like to know how well a baby is growing. I like a better estimate of maturity than is often available.

I like to know exactly where the placenta is in antepartum haemorrhage and in unstable lie and before employing amniocentesis. I like to be able to diagnose twins early and safely and to know if the second head is larger than the first. I like to know why an abdomen may be too large for the dates. I like to know whether bleeding in pregnancy is associated with a live or a dead baby or a hydatidiform mole and, above all, I find it fascinating to watch a well-nidated foetus growing...' (Donald 1967: 79).

Thus, by the late sixties, as a result of the work of the team of clinicians and engineers led by Ian Donald, the medical gaze had breached the 'iron curtain of the maternal wall'. The fetus was visualised, comprehended and medically controlled in ever-increasing detail. Moreover, the pregnant woman was no longer regarded as a reliable arbiter of the condition of her fetus, at any stage of her pregnancy. Her testimony regarding her menstrual dates was no longer crucial in the determination of fetal age: her experience of quickening no longer a significant marker of fetal life. Donald and his colleagues emphasised the greater authority of an objective, quantitative, technologically mediated diagnostic method. Meanwhile, the fetus, for the first time in its history, became a clinical presence, a patient in its own right. What is more, the fetus acquired a public persona. Soon its image would appear in every baby book, pictured as casually as a toddler on the beach. We would shortly get accustomed to seeing the fetus in the media; in newspaper articles, in advertisements for cars, soft drinks and even jobs [fig. 6].

REFERENCES AND FURTHER READING

Donald I.1955. *Practical Obstetric Problems.* London: Lloyd-Duke.

Donald I. 1963. 'Use of ultrasonics in diagnosis of abdominal swellings', *British Medical Journal*, 2, 1154–55.

Donald I. 1965. 'Diagnostic uses of sonar in obstetrics and gynaecology,' *Journal of Obstetrics and Gynaecology of the British Commonwealth*, 72, 907–919.

Donald I. 1967. 'Diagnostic ultrasonic echo sounding in obstetrics and gynaecology', *Transactions of the College of Physicians, Surgeons and Gynaecologists of South Africa*, 11, 61–79.

Donald I. 1969. 'On launching a new diagnostic science', *American Journal of Obstetrics and Gynaecology*, 103, 609–28.

Donald I. 1974. 'Sonar – The story of an experiment,' *Ultrasound in Medicine and Biology*, 1, 109–117.

Donald I. 1980. 'Medical sonar – the first 25 years' in A. Kurjak (ed) *Recent Advances in Ultrasound Diagnosis 2*, 4–20 Excerpta Medica.

Donald I., MacVicar J., Brown T.G. 1958. 'Investigation of abdominal masses by pulsed ultrasound', *The Lancet*, 1, 1188–1195.

Fleming J.E.E., Spencer I., Nicolson M. 1999. 'Medical ultrasound: germination and growth', in Baxter G.M., Allan P.L.P., Morley P. (eds.). *Clinical Diagnostic Ultrasound*, 2nd edn. London: Blackwell Science 1–19.

Gottesfeld K.R., Thompson H.E., Holmes J.H., Taylor E.S. 1966. 'Ultrasonic placentography', *American Journal of Obstetrics and Gynaecology*, 96, 538–545.

Hibbard B. 1962. 'The diagnosis of placenta praevia with radioactive isotopes', 1962, *Proceedings of the Royal Society of Medicine*, 55, 640–2.

Nicolson M. 2004. 'Ian Donald, diagnostician and moralist', website, Royal College of Physicians, Edinburgh, http://www.rcpe.ac.uk/library/donald/donald1.php.

Robinson H.P. 1973. 'Sonar measurement of fetal crown – rump length as a means of assessing maturity in the first trimester of pregnancy', *British Medical Journal*, 4, 28–31.

Spencer I.H., Fleming, J.E.E., Nicolson M. 2002. *'Scenes from the History of Ultrasound: British Medical Ultrasound Society Historical Collection'* www.bmus.org/scenes%20from%20history.htm

Stewart A., Webb J., Giles D., Hewitt D. 1956. 'Malignant disease in childhood and diagnostic irradiation in utero', *Lancet*, 2, 447.

Wild J.J., Reid J.M. 1954. 'Echographic visualization of lesions in the living intact human breast', *Cancer Research*, 14, 277–283.

Willocks J., Donald I., Duggan T.C., Day N. 1964. 'Foetal cephalometry by ultrasound', *Journal of Obstetrics and Gynaecology of the British Commonwealth*, 71, 11–20.

Willocks J., Barr, W. 2004 *Ian Donald - A Memoir*. London: RCOG.

ROBERTA MCGRATH

Moving Pictures:
GENDER AND THE VISUALISATION OF LIFE

In *Window Shopping*, Anne Friedberg charts what she calls a 'gradual and indistinct epistemological tear' along the fabric of modernity, a change that is caused by the growing cultural centrality of a feature that is integral to both cinema and television: a mobilised gaze that conducts a flanerie through an imaginary other place and time (Friedberg 1993: 8).

In this essay I argue that the mother's body is also another imaginary place, set in another time. Through photography, radiography and ultrasound the mother's body in particular becomes a showcase. Photographic and radiographic images are busy thoroughfares, sites of such mobilisation. Read as narrative sequence, they become part of a restless gaze that constantly scans, cutting through the body, rendering flesh transparent. It is also a gaze that is disembodied, unhinged in time and place. This essay discusses the restless images of the nineteenth, and twentieth, century. Both radiography and ultrasound share a desire to enter into the body without killing first – and both technologies have been extensively used in obstetrics. The question that emerges is firstly one of how to animate the dead – and latterly, as we shall see, the not yet living.

Through radiography the human body could be flayed without cutting away flesh and (so it appeared at first), without harming it at all. Looking intently without having to meet the eyes of the subject is a characteristically modern experience, as is close inspection at a distance. Yet, modern 'virtual' technologies of dissection and mass circulation cannot be understood without the physical work of anatomical dissection.

Such material, manual labour is repressed in modern images where the hand is hidden.

Photography, film and electronically generated images construct a smooth, seamless rhetoric of reality. However, this is the outcome of a lengthy historical process that is, in reality, achieved through hard *graft*, material and psychic labour that is rendered invisible in the modern image. All are detailing techniques in a very literal sense; they cut up and cut out, constantly re-framing their objects. The production and consumption of all images – their materiality, their extremely complex crafting, their engineering and assembling – and their interpretation, or reading, are equally important processes. Indeed, Bruno Latour presents a compelling argument that there are simply no major shifts in representation only; he suggests 'small unexpected and *practical* sets of skills to produce images and to write about them' (Latour 1986: 4). How images are made and how we then write about them matters. Modern images must be read alongside much older images, both popular and scientific, that haunt the present historical moment.

Some years ago at a conference on the theme of visual knowledges, I listened to an art historian recount his excitement at the ultrasound image he had just received via the internet of his daughter's to-be-expected baby, or as he described it, his grand-daughter. There was something vaguely troubling in this. I recalled an odd image in a medical textbook of the inventor of ultrasound, Ian Donald, practising the craft on his daughter. I retraced my steps and now sit looking at this photograph. It is captioned: 'Prof. Ian Donald scanning his daughter and grandchild' [fig. 1].

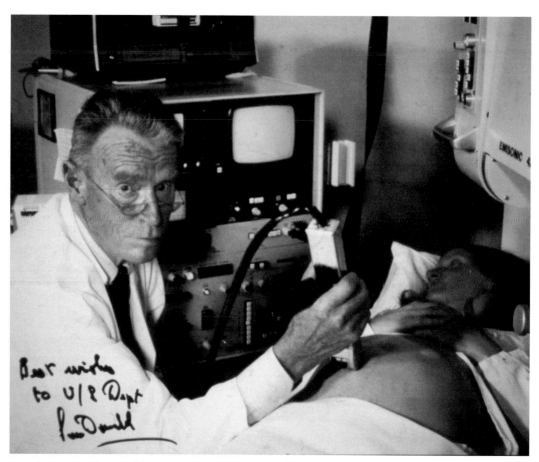

Fig. 1 *Prof. Ian Donald scanning his daughter and grandchild. Courtesy of the British Medical Ultrasound Society.*

The Doctor-inventor looks at me while scanning the body of a woman. The white coat, and half-moon spectacles perched on the end of his nose, signify his profession. The swollen belly is his daughter's, and as the caption tells us – and perhaps more importantly – what lies within is his grandchild. The daughter averts her gaze; her eyes turn towards the small screen (on which there is nothing to be seen). These interlocking gazes, my own, Donald's and the daughter's lead the observer to the machine. The image is signed in the lower left-hand corner: 'Best wishes from Ian Donald'. It is what one might find on a portrait from an entertainer, or on a postcard sent from a far-off land.

Ian Donald is named; his daughter is not. He looks; she turns away. This means that we too can look unimpeded. The hand of the inventor waves the wand over her (at no point does his flesh touch hers), but the pose is of course contrived; the image staged for the camera. What is foregrounded is man and machine. He is upright in foreground, she is prone, pushed to the back and side. In short, it is literally *through* the woman's body that man and machine are connected by an (electrical) umbilical cord. The message is clear: he is the father of both, daughter and ultrasound.

I do not want to describe here in detail Donald's contribution to the development of ultrasound. Rather, I take this image as my centrepiece, as a means to understanding what Bruno Latour calls the two arrows of time: one which drives us in the direction of increasing the distance of objectivity and subjectivity and the other towards ever more intricate attachments (Latour 2004: 235). I want to read this image as

travelling in two directions. I argue that it can only be understood by simultaneously looking back – at radiography, photography and engraving – and forward – by placing Donald's image alongside a new 'generation' of 3 and 4D ultrasound. Moving images become important here in both senses of the phrase: shuffling them around and animating bodies. We could, for example, read the image alongside Bidloo's engraved dissection of a female cadaver [fig. 2]. Or we might recall the history of anatomy as the history of anatomists dissecting relatives (Richardson 1987: 31).

However, in order to move forward to the present we would have to understand the history of radiography and photography. In 1896, Snowden Ward had remarked on the ways in which radiography, photography and surgery might converge: 'Photographers [are] insufficiently acquainted with electricity, electricians insufficiently acquainted with photography, and surgeons insufficiently acquainted with both subjects'. Ward ventured to suggest that 'surgical applications are far the most important at the moment … in obstetrics the enormous value of radiography must be obvious, upon reflection' (Ward 1896: intro, 75). This is where the secrets of man's life and death are held. The womb, as Rosi Braidotti has put it, has 'always held men in suspense' (Braidotti 1994: 68). With the invention of radiography the woman's body becomes a living cabinet of curiosity.

Radiography, the precursor to ultrasound, made it possible to picture, for the first time, the foetus inside the live female body. The price of this visibility was that the mother's body did not register on the radiographic plate. The foetus in *Geburtshilflicher Röntgen-Atlas* [fig. 3] is first seen

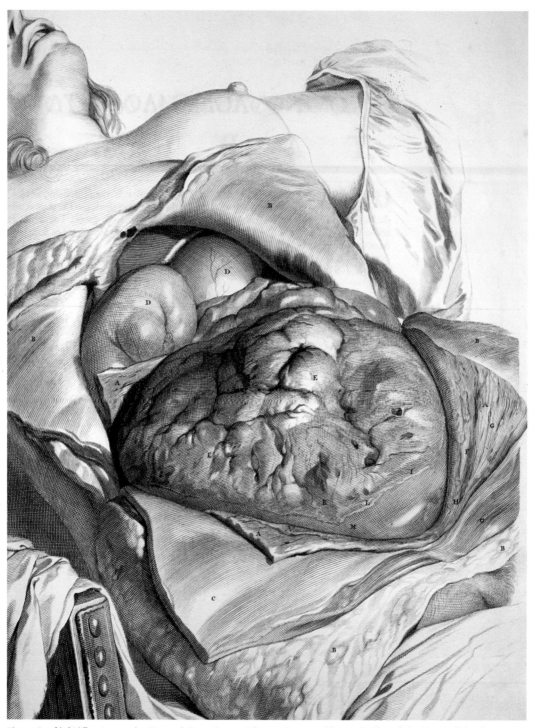

Fig. 2 *Gottfried Bidloo,* Anatomica Humani Corporis, *1685, Plate 55. Courtesy of the Royal College of Physicians, Edinburgh.*

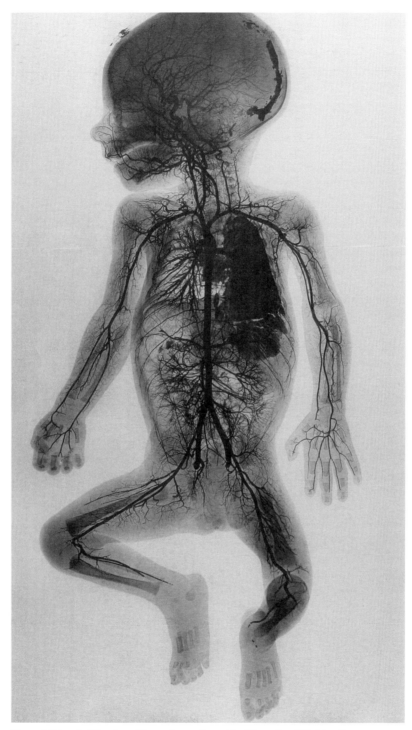

Fig. 3 *Collotype by Römmler and Jonas after a radiograph by G. Leopold and Th. Leisewitz, Geburtshilflicher Röntgen-Atlas, 1908. Courtesy of the Royal College of Surgeons of Edinburgh.* *

as a skeleton; not yet alive but symbolically, already dead. Like older engravings the skeleton here performs a kind of dance of death. To illuminate the reality of a new life behind the surface appearance, or beneath the thin veneer of flesh, surface and interior are inverted; it is both a turning inside out, and a reversal of what is visible and invisible, rendering life itself as deathly immanence. In the foetus and neonate, skin has still the transparency of the unformed, or the yet-to-be-formed whose boundaries are unclear. This makes it easily accessible to radiography and renders it as a special kind of object. So the foetus makes its appearance in early radiography along with other small animals like frogs and rats. In this sense the image relates to earlier illustrations of dissections [fig. 4] and to MacIntyre's (1896) earliest radiographic films or rather animation, of a frog's leg kicking and a heart beating [figs. 5, 6]. We would also have to recall that the first screening of this film was at ladies' night, Glasgow Royal Society, as entertainment. The laboratory and the cinema are not dissimilar places. Indeed it is worth remarking here that X-rays were popular tokens, displayed in department stores (such as Selfridges in London) as well as scientific tools of diagnosis.

As a laboratory animal, the foetus is a substitute for the adult (assumed male) body and the female body itself, and the uterus in particular, becomes a laboratory, a controlled sanitised space where experiments on 'life' can be carried out. It, too, is a kind of operating theatre in which the foetus plays the leading part. In radiography the uterus appears as a dark empty space; its lack of density renders it as nothingness. It is only the spectral formation of the skeletal foetus that

appears as complete, as if floating in a void. Woman is a culture for growing life and through radiography and ultrasound the progress of the foetus is monitored. It is both an identificatory figure and an understanding of the radical otherness of the self. It is both like and different from a child; it is neither subject nor object; neither totally alive nor quite dead; until the moment of birth, the neonate is a product-to-be; a commodity that is not yet finished.

This perception makes it easy to manipulate and ripe for experimentation, as if it were indeed merely a small living organism, such as a cell growing in a kind of fleshy Petri dish. The passage of the foetus from insensate object to sensory subject has been lengthy and controversial. In radiography, pelvis and foetus appear as already separate objects. The mother's body, reduced to her racchitic pelvis, is a problem from which the foetal body, logjammed, must be rescued [fig. 7]. The bones of the narrow or deformed pelvis could be cut and wrenched apart. The pelvis could be opened up through the operations of symphisotomy (or hebosteotomy) and pubiotomy, and the X-ray was employed to demonstrate the success of these operations. Radiography might improve a surgeon's performance, and could be used to advertise and promote surgery. Pubiotomy, introduced in the last quarter of the eighteenth century, was not widely used because of the maternal mutilation that resulted. Howard Speert comments that it fell into decline with the increasing safety of Caesarean section (See Speert, 1973 and Spencer, 1927). However, the date of this atlas suggests that it was still being performed in the early twentieth century.

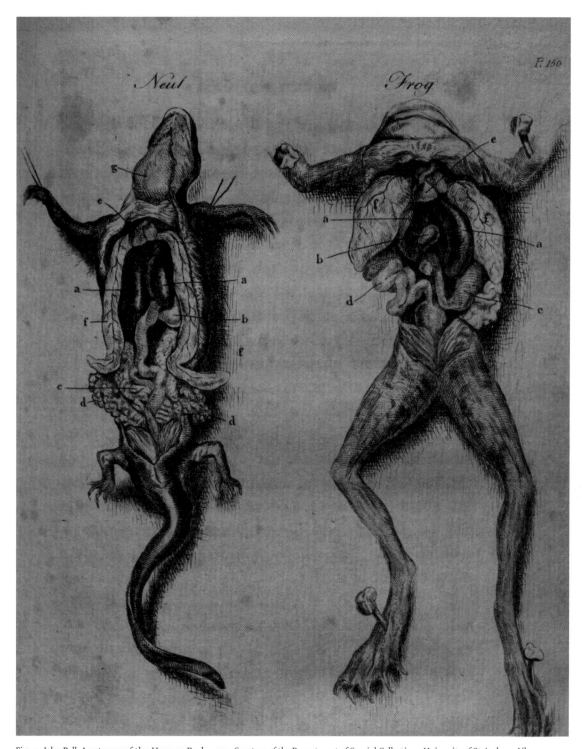

Fig. 4 *John Bell,* Anatomy of the Human Body, *1797. Courtesy of the Department of Special Collections, University of St Andrews Library.*

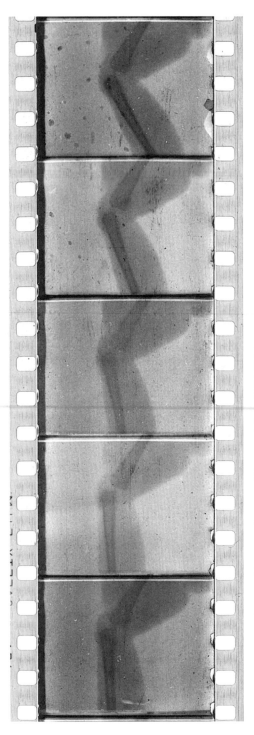

Fig. 5 *Frog's leg, from Dr. MacIntyre's X-Ray Film. 1896. Still image courtesy of the Scottish Screen Archive.*

Fig. 6 *Heart, from Dr. MacIntyre's X-Ray Film. 1896. Still image courtesy of the Scottish Screen Archive.*

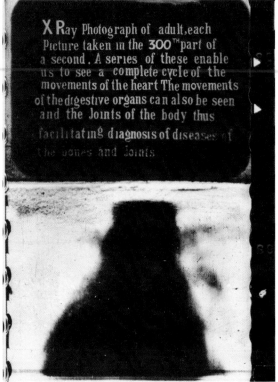

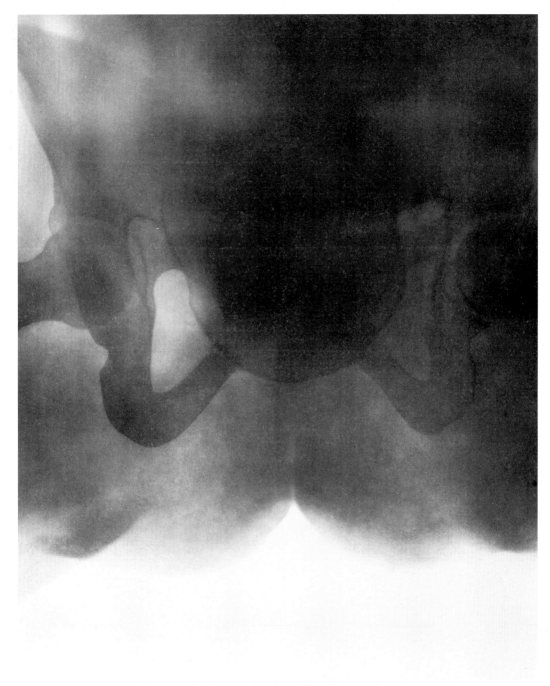

Fig. 7 A woman's narrow pelvis with child's head stuck in the middle of labour. *Collotype by Römmler and Jonas after a radiograph by G. Leopold and Th. Leisewitz*, Geburtshilflicher Röntgen-Atlas, *1908.
Courtesy of the Royal College of Surgeons of Edinburgh. *

Looking at the skeleton body is in one sense to see pictures from a spectral home. These are uncanny images. If the pelvis registers on the X-ray, or the uterus appears as a miasma, the mother's body remains a shadowy phantom, a body everyone must pass out of and into which no one can return. It is knowing the one-way nature of that street, perhaps, that makes the body of the mother and the related search for the secret of life such an enduring symbol; a holy grail of science. Whether consciously or not, in thinking about creating and controlling the environment where life begins, it is the woman's body that is revisited, repeatedly interrogated and observed over and over again.

Photography and radiography are prime models for visual culture as a command performance in its most literal sense. Barbara Duden suggests that only what 'can be visualised, recorded or replayed at will are part of reality' (Duden 1991:17). The repetition and replication of the same consistent images untouched by human hand are crucial in securing their authenticity as objective, scientific images. The result, Duden suggests, is 'a strange mistrust of our own eyes', and indeed, of our own bodies (ibid.). The human body, penetrated by radiant light, shifts the site of the visible from surface appearance to interior depth. The embodied subject fades and finally yields to become a disembodied, fractured object; a thin slice of life; a shadow brilliantly illuminated. Radiography reverses visible and invisible; life and death. The visible surface dissolves to reveal the true reality of life beneath the skin. The black void in which the radiographed object floats is reminiscent of a body part which is not only

without background, but is as if suspended in space. It seems to glow and pulsate; it is an image both fugitive and fixed. These body fragments are not only decontextualised, but dislocated, suspended in space and time. Bones represent the densest objects. Viewed in the dark, with a strong light source behind, X-rays scarcely repress their status as spectres or emanations from another world. These are ghostly images thrown into light and life at the flick of a showman's switch and this is their link to popular culture.

In anatomical atlases, the dead body is brought to life, resurrected, resuscitated, through images; in radiography, the living body is rendered fleshless, bloodless, lifeless and dead. (This is more than a metaphor; as Cartwright reveals, real human flesh and bone, real lives, were destroyed bit by bit by powerful light rays. Early radiography both made visible and simultaneously destroyed the human body, providing evidence that looking can indeed kill (Cartwright 1995:108). Radiography represents a new kind of disciplinary subjugation whereby subjective, live knowledge of the human body is banished as unreliable. The body that emerges after radiography is a body that is no more than the sum of its parts. The historical and cultural experience of being human is stripped; its sedimented structure laid bare. Radiography dissolved flesh and decomposed a body that was shown, for the first time, to reverse life and death. The foetus demonstrated death even before life had begun.

This might allow us to make sense of the emergence of 3 and 4D ultrasound that now provide 'breathtaking moving images of your unborn child, giving you and your family a sneak preview of your

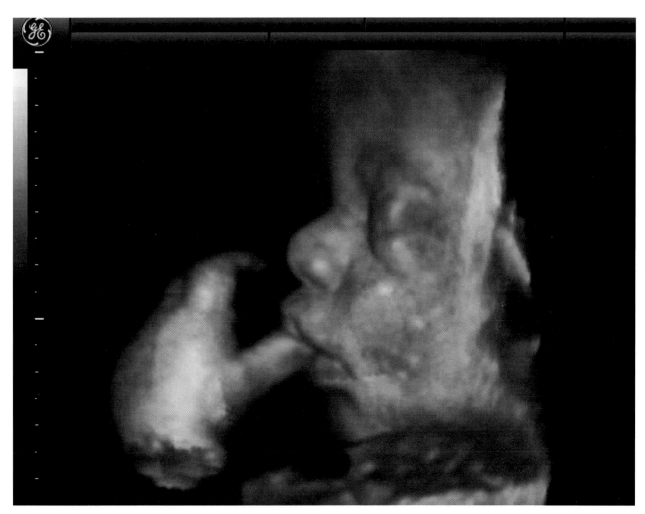

Fig. 8 3D image of a 35 week old foetus. Courtesy of GE Healthcare.

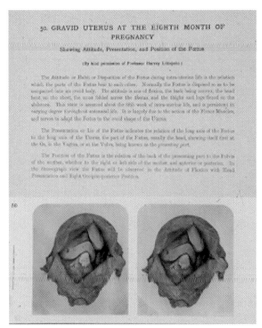

50. GRAVID UTERUS AT THE EIGHTH MONTH OF PREGNANCY

Showing Attitude, Presentation, and Position of the Foetus

(By kind permission of Professor Harvey Littlejohn.)

Fig. 9 *Plate 50. 'Gravid uterus at the eighth month of pregnancy.' (By kind permission of Professor Harvey Littlejohn.). Barbour-Simpson G. and Burnet E., Edinburgh Stereoscopic Atlas of Obstetrics. 1908. London: Caxton Publishing Company. Royal College of Physicians, Edinburgh.*

child in the womb' (www.babyultrasoundcompany. co.uk) [fig. 8]. It is worth noting here the direct voice, you and your and the definite article in 'the' womb – that is not yours. These images, produced in 4D 'studios', and are described as for the purposes of 'aesthetics and reassurance' and as 'bonding and reassurance scans' (ibid.). One might justifiably ask what is meant by this given that prior to birth the foetus is part of the mother's body. Yet these images

are strangely dead and uncannily resemble much earlier stereoscopic images such as published in *The Edinburgh Stereoscopic Atlas of Obstetrics* (Burnet and Simpson 1908-1909) [fig. 9].

Thus in the latter half of the nineteenth century the stereoscope bridged what was a growing chasm between the two-dimensional, fixed image and the three-dimensional, and increasingly fast-moving world. Located between photography and film, and between two-dimensional print and three-dimensional sculpture, stereoscopy placed the observer at a bridging point between two slightly disparate images that appeared to converge into a single image of dramatic depth. Positioned at the apex of a triangle, the observer was plunged into a vivid hyper-reality. It is therefore not surprising that the stereoscope operated at the very edges of both acceptable (scientific) and unacceptable (pornographic) verisimilitude. The latter was the prime use of stereoscopy. Crucially at the point that stereoscopy became closely associated with illicit viewing, it was taken up by medicine (Crary 1990: 127).

In the image shown here a womb is opened up to reveal a dead, but term foetus. One reviewer described it thus: 'The stereogram of the 8th month of pregnancy shows very *beautifully* the normal attitude and presentation of the foetus in utero' (Anon.,1909: 93). The embalming techniques of both pathology and photography coalesced to produce vivid, lively, startling images that jump out at the frozen, fixed viewer. These new ways of looking created new realities, constituted new objects, in effect, *generated* a

new understanding that is further developed and refined in 3D ultrasound.

The modern, industrial environment within which the foetus now exists is a territory that can be controlled. The biological body of the mother is reduced to by-product. A previously hidden, undefined, privately experienced interior world becomes a space opened up to medical scrutiny, a womb that can be monitored and managed. As Anne Balsamo has noted, some obstetricians now go so far as to argue 'that the foetus is the *primary* obstetric patient' (Balsamo 1999: 236). Even the embryo is imagined as already complete, as separate from the mother's body, which can, if necessary, be by-passed. This current conception of the foetus is, however, merely a smarter, cleaned-up, post-modern form of medieval flaying. Women are encouraged to engage with this process and, by and large, seem to consent not only willingly, but also eagerly. Moreover, they do not just participate in the monitoring and management of the foetus, but start to participate in their own surveillance. In that ghastly, and ghostly, token of exchange, the foetal ultrasound image, the mother-to-be is presented with an image of her alienated labour; a simulacrum whose significance is already preconceived [fig. 10].

In the ultrasound image, the boundaries of space and time collapse. Skin is rendered transparent; bone dissolves, and the mother's body vanishes into thin air. In these technologies the mother does not register. She is off-screen, out of frame, no longer a part of the obstetric picture.

The spectacle of 'life', some might argue the greatest show on earth, is dominated by the image of the embryo as increasingly independent and self-sufficient; not internal and embodied, but as disembodied and external, weightlessly floating in outer, rather than inner, space – pictured through 3D ultrasound as 'walking in the womb', conjuring up by analogy walking on the moon, whereby the astronaut is connected to the mothercraft by an umbilical cord that carries oxygen to allow him to survive in an alien environment.

As I finish writing this essay, a headline in *The Observer* newspaper declares, 'Two men and their baby – how science outwits Mother Nature' (McKie and Asthana 2005: 3). I imagine another headline: 'Two women and their baby – how science learns from Mother Nature,' but that headline is, of course, harder to imagine. The article, on the rapid progress of stem-cell research, opens with the line, 'It is a prospect worthy of a science fiction B movie'. Clearly, the popular is still very much alive in science. We would do well to resist the widespread belief that 'popular images can be understood with no specialised knowledge of production and interpretation, but understanding scientific images requires highly expert training' (Treichler et al 1988: 4). The present historical conjuncture both demands and makes necessary the re-evaluation of scientific visual culture and the role that sexuality and subjectivity have played in shaping that culture; it does not mean demonising that culture any more than deifying it. But it does mean looking beneath the smooth surface of the images and bodies and

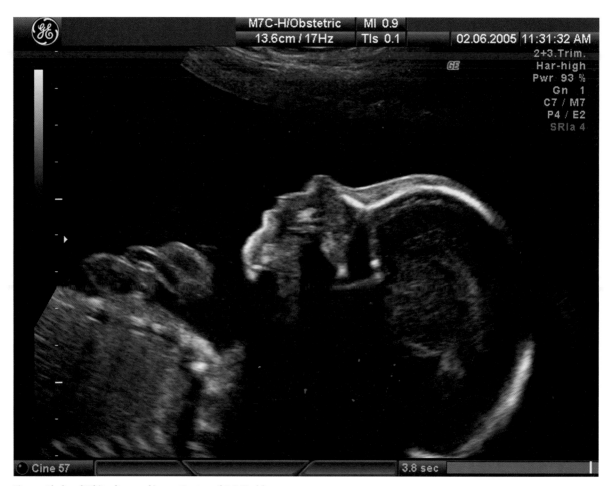

Fig. 10 *Black and White ultrasound image. Courtesy of G. E. Healthcare.*

examining not just our ways of seeing, but the more material techniques of an observer who is gendered. To return to Latour, perhaps we simply can no longer afford to be modern in an old-fashioned way (Elam 1999: 2).

REFERENCES AND FURTHER READING

Balsamo, A. 1999. 'Public Pregnancies and Cultural Narratives of Surveillance,' in Clarke, Adele and Olesen, Virginia, (eds) *Revisioning Women, Health and Healing*. London: Routledge.

Braidotti, R. 1994. *Nomadic Subjects: Embodiment and Sexual Difference in Contemporary Feminist Theory*. New York: Columbia University Press.

Burnet, E. and Simpson, G. F. Barbour (eds).1908–1909. *The Edinburgh Stereoscopic Atlas of Obstetrics*. London: Caxton Publishing Company.

Calder, J. F. 2001. *The History of Radiology in Scotland 1896 –2000*. Dunedin Academic Press.

Cartwright, L. 1995. *Screening the Body: Tracing Medicine's Visual Culture*. Minneapolis and London: Minnesota University Press.

Crary, J. 1990. *Techniques of the Observer*. Cambridge, Massachusetts: MIT Press.

Duden, B. 1991. *The Woman Beneath the Skin: A Doctor's Patients in Eighteenth-century Germany*. Cambridge, Massachusetts: Harvard University Press.

Friedberg, A. 1993. *Window Shopping*. Berkeley: University of California Press.

Latour, B. 1986. 'Visualisation and Cognition', *Knowledge and Society: Studies in the Sociology of Culture Past and Present*, 6.

Latour B., cited in Elam, M. 1999. 'Living Dangerously with Bruno Latour in a Hybrid World'. *Theory, Culture and Society*. Vol. 16, no 4.

Latour, B. 2004. *Politics of Nature: How to bring the sciences into democracy*. Cambridge, Massachusetts: Harvard University Press.

McKie, R. and Asthana, A. 'Two men and their baby – how science outwits Mother Nature', *The Observer*, 13 November 2005.

Richardson, R. 1987. *Death, Dissection and the Destitute*. London: Routledge.

Speert, H. 1973. *Iconographia Gynatrica*. Philadelphia: F.A. Davis.

Spencer, H. R. 1927. *The History of British Midwifery from 1650–1800*. London: John Bale, Sons and Danielsson Limited.

Treichler, P. A. et al (eds). 1988. *Imaging Technologies, Gender and Science*. New York: New York University Press.

Ward, H. S. 1896. *Practical Radiography*. London: Dawbarn and Ward.

www.babyultrasoundcompany.co.uk

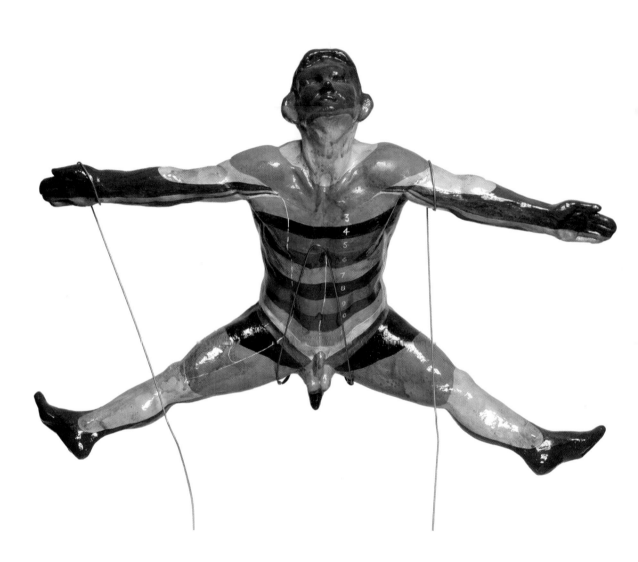

MATERIAL LEARNING

DUNCAN MACMILLAN

The Scalpel and the Burin:

COLLABORATIONS IN EIGHTEENTH- AND NINETEENTH-CENTURY ART AND ANATOMY

When Sir John Medina was invited to add his own portrait to the remarkable series he had painted of the Fellows of the Royal College of Surgeons of Edinburgh, it was a nice compliment. It marked the mutual recognition of two professions, those of the painter and the surgeon, and a staging point in the establishment of both in Scotland. The status claimed by the Surgeons by the building of their new headquarters, Surgeons' Hall, for which these portraits were painted, was an important step in the establishment of medicine at the centre of the dawning Enlightenment in Scotland and of Edinburgh as a medical centre of outstanding importance. Medina's knighthood in 1706 – he was the last to be knighted in the independent kingd om of Scotland – granted similar recognition to the artist's profession.

But the invitation to Medina to join the surgeons also proposes an alliance between artists and surgeons or, more broadly, the medical profession, that was to be central to Edinburgh's success in medicine. We do not know if Medina was lending his skills directly to the Surgeons in their work, but there was already a long-standing recognition of an interest shared by the two professions. Anatomy was a central part of the artist's discipline. Not just Leonardo, but Michelangelo was celebrated for his command of the subject. At the close of the sixteenth century in Florence the painter, Lodovico Cardi, Il Cigoli, had even made himself ill working on dissections in the interest of his art. He also worked alongside the distinguished Flemish anatomist, Theodoro Marian. Il Cigoli was a friend and collaborator of

Galileo and, in contrast to the present day, the common ground between art and science (encompassing medicine) was more important than any differences. Nevertheless what happened in Edinburgh as the new medical school was established, following the reforms in the University structure undertaken by Principal Carstairs, was more than a loose association of professionals in different disciplines with a common interest in anatomy. It was a real creative partnership from which both parties were to benefit.

It was Alexander Monro, always called Primus as he was succeeded by his son and his grandson, who really established Edinburgh University's Medical School. He was appointed Professor of Anatomy in 1721, but was not formally inducted into the professorship until 1725. It was during these same years that the idea of a drawing academy was first mooted and resulted in the establishment in 1729 of St Luke's Academy, Scotland's first art institution. It was housed in the College building of Edinburgh University. The individuals who set it up included James Norie and Roderick Chalmers, the leading Edinburgh painters of the day, William Adam, father of Robert, and the Allan Ramsays, father and son. The most interesting figure in the present context was the treasurer, Richard Cooper, an English engraver who had settled in Edinburgh after a visit to Rome. He was to play a central part in the establishment of printmaking in the city and this was essential for the illustrated publications on which progress in medicine depended. Without it the illustrated publications simply could not have existed, but the opposite is also true. The two disciplines developed in symbiosis. There were of course other important outlets for the engraver's art. Topographical illustration, for instance,

Opposite. Drummond, Young and Watson. The Vestibule of the Royal Institution, Edinburgh, c.1907-1910. Royal Scottish Academy

became very popular in the early nineteenth century. Even Turner turned to Edinburgh to have his illustrations engraved, but those skills would not have been there for him if the exacting demands of medical illustration had not provided the stimulus for their development.

St Luke's Academy does not seem to have survived very long, but Richard Cooper continued to run his own drawing academy at least until the upheavals of 1745-6 and perhaps afterwards, too (Cooper died in 1764). Amongst those he taught were the outstanding engraver Sir Robert Strange and Andrew Bell who is better known, however, for his part in the publication of the *Encyclopaedia Britannica* than as an engraver. Working in London, Strange provided some superb engravings for William Hunter. But in Edinburgh Cooper was even more directly engaged with medical teaching and research. Alexander Monro's own great interest was anatomy and his major publication was the *Anatomy of the Humane Bones*.

Monro's work was marked by intellectual discipline and accuracy of observation, things that he passed on to his numerous pupils. He certainly worked closely with Richard Cooper, and although the *Anatomy of the Humane Bones* was not illustrated in its early editions, some of Monro's contributions to *Medical Essays and Observations* are illustrated (the first illustrated edition of Monro's *Bones* seems to have been produced in France some thirty years later by Jean-Joseph Sue who notably also produced several works of this kind especially for artists.) A vigorous engraving of a skull, illustrating the anatomy of the jaw in an essay by Monro, for instance, is signed by Cooper with the slightly

paradoxical additional information that it was done *ad vivum* [fig.1]. Though the subject is plainly very dead, the point is clear. The illustration, it declares, is a transcription of an actual individual skull. Its accuracy therefore could be relied upon. It is clear that Monro himself already saw the importance of first-hand observation as the basis of record and thus of medical publication, for he was evidently recording his own observations in drawings by this time. Following that innovative departure, he also seems to have established drawing classes with Cooper for his students, just as Cooper also trained his own students in medical illustration.

It was with this groundwork in place that in the next generation, Edinburgh began to become a major centre for the publication of illustrated medical books. Because of Monro's initiative, many of the illustrations had the novel and important distinction that they were drawn by practising surgeons. This had the clear advantage that the artist could be expected to have a professional understanding of the subject illustrated. An outstanding example is *The Structure and Physiology of Fishes Explained and Compared With Those of Man and Other Animals* by Monro's gifted son and successor, Alexander Monro Secundus. There is no doubt that, as his father's son, the younger Monro had learnt to draw, but clearly he thought more highly of the work of his prosector, or senior demonstrator, Andrew Fyfe, than he did of his own talents, for many of the remarkable illustrations in this book are signed by Fyfe [fig. 2]. Fyfe was himself a surgeon and, as these illustrations demonstrate, he was also a magnificent draughtsman.

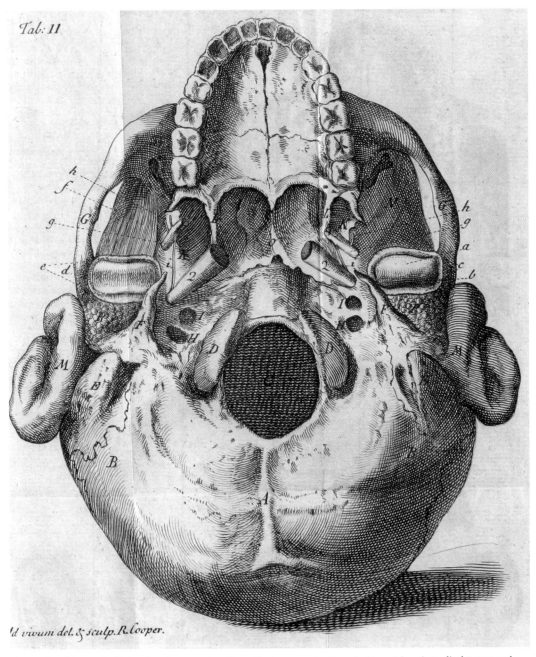

Fig. 1 *Richard Cooper. Skull showing the upper jaw, illustration to an essay by Alexander Monro Primus in* Medical Essays and Observations, *3rd. edition 1747, Table II. Courtesy of the Royal College of Surgeons of Edinburgh.*

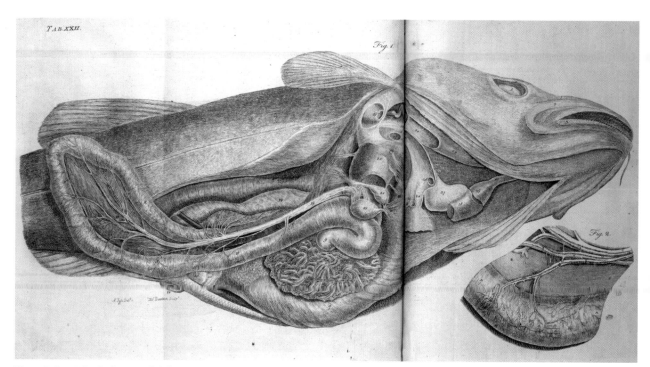

Fig. 2 *Andrew Fyfe*. The heart and abdominal viscera of a codfish with the lacteals, receptacle of the chyle and receptacle of the chyle and lymph injected with wax. *Illustration to Alexander Monro Secundus, Edinburgh,* The Structure and Physiology of Fishes Explained and Compared With Those of Man and Other Animals, *1785. Courtesy University of Edinburgh Library, Special Collections.*

The engraver in this example, Thomas Donaldson, was a pupil of Richard Cooper. He and Andrew Fyfe also together provided most of the illustrations for Monro's *Three Treatises on the Brain, the Eye, and the Ear* and a good many of those for his monumental *Observations on the Structure and Functions of the Nervous System*. They were probably also the authors of a superb life-sized etching and engraving of a male cadaver showing the lymphatic system [fig. 3]. Printed from three large plates it is one of the most remarkable medical images of the period, all the more so as the original cadaver is also preserved in the Edinburgh University Anatomical Museum. The exact purpose of this print is unclear, but the lymphatic system was a particular interest, if a rather vexed one, of Monro Secundus. Its discovery was the subject of a heated dispute over precedence with William Hunter in London. Fyfe, who also learnt to etch and engrave, later published *A System of the Anatomy of the Human Body*. It is largely illustrated with his own superb drawings and occasionally, as in the example shown in fig. 4, these are rendered in prints that he made himself.

Alexander Monro Secundus was for a time joint secretary with David Hume of the Edinburgh Philosophical Society (he was later sole secretary). It should not be surprising therefore to find direct and accurate observation, empiricism in fact, at the heart of his research. But it was another Edinburgh surgeon, John Bell, who, in the preface to his *Anatomy of the Bones, Muscles, and Joints*, set out the explicit principle that first-hand observation of a particular specimen was the essential basis of any meaningful medical illustration,

'I have drawn my plates with my own hand. I have engraved some of these plates and etched almost the whole of them; Which I mention only to show that they have their chance of being correct in the anatomy, and that whatever, by my interference they may have lost in elegance, they have gained, I hope, in truth and accuracy.' (Bell J, 1794: iv)

'No painter in natural history, in botany, in mechanics, nor in anything that relates to science would dare to draw without his subject immediately before him: but anatomists, who most of all need this clearness and truth, have been most arbitrary and loose in their methods; not representing what they saw, but what they themselves imagined or what others chose to report to them.' (Bell, J., 1794: vi)

He also argues that it is no good taking examples from different specimens that may have different histories and in many ways not be comparable. The result, he says, 'cannot be other than a plan when the whole work is accomplished and set up.' (Bell J, 1794: viii) In other words such an image is only generalised. It lacks the truth of the particular.

Thus the etcher's needle and the engraver's burin had joined the scalpel in Bell's medical kit. He had not only learnt to draw, but also to etch and engrave in order to be able to be faithful to his own observations right through till they appeared on the printed page. To assert this authenticity, he prominently signs each plate, stating whether he has etched it or engraved it. He turned to the engraver John Beugo for instruction in these techniques. In setting out the principles on which his own art is based,

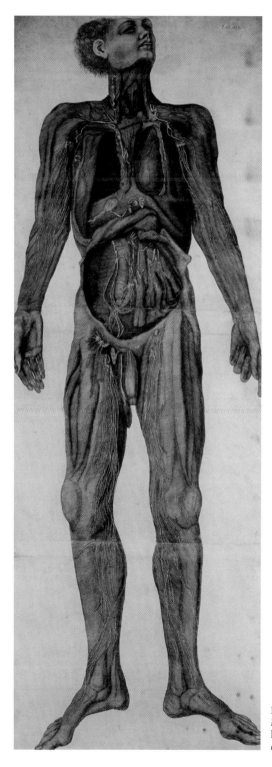

Fig. 3 *Attributed to Andrew Fyfe and Thomas Donaldson.* Male cadaver showing the lymphatic system, *etching and engraving, c. 1788. Courtesy University of Edinburgh.*

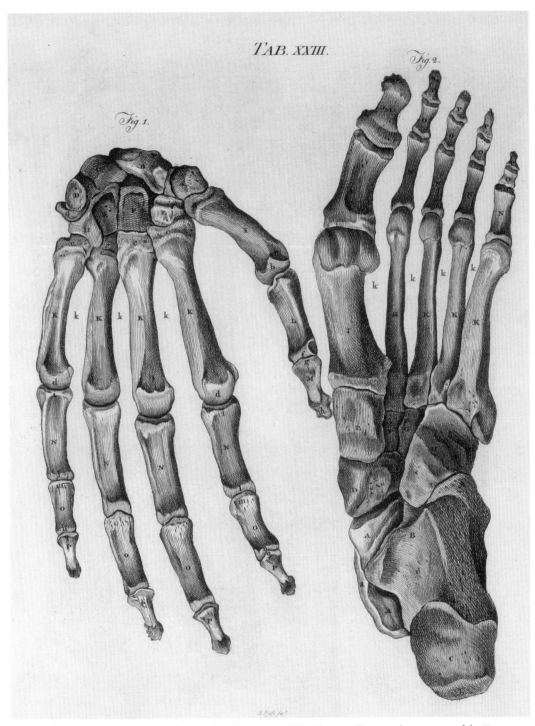

Fig. 4 *Andrew Fyfe.* The skeleton of the hand, in One Hundred and Fifty Plates to Illustrate the Anatomy of the Human Body. 1830. Plate XXIII. Courtesy of the Royal College of Surgeons of Edinburgh. *

Bell largely ignores his debt to the practice of preceding generations in Edinburgh. Nor was he alone in his achievements. Andrew Fyfe, as we have seen, had also become a skilled printmaker. Nevertheless what Bell has to say is a very important demonstration of the philosophy behind this kind of work.

Bell's style is notably novel. In keeping with his declared intention to record what he himself had seen in a particular individual, he eschews altogether the conventional presentation of his subjects in more or less aesthetic guise, which had been the norm since Vesalius. Instead he draws his cadavers as they are on the dissecting table [fig. 5]. If it was necessary to use tackle to support or extend the body, that too is included in the image. The result is graphic and even horrific, a startling and radical departure from the tradition of smooth and graceful anatomical drawings. It was so novel, indeed, that in France it clearly captured Géricault's imagination. One of Géricault's most horrific images is a painting of two bloody, severed heads, one male and the other female, laid out on a white cloth. These have always been thought to be victims of the guillotine, painted, like Cooper's skull, 'ad vivum', but in fact they are an imaginative interpretation in paint of an illustration in Bell's book [fig. 6]. The way Bell disclaims elegance in favour of truth and accuracy is striking. It may well have struck a chord with Géricault and it is likely his taste for macabre studies was encouraged by Bell's example.

If it seems far-fetched to suppose that a major French artist would have turned for inspiration to an obscure Scottish anatomist, in fact there was a close link between them through John Bell's younger brother Charles. And if the debt thus far had been more of medicine to art, it is with Charles Bell that the pay-back begins and art in turn draws its inspiration from medicine.

In order to learn to draw and to contribute to the later volumes of his brother John's *Anatomy*, as he did, Charles Bell studied with the painter David Allan, master of the Trustees Academy, successor institution to the Academy of St Luke and to Cooper's academy. As well as his professional work, Bell continued throughout his life to paint as a relaxation and a number of drawings in Allan's style by him survive in the collection of the Royal College of Surgeons. More important though and also in the collection are the ambitious oil paintings that he made as a study of the pathology of wounds after the battle of Corunna. Like his brother's illustrations, these wound paintings do not shrink from graphic detail. Not surprisingly, given the foregoing, they also bear a striking resemblance to some of Géricault's studies.

Charles Bell's first major independent illustrated publication was *The Anatomy of the Brain* published in 1802 [fig. 7]. It is a collection of 12 large, detailed and exquisitely drawn coloured images of the dissection of the skull and brain, each signed jointly by Bell and by one of the several engravers employed on the project. Bell had set himself an artistic challenge in this as well as a medical one. Indeed he states in the opening sentence of his Advertisement at the beginning of the book that the description of the brain is so intricate that it is a task only capable of an artistic solution:

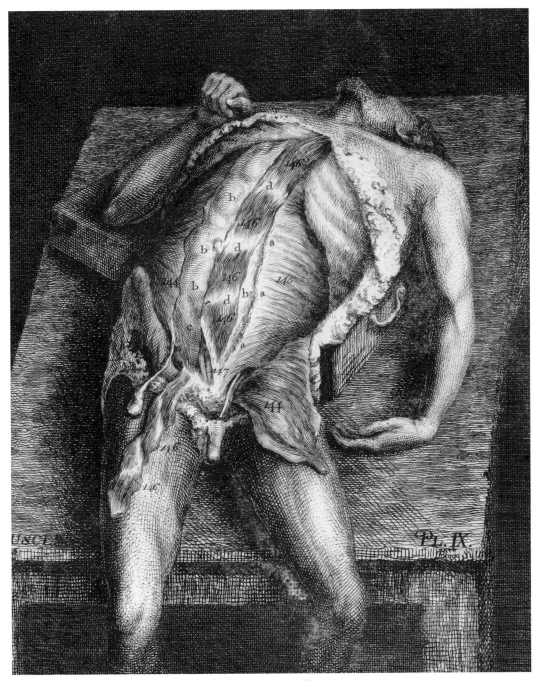

Fig. 5 *John Bell.* The Anatomy of the Bones Muscles and Joints. 1797. *Plate IX.*
Courtesy of the Royal College of Surgeons of Edinburgh.

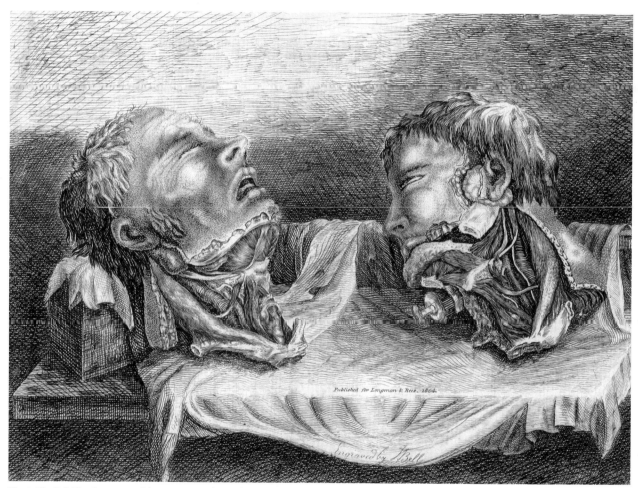

Fig. 6 *John Bell*. The Anatomy of the Bones Muscles and Joints. 1797. 1804 edition. Plate III. Courtesy of *The Royal College of Surgeons of Edinburgh*. *

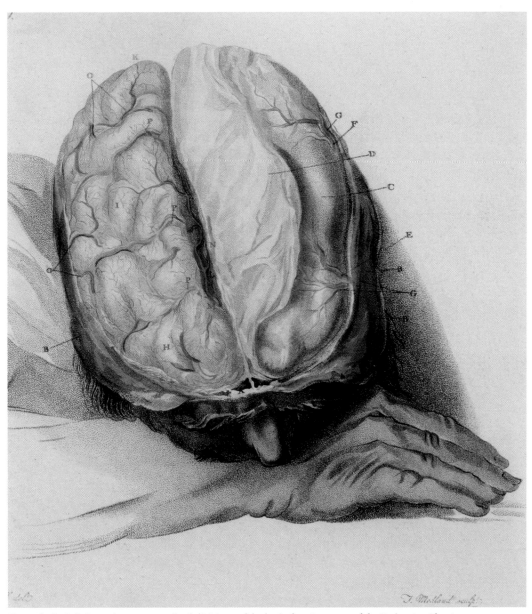

Fig. 7 *Charles Bell. General anatomy and subdivisions of the brain from Anatomy of the Brain. 1802. Plate I. Courtesy of the Royal College of Surgeons of Edinburgh.* *

'In the Brain the appearance is so peculiar, and so little capable of illustration from other parts of the body, the surfaces are so soft, and so easily destroyed by rude dissection, and it is so difficult to follow an abstract description merely, that this part of Anatomy cannot be studied without the help of Engravings.' (Bell Ch., 802: 1)

Thus art is indispensable to surgery.

Bell's *Anatomy of the Brain* was the first step towards his main achievement, the identification of the function of the nerves, but prior to this, he published a book that crossed over from medicine to art, his *Anatomy of Expression for Artists* [fig. 8]. Bell took his cue for the study of expression as the external manifestation of the mind's inner working from the philosopher Thomas Reid, whose ideas were very much current in Edinburgh and are reflected in the work of Raeburn, for instance. Bell developed his own ideas in the city before moving to London where he published the *Anatomy of Expression* in 1806. It is mostly illustrated with his own drawings, but one illustration, of a man laughing, was provided by David Wilkie [fig. 9]. Wilkie built his art on the study of expression as the universal, preverbal and even involuntary currency of social exchange and Bell certainly played a part in turning Wilkie's thoughts in that direction. Wilkie's own art is one of the glories of the first part of the nineteenth century and it had a profound influence not only on art at home but also in France. His influence along with that of Scott was crucial in the way that painters there like Delacroix and Bonington broke with the grand, generalised rhetoric of French history painting to replace it with an art that was psychological, relative and particular

the beginnings of modernism in fact.

Bell also played a direct part in this development in France, however. The preface he wrote to the first edition of his book was as radically anti-academic in principle as his brother's anti-aesthetic anatomical studies were in practice. Later Charles modified his views, but in 1806 he argued that the aesthetic conventions of academic figure drawing were useless, even misleading. The figure could really only be studied in motion, an idea that was not taken up till Degas drew from Eadweard Muybridge's photographs more than sixty years later. Closer in time, in the body of his text, Bell also provided the cue for Géricault's masterpiece, the *Raft of the Medusa*. The picture follows closely what could be called a prescription for horrific grandeur in painting set out by Bell and indeed includes several visual references to Bell's illustrations in his book. Delacroix and other painters in Géricault's circle also demonstrate an interest in Bell.

It is a further measure of Bell's reputation in France that his first biographer was a Frenchman, Amedée Pichot, himself a doctor, but also an early translator into French of works by Scott and Byron. In his biography Pichot remarks that Bell's *Anatomy of Expression*, far from being a digression, 'already contained the elements of his (Bell's) great discovery' (Pichot, 1858: 96). That assertion might be difficult to accept if it were not for the important part that, as a means of studying the mind, the study of expression played in the early history of psychiatry in the work of men like Esquirol, for instance, the French pioneer of psychiatric medicine and of his pupil, Georget for whom Géricault's famous studies of the insane

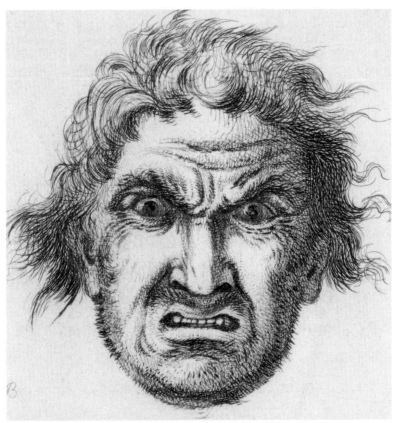

Fig. 8 *Charles Bell*, Rage, *from* Essays on the anatomy of expression in painting.
Fifth edition 1806. Courtesy of the Royal College of Surgeons of Edinburgh. *

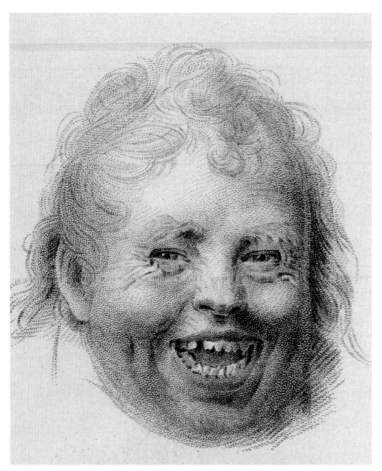

Fig. 9 *David Wilkie, Laughter, from* Essays on the anatomy of expression in painting. *Fifth edition 1806. Courtesy of the Royal College of Surgeons of Edinburgh.* *

Fig. 10 *John Lizars, engraved by William H. Lizars. A System of Anatomical Plates of the Human Body. 1823.*
Plate 5. Courtesy of the Royal College of Surgeons of Edinburgh. *

were painted. In Scotland, Alexander Morison, the first person to lecture in English on the subject, which he did in Edinburgh in 1824, later published *A Physiognomy of Mental Diseases* illustrated with drawings by various artists. Darwin followed with his study of the expression of emotion using the new art of photography for his illustrations. However, it would be a long time before photography replaced the artist in medical illustration.

Several of the illustrated medical publications produced by Edinburgh surgeons and engravers stayed in print through much of the nineteenth century, running into endless editions and being widely translated. One of the finest of all and an example of the extraordinary beauty that these works could achieve through the skill of artist and engraver and the economy of true fitness to their purpose was the folio *A System of Anatomical Plates of The Human Body* [fig. 10] produced by the surgeon, John Lizars, in co-operation with his brother, the engraver, William Home Lizars. John was a superb anatomical draughtsman and his brother was a gifted painter who became an outstanding engraver. He had been a contemporary of Wilkie as a student at the Trustees Academy, but had to take up the engraving business of his father, Daniel Lizars, on the latter's death. Daniel was himself a pupil of the encyclopaedist-engraver, Andrew Bell. Andrew Bell, one of Richard Cooper's students, had himself followed his involvement in the *Encyclopaedia Brittanica* with a monumental encyclopaedia of anatomical illustrations, the *Anatomia Brittanica*.

William Lizars developed his father's business into a major publishing enterprise. After befriending Audubon, he was his first choice for the massive project of engraving the *Birds of America*, life-sized on double-elephant paper. In the end he did not complete the work, though not because of any failure in quality in production, far from it. His prints were superb. But if we may regret that this project was not completed by Lizars, it is nevertheless perhaps appropriate that in its absence the most beautiful production of all the Edinburgh engravers, which I believe the Lizars brothers' *A System of Anatomical Plates of The Human Body* to be, should be a medical book and one that was truly a fraternal collaboration between an engraver and a surgeon-artist.

REFERENCES AND FURTHER READING

Bell, A. *Anatomia Britannica: a system of anatomy: illustrated by upwards of three hundred copperplates, from the most celebrated authors in Europe in six parts.* 1798. Edinburgh.

Bell, C. 1802. *The Anatomy of the Brain Explained in a Series of Engravings* London.

Bell, J. 1794. *Engravings explaining the Anatomy of the Bones, Muscles, and Joints.* Edinburgh.

Darwin, C. 1872. *The expression of the emotions in man and animals.* London.

Fyfe, A. 1830. *One hundred and fifty eight plates to illustrate the Anatomy of the Human Body taken partly from the most celebrated authors, partly from Nature.* Edinburgh.

Lizars, J. *A System of Anatomical Plates of The Human Body (accompanied with descriptions and physiological, pathological and surgical observation).* Edinbugh: William Lizars, London: Daniel Lizars, Dublin: W. Curry jun.

Dublin. Daniel Lizars was William's brother.
The book is undated, but publication was
announced in the *Eclectic Magazine*,
July-Dec. 1823.

Macmillan, D. 1996. 'Géricault et Charles Bell' in Regis
M.(ed). Géricault. 2 vols., Paris: Louvre Conferences
et Colloques.

Monro, A. 1726. *The Anatomy of the Humane Bones.*
Edinburgh.

Monro, A. 1783. *Observations on the Structure and
Functions of the Nervous System.* Edinburgh.

Monro, A. 1785. *The Structure and Physiology of
Fishes Explained and Compared With Those of
Man and Other Animals.* Edinburgh.

Monro, A. 1797. *Three Treatises on the Brain, the Eye,
and the Ear.* Edinburgh.

Morison, A. 1840. *The Physiognomy of Mental
Diseases.* London.

Pichot, A. 1858. *Sir Charles Bell, Histoire de sa Vie et
de ses Travaux.*Paris. Eng. trans. 1860 London.

Rock, J. 2000. 'An important Scottish anatomical
publication rediscovered'. *The Book Collector,*
July 2000.

Sue, M., (J. J.) 1759. *Traité d'ostéologie traduit de
l'anglais de M. Monro... ou, l'on a ajouté des
planches en taille-douce, qui représentent au
naturel tous les os de l'adulte & du foetus, avec
leurs explications.* Paris.

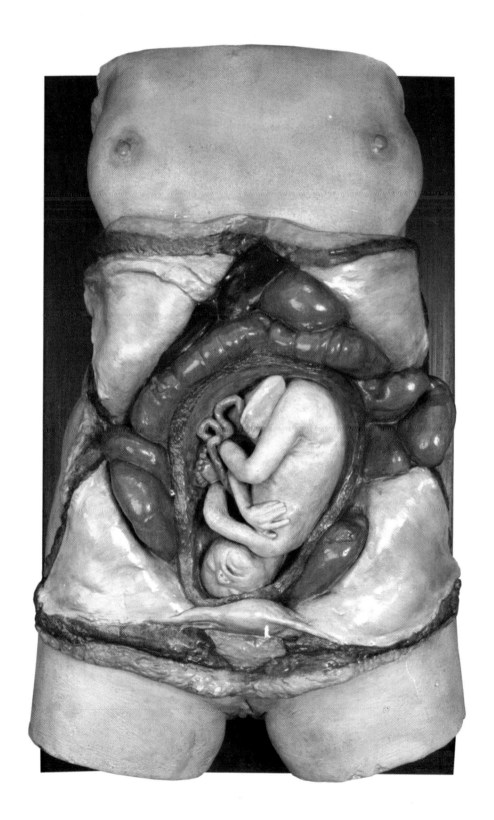

IAIN BAMFORTH

Splendid Cadavers:
A MEMOIR

The first time we visited the big white room at the back of Glasgow University's anatomy department, one dark Scottish morning in the late autumn of 1977, there were 120 of us – half of the year – and we whispered in huddled groups behind the steel doors while the assistants got the place ready.

White-coated and desperately puppy-cheeked, hardly any of us were older than eighteen except for the 'Victors' (the mature students). We were green, in over our heads, all of us driven by adolescent inadequacy to talk in profanely loud voices. Even above our excited talk and the high pitch of adrenalin-doped courage, we could hear the whining of an electric saw. 'Texas Chainsaw Massacre', said somebody at the back. It would strike me later that anatomy lessons were the source of that false bonhomie some doctors adopt with their patients.

I looked at the bust of Hippocrates, and studied the etchings on the wall: Musculosum corpus a parte antica delineatum ex cl. Vefalio, Musculosus corpus in latus versum, Sceleti humani facies anterior, the last with his arm on the spade that had either disinterred him or was about to bury him, face upturned with a kind of sublime anguish rendered comical by the nonchalant way his arm was slung across the handle of the spade – and tried not to associate the grating sound with anything in particular. Like most of the class I was immediately preoccupied with what might be lying in wait for us behind the steel doors.

In the room were twenty stainless steel tables in rows of four, each with a fluorescent lamp above it.

Opposite. *Anon. Life-sized plaster cast of a dissection of the uterus about the sixth month of pregnancy, for William Hunter,1751. University of Glasgow, Anatomy Museum.*

On each table, wrapped in a polythene bag, was a cadaver.

The unpleasant, slightly sour-sweet odour of formalin hung in the air. It got up our noses too, and marked us out, olfactory lepers, for the next year. I'd already attracted odd looks going home in Glasgow Underground's rattling ancient red-liveried carriages with a box under my arm: the boxes contained half-skeletons which had been counted out, bone for bone, at the registry office. We'd had to sign a receipt accepting to bring the skeletons back in near-pristine condition, all bones accounted for. These half-skeletons were ours for the duration of our anatomical studies, to pore over surface markings when we weren't already tired with the day's round of absorbing the few thousand terms of the *Nomina Anatomica Parisiensa*, an edict from the century's start designed to simplify the unholy mishmash of cod Latin and Greek, nationalistic eponyms and ghostly Arabic (in 1900 more than 50,000 terms, many of them interchangeable or eponymic, had been current in the anatomy schools). Having been used to impress my younger brothers, my skeleton went under the bed for a good length of the term where it gave off a steady aromatic hum. All the skeletons on loan, like those at most of the western world's medical schools, came from India, which runs a brisk trade in human remains. Medicine and the market cohabit uneasily: it had been the scandal of the 'resurrectionists' who, as in Robert Louis Stevenson's ghost-story of the same name, divested newly sealed graves of their spoils, and Burke and Hare's notorious joint venture in which the bodies of suffocated victims were sold directly to the Edinburgh anatomists (for about £7 a cadaver) that led to the passing of the

Anatomy Act in 1832, and, to the authorized use of 'unclaimed' bodies by licensed anatomists. Being cut up by your social betters would become one more fear for the Victorian pauper.

Six of us had to share the cadaver, which was two persons too many: the medical class was so big in our year the course organisers had had to ration bodies. We were nervous, but couldn't find anything else worth talking about, and not to other students, who thought 'hands-on' was something you did in the dark after a drunken night in the Students' Union: we'd already spent a year cutting our way up the phylogenetic tree from invertebrates to dogfish – now we were ready for the real thing. Some of us had perhaps seen Broderick Crawford in *Not as a Stranger* whipping the cover off the corpse while he rasps to the eye-popping students, 'There's nothing funny about death.' Some of us, being Scottish, perhaps felt the pull of that black atavistic thrill: staring the enemy straight in the face.

But whatever was in front of us wasn't quite the real thing. These were splendid cadavers, as the Viennese say. Ours was an elderly Caucasian female, cause of death indeterminate, age at death 82. Her toe tag bore the legend A77-35. A completely naked stranger, who made no attempt to get away from us. It was a shock to realise that was all she'd ever do. Anything we could do to her would never touch her. This was a dead show, and really nothing to get excited about. Our cadaver wasn't old; she was ancient, immemorial. The indifference she radiated was massive and heavy, about as close to life as a lump of lard. She would just lie there while we got on with stripping her, and she wouldn't budge as we peeled her cachexic

frame down to the bone, layer by layer – what we might have called a deconstruction, had we been better read or more modish. For the anatomy student, dissecting a body is the first premonition of knowing something other people don't; this is knowledge by slow destruction.

Our cadaver had little wisps of pubic hair and sunken breasts. Her body was a curious greyish-brown, and her skin felt like cheese rind, cold and moist. Her eyes were dull and sunken, the sclera absorbing all of the bright neon light that shone down on them, the irises bleached. The mouth lacked its teeth. Life, according to Leonardo da Vinci, hovers in the triangle between the lateral aspects of the eyes and the glabella, and as far down as the lower lip. But life was gone. This torso was as stiff as a plank, and bore a flat impress along the back. That was all I noticed at first glance, apart from the clipped nails and bunions on the feet, and I doubt Sherlock Holmes would have been any wiser about her life or fate, and the reasons that prompted her to donate her body to 'medical science'. Some people signed their bodies away out of altruism or the idealistic belief that they were helping in a small way to add to the sum total of human progress; others out of financial necessity. Nobody should impugn their motives, but perhaps a cynic might suggest they simply didn't have much experience of medical students. I was told by the mortician that most of the cadavers in the room came from the other side of the country. That was what the medical schools did to avoid students cutting up their own grandmothers or former headmasters.

Seeing what we were about to do to her, it was good, I thought, that she was absent-minded.

We were in this room for a couple of hours two or three times a week, cutting and paring – 'blunt dissecting'. We each brought little dissection sets of scalpels and instruments wrapped in canvas; they became impossibly greasy as we advanced into the recesses of the body. Grease ended up on the books brought into the dissection hall. Our Mr. Clean white coats became as grease-stained as any mechanic's overalls. Grease got on the tiles and made them dangerously slippery. Grease even got onto the tap-handles of the huge metal sluices fitted to the wall in which we had to wash up after cutting – before we were allowed to return to the general student body. At the end of the two hours, after completing the day's dissection, we had to remember to spray water over the cadavers to keep their tissues moist, cover them up with gauze and pull the muslin and plastic wrap over them again like a blanket. It was an oddly domesticated touch.

The method of induction was classic, unchanged for a few hundred years: the lecturer would prepare us in the lecture room adjoining the dissection room, drawing on the board what we already knew we'd be unlikely to see, even with the eye of faith, and then we'd all troop through into the laboratory with our white coats, dissection sets and the latest edition of the anatomy textbooks: Gray's, Grant's, Cunningham's. These books were our Gnostic Bibles, our 'atlases', regional topologies of the human body.

Each table was a chorus of bent heads. Supraspinatus, brachialis, latissimus dorsi, pectoralis minor: this was the fine volatile Latin drone that hovered for the next few months above the assembled tables, half-formalin half-sweat. The only way to remember the huge amount of mostly redundant terms was to invent spectacularly vulgar mnemonics for them: for example, the first letters of the cranial nerves – all twelve of them: olfactory, optic, oculomotor, trochlear, trigeminal, abducens, facial, auditory, glossopharyngeal, vagus, accessory, hypoglossal – generated rococo acrostics. The classic flapper version for remembering these nerves is Oh! oh! oh! To touch and feel a girl's vagina and hymen. There's a more ingenious couplet in tetrameter which runs: 'On Old Olympus' Towering Tops A Finn And German Viewed Some Hops.' Dada medicine. Word-play seems the only channel for the imagination in a science which was 'dead', literally as well as figuratively. Goethe, looking for the intermaxillary bone, and Oliver Wendell Holmes at Harvard in 1847, must have been the last poets to get excited about the imaginative possibilities of anatomy. One day someone will write a story using the mnemonic as an organising principle (if it hasn't already been done). Here are some others from Irving's slightly patronising *Anatomy Mnemonics* (women medical students were not that common at the time of the 4th edition in 1939): And Tonsils Go Septic In Some Little Mouths (branches of the facial artery), A Beautiful Little Bride Looks Distressed If Minus Undies (relations of the extensor retinaculum) and the self-reflexive Queer People Enjoying Anatomy (nerves of the sacral and coccygeal plexus with two roots: nerves to Quadratus femoris and Pyriformis, nervi Erigentes and nerves to the Anal musculature).

Perhaps these curt stories were meant to raise our spirits as we pared away our cadavers in the hope that their acrid tissue would come to

resemble the glossy prints in Gray's Book of the Dead. We understood fairly soon this would not happen, not in a month of Mondays and Thursdays; the pictures in the books were touched up, puffed up, retouched and air-painted – clean-edged morphic substitutes for the real thing that even phenol and formol couldn't keep good for a year. Some of us still managed to be performance artists of a kind, and my partner's high point came when he ineptly managed to stab me in the hand with the scalpel he should have been drawing between the external and internal oblique muscles. It saved me a week's scraping at the pelvis. But it reminded me uncomfortably that stabbing yourself with a scalpel in the old days while cutting up a recently deceased body was a quick way to meet the Maker. antiseptics were injected into cadavers only after the verification of the germ theory and Lister's campaign in 1869, before which many anatomists, famous and incompetent alike, succumbed to septicaemia from minor wounds as they endeavoured to cut open the dead before they deliquesced.

By then some of us were thoroughly fed up. Formalin numbed our fingers; there was the hazard of off-piste scalpels; and the cold made us shiver even though we were sweating under our coats. Now we were down to the ribs and about to enter the thoracic cage, it was all sweat and graft—the bones were tough and resistant and had to be sawn with a hacksaw; blobs of fat flicked by scalpels flew through the air and if you were unlucky landed in your hair. The only practical solution was to elect someone to be a non-dissector for the session: he had the job of turning pages in the atlas and wiping sweat from the faces of those

actually dissecting, since we didn't dare reach up with our half-anaesthetized fingers to so much as scratch our noses. That was how we got along with our cadaver: we made deals about the unpleasant bits – who would prise open the top of the skull, who would guddle out the intestines, who would dismantle the pelvic ligaments. The girls' table next to us didn't want to 'transsect' their male cadaver's penis so one of our table did it for them with a bravado shudder. Cutting up the face was awful, especially when it had been reduced to the striations of the buccinator muscle holding the cheek against the teeth. According to Cunningham, this was a two-faced muscle: when it acted with depressor anguli oris and mentalis it made a Greek tragic mask; when it acted with levator anguli oris an idiotic Stan Laurel. As I recall, my own prize dissections were the branches of the common carotid artery (the 'stupid' artery, since Galen observed that if he placed his thumb on someone's neck and pressed the artery against the tubercle of the sixth cervical vertebra, stupor rapidly followed) and external jugular vein, and the curious platysma muscle fanning out under the chin. This, according to the comparative anatomists, is the equivalent in humans of panniculus carnosus, a superficial muscle which allows animals to twitch their skin. Most of us were so startled by the novelty of finding we actually had a band of muscle just under the skin of the throat we went around for a week drawing our jaws up and baring our teeth in imitation of Bororo dancers. It can also be seen in the iconic photograph 'An Old Man' which Charles Darwin borrowed from the eccentric French physician Duchenne de Boulogne to illustrate 'fear' in his

book *The Expression of the Emotions in Man and Animals* (1872): Duchenne, who applied electrical stimuli to the faces of experimental subjects in order 'to make the facial muscles contract to speak the language of the emotions', thought that this expression, when combined with tonic contraction of the eye and forehead muscles, 'must be that of the damned'.

This was what they called Gross Anatomy. Once a week we left our scalpels in their canvas wallets and studied histology – which provided the 'micro' component to the larger structures we could see with the naked eye. Histology involved studying slices of tissue, 'sections' a few microns thick which had been fixed and stained with dyes bearing exotic names: Alizarin Blue, Giemsa, and the ubiquitous Haematoxylin and Eosin – on the principle that you couldn't understand why elderly Glaswegians had black-speckled lungs if you hadn't found a macrophage with ingested soot particles in the parenchyma of the lung. Gross Anatomy, on the other hand, was something that would follow us through our clinical careers like a vestigial memory; the point of it would come home when we moved from gurneys to bedsides and palpated the grapes of pathology in diseased organs – the spleen slipping down to meet the palm like a huge swollen bean, the hard craggy lip of a metastatic liver, the tight ballooning bladder of urinary retention. We learned the structures delineating the quaintly named anatomical snuffbox so that we'd one day be able to identify a fractured scaphoid at the base of the thumb; we learned where to locate the peritoneal processus vaginilis that stayed open and allowed an apron of male fat to drop through the hole in the muscle

layers; we learned how to locate MacBurney's point and why it was important; we learned how to massage the small clenched bag called the heart.

In fact, it was often very difficult to identify any structures beyond the major vessels and muscles with certainty. The coral-like exhibits standing alongside the wall were casts made by squirting blue or red latex down bronchi or major arteries and then dissolving away the tissue-fluid resin casts they were called. The hall was full of mocking simulacra – mercury injections of the placental vessels; red chalk drawings of the gravid uterus; transparent foetuses in gel with only the centres of ossification made visible, a soft mauve of cranial plates and long bones. Textbooks only served to reinforce the impression that we weren't getting something right. Gray's splendid yellow-tinted dissection of the course of the recurrent laryngeal nerve, for example, or the extensions of the brachial plexus were almost Platonic notions for us: while he had the benefits of a photographer who, for all we knew, might have gone on to do retouches more properly appreciated by the Comintern, we had to separate a few spindly grey objects and nod assent to the tutors roaming between the gurneys, sticking plates of sliced tissue in front of our noses like any cooked breakfast. Sunny side up? Did we have to sniff them? Did they really expect us to re-orientate ourselves that rapidly, recognising the tiny slings of nerves and muscles as if we could slip inside the compartments of our own bodies like Incredible Shrinking Men?

'Jesus wept,' said the same demonstrators, when we dropped our cadaver's large bowel on

the floor, and its contents with it. 'Oh dear, oh dear, oh dear,' they said, when we couldn't find the popliteal artery behind the knee. 'No sweetheart, that cross-section isn't a penis; only angwantibos have penises with bones in them.' That was part of the initiation ceremony – by humiliation. Career anatomists were few on the ground. Tutors were qualified doctors training to be surgeons and they didn't seem too bothered about taming death quite as rigorously as Gray had in his *Anatomy*: they'd seen a few patients already, they knew our anxiety was mostly inexperience. In fact, they were busy relearning everything they'd forgotten from their own pre-med years, and that seemed to make a nonsense of our being there, learning by rote what we'd forget in a year or two.

What we were doing, I suppose, was more ritual than learning: it was laborious fake excavation, toughening up, acquiring what William Hunter in a franker era called 'necessary inhumanity', absorbing *esprit de corps*.

The tutors passed on more – facile, I regret to say – mnemonics for the price of a beer: the zebra bit my cock, which stood for the branches of the facial nerve: temporal, zygomatic, buccal, mandibular, cervical. These memory jogs clearly came from a men-only medical age. As did the name our cadaver now sported: Hortense. I must have been reading Rimbaud's 'Illuminations': 'Every monstrosity violates Hortense's atrocious body language'. I don't think any of us was really shocked by these things, not even by the whining noise we'd all forgotten from the first day outside the steel doors. That turned out to be an electric circular saw cutting sagittal sections through human skulls so that they fell cleanly apart with

a nostril on each side, or cut through limbs like so much bacon. A few years later I read a passage written by R.D. Laing about his experience of being a medical student in the same mortuary:

> At the end of that term when they had all been dissected to bits – suddenly, – so it seemed – no one knew how it began – pieces of skin, muscle, penises, bits of liver, lung, heart, tongue, etc. etc. were all flying about, shouts, screams. Who was fighting whom? God knows.
>
> The professor had been standing in the doorway for some while before his presence began to creep through the room. Silence.
>
> 'You should be ashamed of yourself,' he thundered; 'how to you expect them to sort themselves out on the Day of Judgement?'

The professor's room was on the upper floor of the anatomy museum and adjoined the dissection room, a wood-panelled hall with little alcoves which were ideal for the viva sessions – oral exams when some of the museum's prized specimens would be taken out of the glass cupboards and used as evidence against us. It was a bit like the Garden of Horrors that used to be all the rage in turn-of-the-century Paris fairgrounds; on one side the carousel, on the other the electric wonders of the age – the dynamometer, the van-de-Graaf generator to make your hair stand on end and the waxworks where you paid a few sous to see the twenty classic presentations of tertiary syphilis, human vivisectors at work, or a guillotined head and corpse. Even the morgues were open to the public in Zola's day.

Glasgow University's museum was more restrained. It displayed a couple of William

Hunter's series of dissections from the end of the eighteenth century, including his frontal attack on a pregnant woman (*Anatomy of the Human Gravid Uterus*) and a entire gallery of what looked like pickled walnuts and cucumbers but were actually comparative life-forms. William Hunter (and his more famous brother John) was one of the first superintendents of anatomy in Britain, a science which so fired him with zeal to improve the education of doctors (since he correctly foresaw that if medicine were ever to become a profession and conspire more effectively against the laity, then doctors would have to know more about their bodies than ordinary folk) that he sank £100,000 of his personal fortune into constructing a school for dissection on Great Windmill Street in London.

The professor in 1899 was John Cleland, clearly a passionate comparativist. Upstairs in the anatomy museum the cabinets were crammed with the relics of a life spent dissecting exotica from the far ends of the British empire. No 492: Larynx of Peccary. No 165: Cloacal region of a somewhat smaller Porbeagle. No 224: Gills and Viscera of a Catfish. No 234: Tongue of Echidna. No 483: Mesentery and Lymphatic Glands from Zebra. No 137: Eye of Crocodile.

Some of the exhibits were human grotesqueries. One was a turgid outsize penis from someone who had been hanged: the corpus cavernosum had been injected with red dye to demonstrate its intactness from the corpus spongiosum (blue dye). Simultaneous extension and distraction of the neck causing fracture of the pedicle of the axis was illustrated in the adjoining case: this was the mechanism of death by hanging. No 50.62 was a stillborn descendant of Cyclops, with a single midline eye-slit. A uterus was split

open like a gourd to show the foetus cowering inside; this was one of Hunter's famous plaster models of the child *in utero*. Another case contained prize dissections from the year dot, which made me feel there had been something amiss with our dissecting technique. A cabinet contained an array of children with trisomy 13–15; they'd come into the world with tiny eyes (microphthalmia) and too many fingers (polydactyly) and gaping cleft lips: another set had the worst kind of neural tube defect – rachischisis. The word itself seemed a Greek kind of retribution. There was something deeply discomfiting in the sight of a spinal cord exposed to the exterior: it looked like a huge parasitic leech clinging to the back. Next cabinet along held a set of 'double monsters' – embryos which had twinned due to late splitting of the zygote: they were fused at the chest (thoracopagus) in one jar, and at the buttock (pygopagus) in the other. Some had been born before our great-great-grandparents, if you looked at the date, scowling out of their jars, bejowled and serious infant faces.

They hadn't stayed around long. Except that here they were, ancient homunculi and mutants who peered across the room as we struggled to remember the tantra for the wrist bones or the structures irrigated by the splanchnic artery or the innervation of the pudenda.

Dissection is really the medical student's first exposure to the theatre of cruelty: some want to cry and some want to laugh, and a few even want to do both at once. It's horrible to strip someone of their muscles and make jokes about doing it, but the cadaver is an object with lots of unsuspected comic potential. Dissection is the

equivalent of picking a defenceless person's pockets, except you don't stop at the pockets.

Vesalius' *De humani corporis fabrica*, published in Basle in 1543, is one of the great comic manuals. In this book, for centuries the anatomical book, he poses his 'galvanized' cadavers in exalted Arcadian settings with great strapping slabs of muscle hanging off them, leg on a boulder and elbow on the knee and a gently undulating landscape in the background with cypresses and lemon groves and a very Italianate river carrying horror-stricken laughter from the garden of Eden to the black waters of Lethe. These were convicted men modelled from the platform: they look as if they're about to strut out on a catwalk. Exhibitionists they might be, but the horror is: they don't seem to know they're dead.

Vesalius derives from Wesel, a little town on the Rhine. This was the name adopted by Johannes Witing, when he went to the University of Paris in 1533, barely more than a callow youth. He took his doctor's degree in Padua and became the first professor of anatomy to receive a salary. Working with a pupil of Titian he produced the drawings which have preserved his fame, and it's worth noting that some artists of the time were better informed about the human body, and certainly more zealous to witness its structural truths, than doctors of medicine. Michelangelo, Dürer and Raphael all performed dissections, and Leonardo da Vinci produced nearly a thousand precise anatomical drawings (and discovered many structures confirmed later by professional sawbones) until Pope Leo X put a stop to his dissections. Perhaps the artists weren't as well

read medically as the doctors, but they believed their eyes. So many careers were on the line when Vesalius published *De humani corporis fabrica* that it aroused fierce opposition from physicians everywhere, not least from Paris where his old professor Sylvius was a stout defender of Galen's authoritative but largely unverified anatomy. (Probably the only reason Galen has been so important in the history of medicine was due to the fact that his writings were preserved from third century Rome: those of lots of other physicians went up in flames when the city was sacked.) Vesalius even demonstrated, by public dissections, that certain Galenic structures didn't exist (such as the fabled gastrosplenic duct); but perhaps defending what he could see was the case against what the other professors insisted must be so sapped his strength, for one day he torched his manuscripts, renounced his chair and went off to be court physician to one of the Bourbons.

Having cut No. A77-35 (aka Hortense) into little pieces which we salvaged in the original plastic bag, we said *Adieu* to her at the end of the year in the little chapel behind the dissecting room. We'd only just finished the dissection on schedule. What was the rush?

In fact, there was no service, just some embarrassed shuffling through the chapel, an entry in the Book of Remembrance and private prayers for those who knew how to. It wasn't even obligatory. I tried not to think of her as we had last seen her, all the organs excavated from her body as if her body itself had been a grave. We had been standing at the graveside then, for over a year. The catechism that ran through our heads

was a dummy run for the upcoming exams: 'contents of the cavernous sinus, Professor?... internal carotid, nerves III, IV and VI, and the ophthalmic and maxillary subdivisions of the trigeminal.' The truth was we didn't get to know anything about our cadaver at all, never would, and now she lay in half-competently dissected pieces in the deep freeze awaiting incineration.

Already we were preparing ourselves for the next onslaught of learning: *materia medica*, biochemistry, physiology. But I carried one charged memory away from my last day in the anatomy department. Scraping my chair back,

relieved to know I'd correctly identified the muscles innervated by the first two sacral nerves, one of the exhibits caught my eye. Joseph A –, aged six months, hydrocephalus, aed. 1780, his head preternaturally large and the sutures gaping out between parietal and frontal plates, looked down for a moment through a blur of vinegar and gelatine as if he were trying to figure out what had happened to his life. The glass was thick and distorting, and the preserving fluid viscous, but there was a tiny shiny bleb of air trapped between his lips – a thought waiting to burst from the Year of our Lord 1780.

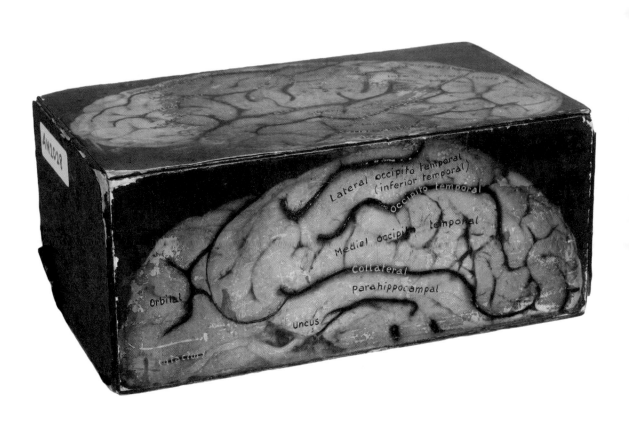

Lateral occipito temporal
(inferior temporal)
Occipito temporal
Medial occipito temporal
Collateral
parahippocampal
Orbital
Uncus
olfactory

STEVE STURDY

Making sense in the pathology museum

Anyone walking into the Pathology Museum of the Royal College of Surgeons of Edinburgh at any time between the late 1800s and the late 1900s would immediately have been struck by the sheer quantity of anatomical and pathological material it contained. 'Wet specimens' – diseased and distorted body parts suspended in jars of amber preserving fluid – crammed the shelves that lined the museum alcoves. Damaged and deformed bones, some disarticulated, some wired together into skeletal limbs and torsos, jostled for space behind the glass doors of wall cabinets. Exquisitely fine red and blue filigree structures, wax injections of the tiny blood vessels that had once perfused kidneys and other organs, stood under bell jars like ornaments in an over-furnished Victorian drawing room. The Museum was a monument to anatomical industry, the work of generations of nineteenth- and early twentieth-century surgeons who had carefully dissected, preserved and catalogued the fruits of their labours for inspection and examination by their peers and their pupils (Tansey and Mekie, 2003).

The purpose of the Museum was pedagogical. From the early nineteenth century until at least the Second World War, anatomy and pathology museums were of vital importance to the teaching of medicine (cf. Reinarz, 2005; McLeary, 2001). For the Edinburgh medical school, internationally acknowledged throughout much of this period to be one of the most influential centres of medical education in the whole of the British Empire (Lawrence, 2005), keeping up the anatomy and pathology collections of the Royal College of

Surgeons of Edinburgh was a matter of pride and prestige. But by the 1960s, the focus of medical education was moving elsewhere. Though the College's museum collections remained of considerable importance as a research resource – indeed, they still do – they ceased to have any role in training doctors to practise medicine. Consequently, when I took small groups of medical students around the museum during the late 1990s, they found themselves in an alien world that was utterly at odds with their own educational experience. Though fascinated by the individual specimens they found there, they were baffled by the sheer size and diversity of the collections. From the point of view of late twentieth-century medical teaching and practice, the museum had simply ceased to make sense.

Yet making sense – both literally and figuratively – was precisely what the museum was all about. Medicine by the mid-nineteenth century was an intensely sensuous matter: a discipline of the senses, as it were. Over the course of the eighteenth century, the practice of medical diagnosis and treatment had shifted from a concern primarily with intangibles – the balance of subtle humours or of vital forces, the patient's mode of life and subjective symptoms – to focus increasingly on the textures of the organs and tissues that constituted the patient's physical body (Maulitz, 1987; Foucault, 1973). Surgeons had been instrumental in advancing this physical understanding of health and illness (Temkin, 1951). Autopsy – the practice of opening the corpse to see the condition of the internal parts – became increasingly widespread through the eighteenth and nineteenth centuries, as surgeons began to ask first whether and subsequently how the signs and symptoms displayed during a patient's life

*Opposite. Anon. Model of the brain, mid 20th century. Courtesy of the University of Aberdeen. ***

Fig. 1 Surgeon's Hall, Pathology Museum, 1920s. Courtesy of the Royal College of Surgeons of Edinburgh.

might be correlated with the appearance of particular internal organs after death.

By the mid-nineteenth century this project had come to dominate medical thinking. More and more forms of sickness and disease were reconceived as the results of localised pathology: damage to or dysfunction of specific organs, ruptures or blockages that disrupted the delicate corporeal machinery, and localised growths that intruded into and upset the organic economy of the body. Doctors' understanding of disease was radically transformed. Previously disease had lain beyond the realm of the senses, an elusive and transient state of being that might be inferred from signs and symptoms but never directly observed. Now it had become something solid and substantial, to be cut out and displayed not only after death but increasingly – as surgeons became ever more confident in their knowledge and skill over the course of the nineteenth century – during life itself (Lawrence, 1992).

If the new physical understanding of disease was to have any real consequence for the practice of medicine, however, it was not enough for such disease to be discernible only once the body had been opened. Doctors also needed to be able to identify internal afflictions with some degree of certainty before any kind of treatment – let alone the hugely risky procedure of delving into the body cavities – was attempted. The challenge facing nineteenth-century surgeons, then, was to devise new ways of in effect seeing into an intact, living human body. In an age before X-rays and other imaging technologies became readily available, that meant training the ordinary human senses to detect what lay behind the body wall (Lachmund, 1998).

Of the five senses available to nineteenth-century doctors, taste and smell were the ones whose medical use was least affected by the anatomical transformation in ideas of disease. Both had played a minor role in the diagnostic modalities of humoral medicine – identifying certain kinds of morbidity by smell, for instance – and while the same olfactory signs readily found a place in new organ-based accounts of conditions such as diabetes, neither taste nor smell offered much else in terms of probing the depths of the body. The sense of sight, too, was largely powerless to penetrate the body wall, though a number of optical instruments, including the laryngoscope, ophthalmoscope, and otoscope, were devised around this time to take advantage of such orifices as permitted at least partial visual access to the interior of the body. Only with the advent of X-rays from the mid-1890s would the deep structure of the intact body be rendered visible – and even then, only partially. While dense materials such as bone, metal and kidney stones appeared clearly on the shadowgrams made by early X-ray apparatus, it was much harder to distinguish the fine structure of the soft tissues of vital organs. For all the excitement that attended their discovery, the diagnostic possibilities afforded by the new rays were thus distinctly limited, and would only gradually be extended over the next fifty years, as incremental improvements were made to the technology, and as new ways were found of settling disputes over the interpretation of the images it produced (Howell, 1995: 103–132).

It was touch and hearing, the two senses capable of receiving information transmitted

Fig. 2 William Playfair's drawing for the New Surgeons' Hall, plan of the principal floor, 1829. The imposing new Hall opened in 1832. From the start, the anatomical and pathological collections occupied the greater part of the building. Courtesy of the Royal College of Surgeons of Edinburgh. *

through solid media, which assumed the greatest prominence in the diagnostic practices associated with the new anatomical medicine. Touch had played a part in medical diagnosis from ancient times, chiefly for taking the pulse, which was understood to convey what modern doctors would consider an unfeasibly large amount of information about the patient's general state of health. But as surgeons began to locate disease in specific organs, so the sense of touch came increasingly to be employed as a way of interrogating those organs through the body wall. Much could be learned about the state of the contents of the abdomen in particular, separated as they were from the outside world only by layers of muscle and other elastic tissues. By the mid-nineteenth century, doctors routinely palpated their patients to determine the state and disposition of the liver, spleen and other abdominal organs. The amount of information that could be obtained in this way by the educated and experienced hand was considerable. Enlargement or displacement, hardening or sponginess, tenseness or flaccidity, smoothness or nodularity of particular organs could all be detected, as could the movement of fluid or solid masses inside the abdominal cavity, or the crepitation caused by accumulation of gas within the tissues (Hutchison and Rainy, 1897; Keele, 1963).

However, it was the sense of hearing that proved pre-eminent in the practice of physical diagnosis during the nineteenth century. Whereas touch could only penetrate the elastic wall of the abdomen, sound could also travel through the rib-cage to tell of the interior of the thorax. With the assistance of the stethoscope, invented in 1816 by the French physician Théophile Laennec, a doctor could listen to the sounds made by the blood as it passed through the heart and arteries, and to the ebb and flow of air in the passages of the lungs. Experienced auditors could discriminate a remarkable range of sound effects, represented by a rich vocabulary of murmurs and hums, rattles and râles, resonances and pectoriloquisms, all of which mapped onto different structural changes in the circulatory or respiratory system (cf. Lachmund, 1999). When the body did not make its own sounds, the doctor could induce them by percussion – tapping the outside of the thorax or abdomen – to demarcate the areas of density and hollowness that defined the boundaries of organs and to identify accumulations of fluid, occluded spaces and adventitious growths. Because it provided such varied and detailed information about the state of the internal organs, auscultation – the art of listening to the body – did more than any other diagnostic technique to diffuse the new anatomical pathology among medical practitioners (Reiser 1978: 23-44; Nicolson, 1993).

By all these means, a remarkably detailed picture of the physical interior of the body could be built up, without having to violate the body's boundaries. However, physical diagnosis was a highly skilled procedure that required considerable training and no little experience if it was to be successful. One way in which medical students' senses were educated for this purpose was through practical training on the wards of a teaching hospital. There, under the supervision and guidance of more experienced practitioners, the students had the opportunity to practise their

sensory skills on actual patients, and first learned to discriminate the kinds of tactile and auditory signs that were crucial for effective diagnosis. But that alone was not enough. Students also needed to learn to see beyond the mere signs elicited by the techniques of clinical examination, and to apprehend the physical reality that lay beneath, concealed within the body.

It was here that pathological museums like that of the Royal College of Surgeons of Edinburgh played a pivotal role in the work of training the senses. In the museum, students could actually see the kinds of diseased organs whose presence they could only infer in the clinic. With their own eyes they could assess the size, shape, and texture of an organ, their gaze impeded or distorted at most by the jars and fluids in which those organs were mounted. The museum thus provided a distinct kind of sensory access to the object towards which all the business of diagnosis was directed: to the disease itself. True, in the museum disease was removed from the context in which it was usually encountered. This was a different experiential world from the world of the clinic. The student could not feel the swelling in the patient's belly or listen to the air in her lungs. But much could be done to bring the experience of the clinic into the museum. Wherever possible, the catalogue entry for each specimen would include a record of the patient's case history and physical examination, with interpretative notes by the physician or the museum curator (Tansey and Mekie 2003: 4, 13; Cathcart, 1893, 1898; Shennan, 1903). In this way, students could learn to correlate the visual appearance of a diseased organ with the kinds of clinical signs they observed at the bedside. Through an act of synaesthetic imagination, they could marry sight, sound and touch, eliding the space between museum and clinic.

The museum offered other advantages too. The range of clinical experience available to students was strictly limited, particularly in a small city like Edinburgh, while the cases they encountered in their clinical training presented themselves haphazardly, as the vagaries of disease dictated. By contrast, the range of experience offered by the museum was limited only by the size and diversity of its collection. A major museum of pathology like that of the Royal College of Surgeons of Edinburgh could aspire to encompass all the physical manifestations of disease that a doctor might meet in the course of a busy career. Moreover, for all its apparent clutter, the museum was an ordered world. Diseases were classified according to the latest theories of the relations between them (Cathcart, 1896). The student could range from one disease to the next, assimilating the subtle differences between cases of the same disease and the misleading similarities between different diseases. With discipline and study, the student could learn to see the order in the clutter. By educating their senses to perceive that same order in the clinic, they learned to manage the disorder and sickness they would one day encounter in their own medical practice (cf. Hooper-Greenhill, 1992).

That was then; this is now. Though doctors still practise many of the techniques of physical examination that so preoccupied them during the nineteenth and early twentieth centuries, they are now able to place far greater reliance on

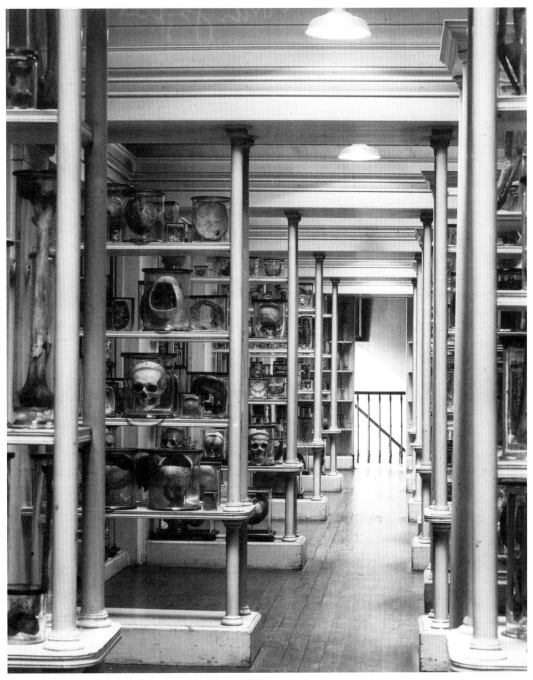

Fig. 3 *Part of the collection of osteological specimens in the gallery of the Playfair Hall. Courtesy of the Royal College of Surgeons of Edinburgh.*

laboratory tests and new imaging technologies than on their unaided senses. To a great extent, the acuity of hearing and the refinement of touch once so vital to good diagnostic practice have been lost. With them has gone the original meaning of the medical museum. In its place, new meanings are being created. The Pathological Museum of the Royal College of Surgeons of Edinburgh is being reinvented as a historical and educational resource whose interest extends far beyond the confines of the medical profession. For doctors and laypeople alike, the Museum and its contents now offer a vantage from which to survey, not just the varieties of bodily illness, but the history of medicine itself. Where once the specimens were scrutinised chiefly for what they told of the physical manifestations of disease, new audiences can read in them a very different kind of story about patients and doctors and the changing nature of medicine. In the medical museum, and the rich, unsettling aesthetic experience it offers, we now have the opportunity to make a new kind of sense: of what medicine was and is and may yet become.

REFERENCES AND FURTHER READING

Cathcart, C.W. 1893, 1898. *Descriptive catalogue of the anatomical and pathological specimens in the Museum of the Royal College of Surgeons of Edinburgh.* Vols. 1 and 2. Edinburgh: James Thin.

Cathcart, C.W. 1896. 'Classification in pathology', *Edinburgh Medical Journal.* Vol. 42, pp. 141–8.

Foucault, M. 1973. *The birth of the clinic: an archaeology of medical perception.* Trans. A.M. Sheridan. London: Tavistock Publications.

Hooper-Greenhill, E. 1992. *Museums and the shaping of knowledge.* London: Routledge.

Howell, J.D. 1995. *Technology in the hospital: transforming patient care in the early twentieth century.* Baltimore and London: Johns Hopkins University Press.

Hutchison, R. and Rainy, H. 1897. *Clinical methods: a guide to the practical study of medicine.* London: Cassell.

Keele, K. 1963. *The evolution of clinical methods in medicine.* London: Pitman Medical.

Lachmund, J. 1998. 'Between scrutiny and treatment: physical diagnosis and the restructuring of 19th century medical practice.' *Sociology of Health and Illness.* Vol. 20, pp. 779–801.

Lachmund, J. 1999. 'Making sense of sound: auscultation and lung sound codification in nineteenth-century French and German medicine'. *Science, Technology, & Human Values.* 24, pp. 419–450.

Lawrence, C.J. (ed.). 1992. *Medical theory, surgical practice: studies in the history of surgery.* London and New York: Routledge.

Lawrence, C.J. 2005. *Rockefeller money, the laboratory and medicine in Edinburgh, 1919–1930: new medicine in an old country.* Rochester, NY and Woodbridge: Boydell & Brewer.

Maulitz, R.T. 1987. *Morbid appearances: the anatomy of pathology in the early nineteenth century.* Cambridge: Cambridge University Press.

McLeary, E.H. 2001. 'Science in a bottle: the medical museum in North America, 1860–1940'. Unpublished PhD thesis, University of Pennsylvania.

Nicolson, M. 1993. 'The introduction of percussion and stethoscopy to early nineteenth-century Edinburgh'. In W.F. Bynum and R. Porter (eds). *Medicine and the five senses.* Cambridge: Cambridge University Press, pp. 134–53.

Reinarz, J. 2005. 'The age of museum medicine: the rise and fall of the medical museum at Birmingham's school of medicine'. *Social History of Medicine*, vol. 25, pp. 419–437.

Reiser, S.J. 1978. *Medicine and the reign of technology.* Cambridge: Cambridge University Press.

Shennan, T. 1903. *Descriptive catalogue of the anatomical and pathological specimens in the Museum of the Royal College of Surgeons of Edinburgh.* Vol. 3. Edinburgh: Oliver & Boyd.

Tansey, V. and Mekie, D.E.C. 2003. *The Museum of the Royal College of Surgeons of Edinburgh.* http://www.rcsed.ac.uk/site/645/default.aspx. Edinburgh: The Royal College of Surgeons of Edinburgh. Orig. pub. 1982.

Temkin, O. 1951. 'The role of surgery in the rise of modern medical thought'. *Bulletin of the History of Medicine.* Vol. 25, pp. 248–59. Reprinted in Temkin. 1977. *The double face of Janus and other essays in the history of medicine.* Baltimore: Johns Hopkins University Press, pp. 487–96.

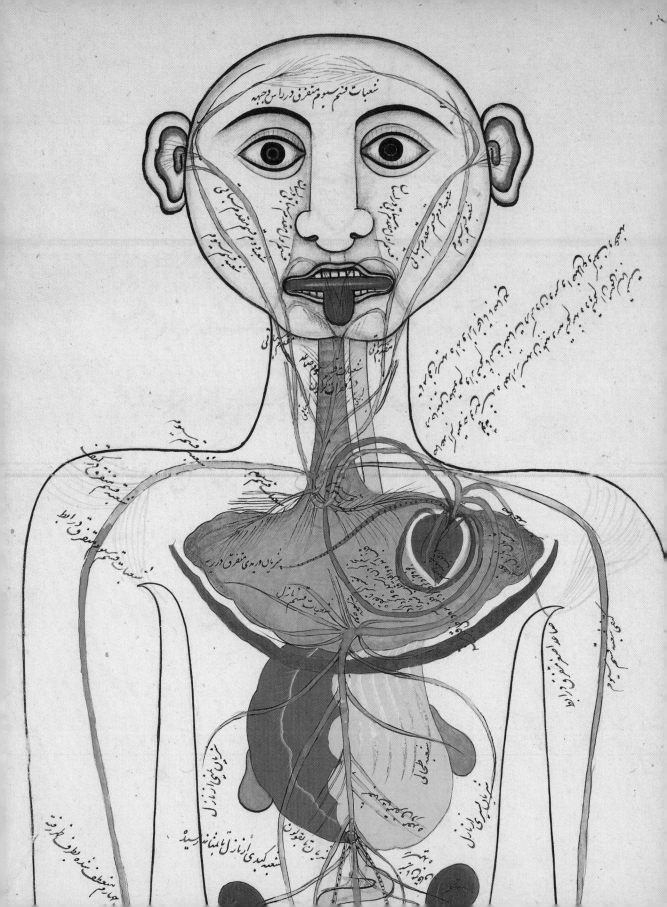

ELIZABETH HALLAM

Anatomy display:
CONTEMPORARY DEBATES AND COLLECTIONS IN SCOTLAND

The biomedical sciences, including anatomy, continue to generate a vast array of compelling material objects and visual images relating to the human body. These are significant in the social relations and cultural practices of medicine. They influence the sensory apprehension of the body, especially through seeing and touching, in and beyond medical contexts. The material and visual cultures of biomedicine have also become fascinating fields of enquiry in the arts and social sciences, leading to innovative exhibitions, visual projects, analytical and literary works. In the context of these developments, this essay discusses some of the current debates surrounding human anatomy and museums. It then considers aspects of contemporary and historical displays of the body in Scotland.

BODIES, MATERIALS, IMAGES

Biomedical practices use extensive material and visual forms, all of which are perceived as vital in the diagnosis and treatment of the body: Magnetic resonance imaging (MRI), X-rays, prostheses, medical textiles, instruments and machines, hospital and laboratory equipment and furnishings. Anatomical models, as well as medical simulation models and phantoms, such as whole-body manikins and synthetic body parts, are manufactured by commercial companies and distributed world-wide to be used in medical education. Biomedical materials are possessed of certain tangible qualities and they have profound implications for experiences of human physicality, health, and pain.

Opposite. Anon. A detail of Tashrih-i Mansuri: The Anatomy of Mansur of Shiraz, (18th century copy of 15th century treatise). University of Edinburgh Library, Special Collections

Deployed in medical encounters as bodily extensions, the influence perceptions of the body's limits. The intricate apparatus of biomedicine has a history that continues to shape how the body works.

Contemporary biomedical materials and images come to inhabit diverse locations – from the human interior to computer screens and the dedicated arenas of operating theatres. This material and visual distribution can be viewed in relation to anatomical practices entailing the dissection, modelling, and imaging of the human body over the last five hundred years. Social scientists have argued that the human body does not belong exclusively in the domain of nature, rather 'the body has a history and is as much a cultural phenomenon as it is a biological entity' (Csordas, 1994:4). By exploring, dismantling, replicating, drawing, and writing about the body, anatomists have been active participants in making histories of the body, just as their work is formative in contemporary perceptions of the human form. Anatomising the body has produced a staggering range of materials: printed books, manuscripts, engravings, drawings, paintings, sculpture, manuscripts, models in wax, papier-mâché and plastic, glass slides, photographs and films, tools and devices. Dissected and preserved body parts, skeletons, and bone specimens are also kept by licensed institutions. In Scotland these materials have been both produced and held in various institutional settings. These varied repositories, such as museums, archives, and hospitals, preserve anatomical materials for a multiplicity of purposes, from medical teaching to the display of the medical past.

In recent years there has been a growing interest in anatomical collections as their historical

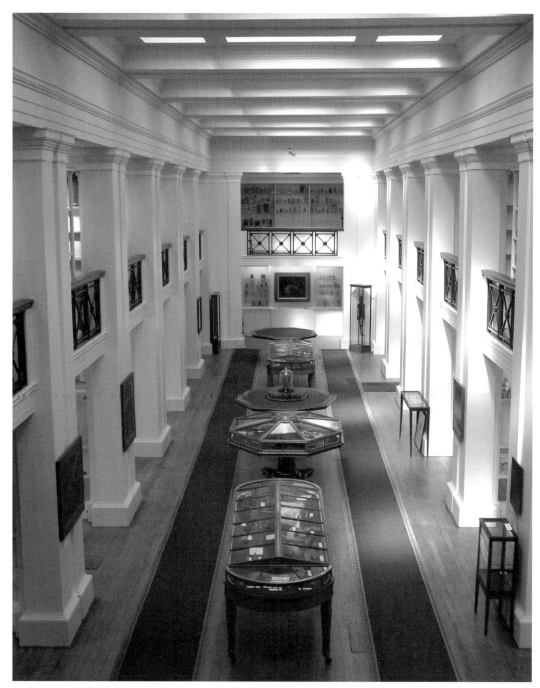

Fig. 1 *Surgeons' Hall Pathology Museum, 2005. Courtesy of the Royal College of Surgeons of Edinburgh.*

significance and current potential are explored by scientists, artists, academics, and museum curators. In medical education, for instance, scientists are re-evaluating collections of anatomical specimens and models. In this respect the uses of anatomy museums are linked to the changing methods adopted in teaching. There has been a decline in dissection as a mode of learning anatomy since the mid-1980s and a rise in the use of plastic models and computer-based anatomical images. Concerns about these changes have been expressed. Older, as a surgeon-anatomist, has asserted that dissection 'leads to a real understanding of the three-dimensional configuration of patients' anatomy' (2004; 81). Those teaching anatomy explain that study in the dissecting room is crucial for developing the manual dexterity and skills required of a doctor, for developing a 'clear mental picture' of what lies below 'examining fingers' and for facing the 'reality of death'. Nevertheless, dissecting rooms are under threat from research laboratories seeking expansion (Ellis 2001:150–151). Others have proposed that anatomy can be productively taught without dissection, using instead life models, medical images and artificial or virtual anatomies (McLachlan and De Bere, 2004). In this teaching context anatomy museums, with their collections of models and preserved specimens, are used alongside imaging technologies, simulated bodies and other emerging teaching techniques. Thus anatomists and medical educationalists continue to debate the implications of the multiple methods necessary in the teaching of anatomy.

Anatomy museums, as places of medical education, are not usually open to the public.

Access is strictly by appointment and is granted to students of anatomy, health professionals, and scholars working on the history of medicine. This applies to the anatomy museums and collections in universities at Aberdeen, Edinburgh, St Andrews, and Dundee. However, in Scotland, there are significant collections that are open to the public, namely the pathological collections on display in the museums at the Royal College of Surgeons of Edinburgh [fig. 1], and the anatomical collections at the Hunterian Museum, University of Glasgow [fig. 2]. Also accessible to the public in England is the Hunterian Museum at the Royal College of Surgeons of England which has undergone extensive redevelopment to create a visually stunning redisplay that opened in February 2005. Anatomy and pathology collections and displays continue to be caught up in prominent debates regarding human remains, especially their donation, storage, and inclusion in public exhibitions. Issues of legality and rights with regard to the bodies/body parts of deceased persons have featured strongly in recent public discussions. The Human Tissue Act 2004 (repealing and replacing the Anatomy Act 1984), is due to come into force in England, Wales, and Northern Ireland in April 2006. It regulates the removal, storage, and use of human organs and tissues from the living or the dead, as well as focusing on the securing of appropriate consent for these uses (Department of Health, 2005). The Human Tissue (Scotland) Bill, introduced in June 2005, addresses the anatomical examination of the deceased body and the display of corpses in public exhibitions. The Bill proposes to enlarge the scope of the former, to allow for training in

Fig. 2 *Hunterian Museum, University of Glasgow, 2005. On the ground floor the Anatomy Museum is divided into anatomical regions showing, in this photograph, bays dedicated to the Abdomen, the Thorax and the Pelvis. The upper gallery displays preserved specimens that relate to various anatomical systems, such as the Nervous System, the Respiratory System, and the Circulatory System. Photo © Hunterian Museum and Art Gallery, University of Glasgow.*

surgical techniques upon donated cadavers, and to restrict the latter by making public exhibitions of anatomical specimens ('under the guise of education or art') subject to licensing by Scottish Ministers (Scottish Executive, 2005a:2). The stated rationale for additional control of public displays of the deceased body is linked to the controversy surrounding the *Körperwelten (Body Worlds)* exhibition which shows real, dissected, preserved corpses (Scottish Executive, 2005b:16). Here are sensitive issues that resist easy resolution. The Bill has generated a range of further questions and calls for clarifications in the hope that the educational potential of existing collections of anatomy and pathology will not be restricted (Health Committee Human Tissue Bill Inquiry, 2005). This latest proposed legislation in Scotland is intended to amend the Anatomy Act 1984 which was in turn the successor of the Anatomy Act 1832. Thus, viewed over time, there are changing legal requirements, expectations, and attitudes relating to anatomical material and its display. These changes are part of social, cultural, and political contexts in which meanings are assigned to the human body. In the present day, medical collections are complex in that they often contain recently donated as well as what is defined as historical human material. These temporal distinctions influence interpretations of the remains. Currently, people make highly valued gifts of their bodies to medical science and they are treated with due care and respect until their return for burial or cremation. With regard to historical collections, important recent concerns have been raised by indigenous groups seeking to identify and reclaim ancestral remains that were collected by museums in colonial circumstances, especially during the nineteenth century (Peers, 2004:4).

Legal and ethical disputes over collections of human remains have clearly intensified in recent years. At the same time there have been extensive public exhibitions of anatomy in galleries beyond the confines of established medical schools and colleges. Such exhibitions have attracted unprecedented numbers of visitors and sustained intense media attention. Gunther von Hagens' *Körperwelten* exhibitions, noted above, opening in Germany, Japan, England, Taiwan, USA, and Canada between 1997 and 2005, have attracted more than 17 million visitors, according to the official website (*Body Worlds*, 2005). These exhibitions have been met with divided responses generated primarily by the act of displaying real preserved human bodies. The displays of women, of foetuses and of pathological conditions have provoked particularly strong reactions, as have the manner in which the bodies have been sculpted, posed, and arranged. Public commentaries upon the *Body Worlds* exhibitions have been conflicting and often critical. The preserved bodies in the exhibition have given rise to multiple interpretations, from the assertion that the exhibits reproduce stereotypical cultural images of gender (Stern, 2003), to the argument that they inspire fascination and awe (Walter, 2004).

Further public exhibitions of anatomy and medicine in England have explored the diversity of visual materials used as means to understand the human body. Notable here are *The Quick and the Dead: Artists and Anatomy* (October – November 1997) which opened at the Royal College of Art,

and *Spectacular Bodies: The Art and Science of the Human Body from Leonardo to Now* (October 2000 – January 2001) at the Hayward Gallery, both in London. In these shows anatomical models and paintings were juxtaposed with the work of contemporary artists, using photography, sculpture, video, and installation to produce new impressions of anatomy. Such innovations in exhibition strategies emerge from different engagements with the materials of science and technology. As these objects are re-positioned by curators and artists they come to yield insights unanticipated by their original makers. The exhibition *Medicine Man: The Forgotten Museum of Henry Wellcome* (June – November 2003) at the British Museum took objects out of storage into display, and this process involved artists, writers and film-makers. Creating images and texts as inspirational responses to museum displays has been facilitated recently at the Royal College of Surgeons of Edinburgh, so that poetry and writing projects are situated in relation to the museum's visual and material dimensions (Conn, 2005; Jamie, 2005).

Contemporary interdisciplinary projects at the interfaces between science and art bring together practitioners and curators to generate new forms of display. Experimental collaborations suggest different ways of seeing and interpreting museum spaces. Relationships between science laboratories, artists' studios, and museum exhibitions have been explored by the curator Hans-Ulrich Obrist who proposes that museums are complex, multi-purpose spaces that are 'always in contact with other oscillating spaces' (2003:150). This is an interesting insight that

applies to museums of anatomy: they have emerged, developed and transformed in relation to other spaces, including dissecting rooms, museum stores, hospitals, archives, libraries as well as museums of zoology, pathology, and anthropology.

The *Anatomy Acts* exhibition brings together contemporary and historical materials from numerous repositories in Scotland. By displaying these objects together for the first time, the exhibition sets up previously unrealised material and visual relationships in the field of anatomical making and imaging. The following part of this essay briefly explores some of the settings from which the objects in *Anatomy Acts* have been drawn – places where eclectic objects accumulate and reside, where the materials of the past are preserved, and where new objects and images are used to develop anatomical ways of seeing and knowing the human body.

ARCHITECTURES OF DISPLAY

Historians and anthropologists have increasingly sought to emphasise that science is made by people in specific locations at particular times, rather than existing as an abstract domain of unchanging, factual knowledge. This insight applies equally to the ways in which anatomical knowledge has been generated in various architectural settings: theatres of anatomy in the sixteenth century, dedicated dissecting rooms and museums built in the universities of the nineteenth century, studios of model-makers and, later, factories producing simulated human patients for medical training in the twentieth and twenty-first

centuries. These are some of the shifting, overlapping spaces in which anatomical work has taken shape. With regard to the science laboratory, Peter Galison has argued that it is 'dynamic and always in flux, that it is not only polymorphous, but also in constant mutation' (2001: 99). Anatomy museums also shift and transform, even though museums have acquired a cultural image as a place for dead and discarded things that remain fixed, ossified. Interpretations of museums as dusty vaults that are frozen in time have fed allusions to museums as cemeteries, but despite these images of stasis, distinctive patterns of change can be discerned.

Anatomy collections in universities have mobility in that their designated rooms are invariably modified over time. Teaching collections are kept in store until needed and then incorporated by curators and technicians into displays in the museum, the dissecting room, the lecture theatre, and other spaces. Many large exhibits have been mounted on platforms or kept in cases with small wheels precisely to facilitate this movement. The role of the curator in these display processes varies according to institution, but anatomical displays are not the outcome of one person's designs. Rather displays emerge and shift as part of interactions between diverse networks of people and materials. Anatomy displays tend to build upon existing architectural structures and material orders, modifying and re-working as different objects are positioned over time. The Anatomy Museum at the University of Aberdeen was built in the 1860s and modelled, according to the anatomist John Struthers, on museums at the Royal College of

Surgeons of Edinburgh, the University of Edinburgh [fig. 3] and the Royal College of Surgeons of England. This modelling was characteristic of the dynamics of museum-making conducted by nineteenth-century anatomists. They regularly visited established museums, as well as collecting, dissecting, preserving specimens, and articulating human and animal skeletons for observation by their students. All of these practices shaped prevailing perceptions of culture, nature, and science.

The Anatomy Museum at Aberdeen was internally reconstructed during the 1950s and a different system of display was installed [fig. 4]. This structure, presently still in place, is based upon the anatomical regions of the body where bays divide and show each region: head and neck, upper limb, lower limb, thorax, abdomen. The museum and the anatomical framework of the human body are therefore aligned. The display of the body in the Anatomy Museum as a series of interrelated regions is a pattern that is realised elsewhere, for this arrangement is also deployed in the current anatomy museums at the Hunterian [see fig. 2], the University of St Andrews [fig. 5], and the University of Edinburgh. The ordering of these sites of anatomical display works according to division into anatomical regions, and within each region the appropriate body parts are situated in the form of preserved specimens and related visualisations of various kinds. These architectures of display shape perceptions of anatomical objects and inflect their meanings. For example, to display a model of the larynx in the section of a museum labelled 'Head and Neck' is to link the fragment to its anatomical region which

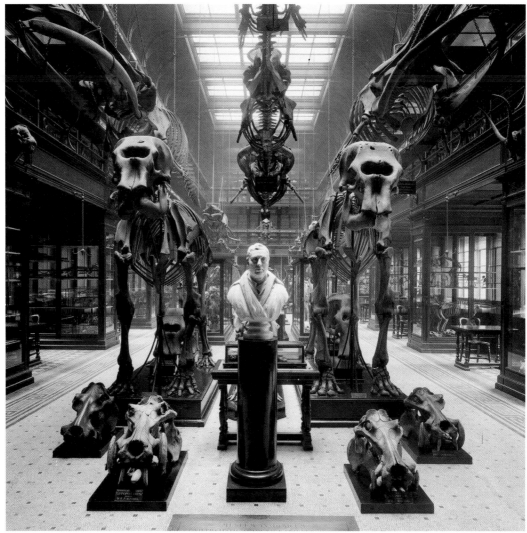

Fig. 3 The Anatomy Museum, University of Edinburgh Medical School, Teviot Place, Edinburgh, 1898, *built 1881-97.*
© *Royal Commission on the Ancient and Historical Monuments of Scotland/Licensed via www.scran.ac.uk.*

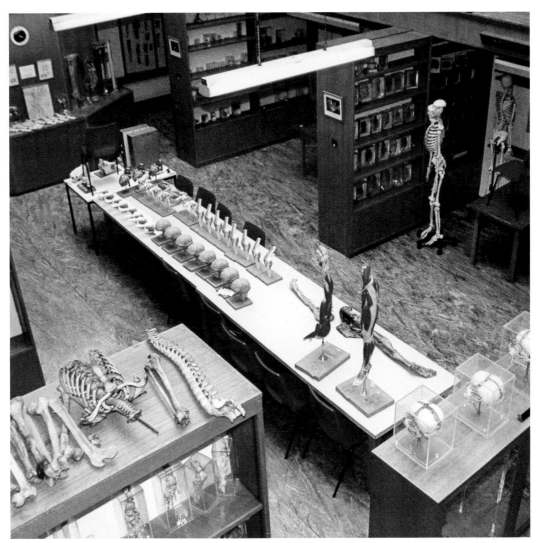

Fig. 4 Anatomy Museum, University of Aberdeen, 1999. *The Museum is divided into bays that display anatomical regions of the human body. It has retained this structure since the 1950s, though some of the objects within the bays have moved into the store or changed their position. The open shelves allow students to remove the models for study at the desks. University of Aberdeen, Anatomy Museum. Photograph, Norman Little.*

Fig. 5 *The Anatomy Museum, University of St Andrews, 2005. Museum Collections, University of St Andrews.*

in turn relates to the series of regions that make up the bodily whole. It is through this spatial association of body part and region that the body displayed in anatomy museums is kept 'intact'. Such display settings create relationships between objects, texts, and images. To look at an object, and absorb its associated descriptions (labels and diagrams in the main) is to move between different renderings of the anatomical part and enter into a process of deciphering, guided by the museum display. Within the main organising structure of anatomy museums there are further frames, cases and enclosures. The shelves, cupboards, perspex boxes and glass jars are the necessary fabric of anatomical exhibiting. Yet these materials are made to appear as marginal supports and surrounds that fade from view. The chairs and tables that furnish the museum are not positioned as museum objects; rather, they are present to facilitate the study of museum objects. What is meant to be seen and what is rendered 'invisible' within anatomy museums is a matter of spatial and visual strategy on the part of museum staff. At the same time, what attracts visual

attention and what fails to engage is influenced by the actions and interpretations of visitors that unfold within museum spaces.

Displaying the body in museums of anatomy is a process that requires other spaces such as museum stores and workshops. After all, a large part of museum collections usually remains in storage, for a time at least unselected for exhibitions. Museum stores are fascinating zones that deserve further study. As the background of museum displays they facilitate the selective emphasis placed on exhibited objects. Stores have their own systems of organisation so that objects are preserved and kept available for future use [fig. 6]. Dissecting rooms are also related to anatomy museums, being the places where medical students dissect the human body as part of their training. At the University of Aberdeen the Dissecting Room adjoins the Anatomy Museum, and so students' perception of the anatomised body is shaped by their movement between these two rooms. Photography in the Dissecting Room is not currently permitted but in 1948 it was possible, as demonstrated by the cinematographer and documentary photographer Wolfgang Suschitzky [fig. 7]. At Aberdeen the dissection of the whole body was undertaken by medical students until 2003 when different methods of teaching were employed. However, the study of anatomy as a series of interrelated regions still guides the exploration of preserved body parts in the Dissecting Room. The internal dimensions of the body are rendered accessible to students who develop skills of anatomical vision and touch.

Learning anatomy entails the movement from bodily exterior to interior. This apprehension of anatomical depth is made possible in the Dissecting Room where the preserved body is explored and in the Anatomy Museum where models are taken apart and reassembled. Anatomical models resemble the dissected body in that they comprise removable parts but unlike a dissection they are readily put back together for repeated study [fig. 8]. These forms of tactile engagement with anatomical materials are significant aspects involved in learning to see anatomically. As the zoologist Arthur Thomson observed, 'the human body becomes translucent to the skilled anatomist' (Thomson, 1911). By way of conclusion, the final section of this essay briefly highlights the interaction of anatomical objects and images as they converge to make visible and tangible the complex anatomy of the human body.

ANATOMICAL INTERMEDIALITY

The concept of intermediality has been used to describe contemporary art projects that utilise diverse interacting media including film, exhibitions, digital images, and websites. The concept of intermediality captures the recycling, quoting, and migrating of figures across different formats that characterise contemporary work such as that of Peter Greenaway (Elliott and Purdy, 2005). We can detect processes of intermediality in the multiple relationships between anatomical images, objects, and texts that in their making and use build upon and incorporate recurring features. Notice the visual alignment of the paper anatomical model and the articulated skeleton in the Anatomy Museum at the University of St Andrews, and note the positioning of transverse sections of the thorax alongside images of these specimens [see fig. 5]. Connections and

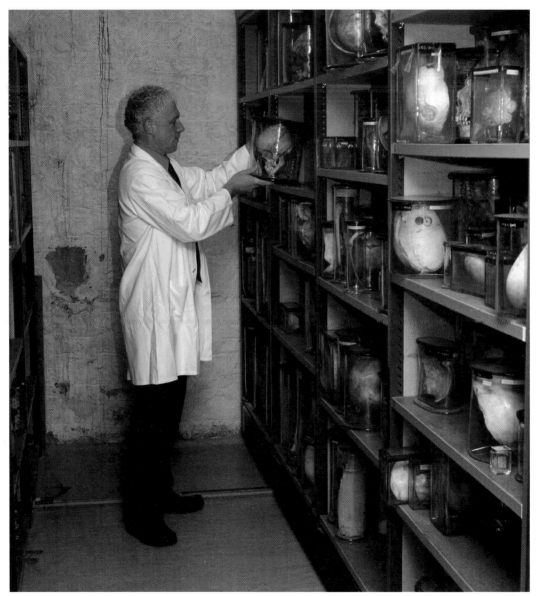

Fig. 6 *The museum store at the Royal College of Surgeons of Edinburgh, 2005. Courtesy of the Royal College of Surgeons of Edinburgh.* *

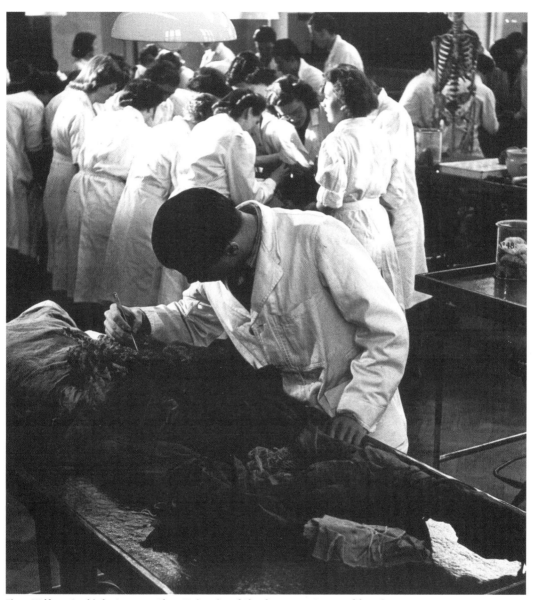

Fig. 7 *Wolfgang Suschitzky,* Anatomy Class, University of Aberdeen, 1948. *Courtesy of the artist.*

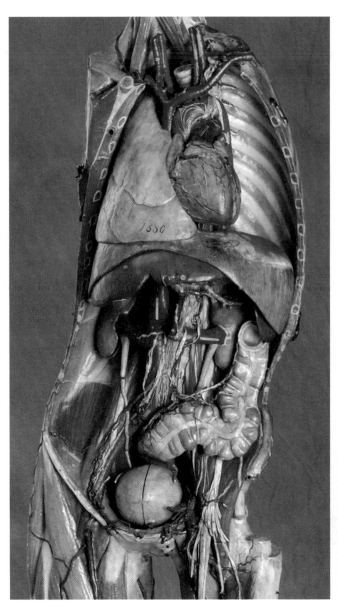

Fig. 8 *Louis Thomas Jérôme Auzoux. Life-size model of a man, c.1870s. This papier-mâché model was designed to be dismantled in order to demonstrate human anatomy and comprises ninety detachable parts. Here various parts have been removed to show an interior view of the thorax and abdomen. The detailed model shows muscles, blood vessels, nerves and the parts are labelled with names and a numerical key. When fully assembled the parts are kept in place with a series of hooks and eyes. Photographer, John McIntosh. Courtesy of the University of Aberdeen, Anatomy Museum.*

amplifications are suggested through the proximity of an anatomical model and drawings of the same bodily part in fig. 9. Historical engravings that present the anatomical body in the form of a lace-work of lines resonate with finely preserved, intricate preparations of blood vessels and nerves [fig. 10]. In short, the anatomy of the human body has been rendered through such a variety of media that anatomy museums become echo chambers of repeated yet modified fragments. These references

and entanglements are significant in practice, as students learning anatomy are expected to visualise the internal dimensions of an integrated living body built up from the visual and manual exploration of dissected bodies and inanimate models. Thus anatomical intermediality aids the imagining of an integrated rather than a dismembered anatomy. Although displays in anatomy museums are based upon the deceased body in parts, what they aim to generate are

Fig. 9 *Anatomical study. 1974. University of Dundee Archive Services. Perth College of Nursing and Midwifery. Courtesy D. C. Thomson.*

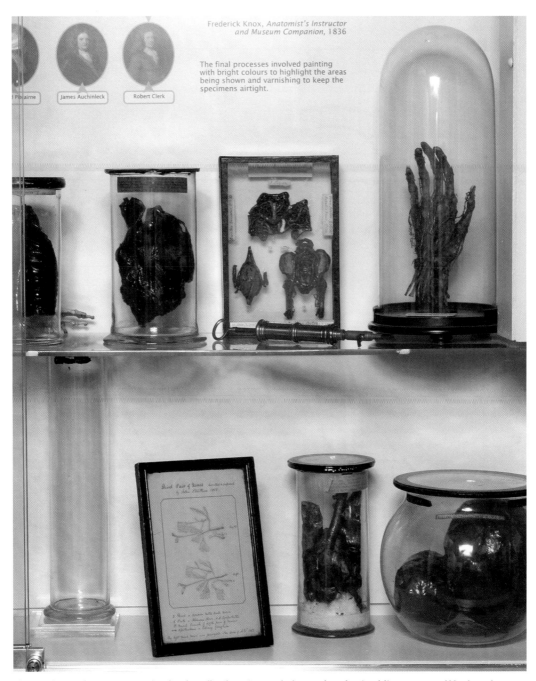

Fig. 10 *Nineteenth century preparations by John Bell, Robert Liston and John Struthers showing delicate nerves and blood vessels. On display at the Surgeons' Hall Pathology Museum, Royal College of Surgeons of Edinburgh, 2005. Courtesy of the Royal College of Surgeons of Edinburgh.* *

visualisations of the living, moving human form. Finally, Mitchell's critique of the term 'visual media' argues that '[ALL] media are, from the standpoint of sensory modality, 'mixed media' in that the visual is not separable from touch, sound and smell (Mitchell 2005: 257). Thus the intermediality of anatomical forms is not exclusively visual, rather it is a matter of sensory engagement where touch in particular is crucial. It is perhaps in this respect that a distinction can be made between anatomy exhibitions in public galleries and restricted access anatomy museums: in the former touch is usually denied and in the latter this sense is cultivated.

REFERENCES AND FURTHER READING

Body Worlds. 2005. http://www.bodyworlds.com/

Conn, S. 2005. *The Hand that Sees. Poems for the quincentenary of the Royal College of Surgeons of Edinburgh*. Edinburgh: Royal College of Surgeons.

Csordas, T. 1994. 'Introduction: the body as representation and being-in-the-world'. in T. Csordas (ed.) *Embodiment and Experience: The Existential Ground of Culture and Self*. Cambridge: Cambridge University Press.

Department of Heath. 2005. *The Human Tissue Act 2004. New legislation on human organs and tissues*. Crown Copyright. http://www.dh.gov.uk/PublicationsAndStatistics/fs/en

Eliot, B. and Purdy, A. 2005. 'Man in a Suitcase: Tulse Luper at Compton Verney'. *Image & Narrative, Online Magazine of the Visual Narrative*, Issue 12.

Ellis, H. 2001. 'Teaching in the Dissecting Room'. *Clinical Anatomy*, 14: 149-151.

Galison, P. 2001. 'Interviewed' in Obrist , H.-U. and Vanderlinden, B. (eds) 2001. *Laboratorium*. Cologne: DuMont, Antwerpen Open and Rommade.

Heath Committee Human Tissue Bill Inquiry. 2005. Submissions at http://www.scottish.partliament.uk/business/committees/health/

Jamie, K. 2005. *Findings*. London: Sort Of Books.

McLachlan, J.C. and De Bere, S.R. 2004. 'How we teach anatomy without cadavers.' *The Clinical Teacher*, 1 (2): 49-52.

Mitchell, W.J.T. 2005. 'There are no visual media.' *Journal of Visual Culture*, Vol 4 (2): 257-266.

Peers, L. 2004. 'Repatriation – a gain for science?', *Anthropology Today*, Vol 20 (6): 3-4.

Obrist, H.-U. 2003. 'Moving interventions: curating at large.' *Journal of Visual Culture*, Vol 2 (2): 147–160.

Obrist , H.-U. and Vanderlinden, B. (eds.) 2001. *Laboratorium*. Cologne: DuMont, Antwerpen Open and Rommade.

Older, J. 2004. 'Anatomy: A must for teaching the next generation'. *The Surgeon: Journal of the Royal Colleges of Surgeons of Edinburgh and Ireland*. 2 (2): 79-90.

Scottish Executive. 2005a. *Human Tissue (Scotland) Bill. Explanatory Notes* (and other accompanying documents). Parliamentary copyright. http://www.scottish.parliament.uk/business/committees/health/index.htm

Scottish Executive. 2005b. *Human Tissue (Scotland) Bill. Policy Memorandum*. Parliamentary copyright. http://www.scottish.parliament.uk/business/committees/health/index.htm

Stern, M. 2003. 'Shiny, happy people: "Body Worlds" and the commodification of health'. *Radical Philosophy*, Issue 118. http://www.radicalphilosophy. com/

Thomson, J.A. 1911. *Introduction to Science*. London: Williams and Norgate.

Walter, T. 2004. 'Body Worlds: clinical detachment and anatomical awe'. *Sociology of Health & Illness*. 2 (4): 464-488.

CREATIVE COLLABORATIONS

V. Frič, Naturalien-Handlung in Prag.

Tab. XXIX Fig. 5. Dim.: 6·2 m. m.

Stylodictya multispina.

Haeckel.

Loc.: **Messina.**

V. Frič, obchod s přírodninami v Praze.

SARA BARNES

Ecologies of Anatomy:
THE COMMISSIONED WORK IN ANATOMY ACTS

'The book is not an image of the world.
It forms a rhizome with the world.'
(Deleuze and Guattari 1988:11)

In *A Thousand Plateaus* Gilles Deleuze and Félix Guattari place rhizomes in direct opposition to trees – 'we're tired of trees' they cry – then go on to use this bi-polar structure in order to make it implode (Deleuze and Guattari 1988: 15). The model of the tree stands for hierarchies and structured knowledges of power which Deleuze and Guattari consider to be a series of fixed points, or roots (Deleuze and Guattari 1988: 7) Rhizomes are a kind of mapping, but far from immutable, they are constantly modified and adaptable shape-shifters and enter the tree by a variety of means and entryways (Deleuze and Guattari, 1988). A-centred, non-hierarchical and subversive, the rhizome worms its way into the tree's stratified systems and linear branching to disrupt its dense solidity. The binary opposites are necessary for Deleuze and Guattari in their political and philosophical thinking: for the rhizomic state to operate it needs the fixity of the arboretum, to penetrate it, sow seeds and blossom into new and strange structures of being and exchange. Such dualisms are created in order to tear them down again, to use opposites to crumble the totalising whole from within.

The tree of anatomical knowledge, despite its substantiality, is not a historically rigid and unified narrative: it is culturally, chronologically, technologically and geographically informed and

Opposite. *Anon. Model of Stylodicta Multispina, c.1890s. University of Dundee, Museum Services, Zoology Museum Collection*

located. It is fed and watered by diverse forays into visual display that a glance through the pages of this volume, or a wander through the labrynthine *Anatomy Acts* exhibition, reveals. Fascinating and mysterious, fabulous and frightening, anatomical knowledge and anatomical display is a richly textured and complex relationship. Distanced by years and bemusement as to how that knowledge was first seen, heard and then visually conveyed, *Anatomy Acts* celebrates that relationship in all its diversity: the zodiac man, the wound man, ultrasound, the papier-mâché gastropod, the Zeigler embryonic models, an alizarin injected fetus, texts of surgical procedures, Dr McIntyre's X-ray films, ink and chalk écorchés, bone casts, numbered codes for magnetic resonance imaging (MRI).

Despite the frequently innovative and far reaching effects visualising techniques have had in the production and distribution of medical knowledge and beyond, it would be going too far to liken such endeavours too closely to the rhizome model, for their role, on the whole, has not been subversive. Rather, anatomical display enhances and shores up the arboreal structure of anatomical knowledge and its function can closely resemble Deleuze and Guattari's 'tracing' – that is to say, representations of that which already exists (Deleuze and Guattari 1988:12). Yet anatomical display also suffuses anatomical knowledge with the promise of rhizomic possibilities: the seemingly monolithic tree, in being creatively penetrated, allows for novel conditions and modes of communication and understanding to flourish. Although Deleuze and Guattari's rhizomes are non-signifying, anti-genealogical states, anatomical display *is* genealogical and *is*

signifying. But, as the authors and artists involved in *Anatomy Acts* demonstrate, what is signified is either open to question or suggests that there is more to anatomical display than meets the eye.

If there are multiple layers of meaning to anatomy, we can think of these layers as an ecology of meaning, one which includes research and research methodologies and how articulation and dissemination of knowledge takes place, in sum, the processes of anatomical knowledge and understanding. Whatever the formal vocabulary, meaning is to be found as much in the process as the end result and meaning is not necessarily intrinsic or easily absorbed, but is acquired by more than simple observation. To dig beneath surface appearance, from the macroscopic to the microscopic, may reveal ever-changing systems of relations between seemingly disparate starting points. Hybrid ecological networks expose the interdependence of the tree and the rhizome and the sometimes fragile, tenuous links that hold the whole together.

It is within these networks and ecologies – travelling the interconnected routes and navigating the negative spaces through which they run – that the commissioned artists for *Anatomy Acts* take their bearings. Trees, networks, circuits, branches, rhizomes, roots, filaments, seeds, ecologies, organic growth and decay feature strongly, either literally or metaphorically. There is no definitive beginning or ending, no specific meanings with identifiable conclusions, but multiple connections and a dizzy orienteering 'toward an experimentation of contact with the real' (Deleuze and Guattari 1988: 12). Christine Borland, Joel Fisher, Claude Heath and Kathleen

Jamie work within the ecological networks of anatomical structures, chemical sparks and communicative gestures which form the flows of human being.

> 'though they're dead things
> washed up on the sand
> each carries a part
> – a black tip, say, to the vane'

('Moult' from *The Tree House*)

The networks of anatomical ecology are long, deep and tangled paths to travel; they incorporate growing, seeing, feeling, mirroring, charting; anatomical memories are gained and lost, filtered and purified. Pared down, dissected, etiolated they may lie low for years then re-emerge and flourish when conditions allow. Such is the work by Joel Fisher, accumulating and shifting over long periods, his work not only probes incubation, but actively incubates. *Shade*, (fig. 1) formally arranged crescents of the artist's beard hair shaved off from time to time over 35 years then framed and meticulously grouped in rectilinear fashion, conjures with visions of the moon, with duration, contemplation, continuum. *Shade* relishes the contrasts of biological time, lunar time and calendar time, of growth and limitation, nurturing and harvesting, obscurity and presentation. The work is cyclical in that the transference from inside to outside, from dark into light as each tiny hair strand emerges in tact from within, then pruned and collected to make way for more growth to occur. This patterning of time crosses a physical and metaphorical threshold and is made manifest

Fig. 2 *Joel Fisher, Divination Dogs. Video. Courtesy of the artist.*

Fig. 1 *Joel Fisher, Shade. Mounted and framed beard hair. Courtesy of the artist.*

Fig. 3 (overleaf) *Joel Fisher, Aletheia. Reproduced drawings on paper. Courtesy of the artist.*

in *Shade's* choreographed, but not quite taxonomical, display. As a material articulation of bodily imprints, of bodily memory, Fisher's beard may be examined for inconclusive whispers in forensic investigations and genetic profiling or pretend to convey minute snippets of information in its tiny capillaries in the steps of medical diagnosis, but it remains elusive in its waxing and waning.

The process of divination to arrive at diagnosis characterises the making of anatomical networks: links in chains of information, connections between different kinds of knowledge, observation, auscultation, recognition, elimination, conclusion. Named, like pets, by Fisher and restrained at least in part by the burden of historical nomenclature and the orthodox, though nonetheless decorative, collars of their profession, the *Divination Dogs* nod their way through the steps of a fantastical diagnosis (fig. 2.). Attempting to uncover hidden information, to share it and

identify it, is central to diagnosis and the dogs nod, unblinking, as though in agreement with questions raised. Or are they asking the questions? Or is it an habitual blank nodding – communicating an empathy, an understanding, quietly concurring even if secretly disagreeing within.

Diagnosis involves memory, mining the shared knowledge of anatomical narratives, excavating snippets from textual material here and recalling sensual experiences of previous meetings between mind and body there. Self-inquisition, probing and remembrance of thoughts and bodily facsimiles, are also core elements of Fisher's projected video *A Generosity of Witness* and the drawings of *Aletheia*. The video will directly negotiate with aspects of individual memory, experience and decision making, its mature participants dwelling upon the accumulation of experience and memory throughout the course of their lives. The physiological networks allowing for

141

the build-up of these memories are physically, chemically and neurologically explainable, but the spaces in-between the networks are elusive, mysterious and beyond measure. This is the indefinable terrain where the singularity of experience is indelibly stored, where the synonymous structure and function of anatomical brain circuitry gives way to the miasmic soup of dreams, false leads and suppositions: in short, imagination.

The knowledge of how the seeds of recollection are planted over a life's time and how they come to fruition may be insuperable and their origin may have become clouded in the heady brew of experience, but, like Fisher's work for *Anatomy Acts*, memories quietly amass and change throughout their subterranean existence to emerge at appropriate moments. Fisher addresses the evolution of memory and its material outcome – which details we recall and how, as knowledge, those details are handed on – in *Aletheia* (fig. 3). Presenting volunteers with an image, a seed such as the Armorial Bearings of the Royal College of Surgeons of Edinburgh or an image of a wound-man, to study for three minutes with the instruction to memorise it, they are then asked to recreate it by drawing. This new image is then passed on to another person to memorise and recreate and continues from person to person, the visual Chinese Whispers never quite running its course. Features are increasingly omitted as the drawings are passed along the human chain. Visually abridged, what is excluded is as imperative as what remains. Resonating with first hand observation of anatomy and its transference as knowledge through word and image, *Aletheia* highlights both rational decision

making – choosing which knowledge to pass on – and unexplained decision making – where what is passed on seems beyond control and vulnerable to the vagaries of the mind. However, as if to make up for the lapse of memory, additional elements creep in to the drawings, filling the gaps that a lack of attention or a failed memory have created: the sparks of anatomy's neurological networks are sustained by the indefinite spaces between them, imagination supersedes the function of memory.

Attention is again turned to traces of the body in *Between Two Waters*, but here the concern is not so much recalling or diagnosing, but a shaping of recorded chance. The work involves two distinct stages, first a photographic record of either rural ice formations or dog urine stains in urban thoroughfares, (fig. 4, 6) then Fisher's careful sculptural transformation of the stain's outline in clay (fig. 5, 7). Both the ice and the urine can be seen as some kind of marking of territory: the ice in meteorological surveillance perhaps, the urine, as with Fisher's collection of beard hair, in a forensic enquiry or the ancient diagnostic practice of examining urine by taste or smell (a licking and sniffing that is familiar ground for the *Divination Dogs*). But it is the unpredictable outcome of the ice formations and urine splatterings which both

Fig. 4 (top left) *Joel Fisher, Between Two Waters. Photograph. Courtesy of the artist.*

Fig. 5 (top right) *Joel Fisher, Between Two Waters. Clay, work in progress. Courtesy of the artist.*

Fig.6 (bottom left) *Joel Fisher, Between Two Waters. Photograph. Courtesy of the artist.*

Fig. 7 (bottom right) *Joel Fisher, Between Two Waters. Clay, work in progress. Courtesy of the artist.*

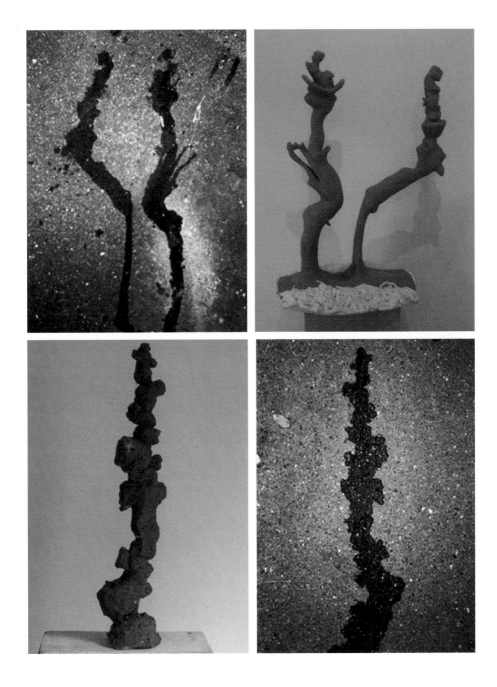

form and inform the work. Modelling the clay from the only available visual source of each temporary watery production – a photograph – Fisher signposts the time-worn task of articulating an impermanent and swiftly changing organic phenomenon in concrete form. However, although the stains seem to be all surface with little hint of hidden depths in the randomly created shadowy shapes and although they are transitory reminders of a recent passing-by, it is the tottering towers of clay, despite their material density, that seem vulnerable in their precarious balancing act. Whereas the two dimensional image appears to be a vibrant tree-like silhouette stretching heavenwards towards a blinking starry sky, the three dimensional tree stands alone, pitted with scars and notches, burnt out, dried up, going nowhere.

> 'At the end of my winter
> I walked in the wood,
> and she, in her kindness
> gave what she could
>
> of beard lichen, lungwort
> blaeberry sprigs,
> tendrils of cold moss,
> broken birch twigs'

Fisher's arid tree-like stumps, devoid of luscious foliage, resonate with the trees presented by Christine Borland in the gallery space. Unlike the trees in the forest teeming with ecological life even if the central arboreal core is officially dead, the trunks in the gallery are already inanimate matter. In the forest an inert tree provides structural shelter for any number of minute organisms, but Borland is struck by one particular invasive property: the discolouration of trees caused by the fungus *aspergillus nigrum*. During a 2004 residency at Glenfiddich Distillery the artist became curious about the trees in close proximity to the industrial production of the whisky, which can turn black when the alcohol evaporates during the maturation process (figs. 8, 9). The trees play host to an unwelcome visitor that has latched on to its surface, sooty fungal filaments spreading indiscriminately by stealth. The trespassing fungus is promiscuous and the tree, as its adopted home, quietly aids and abets its fecundity, simultaneously permitting new life forms to develop among its newly acquired decaying mustiness. Like a smoker who rejects the weed and gives the lungs an opportunity to regain some of its former unclogged rudeness, removing a living tree from exposure to the fungus enables it to resume its usual colour – albeit one which has been tainted and retains traces of contamination. Borland, however, has transferred cut trees and they retain the black colour they had already attained before felling.

Observing the meticulous strategy of the tree surgeons dismantling a tree in her own garden – scaling it with ropes and lopping off its limbs – Borland fragmented the tree further in her studio. With a nod to dissection procedure she began to arrange the sections and consider the effects of fumigation on the ecology of the tree, a necessity for its display in the artificial environment of the

Fig. 8 (top) *Christine Borland, The Velocity of Drops, Copse, detail, 2004. Courtesy of the artist.*

Fig. 9 (bottom) *Christine Borland, Apergillus Nigrum. Courtesy of the artist.*

gallery and one that preserves the tree as a specimen. This retains an integrity of material, but can induce changes in the fungal growth and highlights how the preservative processes of organic material are embedded in the final result. For *Anatomy Acts,* the blackened tree, sitting among a sea of white, displayed in controlled local conditions such as filtered natural light, articulates nature as a mediated entity. It echoes horticultural intervention and scientific research where the organic is configured, where nature is somehow natural and unnatural at the same time. Placing trees individually as singular units and disconnected from the possibility of defilement from other organic, bacterial sources, minimises external damage and mouldering. Maintained in a precious state they are set free from the interconnectedness between other trees and their ecologies. Instead, any ecology which does occur, does so simply within its self, its own series of networks, a mapping with no clear horizons, travelling a constant route of circulation, going somewhere and nowhere, tree-bound in perpetuity. The trees await the next stage of their fate – will there be further intervention, an investigation perhaps into the cause of death, a microscopic analysis of the structure of the offending fungal interloper, a routine stripping of bark and slicing of woody sinews or will they be left alone here to rot quietly away under constant curious observation?

In the forest, the introduction of a white barked tree into a wealth of already blackened ones emphasises the community of yet to be infected stock. Initially the white trees stand alone, isolated until the fungal networks eventually fix on to the silvery husk of the birch. The poison connects the

hybrid layers of ecologies of trees, flourishing in certain conditions and linking them both to each other and their surrounding underground networks and air-borne flows. Monitored and recorded, the daily fungal growth is barely perceptible as it expands its soundless colonisation.

> 'What are we to imagine, the breathing area of our lungs, the 600 million alveoli? Spread out like what? Tarpaulin? Frost? A fine, fine cobweb, exchanging gases with the open air?'
> ('Fever' from *Findings*)

Where Fisher's networks address seeds of knowledge, its communication and its storage in memory banks like building blocks as a means to diagnosis or furthering understanding, Borland's networks are silky, sweeping swathes of fungi. Recalling her exploration of the U.S. military's research into the use of genetically engineered spider silk for the production of bullet-proof vests, the fingers of *aspergillus nigrum* resonate with the flimsy looking threads of spun silk and her bullet shattered glass panels where flinty cracks emanate from gaping holes in web-like form [fig. 10]. Both visually and in their vigorous, functional capacity, glass and spider silk's assumed fragility belies their formidable strengths. Branching glass bronchial structures are bound with spider thread in plexi-glass vitrines and we can only guess as to whether this is to suppress or protect the transparent and unsullied anatomical apparatus in their rarified, air-

Fig. 10 *Christine Borland, Webs of Genetic Connectedness, 2000. Three sheets of shot, laminated glass, pine supports. Unlimited edition. Dimensions variable. Courtesy Sean Kelly Gallery, New York.*

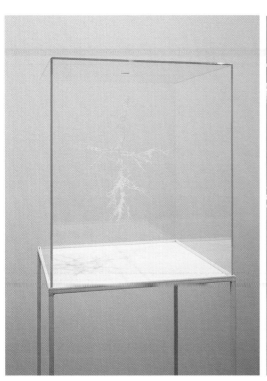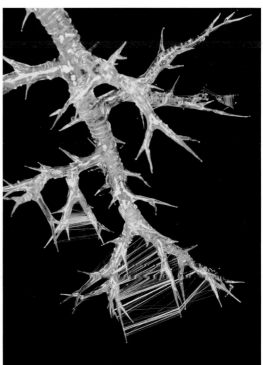

filled, but sealed environment [fig. 11].

Like her stark juxtaposition of blackened, white birch bark, Borland's pristine bronchial structures sharply contrast with those fleshy lungs encroached upon by external pollutants – smoker's lung, miner's lung, asbestosis – commonly displayed in collections of pathology [fig. 12]. Visual diagnosis of diseased organs by X-ray reveals the extent of a white submission to dark forces: Barbara Smith has recounted studies into Black Lung where X-rays became a deciding factor in whether miners were entitled to compensation for the bronchial illnesses they had acquired in the course of many year's labour. (Smith,1981) The whiter the picture, the blacker the lungs were deemed to be. For the doctors involved in the case this was an objectified and standardised view, for the miners it was arbitrary and had little to do with the level of suffering they endured from the dirty progression of disease; the shadowy negatives denied the particularity of human experience.

'… your blinds and veils
are drawn gently aside, but you don't see us
examine you in your privacy'

An X-ray image blocks out certain anatomical structures revealing expanses of what appear to be negative spaces or body cavities which are, in corpo-reality, crammed with organs, muscles, veins, nerves and fatty padding. During a

dissection, much of this content is set apart and permits an alternative perspective on the body, but also on the human ecology of relations – between life and death and the shaping of knowledge about the living and the dead. Photography and its advanced technological offshoots into digital imaging have been crucial in this, not only in articulating anatomical knowledge, but facilitating access to gaining knowledge in the first place. The stereoscope, dating from the mid-1830s, was developed as an experimental tool for exploring binocular vision and played a key role in the dissemination of anatomical insight once photography became a common place in the early twentieth century. Based on principles of perspective, light and shade to produce an effect of solidity, it functions by utilising two photographs taken from slightly different positions and viewed together through the stereoscope. This gives an illusion of three dimensionality. Stereoscopic atlases of the dissected body consist of series of these double photographs with accompanying explanatory text printed on cards inserted into the optical apparatus – box shaped or hand held stereoscopic viewers.

Tricking the eye-brain network system of visual perception into sensing depth and tangible reality, the stereoscopic atlases of anatomy fool us into thinking we can reach inside the body, place our hands carefully around an organ or grasp the tangled strips of flesh. Claude Heath's installation for *Anatomy Acts* recreates such illusions on a grander scale so that the visitor to the exhibition may engage with the work stereoscopically. Peering through a small aperture placed within an enclosing wall (in which a set of mirrors is mounted), the visitor sees a single image with

Fig. 11 *Christine Borland, Bullet Proof Breath, 2001. Glass, spider silk, 14 x 12 ins., plexiglass vitrine, painted stell pedestal. Edition of four. Collection The Fabric Workshop and Museum, Philadelphia.*

Fig. 12 *Detail of Fig 11.*

apparent depth values, although in fact it is a double image. As the detail slowly emerges, the more the viewer can immerse themselves in the increasingly focused clarity of Heath's three-dimensional drawings.

It was just such atlases – *The Edinburgh Stereoscopic Atlas of Anatomy* (1906) and *The Anatomy of the Human Eye* (1912) – that Heath investigated in his anatomical research for *Anatomy Acts*. Heath is no stranger to the complexities of visual and tactile perception. In his blindfolded drawings he feels an object with one hand while drawing with the other, marking out his tactile experience by disrupting the accepted order of hand eye co-ordination we associate with mark making [fig. 13]. The finished images are revealed as tangled skeins of colour or layered paths of tiny dots with a remarkable sense of cohesion and consolidation about them. More recent enquiries involve drawing in three dimensions with the aid of aerial photographs and computer software to create landscapes of Ben Nevis and revolving animated maps and paintings of the constellations – each delving into the route patterns of existing phenomena and how we perceive them [fig. 14].

Engaging with the innovative research project 'Hands On' (formerly 'Tacitus') at Edinburgh College of Art and Edinburgh University's School of Informatics, Heath has utilised 3D computer software in his digital drawings based on the stereographic pictures of the human eye and the thorax. With the use of stereo glasses and a haptic feedback device that the user manipulates in space and which provides a sensation of touching the surfaces of lines and objects being created on screen, he draws freehand in a 3D interface. The

haptic feedback involves exerting pressure on the end point (stylus) of the tool to gain tactile sensation and the stereo vision is achieved by the use of the glasses and a built in mirror in the display panel – a high-tech version of the original stereographs which afford the user with a floating digital 3D image which can be rotated in space. The user thus not only sees the 3D object, but feels it and can manipulate the objects and lines to create a variety of surfaces – feeling soft and spongy, for example, or hard and taut. The artist's network of nerves transmitting information and functioning somewhere between touching and seeing, conceiving and cognition, is thus heightened by its woven connection with the electronic network of the system software. The Edinburgh project is aimed at designers, artists and animators, but with these fast developing capabilities, haptic systems are being researched and trialed as aids to learning anatomy and training in medical procedures.

'See – at the human core
lies not the heart

but a forked stick
– a divergence
we illustrate well'

The original stereoscopic images of the eye [fig. 15] and the thorax [fig. 16] are seen in isolation, distanced from their organic context – their bodily

Fig. 13 (top) *Claude Heath, Pith 3, 1998. Acrylic on linen. 119. 5 x 114.*

Fig. 14 (bottom) *Claude Heath, Ben Nevis.*

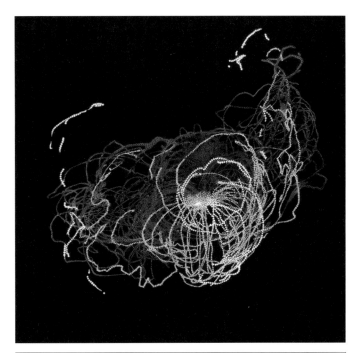

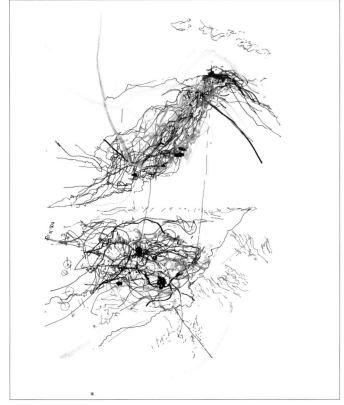

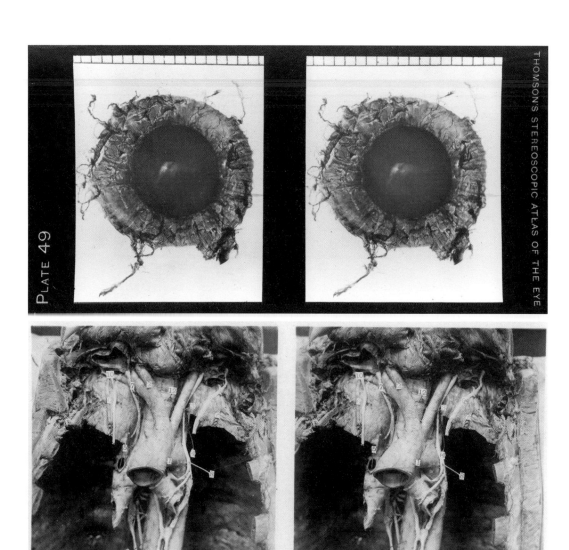

home – and viewed in a disembodied, abstract form. Yet the sepia images are startling as a reminder of the human body as organic in comparison to today's visual objectification of the body and its parts as transformable, transfigured, transferable, transgenic. Here, the eye's smooth, shiny globe lens with its reflection – a window in the sunlight? a face peering through a camera lens? – appears to pulsate with a primeval urge to pop out from its flimsy filigree nest or else sink softly into further depths, its tendrils ready to close protectively in. In Heath's 3D drawing the doubling of the eye bristles with the intricate fragility of Borland's gossamer spider webs and the bullet holes with their cracked, spindly spurs. From two

Fig. 15 (opposite top) *Arthur Thomson, The Anatomy of the Human Eye, 1912. Oxford, Clarendon. Courtesy of the Royal College of Surgeons and Physicians of Glasgow.*

Fig. 16 (opposite bottom) *David Waterson (ed.), The Edinburgh Stereoscopic Atlas of Anatomy, London, 1906. Courtesy of the Royal College of Surgeons of Edinburgh.*

Fig. 17 (above) *Claude Heath, work in progress, 2006. Courtesy of the artist.*

Fig. 18 (overleaf) *Claude Heath, work in progress, 2006. Courtesy of the artist.*

small circular solids, his depictions of the eyes radiate from the centre into a silky blackness [fig. 17].

The *Thomson* stereographic eye appears luscious, but it is a hollowed out seemingly woody scene that the *Edinburgh Atlas*' stereograph of the thorax presents to us. The vital organs of the heart and lungs have been removed so that a framed cavity of intricate topography fills the pictorial space. What seem like withered stalks and staunch trunks are of course clipped ribs, veins and arteries with an overarching canopy of membranes, muscle and skin. The numbered pointers correlate with an anatomical index and remind us of the educational context of the stereographic picture, but the viewer is still drawn in to a place of dark imaginings: robbed of the heart and bellows, the ground also seems to cave in, leading down to as yet unplumbed depths. Heath's sequential studies of the thorax [fig. 18] progressively fill the negative spaces with the digitally created lines tracing the movements of his drawing hand. Reinstating drawing into the stereoscopic repertoire as originally created by Charles Wheatstone just prior to the invention of photography, the 3D objects (rather than simple lines on a 2D surface) create

their own shadows lending them a greater depth and sensuality. These looping and sinuous strokes have a sumptious ribbon-like quality about them, their elegant weaving through inky space resemble highly stylised corsets – a kind of body bondage which can be read as soothingly protective or threatening in its restrictive zeal. Yet these velveteen, slinky straps have failed to restrain what Heath refers to as 'the little bounder' '– *Oh yes, the heart itself*' – the heart of the matter, removed from the scene.

Heath's network of snaking marks cosset, entwine and penetrate a central unrealised core, but do not yoke themselves to it. As with Borland, Fisher and Jamie, the works continue in a meandering, open-ended and evolving ecology. This is not only in the material life of the work itself – Fisher's beard growth, Borland's trees – but in art's ecological networks, its connections, meanings, sensations, interpretations and transformations. It is a flow of art that distinguishes it from a simple tracing, and permits the penetration of the tree in diverse forms from multiple entry points and, therefore, multiple exit points or lines of flight – leaking, rupturing, re-emerging, re-connecting (Deleuze and Guattari 1988: 9). Anatomical knowledge is not imperviously sealed, but entails and invites rigorous and novel assaults on its hierarchical structures, roots and branches. Anatomical display supports it with a precarious binding of its ecology. But it is the rhizomic mapping of art's imagination that not only penetrates the tree, but also offers a line of escape.

REFERENCES AND FURTHER READING

The author thanks the artists, Christine Borland, Joel Fisher and Claude Heath for conversations and notes on *Anatomy Acts* and poet Kathleen Jamie for permission to use extracts from her poems in this essay.

Please see the Artists' Details in this book for comprehensive artist bibliographies.

Deleuze, G. and Guattari, F. 1988. *A Thousand Plateaus: Capitalism and Schizophrenia*. Trans. Massumi, B. London: Athlone Press, from the original, 1987. *Mille plataux*. Vol.2 of *Capitalisme et schizophrenie*. Minneapolis: University of Minnesota Press.

Ede, S. (ed). 2000. *Strange and Charmed. Science and Contemporary Visual Arts*. London: Calouste Gulbenkian Foundation.

Jamie, K. 2004. *The Tree House*. London: Picador.

Jamie, K. 2005. *Findings*. London: Sort of Books.

Holmes, O. Wendell. 1859. 'The Stereoscope and the Stereograph' in Goldberg,Vicky (ed). 1981.*Photography in Print*. Albuquerque: University of New Mexico Press.

Smith, B. 1981. 'Black Lung: The Social Production of Disease,' in Berg, M. and Mol, A. (eds.). *Differences in Medicine. Unravelling Practices, Techniques and Bodies*.1981. London: Duke University Press.

Tacitus (Hands On) website http://www.eca.ac.uk/tacitus

Thomson, A.1912. *The Anatomy of the Human Eye*. Oxford: Clarendon.

Waterson, D. (ed.). 1906. *The Edinburgh Stereoscopic Atlas of Anatomy*. London.

KATHLEEN JAMIE

Surgeons' Hall

The arm hangs relaxed, the fingers of the hand curled slightly toward the palm, a habit, they say, which links us to our ancestral apes. Because of the hair, I think it is a man's arm and it has been severed just below the elbow.

It startled me. I'd been looking at something else, but then, having been invited to gaze at the severed arm, I kneel on the polished wooden floor and do so. It's held very still in a rectangular glass jar. You could read its fortune, the life-line and heart-line are so clear and the fingernails are just too long. Perhaps they kept growing after death.

The whole is stained a faint rust-red. The flesh of the forearm, though, is corroded and blotched with cancerous growths. Stuck to the jar is a label which has been typed unevenly on an obsolete machine. It reads, tersely, 'paraffin worker's arm. 1936'.

The jar containing the arm stands silently on a white shelf, one in a row of other jars. Above it are more white shelves, holding more glass jars, and within the jars, more specimens. There is a whole hall of them, with an upper gallery too, where further shelves hold further objects suspended in sealed jars. The hall is illuminated by a soft daylight, which falls evenly from frosted glass roof-lights and the windows, which are screened by pale blinds. Beyond the windows is a world, where it is Autumn. Almost, one can hear the city traffic, occasionally a shout or a door closing elsewhere in the college building. Within the hall though, the rows and rows of jars know no season, no traffic or haste.

The chemical intervention which arrests the natural processes of decay is called 'fixing'. Once fixed, a specimen can be kept for a long time. The oldest here have been fixed in their jars for two hundred years, and they are displayed in a place of special privilege. They stand up in the gallery, facing the hall's main doors. Within those jars, preserved in fluids which are viscous and nicotine-coloured are objects which could be fruits, but you know in your heart they are not.

Each of the bays on the main floor of the Playfair Hall is given to a particular body part or type of ailment. Thus the specimens taken from cancerous breasts oppose, as though in a shy dance, those from cancerous testicles. A label gives the condition, the date and the name of the surgeon who donated the specimen. The blood colours are all leached away and the objects reduced to pallid shades of beige. Here, says the typed label, is a breast with Paget's disease. Suspended in its solution the object resembles not a woman's breast, or even part of a breast. It looks like a mango stone. A few steps away are jars containing parts of men's testes. In one – the thick glass magnifies the sample slightly, and a few pubic hairs still issue from the skin – layer after layer of skin and subcutaneous tissue have been neatly cut through to reveal a tumour. The layers the scalpel has pared away are so thin and finely graded in colour, they resemble the bands in polished agate. In another jar are pebbles so smooth and round you'd be happy to pick them up on a beach and keep them in your pocket, but these are displayed within a urinary tract. There is a pale slice of kidney. The label, clattered out on that same machine, reads 'war gas inhalation'.

For two, perhaps three hours, I have been gazing in silence at the objects in jars, privileged to be alone, moving from shelf to shelf in the calm light. The shelves are low: to examine the

specimens you have often to bend down or kneel, as you do with a child who has cut his knee. Unless you have a professional interest, it's possible that the only bodies you've been intimate with, have scrutinised, have been the bodies of lovers or children. The act of unhurried, unmediated examination has hitherto been an act of love. Perhaps as a consequence, or perhaps because, given the opportunity, we do indeed feel for all of suffering humanity, a stranger's arm with his corroding carcinoma, a diseased breast, a kidney taken from a man gassed on the Western Front, all call forth the same plain tenderness. At certain shelves, as I say, you have to bend and look closely, without knowing what you might see. It will be pale and strange, and possibly quite beautiful. It will be someone's catastrophe and death. Here is a femur with, attached, a cyst the size of a wasps' nest. Here, a rotten plum, but this is someone's finger. On a low shelf is a row of balloons, shellac-coloured; they are hydrocephalic skulls. In this bending and looking, I'm reminded of Goya's *Disasters of War*, which he drew so small that to see them you must approach very close. The tiny captions Goya had appended to his images come to mind. 'One cannot look at this'. 'This is the truth'. 'This is what you were born for'.

There are certain names we know. We know the names of the two men whose collections of anatomical specimens formed the basis of this museum. One, John Barclay, was an anatomist who taught classes near here, and who, in 1821, donated his collection of comparative anatomy to the Royal College of Surgeons of Edinburgh. Also, we know the name of Sir Charles Bell, whose collection of pathological and anatomical

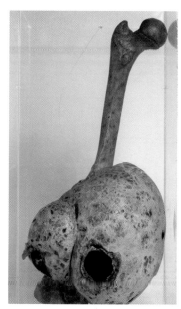

Bone. Femur. Cyst aneurismal. *Courtesy of the Royal College of Surgeons of Edinburgh.* *

specimens was bought in London in 1825, shipped North, and then conveyed on a gun carriage from Leith to Surgeons' Hall. Other, more recent surgeons and anatomists added to the collection. We know these names, and also the name of the architect commissioned to design Surgeons' Hall, and sequestered within it the museum where these anatomical collections were to be housed. That architect was William Playfair, who was responsible for much of Edinburgh's neoclassical grandeur. Consequently, this hall is known as the Playfair Hall, and like the specimens it contains, it too, is fixed. Its proportions cleave to the unchanging truths of mathematics. We know the names and deeds of those men, and the many

other long-dead men whose faces are fixed in oils, whose portraits hang in the corridors and function rooms of Surgeons' Hall. The names, though, of the tribe of dead whose body parts are contained here in glass jars, we do not know.

There are shelves, and there are also display cases, which stand on tapering legs in a line in the hall's wide aisle. The display cases show their contents under glass, and in so doing illustrate a distinction which William Playfair must have considered well: between being shown as an exhibit, and being housed as a specimen. The specimens, the human remains, are not exhibited in fancy cabinets. They are given the plain white shelves.

No Frankenstein extravagance then, and other than a faint pleasant oil, there is no smell, certainly no school-lab formaldehyde. Aside from my own slow steps, my own occasional long drawn breath, there is scarce any sound in the hall either.

'We are the geese', wrote Dr Barclay, who, after the reapers and gleaners have done their work, 'still contrive to pick up a few grains...and waddle home in the evening, poor things, cackling with joy because of their success.' By the reapers with their scythes he meant the early anatomists of modern Europe, the explorers and discoverers who, absorbed in their task, had delved ever deeper into animal or human tissue, feeling their way, peeling and following a thread of artery or sinew, making connections in their minds even as

they severed them with their scalpels. With his students Barclay was popular and respected; they favoured his classes over the dreary ones offered at the university. A precise man, he lamented the slack language of anatomy. Several times, in his writings, he approached anatomy through metaphor, striving for exactitude. 'The opened body is as a foreign country,' he wrote. 'Anatomy is as a harvest field'; 'Anatomy is as to medicine as sight is to the body'. I wonder what he felt toward the objects that made up his collection. He donated them on condition that they be devoted to the purposes of 'professional utility', but was there a familial affection, too? To acquire bodies, anatomists had to deal, turn blind eyes, fail to ask questions. Barclay bought some of his specimens, some were gifted, some he dissected by his own hand. Where, I wonder, does one acquire the corpse of a toddler?

I wonder also, as I pass the jars on the shelves, here a tiny hand, there a bedraggled larynx, if the early anatomists regarded their collections with the same pride as do the collectors of stamps or tin toys. The portraits lining the corridors of the Royal College show faces which are, for the most part, concerned, intelligent and vain. Indeed, there is a marble bust of Barclay himself, which his students commissioned after his death as a mark of their esteem. You might imagine someone cadaverous, but he looks rather like an earnest dog: his head is cocked, his heavy eyebrows puckered and his lips are parted as though he had just been asked a question, and is clarifying the answer in his own mind before he replies. There are many faces, almost all men's, in the college - marble busts, and portraits hung high on

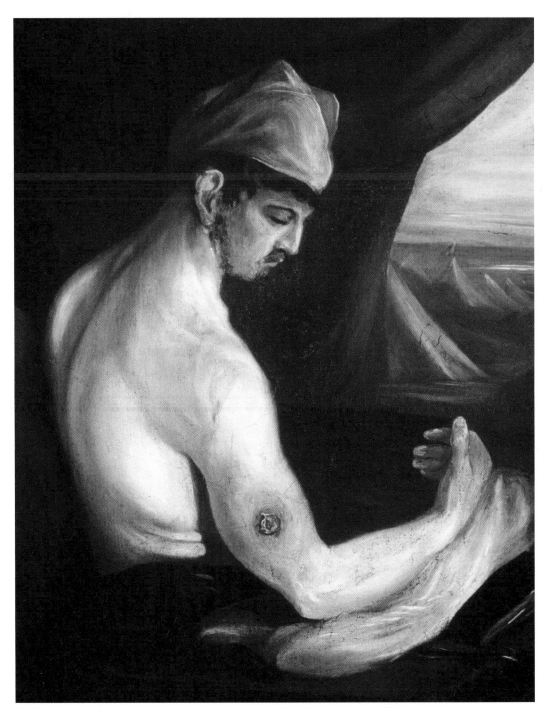

Charles Bell Gunshot wound of the humerus. 1809. *Courtesy of the Royal College of Surgeons of Edinburgh.* *

the walls, but should you want to study a real nineteenth-century face, you may: that of a person whose head is preserved in a small tank. His eyes are placid and half closed in the manner of certain Buddhas, the skin is puffy and pale. To examine this face, we must kneel.

There are disasters of war in the Playfair Hall, too. On each of the gallery piers hangs a painting. They are by the same Charles Bell whose collection stands on the shelves around them. In 1809 Bell responded to an appeal for doctors and surgeons and hastened to Portsmouth, where thousands of soldiers, sick and hacked and shot, were being disembarked from Spain. The troops, in the face of Napoleon's attacks, had been evacuated from Corunna, and had then endured the sea-voyage home. Bell treated them, and later made this series of paintings from his notes and sketches. What they show, in a sombre palette, are young men with gunshot wounds. The men are wounded in the head, the testicle, the thigh and they display their wounds for us sorrowfully. The first painting shows a boy shot in the upper arm. He wears a soft cap on his thick, dark hair. But for this cap, he is naked to the waist. With head lowered, and shoulder turned toward us, he gazes down at the arm he is soon to lose. The artist and doctor are one; the model and patient are one. So the young man displays his wound. The doctor has made notes. The hole in the boy's upper arm is 'apparently trifling', but 'when I feel thus the finger passing through the bone, this is a case for amputation'. Amputation tools are displayed in the polished cabinets.

There are shining saws and metal retractors. For some aesthetic or religious reason of his own, Bell has depicted the young man as though alone in a cave, like St John in the Wilderness. Beyond the wounded boy, through the cave mouth, is a landscape dark with hills.

In the museum, stairs lead up to the gallery. The stairs are asymmetrical, a flight in opposing corners. On the walls of the north-eastern stair are water-colour drawings of more men with grotesque war injuries, this time from Waterloo. These drawings are also by Charles Bell. The ragged stumps where arms have been blown off are rendered in pastel pinks and greys. Up in the gallery are specimens which demonstrate diseases all but banished: leprosy, tuberculosis of the spine. There are skeletons of two people who suffered rickets. Their legs are shrunken and hooked up against the body like those of a bird in flight. Leaning over the white banister, I look down at the hall below with its jars of stilled disasters and diseases, its fixedness.

But nothing is truly fixed. The world changes; attitudes and taboos change. The objects in their jars have been so long dead they have outlived their function. No longer will they be carried into lecture halls and displayed to ranks of rowdy young men to illustrate a point, to describe a medical condition. Leaning over the banister, in the silent hall, I wonder what they are becoming, even as they stay the same.

Many of the specimens are beautiful. One of the earliest is what looks like bracket fungus, but it is actually a fine slice of intestine into which the

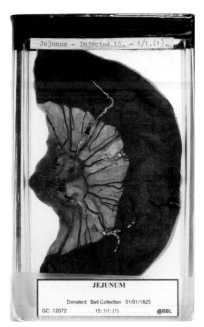

Jejunum injected with mercury.
Courtesy of the Royal College of Surgeons of Edinburgh. *

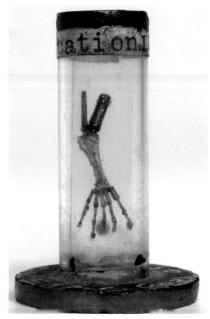

Foetal hand. Ossification. *Bell Collection.*
Courtesy of the Royal College of Surgeons of Edinburgh. *

then conservator has introduced mercury. Silver threads of mercury fan through the tissue, illustrating its blood vessels. It is quite lovely, one could wear it as a brooch. You think 'bracket fungus'; and the tiny veins around an ectopic kidney are identical to dried lichen. There are 'bezoars' – hard masses of indigestible material like hair or straw, which people have swallowed, and which, over time have mixed with mucus and moulded to the shape of the stomach, so when removed the bezoars resemble peaches or birds' nests.

We consider the natural world as 'out there', an 'environment', but these objects in their jars show us the forms concealed inside, the intimate unknown, and perhaps that is their new function.

Part art gallery, part church for secular contemplatives. 'In the midst of this city, you think you are removed from nature', they say, 'but look within'.

A whole Neolithic burial, a row of tiny hands, and now I'm looking at conjoined twins. The jars are too small, they are almost squashed. There are just too many limbs. One pair have hair, and they are joined at the chest. Each has but one arm, which cross as though they are hugging each other, and their mouths are close together, 'but never, never canst thou kiss'. I think I'm inured by now, but at the twins, at last I want it all to stop. Here at last I want to stop gazing and just open the jar and take the twins out, to blow life into them, tell them it's okay, we can do something now. In another jar

William McGillivray, Linnets. *Courtesy of the Natural History Museum.*

beside these twins is . . . what shall we say, what is the word? A lump, a blob, these are not good words, because it is a human thing. A fleshy lump, the size of a bag of flour. I can discern more than one mouth, some eyes, a tendril of umbilicus. The conjoined twins make me weep and I turn away, and behind is a wren, so bright, charming and complete, it could have been real.

A wren, and a branch full of linnets, and the warbler which bears his name: facing the twins in their jars are the bird paintings of William McGillivray, the naturalist who was conservator of this museum in the 1830s. His pictures of the birds he shot, then painted so exquisitely in their natural colours, enable us to see the birds clearly; they are halted in the moment before they fly. By these pictures, we know the birds. By the specimens, we know our bodies, our conditions. In this place of silence and slow time, it's as though the conjoined twins hug each other and look happily forever upon the bright linnets and wrens. Which, I remind myself through tears, is ridiculous. But in the bodily business of weeping, I'm reminded that I'm hungry, and suddenly time begins again, and the Playfair Hall loses its sense of stilled catastrophe, and it's proper to leave.

Extracted from 'Surgeons' Hall', an essay in *Findings*, published by Sort Of Books. 2005.

ANDREW PATRIZIO

Subtle Knots and Strange Stations:
ON CURATING 'ANATOMY ACTS'

In the land of the living, sister,
The laws of the land obtain –
And the dead know that as well.
The dead will have to forgive me.

'The Burial at Thebes', Sophocles' *Antigone*, trans.
Seamus Heaney, 2004

Gife I can ocht of the craft,
Heir be it sene

(If I know anything of the craft/Here be it seen)

Sum Practysis of Medecyne, Robert Henryson

I very much doubt… whether this be a fit
subject for legislation, or even for public
discussion.

Robert Peel to Jeremy Bentham, 4 April 1826

I

Making an exhibition inspired by anatomy is quite
an operation. It involves taking the various
residues of surgical and medical enquiry (the
models, drawings, prints, photographs, data, tools,
software, and specimens) and resuscitating them
within a new environment. I have often been struck
by what seemed to me an important theme,
namely the rite of burial and its suspension or
deferment – not just of bodily remains but of
these associated images and objects of anatomy
that, through the making of an exhibition, are
disinterred from one context into another. This is
why I begin with Sophocles' *Antigone*, the Greek
tragedy in which the burial of the recently killed
Polyneices is banned by order of Creon, ruler of

Thebes. Creon's reason is that Polyneices took
arms against Thebes, his own city, and it is left to
his sister, Antigone, to argue the prior claim of
natural law – the right to burial – above civic law as
determined by Creon. *Antigone* is a play where
art, ethics, and burial are entwined, hence its
pertinence to an exhibition about anatomy.
However, it is not treason that keeps anatomical
imagery circulating unburied in our culture, but
education. Anatomy Acts looks particularly at how
surgeons and artists have been educated through
art and artefacts, but of course it is also about
how we educate – and hence come to know –
ourselves.

II

Robert Pogue Harrison describes human beings
beautifully as 'a fold, a crypt, a wrinkle of
insideness in the fabric of nature's externality.'
(Harrison 2003: 44). In a contemporary world
where feelings of disarticulation and isolation
seem commonplace, the warm, dynamic
complexity of the human body (this 'wrinkle of
insideness') is becoming increasingly strange to
us. For Harrison, this is no less than a crisis: '…we
find ourselves in a situation where each of us must
choose an allegiance – either to the posthuman,
the virtual and the synthetic, or to the earth, the
real and the dead in their humic densities.' (34)
The findings of Renaissance, Enlightenment, and
Modern pioneers which populate medical books
are exhaustive to the extent that the technical
exercise of describing our own gross anatomy
is a task complete. The tools of perspective,
geometry, and anatomy were employed by artists

and scientists alike in doing this work. Now we research and model the inter-relationship of small parts and the processes that pertain at the cellular and genetic level: what we might call the micro-mysteries of anatomy (so much so that it is difficult to get a research grant in biology for much else). *Anatomy Acts* has been developed in a society in which new mysteries are born as quickly as old mysteries die out. Yet are we in danger of losing our sense of 'humic density' by spending too much time modelling the near invisible? We live in a world in which we visualise cell division more clearly than the site of our future burial.

Unburied and visible human bone, muscle and tissue has extraordinary power for us because they float in this limbo between the rights of the living and the rites of the dead (Richardson: 2000). Likewise, *images* of the anatomised body share by proxy this power and so induce a similar sense of revulsion with regard to our visual and moral faculties. Behind some of the amazing technical visualisations in *Anatomy Acts* we guess there is a tragedy at hand (premature death, exploitation of the dying, paralyzing pain) but we cannot always be certain as to its location. Is it only in the life of the person whose flesh this once was? There is a tendency to take offence at the tragic anatomical image itself, but I have increasingly come to think this is a diversionary technique to avoid dealing with many of the real tragedies at hand, which mainly stem from our culture's hesitancy over death and our complex historical relationship with those who we let look after our bodies.

In the anatomy and pathology museum the basis technique for revealing information about human form is to string it up in whole or in parts, adjusting the body from dead horizontal into faintly animated vertical. In all cases, the sign above the museum door is 'Education', behind which body parts are made to stand in the name of understanding. It is surely of note that education has enough leverage in our culture to keep other rites, in particular burial, at bay. No society wants its subjects to be operated on by unprepared professionals, although it will vent its anger if such knowledge is gained illegally (as burkers and neo-natal surgeons will tell you). Unethical acts tend to prompt new Acts that follow with speed. Amongst the many temporarily sanctioned activities within the complex territory created by a dead or ill body in the period that it enters the orbit of medicine (alongside studying, cutting, and feeling) are the related visual and artistic ones of drawing, photographing, and scanning. Hence quite naturally practitioners within arts and medicine have used the body to train themselves to look more closely, and so link image-making with diagnostics and health. *Anatomy Acts* (a project developed under the shadow of the Human Tissue (Scotland) Bill, the legal successor to The Anatomy Act of 1832) spotlights an unwritten contract in medical culture, whereby the unborn and the dead are compelled to serve the living, and by doing so the living serve the yet-to-be-born.

III

'…only when our breath finally fails to cloud the glass shall we apprehend with absolute

perspicacity… We inhabit a world of impregnable reflections.' (François Aussemain, *Journal*, 1894–99, in Paterson 1997: 57).

Items in *Anatomy Acts* have been generously loaned from diverse collections across the arts and sciences including public galleries, medical research laboratories, university special collections and archives, artists' studios, professional and learned societies, hospitals and teaching departments in medical faculties, and commercial companies. This represents a large and varied institutional landscape where purpose, funding, and intention are sometimes commensurable, sometimes not. (Whilst we might presume that art exhibits and anatomical specimens are distinct kinds of museum object, it is worth noting that anatomical specimens acquired by the likes of William and John Hunter were sold at auction alongside works of art and therefore were part of the same economy of valued assets (Chaplin 2004). *Anatomy Acts* is concerned with the territory of visualising and sensing the body (living and dead) as evidenced in the magnificent material holdings of Scottish collections. The diagrams, drawings, photographs, and scans are the very territory upon which knowledge is built, assumptions made, diagnoses given, self-awareness gained, and art and poetry inspired. The body is the ground out of which art and images grow, images which in turn change the way we view the corporeal body in an ongoing cyclical, ecological system. Think of the way that Vesalius's *De humani corporis fabrica* (1543) and its successors were intended as 'virtual reality' substitutes for dissection itself, interestingly now further inscribed into the virtual through

Edinburgh's *Ars Anatomica* collaboration between the Royal College of Physicians of Edinburgh and the University, through which the Vesalian tradition has been comprehensively digitised [fig. 1].

The structures of museums (whether medical or historical) tend unavoidably to fix their subject into a shape that does not completely reflect the true, often messy, characteristics of that same subject. Inevitably future generations enjoy discovering the gaps, the silences, the problems, and the paradoxes that arise from the creative incompleteness of the museum. Anatomy is as impure as any other subject and can be connected to myriad discourses; its techniques too are mobile and transferable. For example, Leonardo's stunning innovations in drawing anatomy, such as the cross-section, derive from the modes of visualisation he knew from architecture and engineering (Herrlinger 1970: 71). Arbitrary decisions are made in medical illustration at every turn and images of anatomy are approximations rather than fixed descriptions of an absolute internal structure. As Miller and Goode write: 'The possible variations in anatomy alone are almost beyond computing. One anatomical atlas shows diagrams of six different ways in which the major arteries branch out of the aorta, five different variations in one single muscle of the index finger, eight versions of the branching and connections of the facial nerve. All were found in different individuals, and all were normal.' (Miller & Goode 1961: 333). The gaps and silences in the subject create spaces for a creative response to the hidden emotion of the anatomy and pathology museum (see Richardson, 1998: 266-272 and Jamie, 2005: 128-145).

Fig. 1 *Virtual lightbox from the* Ars Anatomica:Imaging the Renaissance Body. *Online image collection. A collaboration between The University of Edinburgh and the Library of the Royal College of Physicians of Edinburgh. © Edinburgh University Library, Special Collections.*

IV

Many people may not recognise important distinctions between a museum display and a temporary exhibition, but I want to explore the idea that we can bring certain methods to bear in the latter that have certain experimental dynamics that differ from the former. Thus visitors can be engaged in new ways. Exhibitions in their increased degree of ephemerality open up spaces that are qualitatively different from the museum, library, and archive. Why not be transparent about some of the curatorial methods and the thinking that has inspired exhibitions and so go some way to countering the impression of opacity in most curatorial work?

If, as Scottish poet Don Paterson asserts, poets do not mediate words, but *employ* them, then perhaps one might say that curators do not mediate art works and objects; they also employ them. Paterson's observation on poets touches well the simultaneous simplicity and complexity of the task of people who present sequences of artefacts (words, objects) that themselves have lives of their own. 'We see the nerve in the bare tree, we hear the applause in the rain. These things are, in other words, *redreamt*, they are *reimagined*, they are *remade*.' (Paterson, 2004). Without wishing to overstate the creativity involved in curatorship, how might *Anatomy Acts* re-dream, re-imagine and re-make the objects of anatomy?

My answer has been to organise the artefacts through the use of *verbs*; in other words to strip out the chronology of Western anatomical enquiry, to place the historical and specialist detail in other, more suitable formats, and to create a set of 'strange stations' around which works from any century orbit in productive disturbance. This way

they might fascinate and re-connect us to our own experience and to each other. Hence the use of gerund titles in the exhibition around which groupings, each with differing scales of intensity, are organised. These are 'Growing & Forming', 'Looking & Listening', 'Feeling', 'Mirroring & Multiplying', and 'Charting'.

'Growing and Forming' pays homage to Scots polymath D'Arcy Wentworth Thompson and acknowledges the visual codes of description that allow us to connect the human body with its 'liqueous, ferric, coral state' (Alphonso Lingis in Grosz 1995: 291). The human form takes its place within nature as a whole, with a particular focus on fetal growth and naturalistic forms. Miniature landscapes open up in this particular 'fantastic voyage', whether within the mossy undergrowth of Leopold & Leisewitz's X-ray images used for the front of this book, or the fungiforms of John Lizars' *Observations on extraction of diseased ovaria* (1825). [fig. 2] As Richardson has noted, we even have generated our own descriptive titles of the nicest specificity. We have, for example, 'nutmeg' and 'sponge' livers, 'horse-shoe' kidneys and 'staghorn' calculi...' (Richardson, 1998: 271). 'Growing and Forming' is yet another place where anatomy conjugates with the rest of the world.

'Looking & Listening' is where visual and auditory cues are primary. The section takes us to many places, including 1950s Glasgow where Ian Donald and his team built upon military sonar technology to create ultrasound images, some early prototypes of which look like cirrus clouds on a winter's day rather than the first glimpses of fetal life *in utero*. The concept of sound too has a fortunate ambiguity to it, as signalling both noise

Fig. 2 *John Lizars, Observations on extraction of diseased ovaria. 1825. Plate 2.*
Courtesy of the Department of Special Collections, University of St Andrews Library.

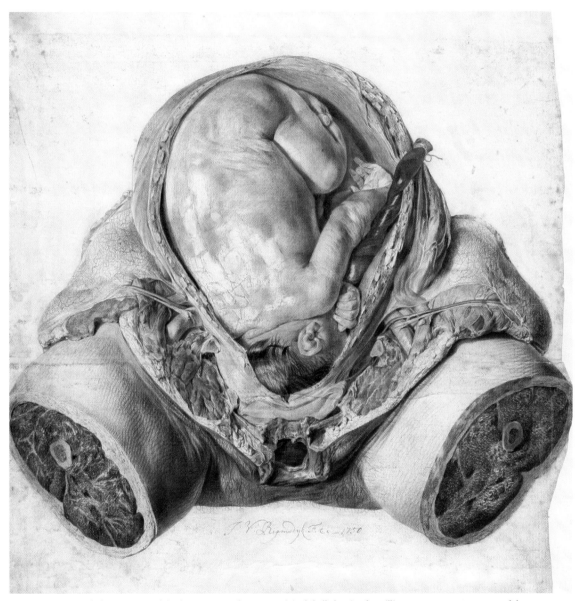

Fig. 3 *Jan van Rymsdyck*, Anatomy of the human gravid uterus. *Original chalk drawing for William Hunter, 1774. Anatomy of the human gravid uterus. London. Tab III. Glasgow University Library, Department of Special Collections.* *

and stability, as in to make a broken bone sound – look to Robert Henryson's 'With sawis thame sound make' 'With salves to make them sound' (Henryson, *Sum Practysis of Medecyne*', in Tasioulas 1999: 257). 'Looking and Listening' also takes us deep into empirical observation, in such places as William Hunter's rooms where light falls from the window on to the silvery uterus as

depicted in Jan van Rymsdyck's magnificent 'gravid uterus' chalk drawings fittingly partnering the Hunters' originality in 'acute observation and manual dexterity' (Richardson, 2000: 39) [fig. 3]; or the notebook of surgeons Thomson & Somerville as they stepped across the battlefield at Waterloo, making their sad inventory [fig. 4]; or, in Aberdeen University's Anatomy Museum, where we find

Fig. 4 *Dr. John Thomson and Dr. William [?] Somerville,* Sketches of the wounded at the Battle of Waterloo. *1815. p.21. © Edinburgh University Library, Special Collections.*

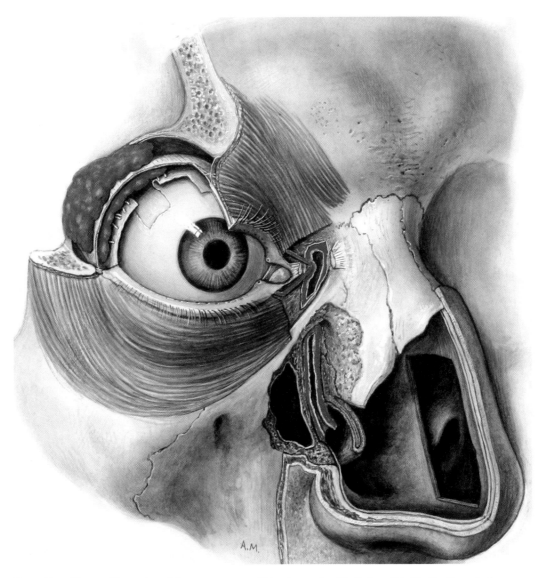

Fig. 5 *Alberto Morrocco, Illustration of the eye. 1940s-1950s. Watercolour, produced for Professor Robert Lockhart's 1959 book,* Anatomy of the Human Body. *Courtesy of the University of Aberdeen.* *

Alberto Morrocco and colleagues' delicate illustrations to Robert Douglas Lockhart's 1959 *Anatomy of the Human Body* works entirely unknown to the Scottish art world, where Morrocco made his name [fig. 5].

'Feeling' is a deliberately ambiguous term. It reminds us that at its most stark '…the business of a surgeon is deliberately to wound and sometimes to mutilate their fellow human beings' (Drife 1998: 110), albeit towards a common good. Behind this wounding and mutilation, or what William Hunter called a 'necessary Inhumanity' (Richardson, 2000: 31) lies a tenderness, intimacy and subtlety that is often communicated by artists in their imagery. This tenderness struck me when I caught the glance of a student who looks directly out of the frontispiece painting from the *Anatomical Tables of John Banister* (c. 1580). Whilst catching our eye, his left hand simultaneously touches the face of the cadaver spread before Banister and his students. [fig. 6] This minute moment between (living) little finger and (dead) chin provides, for me at least, the synaptic spark for the work. In the same manner, one can turn to Bourgery's *The Complete Anatomy of Man* (1840) for a supreme image of feeling – two pairs of surgeons' hands move, hold and cut into two clubbed feet. [fig. 7] The surgical instruments are so incidental that the general impression is not of an operation but of a dance between human extremities.

The recurrent 'Mirroring & Multiplying' of images and specimens struck me in every collection. This section includes the tender oil painting by Macdairmid of conjoined twins seen from back and front [fig. 8] as well as Charles Bell's sequences of pathological specimens, paintings and published prints that represent a single injury multiplied through media. [figs. 9a, 9b] Various other forms of double vision abound, such as that represented by stereoscopic atlases – those strange machines that collaborate with our own seeing brain in order to create three dimensions from two, as well as the imaginary doubling of the totem or talisman, such as the a baby's caul, framed like a vellum artwork and splayed open like bat-wings, which traditionally is a lucky charm for sailors traversing the ocean [fig. 10].

'Charting' recognises the fact that anatomists from all eras, including our own, have made images that plot and map the very process of 'coming to know ourselves' from the gross level to the microscopic. Just as Leonardo employed conventions from architecture and engineering, so the art of the cartographer has been in dialogue with the medical illustrator to create new-found lands from our own interior. Such spaces have been well described by Elizabeth Grosz as 'sites of uneven intensity, patterns and configurations of feeling, labyrinthine maps of voluptuous pleasures and fluxes.' (Grosz 1995: 288). Consequently the use of cartographic and mapping devices (indication lines, colour, sequencing, sections and detailing) has been imported into anatomical illustration. The papier-mâché surface of Auzoux's full-size man from Aberdeen University is encrusted with veins and arteries that disappear into subcutaneous depths. [fig. 11]

V

Anatomy Acts attempts to tell an expansive story about anatomy and art that draws on specialist knowledge and the sensory quality of exhibitions. It builds up an intuitive poetics around anatomy by setting up unusual combinations and evanescent

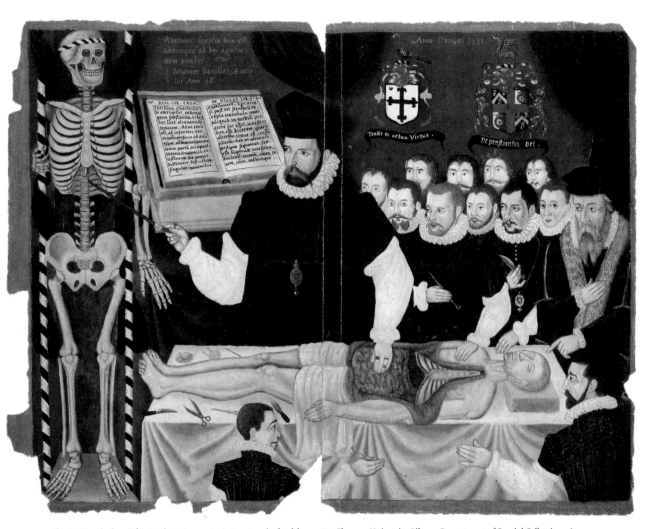

Fig. 6 *Frontispiece, John Banister (1540-1610), Anatomical tables. 1580. Glasgow University Library, Department of Special Collections.* *

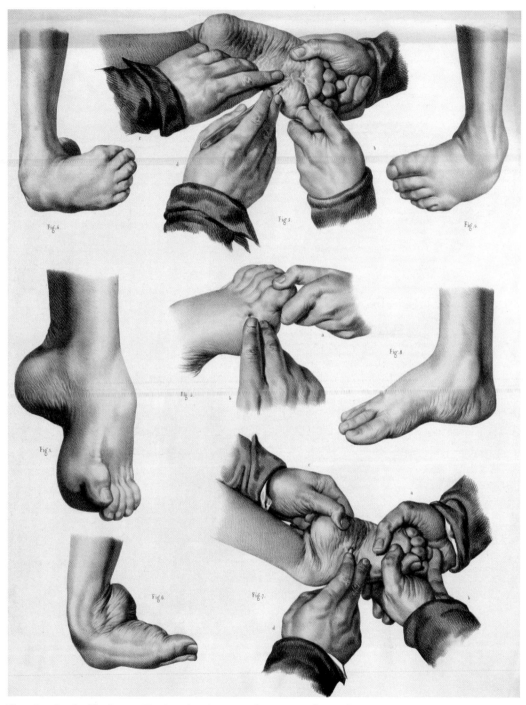

Fig. 7 Jean-Baptiste Marc Bourgery The Complete Anatomy of Man. 1840. Volume 7, plate 1.
Courtesy of The Royal College of Surgeons of Edinburgh. *

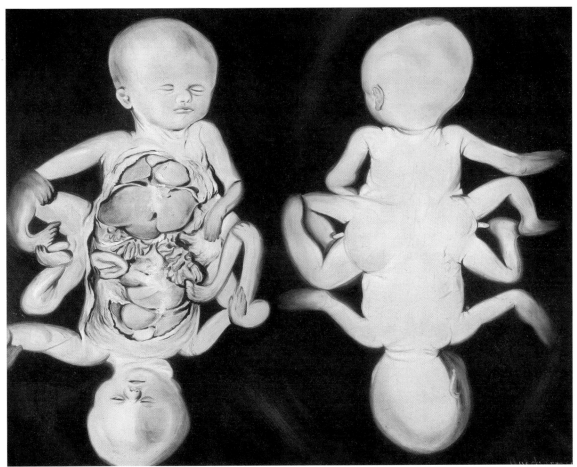

Fig. 8 *Macdairmid*. Painting of conjoined twins. Date unknown. *Courtesy of the Royal College of Surgeons of Edinburgh.* *

connections – half-rhymes, one might say. Visitors should be given time for deep and sustained observation at close quarters and so be taken by surprise. I have used three exemplars in particular to support this strategy of serendipity and chance; the poet, André Breton, the film-maker, Andrey Tarkovksy, and the visual artist, Tacita Dean.

Firstly, Tacita Dean's *An Aside* (2005) was an artist-curated exhibition that purposely emerged from her 'meandering, ill-informed thought process where the minutest of incidents can, and have, instructed major decisions.' (Dean 2005: 4). Curating at its best can be a very particular form of bundling together and connecting that is a specialist strategy all of its own and Dean's exhibition showed that

working with our silences, our intuitions and our knowledge gaps in relation to our humours and temperaments (as Hippocrates and Galen might have put it) is not an easy thing to do. As a response to previous and important exhibitions on art and anatomy (for example Petherbridge, Kemp & Wallace, and Kornell) where established subject specialists took their knowledge of anatomy into the performative space of art galleries, my method was to use the medical collections of Scotland to explore the associative, intuitive, meandering world of anatomy and its images and to maintain a position that may not have been strictly ill-informed, but was certainly generalist (in true Scots' fashion). Dean's sensitivity to speaking the

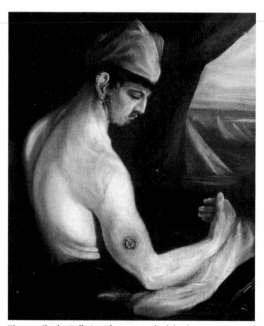

Fig. 9a *Charles Bell, Gunshot wound of the humerus. 1809. Courtesy of the Royal College of Surgeons of Edinburgh.* *

Fig. 9b *Charles Bell, A System of Operative Surgery, vol 2, 1814, plate 4. fig. 1. Courtesy of the Royal College of Surgeons of Edinburgh.* *

~ A Baby's Caul ~

Membranes from the head of a female child
born at Colchester, Essex, 19th April 1888, and
much prized by the mother on account of their
supposed supernatural virtues.

Fig. 10 *Baby's caul. 1888. Courtesy of the Royal College of Surgeons of Edinburgh.* *

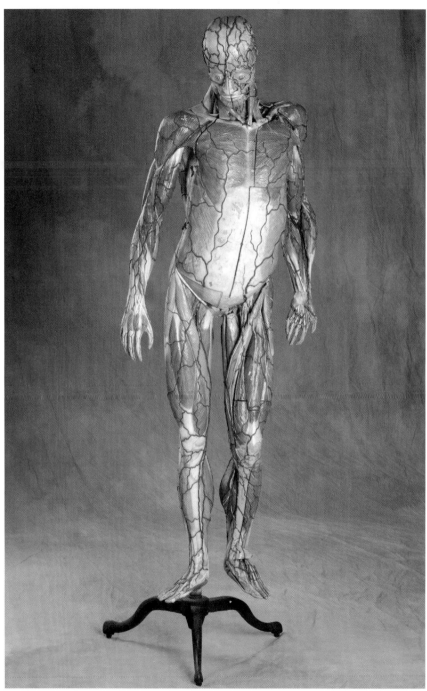

Fig. 11 *Louis Thomas Jérôme Auzoux. Life-size model of a man. France, c.1880s, papier-mâché. Photo by John. Courtesy of the University of Aberdeen.* *

unspoken and combining the separate is a strategy also shared with the commissioned artists on this project – Christine Borland, Joel Fisher, Claude Heath and Kathleen Jamie. What they produce has an absolute bearing on the topic of anatomy in our culture, but not perhaps in the form that we might expect it (see Barnes essay).

Tacita Dean's inspiration for *An Aside* was André Breton, the chief poet and spokesman for the Surrealist movement, who claimed the importance of 'objective chance' in the making of art. The artist seeks to free him/herself from history and circumstance to the maximum extent possible (Breton 1972: 225-278). Breton draws our attention 'to certain disturbing facts, to certain overwhelming coincidences…the problem of objective chance, or in other words that sort of chance that shows man, in a way that is still very mysterious, a necessity that escapes him, even though he experiences it as a vital necessity. This still almost unexplored region of objective chance at this juncture is, I believe, the region in which it is most worth our while to carry on our research.' (Breton: 268). The objects in *Anatomy Acts*, sitting in their strange stations, become focal points for speculation and revelation for the visitor as much as for the person who made them or the person who selected them for exhibition. As Andrey Tarkovsky, who I come to now, once wrote: 'the artist obliges the audience… to think on, further than has been stated.' (Tarkovsky 1986: 21)

Exhibitions are not only (or not at all) static propositions comprising of bounded objects, however much they connect through the layered and embodied experience of walking through a gallery (as discussed by Bruce Ferguson (1996) among others). Exhibitions are made to be *moved through*. They are multi-medial (i.e., employ different media) and also *hyper*-medial (i.e., visitors have freedom of movement and so lay down their visual and cognitive experience in unique fashion). Exhibitions are filmic and dynamic experiences, whether or not they use moving imagery as a constitutive part. A need for precision and poetry within a psychologically mobile setting brought me to Andrey Tarkovsky, whose book *Sculpting in Time. Reflections on the Cinema* (1986) is a deep reflection on his considerable activity within the film medium. He seems to share Breton and Dean's concern with the creative and generative power of making connections, in his case via what he calls 'poetic logic'. He asserts: '…film material can be joined together in another way, which works above all to lay open the logic of a person's thought… In my view poetic reasoning is closer to the laws by which thought develops, and thus to life itself, than is the logic of traditional drama.' (Tarkovsky 1986: 20). Tarkovsky sought to 'lay open', as he says, psychological processes in the name of a higher kind of realism than we are used to expecting; where better to follow this expanded kind of laying open than in the anatomy class?

Tarkovsky's approach is even more meaningful and urgent because he insists on always bringing his concerns back to the audience experience; to state it more strongly, he is concerned to hand serious responsibility to his audience in the generation of meaning. 'Through poetic connections feeling is heightened and the spectator is made more active. He becomes a participant in the process of discovering life, unsupported by ready-made deductions from the plot or ineluctable pointers by the author… What

Fig. 12 Curatorial layouts and images for Anatomy Acts, exhibition, 2005-6. Courtesy of the author. *

can it mean to [the audience] when they have not shared with the author the misery and joy of bringing an image into being?' (Tarkovsky 1986: 20). There are important implications here for the viewer if we truly want to move from a platform, however great, for passing on information of a largely technical or historical nature to one of offering viewers new ways of confronting some of the most powerful images ever produced and making sense of them. It is not particularly important whether the images, models and instruments are thought of as art; it is important that *Anatomy Acts* constructs a physical and mental place for us to react to them in our own way. As Tarkovsky claimed: '...the indisputably functional role of art lies in the idea of *knowing*, where the effect is expressed as shock, as catharsis.' (Tarkovsky 1986: 36). One cannot come to know oneself (viz. the subtitle of *Anatomy Acts*) without a little shock to the system. [fig. 12]

VI

Vesalius presciently argued, in Book 7 of *Fabrica*, for harmony between our brain and our sense organs. Indeed *Anatomy Acts* coincides with a wave of renewed interest in the sensory as it informs human awareness and knowledge echoed in many of the essays contained here, as well as recent publications such as David Howes' *Empire of the Senses* (2005). In Howes' edited book we find proof of what doctors and surgeons have known for a long time – that we experience the world, and the ill patient within that world, using sensory cues simultaneously embedded in many of the senses. As John Donne describes humans as

'a subtle knot', so Michel Serres, paraphrased in the words of Steven Connor, asserts: 'that each sense is in fact a nodal cluster, a clump, confection or bouquet of all the other senses, a mingling of the modalities of mingling.' (Connor 2005: 323). Furthermore, 'Open like a star, or quasi-closed, like a knot to all directions, mobile in every dimension and scanning everywhere, sensibility gives itself, indefatigably, to this dancing excursion, a functional intersection until the very hour of its death.' (Serres 1998: 404-5). In this context it is striking and sobering to note Andrey Tarkovsky's assertion that 'The aim of art is to prepare a person for death.' (Tarkovsky 1986: 43).

Is it too much to say that the art in *Anatomy Acts* helps to prepare us for death? These bodies, that have either been suspended from burial or through imagery give the appearance of lying unburied, offer us incredible information on how we might come to know ourselves. Everyone will put that information together in a unique way. What the many artists from across the ages are suggesting to us in *Anatomy Acts* is that whilst the work of the anatomist has given us enormous bodily knowledge, it can be used poorly or be used creatively. The strategies used in making this exhibition try to support the latter by lighting the subject of anatomy from two angles, so to speak – the orthodox one for the straight-ahead view and the tangential one which offers perhaps a truer likeness.

REFERENCES AND FURTHER READING

Breton, A. 1935. 'Surrealist Situation of the Object. Situation of the Surrealist Object', in Breton, A. 1972/1969. *Manifestos of Surrealism*. Arbor: Michigan University Press.

Cazort, M., Roberts, K. B., Kornell, M. (1996), *The Ingenious Machine of Nature: Four Centuries of Art and Anatomy*, Ottawa: National Gallery of Canada.

Chaplin, S. 2004. 'Distilled Lives: John Hunter and the art of anatomy', unpublished conference paper, 'George Stubbs and the Hunter Brothers' Study Day. Hunterian Art Gallery, Glasgow, 1 October 2004.

Connor, S. 2005. 'Michel Serres' Five Senses', in Howes, D. (2005), *Empire of the Senses. The Sensual Cultural Reader*. Oxford: Berg.

Dean, T. 2005. *An Aside*. London: National Touring Exhibitions/Hayward Gallery.

Drife, J. O. 1998. 'Narrative in surgery', in Greenhalgh, T. and Hurwitz, B. (eds.), *Narrative-Based Medicine. Dialogue and discourse in clinical practice*. London: BMJ Books.

Ferguson, B. W. 1996. 'Exhibition Rhetorics: material speech and utter', in Nairne, S., Greenberg, R., Ferguson, B. (Eds), *Thinking about Exhibitions*. London: Routledge.

Grosz, E. 1995. 'Animal Sex' in Grosz, E. & Probyn, E. *Sexy Bodies. The Strange Carnalities of Feminism*. London: Routledge.

Harrison, R. P. 2003. *The Dominion of the Dead*. Chicago: University of Chicago Press.

Heaney, S. 2004. The Burial at Thebes. Sophocles' *Antigone*. London: Faber & Faber.

Herrlinger, R. 1970. *The History of Medical Illustration*. London: Pitman Medical.

Howes, D. 2005. *Empire of the Senses. The Sensual Cultural Reader*. Oxford: Berg.

Jamie, K. 2005. *Findings*. London: Sort of Books.

Kemp, M. and Wallace, M. 2000. *Spectacular Bodies. The Art and Science of the Human Body from Leonardo to Now*. London: Hayward Gallery/Berkeley: University of California Press.

Miller, B. F. and Goode, R. 1961. *Man and his Body. The Wonders of the Human Mechanism*. London: Gollancz.

Paterson, D. 1997. *God's Gift to Women*. London: Faber & Faber.

Paterson, D. 2004. 'The Dark Art of Poetry' T.S. Eliot Poetry Prize Lecture. London (full transcript at http://www.poetrylibrary.org.uk/news/poetryscene/?id=20)

Petherbridge, D. 1997. *The Quick and the Dead. Artists and Anatomy*. London: National Touring Exhibitions/Hayward Gallery

Richardson, R. 1998. 'Organ Music', in Greenhalgh. T. and Hurwitz, B. (eds.) *Narrative-Based Medicine. Dialogue and discourse in clinical practice*. London: BMJ Books.

Richardson, R. 2000/1987. *Death, Dissection and the Destitute*. Chicago: University of Chicago Press.

Rinpoche, S. 2002. *The Tibetan Book of Living and Dying*. London: Rider/Random House.

Serres, M. 1998. *The Five Senses*. Paris: Hachette.

Tarkovsky, A. 1986. *Sculpting in Time. Reflections on the Cinema*, trans. Kitty Hunter-Blair. Austin: University of Texas Press.

Tasioulas, J. A. (ed.) 1999. *The Makars. The Poems of Henryson, Dunbar and Douglas*. Edinburgh: Canongate.

CATALOGUE OF WORKS

Catalogue of Works

Note: measurements are in centimetres, height x width x depth unless otherwise stated.

Anon.
Roman sculpture of pagan votive offerings (breast and penis, 2nd century BC to 1st century AD
stone; 5.8 x 4.7; breast 10.5 x 9
ABDUA61677; Alexander Thomson Collection
Courtesy of the University of Aberdeen

Anon.
Mexican sculpture of skull, 1450
stone; 22.1 x 13.4 x 19
ABDUA63463; Dr. John MacPherson collection
Courtesy of the University of Aberdeen

Anon.
Carving of distorted human skeleton, Tibet
bovine femur (possiblly Yak);
1.2 x 10 x 3.3
46/292
University of Edinburgh, Anatomy Collection *

Femoral Trumpets and Calvarial Drums, Tibet
human bone;
femur 34 x 7.5 x 5.5,
femur 35.5 x 7 x 5.5,
femur 32 x 6.8 x 7,
skull cap 15.5 x 10.5 x 7.6,
skull cap 20 x 15 x 9.5
University of Edinburgh, Anatomy Collection *

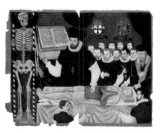

Anon.
Anatomical Lesson. John Banister lecturing on anatomy. Frontispiece, *John Banister: Anatomical tables,* c.1580
oil on paper; 40.5 x 56
Ms Hunter 364 (V.1.1)
Glasgow University Library, Special Collections *

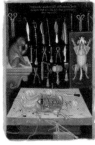

Anon.
Anatomical Instruments with ape and dog from *John Banister: Anatomical Tables.* Table 1 & 2, c.1580
oil on paper; 40.5 x 56
Ms Hunter 364 (V.1.1)
Glasgow University Library, Special Collections *

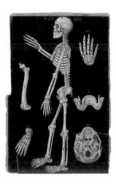

Anon.
Skeleton with limb articulations from *John Banister: Anatomical tables.* Table 3 & 4, c.1580
oil on paper; 40.5 x 56
Ms Hunter 364 (V.1.1)
Glasgow University Library,
Special Collections *

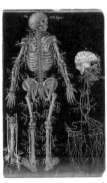

Anon.
Skeleton, brain, nerves from *John Banister: Anatomical tables.* Table 5 & 6, c.1580
oil on paper; 40.5 x 56
Ms Hunter 364 (V.1.1)
Glasgow University Library,
Special Collections *

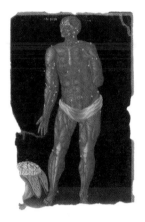

Anon.
Man, eye, cut-outs from *John Banister: Anatomical tables.* Table 11 & 12, c.1580
oil on paper; 40.5 x 56
Ms Hunter 364 (V.1.1)
Glasgow University Library,
Special Collections *

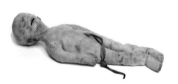

Anon.
Obstetric doll, 18th century
leather; 46.5 x 16 x 7
Royal College of Physicians of Edinburgh *

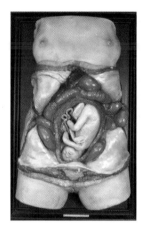

Anon.
Life-sized plaster cast of a dissection of the uterus about the sixth month of pregnancy, for William Hunter, 1751
plaster, paint; 80.5 x 48 x 51
48.13
University of Glasgow, Anatomy Museum

Anon.
Forceps of a design by William Smellie, c. 1750s
leather-covered iron; blades
27 x 6 x 2
HC 1 30 2
Courtesy of the Royal College of Surgeons of Edinburgh *

190

Anon.
*French officer's skin from
the Battle of Breda*, 1793
skin, human specimen;
frame 93 x 32
LGN
Courtesy of the Royal College
of Surgeons of Edinburgh *

Anon.
*Model of the eye showing
the cornea and lens*,
late 18th century
brass, glass, enamel diameter
23.5 x 11
ANDBP200026a;
Copland Collection
Courtesy of the University of
Aberdeen *

Anon.
*Tashrih-i Mansuri: The Anatomy
of Mansur of Shiraz*, undated,
(probably early 19th century
copy of c.1400 treatise)
hand-coloured manuscript;
30.7 x 18
OR.MS416
University of Edinburgh Library,
Special Collections

Anon.
Standard head, central
India,19th century
brass; length 46 x 24 x 3.2
diameter base
A.1944.651
Middle East/South Asia
Collection, National Museums of
Scotland

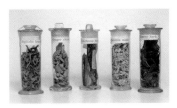

Anon.
*Herbal Medicine Jars
(Materia Medica specimens)*,
date unknown
glass containers, plants;
17 x 7 x 7
DUNUC 4082-4108
University of Dundee Museum
Services, Tayside Medical History
Museum *

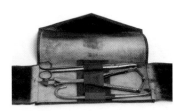

Anon.
*Leather case containing
obstetric instruments*,
early 19th century
leather case, steel instruments;
case 3 x 34 x 16
DUNUC 8094
University of Dundee Museum
Services, Tayside Medical History
Museum *

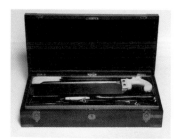

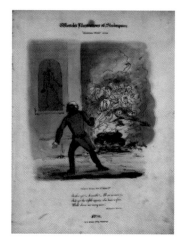

Anon.
Presentation Box and Set of Amputation Instruments presented to Dr. McCrae by students of the class of John Lizars 1826-1827, 1827
ivory handled instruments, velvet lined wooden box; box 32 x 52.2 x 25
HC 1.12.19
Courtesy of the Royal College of Surgeons of Edinburgh *

Anon.,
lithographer R. H. Nimmo, c. 1829
Wretch's Illustrations of Shakespeare: dedicated without permission, no.1 & 2 of second series
hand coloured lithograph on paper, 36.4 x 26.8
SP VI 166.8
Scottish National Portrait Gallery

Anon.,
lithographer R. H. Nimmo, c. 1829
Wretch's Illustrations of Shakespeare, plate 6
hand coloured lithograph on paper, 36.4 x 26.8
SP VI 166.12
Scottish National Portrait Gallery

Anon.,
lithographer R. H. Nimmo, c. 1829
Noxiana: The Lecturer all armed
hand coloured lithograph on paper; 36.4 x 26.8
Pl1/1 SP VI 166.2
Scottish National Portrait Gallery

Anon.
The Great Deliverer of Scotland), 1838
ink, watercolour; 30.2 x 24.2
Royal College of Physicians of Edinburgh *

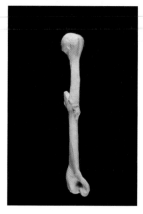

Anon.
Cast of the humerus of David Livingstone, (d.1874)
plaster, wood and glass box; box 7.7 x 38.7 x 9.5
Royal College of Physicians and Surgeons of Glasgow

Anon., signed AGS
Dissection Extraordinary,
1884/1885
ink on paper; 31 x 47
MS 3083; Trail Collection
Courtesy of the University of
Aberdeen

Baby's Caul, 1888
specimen; framed mount
22.6 x 53.5
Courtesy of the Royal College of
Surgeons of Edinburgh

Framed Tattoos, c.1890s
specimens, wooden frame; 29 x
45
DUNUC 3799
University of Dundee Museum
Services, Anatomy Collection *

Anon.
Experimental X-ray tube, used
by George Alexander Piri
(1863-1929), c.1897
glass, metal, wood; 12 x 29 x 10
DUNUC 4331
University of Dundee Museum
Services, Tayside Medical
History Museum

Anon.
Operating table used by
William Macewen,19th century
wood, metal wheels;
92 x 197 x 52.5
Royal College of Physicians and
Surgeons of Glasgow

Anon.
*Embryology model including
trachyus*, late 19th century
wax; metal; wood 25 x 18 x 8
ABDAN2050;
Struthers Collection
Courtesy of the University
of Aberdeen *

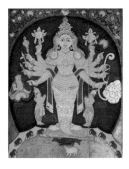

Anon.
South Asian miniature of Vishnu,
late 19th century
paper mounted on card,
silvered and gilt; 44 x 32.7
A.1960.326
Middle East/South Asia
Collection, National Museums
of Scotland

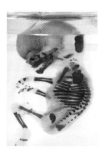

*Fetus, injected with alizarin dye
and cleared in glycerine*
human specimen;
Accession C1/Ca4/14
University of Glasgow, Anatomy
Museum

Anon.
*Perfecscope Stereoscopic
viewer*, c.1895
wood, metal; 19 x 31 x 19
Royal College of Physicians of
Edinburgh *

Anon.
Dr. Macintyre's X-ray Film c.1896-
1909
black and white film; 35 mm
0520
Courtesy of Scottish Screen
Archive

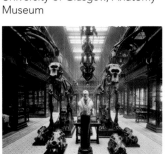

Anon.
Teviot Place Anatomy Museum
photograph;
University of Edinburgh,
Anatomy Collection

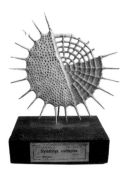

Anon.
Model of Stylodicta Multispina,
c.1890s
plaster, wire and wood;
20 x 15 approx.
DUNUC 3660
University of Dundee Museum
Services, Zoology Museum
Collection

Anon.
Tumours, photographs
belonging to Neil Stewart and
William Tennant Gairdner's
Pathology Drawings collection
c. 1900
photographs; 21.5 x 20.3;
19.3 x 12.8; 19.3 x 12.8; 18.8 x 13
DUNUC MS16/7/23
University of Dundee Archive
Services

Anon.
Male Dermatome Model,
20th century
papier-mâché, paint;
52 x 72 x 18
University of Edinburgh,
Anatomy Collection *

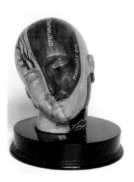

Anon.
Model of head
wood, paint;
18.5 x 20 x 20
University of Edinburgh,
Anatomy Collection *

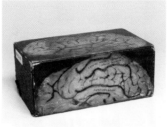

Anon.
Model of the brain,
mid 20th century
paper over wood;
7 x 17 x 10
ABDAN2028
Courtesy of the University
of Aberdeen *

Anon.
Midwifery Forceps,
20th century
steel; 5 x 35 x 10
DUNUC 4469
University of Dundee Museum
Services, Tayside Medical History
Museum *

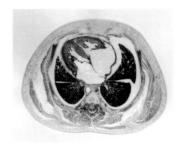

*Serial transverse section of the
thorax of a full term fetus,*
c.1940-50s
human specimen on paper,
Gough/Wentworth technique;
12 x 29
Museum Collections,
University of St Andrews *

Anon.
Anatomical study, 1974
photograph;
25/4/1/20
University of Dundee Archive
Services, Perth College of
Nursing and Midwifery *

Anon.
MRI mouse box, coils and MRI scan, 1974
NMS.T.2006.13
National Museums of Scotland, Science and Technology Collection

Ars Anatomica, 2006
website
Courtesy of University of Edinburgh and the Royal College of Physicians of Edinburgh

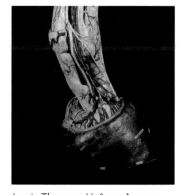

Louis Thomas Jérôme Auzoux
Articulated model of horse hoof, c1880
papier-mâché; 30 x 15.5 x 15.5
RN26,979; Struthers Collection
Courtesy of the University of Aberdeen

Aikman
Silenus and the Infant Bacchus, 1894
stump drawing; 69 x 48
Royal Scottish Academy

Louis Thomas Jérôme Auzoux
(1797-1880)
Anatomical model of a snail, 1840s
papier-mâché; 36 x 70 x 35
RN50,066; Struthers Collection
Courtesy of the University of Aberdeen *

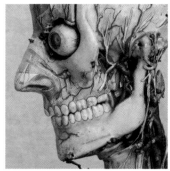

Louis Thomas Jérôme Auzoux
Full size articulated model of a man, c.1880s
papier-mâché;
case 2100 x 77 x 65
ABDAN204; Struthers Collection
Courtesy of the University of Aberdeen.
Photo by John McIntosh

Charles Bell
*Gunshot fracture. Bone.
Humerus. distal left*, c.1809
bone, human specimen, perspex
box; box 27 x 10.5 x 9.5
GC 1.38.30-1, Bell Collection
Courtesy of the Royal College of
Surgeons of Edinburgh

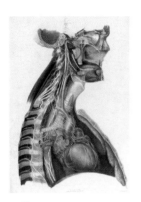

William Bagg
loose leaf folio, *Drawn from
nature*, plate 6. Published
by Taylor & Walton,
London. c.1840s
lithograph; 31.4 x 53
RCSEd Library RR E7
Courtesy of The Royal College
of Surgeons of Edinburgh *

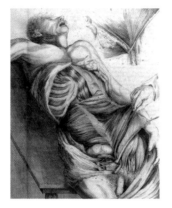

Charles Bell
*A system of dissections
explaining the anatomy
of the human body*,
Edinburgh 1798-1803
book; 48 x 34
RCSEd Library RR E7
Courtesy of the Royal College
of Surgeons of Edinburgh *

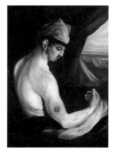

Charles Bell (1774-1842)
*Gunshot wound of the
humerus*, c.1809
oil on canvas; 50 x 45
GC 1.38.30
Courtesy of the Royal College
of Surgeons of Edinburgh *

G. Barbour-Simpson
and E. Burnet (eds)
*Edinburgh Stereoscopic Atlas
of Obstetrics* London, Caxton
Publishing Company, 1908
albumen paper prints;
cards 24 x 19
Royal College of Physicians
of Edinburgh *

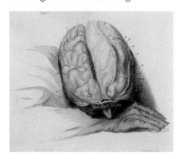

Charles Bell
The Anatomy of the Brain,
London, 1802
book; 30 x 25
RCSEd Library BS K14
Courtesy of the Royal College
of Surgeons of Edinburgh *

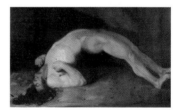

Charles Bell
Tetanus. Gunshot wounds,
c.1809
oil on canvas; 116.5 x 96
GC 1.38.42
Courtesy of the Royal College
of Surgeons of Edinburgh *

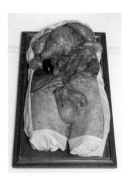

Charles Bell
Torso, small intestine,
early 19th century
wax, plaster,wood mount;
17 x 38 x 68.5
GC 1.43.04
Courtesy of the Royal College
of Surgeons of Edinburgh *

Charles Bell
*A system of operative surgery,
founded on the basis of
anatomy,* vol. 2, 2nd edition,
London, 1814
book; 22 x 14
RCSEd Library BS K14
Courtesy of the Royal College
of Surgeons of Edinburgh *

Charles Bell
*Illustrations of the great
operations of surgery,*
London,1821
book; 28.5 x 39
RCSEd Library RR E8
Courtesy of the Royal College
of Surgeons of Edinburgh *

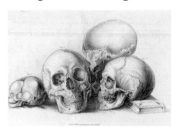

Charles Bell
*The Anatomy and Philosophy
of Expression as Connected
with the Fine Arts,* London 1865,
fifth ed. First edition 1806
book; 25 x 18
RCSEd Library BS K14
Courtesy of the Royal College
of Surgeons of Edinburgh *

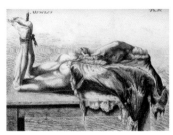

John Bell
*Engravings explaining the
anatomy of the Bones, Muscles
and Joints,* Edinburgh, 1794
book; 27.5 x 22
RCSEd Library RR T8
Courtesy of the Royal College
of Surgeons of Edinburgh *

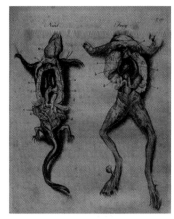

John Bell and Charles Bell
*The Anatomy of the Human
Body,* vol.2, Edinburgh,1797
book; 24 x 15
s QM21.B3D97
Special Collections,
University of St Andrews

John Bell and Charles Bell
*The Anatomy of the Human
Body*, vol.2, 2nd ed. (first edition
1797), London, 1802,
book; 24 x 15
RCSEd Library BS A21
Courtesy of the Royal College
of Surgeons of Edinburgh

Berengarius (Berengario da
Carpi) (c.1460-1530)
*Commentaria cum amplissimis
additionibus super Anatomia
Mundini,*
Bologna, 1521
book; 21.4 x 15.7
SM4.21
Royal College of Physicians
of Edinburgh *

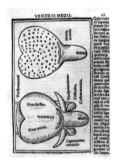

Berengarius
(Berengario da Carpi)
*Isagoge breves perlucide ac
uberime in anatomiam humani
corporis*, Venice, 1535
book; 20.7 x 15.7
SM 3.26
Royal College of Physicians
of Edinburgh *

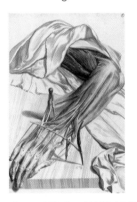

Govard Bidloo (1649-1713)
Anatomia humani corporis,
Amsterdam, 1685
book; 53.5 x 38.5
Ce.1.11
Glasgow University Library,
Special Collections *

Bock Lips Steger, Leipzig
Structural model of the eye,
late 19th century
plaster; glass 10 x 10 x 8
ABDUM M.J.133
Courtesy of the University
of Aberdeen *

Christine Borland (1965 -)
*Black, White and
Shades of Grey*, 2006
sapling on supports,
photographs
special commission for
Anatomy Acts
Courtesy of Lisson Gallery,
London

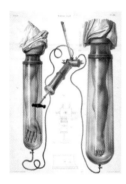

Jean Baptiste Marc Bourgery
(1797-1849)
Loose leaf folio for *Traite
complet de l'antomie de
l'homme*, vols. 6 & 7,
Paris 1832-40,
loose leaf folio; 42.5 x 31
RCSEd Library RR B8
Courtesy of The Royal College
of Surgeons of Edinburgh *

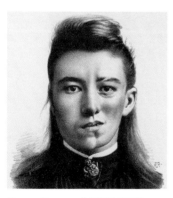

Byrom Bramwell (1847-1931)
Facial Hemiatrophy from *Atlas of
Clinical Medicine*, 1892, p. XI
book; 38.5 x 30
Royal Scottish Academy *

Thomas G. Brown (1933 -)
and Ian Donald (1910-87)
*Ovarian cyst. Abdominal
swelling 30/52 size. Looking
through the cyst*, 1956
ultrasound A-scan trace,
copy print;
Courtesy of the British Medical
Ultrasound Society

Thomas G. Brown and Ian
Donald (1918-87)
*First ultrasound B-scan image,
2D cross-section of abdomen*,
1957
copy print;
British Medical Ultrasound
Society

J. Brunner
Pocket microscope, Paris 1846
tortoiseshell,brass; approx.
17 x 5.5 x 5.5
1980.L9.13
University of Edinburgh

Harold Garnett Callan
(1917-1993)
DNA images, 1980s
photographs; 29 x 21
msms38367 F/3/32/25, 26, 27, 29
Special Collections, University
of St Andrews *

Guido de Cauliaco
(c. 1298 -1368)
Cyrurgia Parua Guidonis, with
*Abulcasis: Chirurgia cum formis
instrumentorum (trans. Gerardus
Cremonensis). Jesus filius Hali:
De oculis (trans. Dominicus
Marrochinus). Canamusali de
Baldach: De oculis*, Venice, 1500
book; 31 x 21.5
Typ IV.B00LG
Special Collections,
University of St Andrews

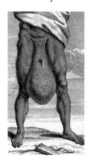

William Cheselden
*The Anatomy of the Human
Body* 1722, 2nd ed.
book; 21.5 x 13
RCSEd Library RR F22
Courtesy of the Royal College
of Surgeons of Edinburgh *

Jules Cloquet (1790-1883)
Anatomie de l'Homme, vols. 2
(1822), 3 (1828) & 5 (1831), Paris
book; 53.8 x 36.7
RCSEd Library RR E8
Courtesy of The Royal College
of Surgeons of Edinburgh *

Charles Connachie
Female right foot, March 1922
from *Anatomical Variations, The
Aberdeen Anatomical and
Anthropological Society,
drawings by medical students*
ink and paint on paper, 27 x 21
MSU 1438/3/1-2; Aberdeen
Anatomical and Anthropological
Society Collection
Courtesy of the University
of Aberdeen

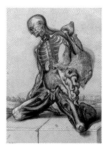

Pietro da Cortona (1596-1669)
Anatomical drawing, c.1618
black chalk washed with blue
and grey ink, highlighted with
white paint, paper; 53 x 35.5
Dl.1.29
Glasgow University Library,
Special Collections *

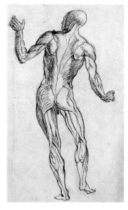

William Cowper (1666-1709)
Écorché, rear view,
early 18th century
ink, red chalk on paper;
27 x 16.2
Box 3/1 Dl. 131
Glasgow University Library,
Special Collections *

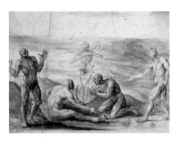

William Cowper
Four écorché depicted as a demon, two playing dice and a skeleton early 18th century
pencil and ink wash; 15 x 20.5
DI.1.31
Glasgow University Library,
Special Collections *

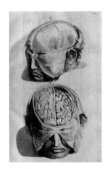

William Cowper
The Anatomy of Humane Bodies, 2nd ed., Leiden,1737
book; 52 x 38
sff QM25.C6D37 (SR)
Special Collections,
University of St Andrews *

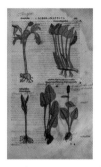

Pedanius Dioscorides
(c.40- c.90 A.D.)
De Medicinali Materia,
Frankfurt,1549
book; 31.5 x 20.5
Sim R126.D5B49
Special Collections,
University of St Andrews

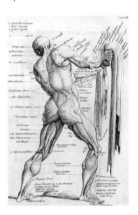

William Cowper
Myotomia reformata: or an anatomical treatise on the muscles of the human body,
London, 1724
book; 48 x 35.5
Ay.2.3
Glasgow University Library,
Special Collections *

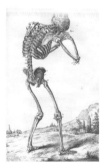

Denis Diderot (1713-84) and
Jean D'Alembert (1717-83)
Encyclopédie, ou, Dictionaire raisonné des sciences, des arts et des métiers, par une société de gens de letters,
Paris: 1751-80
book; 40 x 26.5
SB f 034 Did
Courtesy of the University
of Aberdeen *

A. Don (artist), Professor R.W.
Reid (anatomist, 1851-1931)
Watercolour of Dissected specimen, 1892
watercolour on paper;
45 x 30
Reid Collection
Courtesy of the University
of Aberdeen

Ian Donald
Ultrasound scans, 1960s
copy prints of Polaroid
photographs; 9.5 x 12.7,
9.7 x 12.7, 9.7 x 12.7
Courtesy of the British Medical
Ultrasound Society

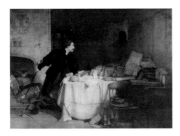

Sir William Fettes Douglas FRSA
(1822-1891)
*The Summons to the Secret
Tribunal,*1860
oil on canvas; 142 x 180
1/46a
Courtesy of Perth Museum
& Art Gallery, Perth & Kinross
Council

Drummond, Young and Watson
*The Vestibule of the Royal
Institution, Edinburgh*,
c.1907-1910
photograph, 23.5 x 28.5
Royal Scottish Academy

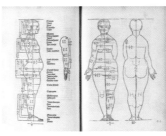

Albrecht Dürer (1471-1528)
*Diagram of the proportions of a
woman* from *Alberti Dureri
Clarissimi pictorius et Geometræ
de Symetria partium in rectis
formis humanorum corporum*,
Nuremberg, 1534
book, woodcut; 30 x 21
Royal Scottish Academy *

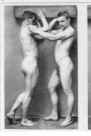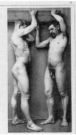

Heinrich Eickmann
*Akte Kunststudien über den
Nackten*, Berlin and New York,
1900, loose leaf, p. 65
black and white photograph,
leaf 42 x 33
Royal Scottish Academy,
Robert Burns collection *

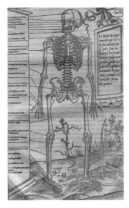

Charles Estienne (1504-1564)
*La Dissection des Parties du
Corps Humain*, French edition,
Paris,1546
book; 37 x 25.5
Typ FP.B46CE
Special Collections,
University of St Andrews

Bartholomaeus Eustachius
(c.1500 – 1574)
Tabulae anatomicae,
Amsterdam,1722
book; 39 x 26.5
rf QM25.E8
Special Collections,
University of St Andrews *

J. R. Farre
*The Morbid Anatomy of the
Liver*, 1815, Order 1,
Tumours, Pt II
album; DUNUC MS16/12/37
University of Dundee Archive
Services

Joel Fisher (1947-)
Diagnosis, 2006
artist's book, limited edition
special commission for
Anatomy Acts
Courtesy of the artist

Joel Fisher
Aletheia, 2006
reproduced drawings on paper
special commission for
Anatomy Acts
Courtesy of the artist

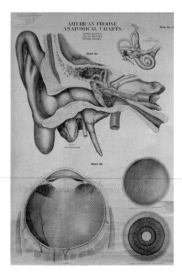

Franz Frohse and Max Brodel
*The Human Ear & The Left
Human Eye*. Anatomical
teaching chart from the
American Frohse series,
plate 5, 1918 –1939
canvas; 156 x 110
DUNUC 3840/10
University of Dundee Museum
Services, Biological Sciences
Collection *

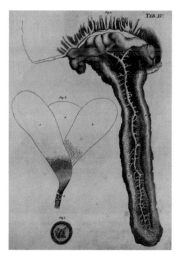

Andrew Fyfe
*One Hundred & Fifty Eight
Plates to Illustrate the Anatomy
of the Human Body*,
Edinburgh, 1830
book; 30 x 23
sf QM25.F8
Special Collections,
University of St Andrews

David M. Greig
A Neanderthaloid Skull, 1933,
Edinburgh and London
book; 24 x 16
MPN
Courtesy of the Royal College
of Surgeons of Edinburgh

*Neanderthaloid adult skull
showing malformation*
belonging to David M. Greig
bone, human specimen;
GC9413
Courtesy of the Royal College
of Surgeons of Edinburgh *

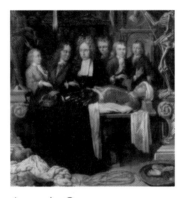

A. van der Groes
A Surgical Demonstration,
c.1700
oil on canvas; 92 x 83.5
Courtesy of the Royal College
of Surgeons of Edinburgh *

Claude Heath (1964 -)
Heir be it Sene, 2006
paintings, stereoscopic
installation
special commission for
Anatomy Acts
Courtesy of the artist

*Neanderthaloid adult skull
showing malformation*
belonging to David M. Greig
X-ray;
GC9413
Courtesy of the Royal College
of Surgeons of Edinburgh *

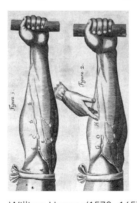

William Harvey (1578 -1657)
*Exercitatio Anatomica de Motu
Cordis et Sanguinis in animalus*
Frankfurt, 1628, first edition
book; 19 x 15
RCSEd Library
Courtesy of the Royal College
of Surgeons of Edinburgh *

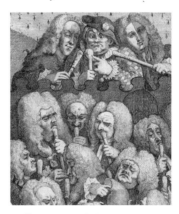

William Hogarth (1697-1764)
The Company of Undertakers,
1736
engraving; 33 x 25
Royal College of Physicians
of Edinburgh *

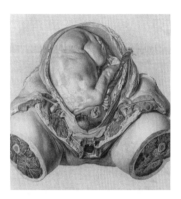

William Hunter (1718-1783)
Anatomy of the Gravid Human Uterus, 1774
book; 65.2 x 49
Spec.Coll. e59
Glasgow University Library,
Special Collections

John of Arderne
(1307- c. late1370s)
The Practice of Surgery,
England, c.1425-1450
book;MS Hunter 251 (U.4.9)
Glasgow University Library,
Special Collections

Frederick Knox (1794-1873)
Skull of a cod fish,
mid 19th century
specimen, glass case;
35 x 35 x 28.5
RN22,807; Struthers Collection
Courtesy of the University
of Aberdeen

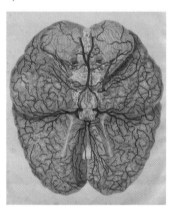

Kathleen Jamie (1962 -)
Six poems, 2006
special commission for
Anatomy Acts, 2006
Reproduced courtesy
of the author *

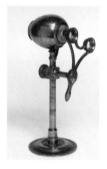

W. & S. Jones, London
Model of the eye showing the application of spectacles,
late 18th century
brass, glass; diameter 8 x 21
ABDNP200388a;
Copland Collection
Courtesy of the University
of Aberdeen *

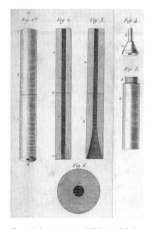

René Laennec (1781-1826)
De l'auscaltation mediate,
vol. I, Paris, 1819
book; 21 x 13.5,
fold out page 20 x 25
SM 3.20
Royal College of Physicians
of Edinburgh *

René Laennec
Stethoscope, 19th century
wood; 30.1 x 3.5 x 3.5
Royal College of Physicians
of Edinburgh *

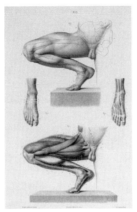

Jean Baptiste François Leveillé
(1762-1829)
The lower leg and foot,
showing muscle action, c.1825
lithograph; 27.5 x 36.5
Royal Scottish Academy *

John Lizars (1792-1860)
A System of Anatomical
Plates of the Human Body,
Edinburgh, 1823
book; 43 x 28.5
RCSEd Library RR C8
Courtesy of the Royal College
of Surgeons of Edinburgh *

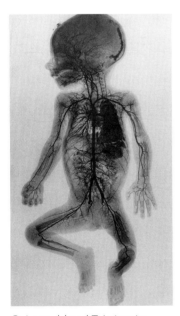

G. Leopold and T. Leisewitz
Geburtshilflicher Röntgen Atlas,
Tab. 10, pl. 9, Dresden, 1908
loose leaf folio; 48 x 32
RCSEd Library RR Q7
Courtesy of The Royal College
of Surgeons of Edinburgh *

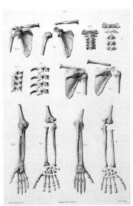

Jean Baptiste François Leveillé
Bones of the hand, lower arm
and shoulder, c.1825
lithograph; 27.5 x 36.5
Royal Scottish Academy *

John Lizars
A System of Anatomical
Plates of the Human Body,
Edinburgh, c. 1832
book; 44.5 x 30.5
sf QM25.L5
Special Collections,
University of St Andrews

John Lizars
*Observations on Extraction
of Diseased Ovaria*,
Edinburgh, 1825
book, 46 x 30
sf RG441.L5
Special Collections,
University of St Andrews

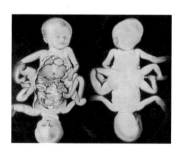

Macdairmid
Conjoined Twins, date unknown
oil on canvas; 68 x 80.5
LGR
Courtesy of the Royal College
of Surgeons of Edinburgh *

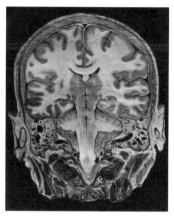

William Macewen
and James Maclehose
Coronal Section, from *Atlas of
Head Sections*, Plate 9,
Series A. IX, 1893
28.5 x 22.2
University of Glasgow, Hunterian
Museum; Royal College of
Physicians and Surgeons of
Glasgow

William Macewen
Specimen for *Atlas of Head
Sections*, 1893
human specimen, 25 x 20 x 8
122504
University of Glasgow,
Hunterian Museum

William Macewen
*Casts of brain sections to
demonstrate distribution of
nerve elements*,
late 19th - early 20th century
plaster, paint;
25 diameter x 2.5 d.
122580 (C.12)
University of Glasgow,
Hunterian Museum

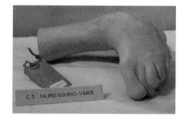

William Macewen
*Cast of the left foot of a young
adult showing fully developed
equino-varus*,
late 19th - early 20th century
plaster cast, paint; 20 x 20 x 11
122571 (C.3)
University of Glasgow,
Hunterian Museum

William Macewen
Spina Bifida and *Hydrocephalus*,
date unknown
copy prints;
HB14/19/67; HB14/19/52
Glasgow Royal Infirmary Clinical
Photographs
Greater Glasgow Health Board
Archives, University of Glasgow

Sir James MacKenzie (1853-1925)
Lewis-MacKenzie Polygraph
metal, rubber, paper, glass;
7 x 40 x 12
DUNUC 4266
University of Dundee Museum
Services, Tayside Medical History
Museum

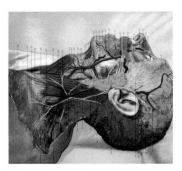

George McLellan
*Regional anatomy in its Relation
to Medicine and Surgery*, vol.1,
Edinburgh and London, 1891
book; 30 x 24
RCSEd Library RR E8
Courtesy of the Royal College
of Surgeons of Edinburgh *

Robert Wilson Matthews RSA
(1880-1940)
*Adult Neanderthaloid skull
showing malformation*,
drawing for D. M. Greig,1931
watercolour; 35 x 44.5
GC 94.14
Courtesy of the Royal College
of Surgeons of Edinburgh *

Robert Wilson Matthews RSA
*Adult Neanderthaloid skull
showing malformation*, drawing
for David M Greig, 1933
watercolour; 35 x 44.5
GC 94.14
Courtesy of the Royal College
of Surgeons of Edinburgh *

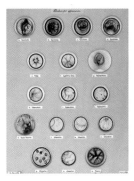

A. K. Maxwell
Proctoscopic Appearances
watercolour; 44.5 x 35
GC 7099
Courtesy of the Royal College
of Surgeons of Edinburgh *

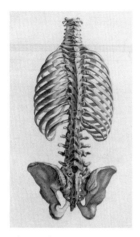

Alexander Monro (1697-1767)
Traite d'Osteologie, Paris, 1759
book; 60 x 17.7
Royal College of Physicians
of Edinburgh *

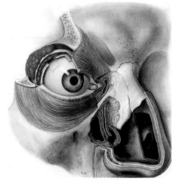

Alberto Morrocco (1917-1998),
Anatomical works on paper,
for Professor Robert Lockhart's
*Anatomy of the Human
Body*, 1959
ink and paint on paper;
20 x 30
Courtesy of the University
of Aberdeen *

Nachet & Fils
*Three way demonstration
microscope*
brass, 30 x 37 x 37
University of Edinburgh

Alexander Monro
*Engravings of the Thoracic
and Abdominal Viscera*,
1814, first edition
book; 30 x 24.5
RR C7
Courtesy of the Royal College
of Surgeons of Edinburgh *

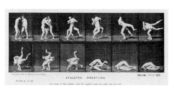

Eardweard Muybridge
(1830-1904)
Athletes Wrestling, from *The
Human Figure in Motion*,
London, 1901, p.75
photograph; book; 25 x 35
James Guthrie collection
Royal Scottish Academy *

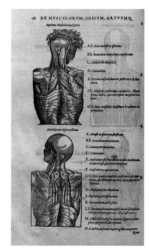

Ambroise Paré (1510-1590)
Opera Chirurgica, Frankfurt
am Main, Latin edition,1594,
first edition1582
book; 35 x 23.5
Typ GF.B94FP
Special Collections,
University of St Andrews

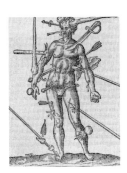

Ambroise Paré
Opera Chirurgica,
Frankfurt, 1594
book; 35 x 23.5
RCSEd Library BS O5
Courtesy of the Royal College
of Surgeons of Edinburgh *

Ambroise Paré
*The Workes of that famous
Chirurgion Ambrosie Parey.
Translated out of Latin and
compared with the French*,
London,1634
book; 33 x 22
RCSEd Library BS O6
Courtesy of the Royal College
of Surgeons of Edinburgh *

Sir Joseph Noel Paton RSA
(1821-1901)
Apollo in his Chariot, 1843
graphite; 55.5 x 73.5
1994.3171
Purchased in 1994 with a 50%
grant from the National Fund for
Acquisitions
Reproduced courtesy of Perth
Museum & Art Gallery,

Pfurtscheller, Germany
*Gastropoda Pulmonata. Helix
Pomatia* (*Anatomy of the Roman
Snail*) c.1890s. zoological wall
chart used by Prof. D'Arcy
Thompson (1860-1948);
144 x 134. DUNUC 3841/21
University of Dundee Museum
Services, Zoology Museum
Collection

Jones Quain (ed)
*The Muscles of the Human
Body*, London, 1836
book; 51.6 x 33.5
RCSEd Library RR C8
Courtesy of the Royal College
of Surgeons of Edinburgh

Richard Quain (1800-1887)
*The Anatomy of the Arteries
of the Human Body*, London,
1841-1844
book; 56 x 42
sff QM191.Q2
Special Collections,
University of St Andrews

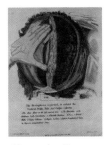

Alexander Ramsay
*Anatomy of the Heart,
Cranium and Brain*,
vol. 2, Edinburgh,1813
book; 29 x 24
sf QM25.R2
Special Collections,
University of St Andrews

Professor Robert Reid
(1851-1931)
*Anthropometry cards of
fingerprints of medical students*,
1897, University of Aberdeen
Anthropometric Laboratory
ink and paper folder 37 x 27 x 9;
loose pages 31 x 21
MSU 1332/5/2/1-8;
Courtesy of the University of
Aberdeen

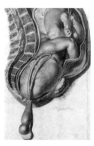

Jan van Rymsdyck (1750-1784)
Foetus in profile, and *Foetus
and forceps*, drawings for
William Smellie (1697-1763),
*A Sett of Anatomical Tables,
with Explanations*, London,
1754, tabs. 10 and 16
red chalk on paper; 54 x 36.5
DI. 1.27
Glasgow University Library,
Special Collections *

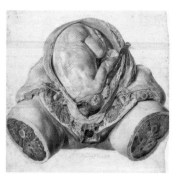

Jan van Rymsdyk
*Anatomy of the human gravid
uterus* for William Hunter,
*Anatomy of the human gravid
uterus*, London, 1774,
Tabs I, II, III, IV, VI
red chalk on paper; 81.3 x 55.7
Az.1.4
Glasgow University Library,
Special Collections *

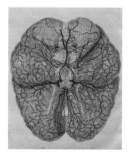

Antonio Scarpa (1752-1832)
*Engravings of the Cardiac
Nerves, (Tabulae Neurologica)*,
Edinburgh, 1832
book; 29 x 23
sf QM25.S3E32
Special Collections,
University of St Andrews *

S. Smith and Sons, Glasgow
with additions by Dugald
Cameron (1939-)
Design for 1962 scanner, sketch
based on a suggestion by
Tom Brown (1933-) for Dugald
Cameron, c.1950s-60s
dyeline print; 44 x 53.8
Courtesy of the British Medical
Ultrasound Society

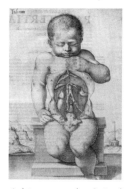

Adriaan van der Spieghel
(c.1578- c. 1625)
De Humani Corporis fabrica,
Venice, 1627
book; 40.5 x 28
X1.1
Glasgow University Library,
Special Collections *

212

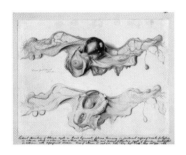

Neil Stewart
Fallopian Tubes and *Lobular
impacted condensation of lungi*,
1851, from the Neil Stewart and
William Tennant Gairdner
Pathology Drawing collection
watercolour; DUNUC MS16/4/13
and MS16/10/25
University of Dundee Archives

Prof Sir Thomas Peter Anderson
Stuart (1856-1920)
*Instrument for Locating the
Blind Spot on the Retina*
wood, metal; 52 x 27 x 2
Manufactured by Cambridge
Scientific Instrument Co
DUNUC 4221
University of Dundee Museum
Services, Physiology Collection *

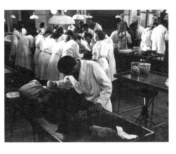

Wolfgang Suschitzky (b.1912)
*Anatomy Class, University of
Aberdeen*, 1948
photograph; 30 x 39.3
Courtesy of the artist

John Henderson Tarbet (d. 1938)
*Anatomical study of a skeleton
within the outline of Cleomene's
Roman orator*, 1887
ink, wash and red line on paper,
70 x 35.5
Royal Scottish Academy *

John Henderson Tarbet
The Laocoön Group, c. 1887
pencil (stump drawing); 79 x 54.5
Royal Scottish Academy *

John Thomson and
(William?) Somerville
*Sketches of the Wounded at
Waterloo*, 1815
book; 26.5 x 21.5
Gen .594
University of Edinburgh
Library, Special Collections

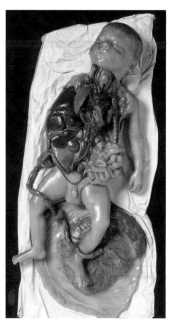

Mson. Tramond of Paris
Anatomical model of new born baby, c.1880s
wax, metal and wood; 20 x 68 x 39
ABDAN2367; Struthers
Collection
Courtesy of the
University of Aberdeen *

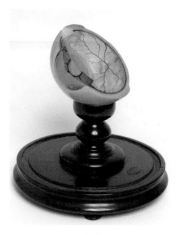

Mson. Tramond of Paris
Model of the Human Eye in section, c.1890s
wax, wooden stand; 23 x 20 x 20
DUNUC 9101
University of Dundee Museum
Services, Anatomy Collection *

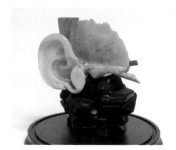

Mson. Tramond of Paris
Model of the inner ear, c.1900
wax; 26 x 27 x 27
AP73
Museum Collections,
University of St Andrews *

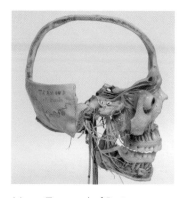

Mson. Tramond of Paris
Model of half dissected human skull, c.1900
wax; 38 x 29 x 18.5
MSAM11
Museum Collections,
University of St Andrews *

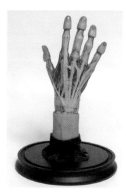

Mson. Tramond of Paris
Model of hand with fabric sleeve, c.1900
wax, fabric; 40 x 22 x 22
MSAM1
Museum Collections,
University of St Andrews *

Juan de Valverde de Hamusco
(c.1525 - c.1588)
Anatomia del corpo humano,
Rome, 1560
book; 30.5 x 21.5
Dk.2.9
Glasgow University Library,
Special Collections *

Andreas Vesalius (1514-1564)
Tabulae anatomicae sex, six
plates, Venice 1538
woodcuts with printed
letterpress text; 63 x 51
Az.1.10
Glasgow University Library,
Special Collections *

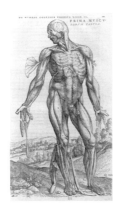

Andreas Vesalius (1514-1564)
Muscle-man, Liber secondus,
from *De Humani corporis
fabrica*, Basel, 1543, p.181
engraving; book; 70 x 28.5
Royal Scottish Academy *

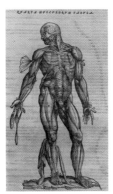

Andreas Vesalius
De humani corporis fabrica, libri
septum, Venice, 1568
book; 32.5 x 22
Sim QM21.V2
Special Collections,
University of St Andrews *

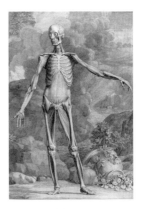

Jan Wandelaar
Male Muscle-man, for Bernard
Siegfried Albinus, *Tabulae
sceleti et musculorum corporis
humani*, Leiden, 1741,
Musculorum Tabula III
engraving; 81.5 x 61.5
Royal Scottish Academy *

Jan Wandelaar
*Male Muscle-man and Dutch
rhinocerous*, for Bernard
Siegfried Albinus, *Tabulae
sceleti et musculorum corporis
humani*, Leiden, 1741,
Musculorum Tabula IV
engraving; 81.5 x 61.5
Royal Scottish Academy *

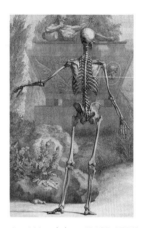

Jan Wandelaar (1697-1759)
Plates for Bernard Siegfried
Albinus, *Tabulae Ossium
Humanorum*, Leiden 1753
book; 60 x 51
ZE24
Royal College of Physicians
of Edinburgh *

Ziegler, Germany
*Anatomical model of brain
development*, late 19th century
wax, metal,wood; 37 x 84 x 40
ABDAN2318;
Struthers Collection
Courtesy of the
University of Aberdeen *

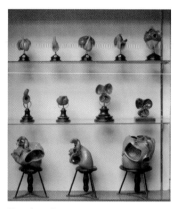

Zeigler, Germany
*Three models of embyonic
development of heart*,
late 19th century
wax; 12 diameter x 20 h approx.
123356
University of Glasgow,
Anatomy Museum

David Waterston (ed)
*The Edinburgh Stereoscopic
Atlas of Anatomy*, London,1906
viewer wood, metal; 21 x 25 x 20
atlas EBG; viewer EBA
Courtesy of the Royal College of
Surgeons of Edinburgh *

Ziegler, Germany
*Two anatomical models of
chicken heads showing skull
development*, late 19th century
wax, glass cases: 6 x 36 x 36
ABDAN2361; Struthers
Collection
Courtesy of the
University of Aberdeen *

Lenders to the Exhibition

British Medical Ultrasound Society

Greater Glasgow Health Board

National Museums of Scotland

Perth Museum and Art Gallery

Royal College of Physicians of Edinburgh

Royal College of Physicians and
Surgeons of Glasgow

Royal College of Surgeons of Edinburgh

Royal Scottish Academy

Scottish National Portrait Gallery

Scottish Screen

Wolf Suschitsky

Tayside Medical History Museum

University of Aberdeen: Anatomy Museum;
Marischal Museum; Natural Philosophy Collection
of Historical Scientific Instruments; Pathology and
Forensic Medicine Collection; Special Libraries
and Archives; Zoology Museum

University of Dundee: Archive Services;
Museum Services

Edinburgh University: Anatomy Collections;
Library, Special Collection

University of Glasgow: University Library,
Special Collections; Anatomy Museum;
Hunterian Museum

University of St Andrews: Museum Collections
Unit; Department of Special Collections,
University Library

Photography credits:
* Photographs by Max Mackenzie
All images © the lenders

Scottish Medical Collections

THE BRITISH MEDICAL ULTRASOUND SOCIETY

The British Medical Ultrasound Society (BMUS) grew from a small informal group of medics, physicists and engineers that emerged in the 1960s. With the support of the Hospital Physicists Association (now The Institute of Physics and Engineering in Medicine - IPEM) and British Institute of Radiology this became The British Medical Ultrasound Group. The rapid growth of the subject lead to a more formal structure and in 1977 BMUG became BMUS. Today BMUS has 2100 members - Sonographers (49%), Radiologists (25%), Obstetricians (12%), Physicists & Scientists (5%), and others including Cardiologists, Paediatricians, Midwives, Medical Technical Officers, Vets, GPs and equipment manufacturers; 10% of members are from overseas.

In about 1980 John Fleming was asked by Tom Brown to store and care for the original contact scanner that he had designed and built in 1957 (Fleming pictured,1990). This machine generated the images for the 1958 landmark Lancet paper (Donald, MacVicar and Brown). In 1984 BMUS having decided to expand its educational activities asked Fleming to 'co-ordinate' the establishment of an Historical Collection. This was undertaken with the help and support of the University of Glasgow's Hunterian Museum. Fleming was appointed Honorary Assistant Keeper of Ultrasonic Equipment to the Museum. The very substantial Collection now consists of scanners, transducers and associated hardware; images, films, video and audio tapes; photographs of instruments and people; manufacturers' documents (all types); personal accounts, letters and interviews, originals of papers; reviews and books.

The hardware is stored in the Hunterian Museum - Brown's contact scanner will be on public display in the new medical gallery in the Museum due to open spring 2006. The books are in the library of the Centre for the History of Medicine, University of Glasgow. The other material is currently being transferred to the NHS Archive housed in the Mitchell Library, Glasgow. All is accessible for education, research and general interest by contacting the Collection Co-ordinator or the General Secretary.

After 18 years as Historical Collection Co-ordinator John Fleming retired and passed this task to Mr Chris Haydon whose enthusiasm and long experience as a senior radiographer working in ultrasound makes him ideal for the task of maintaining and developing the Collection.

Mr Chris Haydon
BMUS Historical Collection
Ultrasound Department
Derriford Hospital
Plymouth PL6 8DH

Tel: 01752 53256
Email: chris.haydon@phnt.swest.nhs.uk
Web:
www.bmus.org/history_of_ultrasound.htm#med

The General Secretary
BMUS
36 Portland Place
London W1B 1LS

Tel: 020 7636 3714
Email: secretariat@bmus.org
Web: www.bmus.org

ROYAL COLLEGE OF PHYSICIANS OF EDINBURGH

The College
In the seventeenth century, Edinburgh physicians began to hold meetings in their own homes to discuss the regulation of medical practice and the ways in which standards in medicine could be improved.

Sir Robert Sibbald, an eminent physician and noted historian, was a member of this group. He had the opportunity to petition King Charles II, who granted the Royal College of Physicians of Edinburgh its Royal Charter in 1681. Sir Robert is

generally accepted to be the founder of the College.

The founding Fellows of the College were concerned not only with the advancement of medicine as a reputable science, but also with alleviating the miseries of the City's poor and needy.

For more than 300 years, the College has remained independent of control by government. The College's mission today lies close to the ideals of its founders: to promote the highest standards in internal medicine not only in Edinburgh where the College was founded and has developed, but wherever its Fellows and Members practise.

The College acts in an advisory capacity to government and other organisations on many aspects of health and welfare and medical education. It was instrumental in founding the Royal Infirmary of Edinburgh and, over the years, has influenced the development of medical schools in North America, Australasia, Asia and Africa.

The Library

The Library of the Royal College of Physicians of Edinburgh was established in 1682 and was the first in Scotland specifically intended for the study of medicine. Sir Robert Sibbald, who had been the foremost figure in the creation of the College, donated 'three shelfes full of books to the Colledge of Physitians.' Since then the Library has provided over three hundred years of continuous service to members of the College, and has grown into a comprehensive collection ranging from the earliest and rarest of medical writings to modern books, periodicals and online resources.

Library access

The Library provides services to Fellows and Members of the College. The Library is also open to the public for research, but we may have to charge for some of our services. Please contact us to make an appointment.

Royal College of Physicians of Edinburgh
9 Queen Street,
Edinburgh
EH2 1JQ

Tel: 0131 225 7324
Fax: 0131 220 3939
Web: www.rcpe.ac.uk

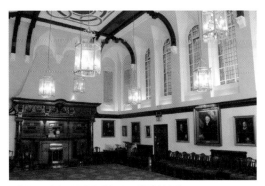

ROYAL COLLEGE OF PHYSICIANS AND SURGEONS OF GLASGOW

Founded in 1599, the RCPSG enjoys a history spanning four centuries. The College enjoys a unique position among its sister Colleges in the UK in that physicians, surgeons and dentist make up its Membership and Fellowship.

The College was founded in 1599 by Peter Lowe, a Scottish surgeon who had practiced a number of years in France. On his return to Scotland, he was so horrified at the state of medical practice in Glasgow that he petitioned King James IV to be allowed to establish a regulatory body which would ensure that people acting as doctors (physicians and surgeons) in the city were properly trained.

In its long history the College (originally called the Faculty) has had several homes, meeting in different places such as Blackfriars' Kirk and Hutcheson Hospital. Its first Faculty Hall was in the Trongate and, in 1791, it moved to St Enoch's Square. Finally, in 1862, it moved to the present accommodation in St Vincent Street.

Archives

Archives of the College date from the early seventeenth century. The first minute book starts in 1602 and the minutes run with just one gap (from 1688-1733 when a minute book was lost in a fire) up until the present day. The majority of the material dates from the 19th and 20th Centuries and includes examination registers, papers relating to College committees and records relating to property including plans of College Hall designed by J. Burnet in 1892. There is a large collection of photographs containing portraits of many nineteenth century Members and Fellows as well as covering more recent events. The archive is not a static entity and is being added to regularly so that the history and events of the College are preserved for future generations.

Apart from the main College archive there are also deposited archive collections relating to former (and present) Members and Fellows of the College. These include the papers of Sir William Macewen and Joseph Lister. There are also several collections relating to Glasgow and West of Scotland medical societies.

Instrument collection

Over the years, the College has acquired a collection of medical instruments dating from the eighteenth century right up to the present day. These include sets of surgical instruments including those used by Dr David Livingstone (c.1840) and by Sir William Beatty - the surgeon onboard HMS Victory at the Battle of Trafalgar (c.1783-1819), Lister's Carbolic Spray (1870-1890), and the Jackson 'focus' X-ray tube (1895).

Carol Parry
College Archivist
RCPSG
232-242 St Vincent Street
Glasgow
G2 5RJ

Tel: 0141 227 3234
Email: carol.parry@rcpsg.ac.uk
Web: www.rcpsg.ac.uk

James Beaton
College Librarian
RCPSG
232-242 St Vincent Street
Glasgow
G2 5RJ

Tel: 0141 227 3204
Email: james.beaton@rcpsg.ac.uk
Web: www.rcpsg.ac.uk

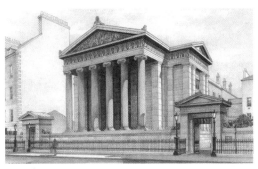

ROYAL COLLEGE OF SURGEONS OF EDINBURGH

Surgeons' Hall Museum

The Royal College of Surgeons of Edinburgh, founded in 1505, is the oldest medical institution of its kind in the world and the College holds the largest collection of medical, anatomical and pathological material in Scotland, dating from Roman times to the present day.

Surgeons' Hall, designed by Sir William Playfair opened in July 1832, the month before the first UK Anatomy Act became law. The entire upper floor of Surgeons' Hall was dedicated to the College's teaching collections of Comparative Anatomy and Pathology. Although much of the Comparative Anatomy collection has been dispersed in the intervening years, the pathology collection has survived almost intact. It is probably one of the few early nineteenth century medical museums in the world that still has most of its original collection on display and in the original space provided for it. It is Scotland's oldest medical museum.

Surgeons' Hall Museum includes early

specimens from the College's first anatomy and pathology museum established in 1807; Sir Charles Bell's oil paintings of wounded soldiers from the Napoleonic Wars; David Middleton Greig's skull collection; John Menzies Campbell's comprehensive dental collection; early microscopic preparations, microscopes and microtomes; historic anaesthetic and antisepsis equipment (including the most complete Squires II Inhaler known and a range of Lister carbolic spray machines); Lord Lister's frock coat and dissection kit; Sir James Young Simpson's top hat and medicine chest; original pathological drawings; X-rays, photographs and scans and over 3,000 surgical instruments dating back to classical times.

Displays show the methods for preservation and representation of the human body since1505 and highlight developments and links between 'Classical' surgery and contemporary specialisms such as reconstructive facial surgery and sports and exercise medicine. Displays on the notorious murderers Burke and Hare and the anatomist Dr Robert Knox include a wallet reputedly made out of the skin of William Burke. Multi media access provides more in depth medical/surgical information and interdisciplinary cross-referencing.

Surgeons' Hall Museum
The Royal College of Surgeons of Edinburgh
Nicolson Street
Edinburgh EH8 9DW

Tel: 0131 527 1649
Email: museum@rcsed.ac.uk
Web: www.edinburgh.surgeonshall.museum

Library and Archive

RCSEd library is one of the largest medical libraries in Scotland. Collections include: historic and rare books including many early anatomical atlases and medical and surgical monographs dating from the 16th century and a large stock of contemporary medical/surgical journals and books.

The archive holds the institutional records of the College dating from the early 16th century and private papers relating to famous medical pioneers including: Sir James Young Simpson, Joseph Bell (the inspiration for Sherlock Holmes). and Sir Michael Woodruff.

Open for research by appointment.

Library and Archives
The Royal College of Surgeons of Edinburgh
Nicolson Street
Edinburgh EH8 9DW

Tel: 0131 527 1630
Email: library@rcsed.ac.uk
Web: www.rcsed.ac.uk

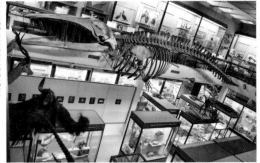

PHOTO BY MARTYN GORMAN

notable strengths: skeletal material, fluid-preserved specimens of human tissues, modern plastic anatomical models' historical anatomical models (of wax, papier-mâché and plaster), and works on paper, including nineteenth century watercolours and anatomical drawings by Alberto Morrocco. In addition, the museum has a small collection of associated material, like anti-grave robbing devices used in the north-east of Scotland in the nineteenth century.

Access to the collection is restricted.

UNIVERSITY OF ABERDEEN

Anatomy Museum
The origins of the Anatomy Museum in Aberdeen are unclear but there is documentation which describes the opening of the refurbished Anatomy Museum at Marischal College in 1881 as part of a general refurbishment of the Anatomy department, at that time under the guidance of the first Regius Chair of Anatomy Professor John Struthers. Struthers was ahead of his time in terms of the needs of medical education and following his retirement from Aberdeen he went on to become the first Chair of the Medical Education Committee of the General Medical Council. Struthers was succeeded by Professor Robert W Reid who occupied the Regius Chair of Anatomy from 1889-1925. Professor Reid was a skilled dissector and made a sizeable contribution to the cadaveric objects within the Anatomy Museum.

The collections are wide ranging and the earliest specimens can be traced back to the 1870s. Collecting of objects for the museum has been driven by the research and teaching activities of staff over the years and the museum has some

Honorary Curator
School of Medical Sciences (Anatomy)
University of Aberdeen
Marischal College
Broad Street
Aberdeen
AB10 IYS

Tel: 01224 274320
Email: museums@abdn.ac.uk
Web: www.abdn.ac.uk/museums

Marischal Museum
Originally founded in 1786, Marischal Museum was re-established in 1907 as the University's Anthropological Museum at Marischal College and now houses exhibitions and activities which use the collections of Scottish archaeology and folk life, ethnography, Egyptian antiquities, numismatics and militaria. An award winning virtual version of the museum is available at http://www.abdn.ac.uk/virtualmuseum

Marischal Museum
University of Aberdeen
Marischal College
Broad Street
Aberdeen AB10 1YS

Tel: 01224 274301
Email: museum@abdn.ac.uk
Web: www.abdn.ac.uk/museums

Special Libraries and Archives
The University of Aberdeen was founded in 1495 and, until the 1970s, was the main repository for archival collections in the northern half of Scotland. A Special Collections department was formed in the 1960s to care for the university's unique and internationally significant range of printed, archival and other documentary sources. The richness of these collections extends across all the disciplines of the medieval and early modern university curriculum and across the European world of learning. Printed material comprises over 150,000 printed volumes, dating from the 1460s to the late-twentieth century, administered as four distinct chronological collections, which represent the evolution of the printed book and the University's unique legacy of over 500 years of learning; and forty named collections, covering a wide variety of subjects, most of which have come to the University since the mid-nineteenth century. Archival holdings include medical archives reflecting the University's expertise, from the late-nineteenth century, in the allied fields of anatomy, physiology, pharmacology and pathology. The collection provide researchers with the opportunity to explore the unique contributions made by

significant members of this community to their professions; and to trace the developing role of these relatively new disciplines in medical education.

Special Libraries and Archives
King's College University of Aberdeen
Aberdeen
AB24 3SW

Tel:01224 272598
Email: speclib@abdn.ac.uk
Web: www.abdn.ac.uk/diss/historic/index.shtml

Zoology Museum
The Zoology Museum has the only large, internationally important collection of zoological specimens in the north of Scotland. The earliest reference to the collections dates from 1782. In his book, A General Description of the East Coast of Scotland from Edinburgh to Cullen, Francis Douglas wrote, 'Commencing about 1772 Professor William Ogilvie began of his own accord to put together a collection of specimens for a museum of natural history in the King's College, and has now fitted up, and furnished three apartments for their accommodation...' The collection was later at Marischal College and has been at its present location in Old Aberdeen since 1973

The Zoology Museum cares for an extensive range of material, worldwide in scope, which covers the whole of the animal kingdom, from protozoa to the great whales. The collection contains around 75,000 specimens and it has resulted from over 200 years of collecting. Not

only does it reflect the teaching and research interests of our staff and students, but also the gifts of graduates and friends of the University.

Honorary Curator
Department of Zoology
University of Aberdeen
Tilldrone Avenue
Kings College
Aberdeen AB24 2TZ

Tel: 01224 272850
Email: museums@abdn.ac.uk
Web: www.abdn.ac.uk/zoologymuseum

UNIVERSITY OF DUNDEE

Archives
The University of Dundee Archives hold a wide variety of collections that contain a wealth of material for all types of researcher: academic staff, postgraduate and undergraduate students, private researchers, including family historians, and school pupils.

The diversity of medical related research themes to be found within the collections is immense and includes history of insanity, tropical medicine, medical missions, surgery, pathology, infectious diseases and the experiences of women in the medical and nursing professions. These

include documents and photographs from the Tayside Health Board in the Tayside area (asylums, hospitals, Boards of Management, Colleges of Nursing, for example); Dundee Dental Hospital; Manuscript Collections; and the University Records Collection which contains the records of various medical professors and lecturers

The collection also consists of various pathological material, including drawings, engravings and photographs. The majority of the pathological drawings are by Neil Stewart and feature comments by Sir William Tennant Gairdner, the eminent pathologist and physician.

Archive, Records Management
University of Dundee
Dundee DD1 4HN

Tel: 01382 384095
E-mail: museum@dundee.ac.uk
www.dundee.ac.uk/archives

Museum Services
The University has a wide variety of museum collections acquired during the 125 years of the institution's existence, all of which are cared for by Museum Services. As well as Medicine, the collections include Botany, Chemistry, Dentistry, Engineering, Ethnography, Fine Art & Design, Mathematics, Physics, Psychology and Zoology.

Tayside Medical History Museum
Founded in 1989, the Tayside Medical History Museum is jointly managed by the University of Dundee Museum Services and NHS Tayside. Its collections represent the history of medicine and

medical teaching in Dundee and Tayside over the past 150 years, and are displayed in a series of temporary exhibitions at Ninewells Hospital & Medical School, Dundee. Some of the highlights of the collection include early surgical instruments, plant medicines and microscopes.

Old Medical School, University of Dundee
Medicine was considered one of the key subjects at University College Dundee when it was first founded in the 1880s. Chairs of anatomy and physiology were established in 1888-9, and soon a Conjoint Medical School was set up between UCD and the University of St Andrews. By the time UCD became a College of St Andrews a separate Faculty of Medicine had also been established in Dundee. It was not until 1902, however, that work started on a proper Medical School building, which was opened in 1904. Students would do their pre-clinical work here, with most of the practical classes given at Dundee Royal Infirmary. In 1967-8 a separate Medical Sciences Institute was built to house anatomy and with the opening of Ninewells Hospital in 1974 most medical teaching moved there. The Old Medical School is now used as part of the School of Life Sciences.

Ninewells Hospital & Medical School
Now the largest medical complex in the UK, Ninewells Hospital was opened in 1974, its foundation stone having been laid almost a decade earlier. Its numerous buildings (which include the Medical School and part of the School of Nursing & Midwifery), stand on a sloping parkland site with spectacular views across the River Tay. One of the most recent additions to the

site is the new Maggie's Centre, designed by internationally-renowned architect Frank Gehry.

University of Dundee Museum Services
5-7 Hawkhill Place
University of Dundee
Dundee DD1 4HN

Tel: 01382 344310 / 384310
Email: archives@dundee.ac.uk
www.dundee.ac.uk/musem

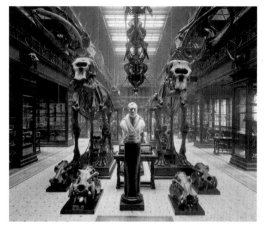

UNIVERSITY OF EDINBURGH
Rich collections dating from the seventeenth century including manuscripts, books, specimens and iconic items such as William Burke's skeleton.

Special Collections
Special Collections includes early mediaeval and Middle-Eastern manuscripts, the papers of major Scottish Enlightenment figures, architectural drawings and the papers of seventeenth-twentieth century scientists. These collections are quite diverse, but largely reflect our strengths in the areas of medical and scientific history, Scottish literature, Middle Eastern studies, architecture, music, Gaelic and Celtic studies and theology. Edinburgh University Archives maintain the historical records of the University of Edinburgh (particularly post-1858 but many records date from earlier periods), its predecessors and affiliated bodies.

Special Collections welcomes users engaged in bona fide research.

Edinburgh University Library,
George Square,
Edinburgh EH8 9LJ

Tel: 0131 650 8379
Email: special.collections.library@ed.ac.uk
Web:
http://www.lib.ed.ac.uk/resources/collections/spec
division

Lothian Health Services Archive
Lothian Health Services Archive is housed within
Special Collections but is managed separately
under the University Collections Division.

Tel: 0131 650 3392
Email: lhsa@ed.ac.uk
Web: http://www.lhsa.lib.ed.ac.uk/

Anatomy Resource Centre
During the eighteenth and much of the nineteenth
centuries, the University of Edinburgh was
regarded as the leading medical centre in Europe
and up to the present day can claim many
distinguished medical practitioners and scientists
among its alumni and staff.

Edinburgh's Anatomy Museum, founded and
developed by the Monro dynasty, flourished under
Sir William Turner, Professor of Anatomy from 1867
to 1903, and thereafter Principal of the University
till his death in 1917. Turner's main interests were
in comparative mammalian anatomy, anthropology
and craniology, and Edinburgh was perhaps
unusual in that these aspects of the study of
evolution remained so firmly based in the Medical
Faculty. The Anatomy Museum was the central
feature of Rowand Anderson's Medical School,
designed as a three-storey top-lit galleried hall,
with skeletons of whales and dolphins suspended
from the ceiling and a wealth of historical and
anatomical specimens on display. In the 1950s the
hall was subdivided into three separate storeys
and many of the zoological specimens were
transferred to other institutions. The museum now
exists in its modern form, the Anatomy Resource
Centre, where collection are used in teaching,
learning and research.

The imposing Museum Lobby still contains
elephant skeletons and other exhibits from the
original museum. A number of historical treasures
survive in the Anatomy Museum, including the
skull of George Buchanan, sixteenth century
Scottish humanist and tutor to King James VI
(founder of the University). Of particular note is the
skeleton of William Burke, the Irish murderer who
was hanged and subjected to useful dissection by
Professor Alexander Monro tertius in the University
in 1829, for his part (with William Hare, who turned
Queen's evidence) in supplying freshly suffocated
corpses for dissection by the extra-mural
anatomist Dr Robert Knox.

The Anatomy Lecture Theatre is also of note. It
follows the traditional pattern with steeply raked
wooden benches rising above the central
dissecting table and is still used today both for
student lectures and Public Inaugural lectures
given by new professors.

Visits to the Anatomy Resource Centre are by
appointment only.

Tel: 0131 242 9300
Email (general enquiries): mvm@ed.ac.uk

The University of Edinburgh is home to wonderful collections of items which tell the story of over 400 years of University history and reflect academic endeavour through the centuries and provide a wealth of resources for use in today's teaching and research.

To find out more about the University of Edinburgh's diverse collections, including information on using its libraries and visiting its museum and galleries, please visit our online interactive exhibition, Object Lessons, http://www.objectlessons.lib.ed.ac.uk, the Talbot Rice Gallery http://www.trg.ed.ac.uk

UNIVERSITY OF GLASGOW

The Hunterian Museum and Art Gallery

The Hunterian Museum and Art Gallery was opened to the public in 1807 and is Scotland's oldest museum. It was established around the collections of Dr William Hunter, the celebrated eighteenth century anatomist, doctor and obstetrician. As a physician and collector, he was unique amongst his contemporaries in several ways, not least in having had the foresight to bequeath his entire museum collections and library to his alma mater, Glasgow University, thereby avoiding their dispersal in the salerooms. Hunter also bequeathed £8000 for the construction of a suitable museum.

The collections of coins, paintings, minerals, shells, anatomical and natural history specimens, printed books and manuscripts gave the University an incalculable boost, from which it is still benefiting. At the very core of the collections are the anatomical preparations made by Hunter and his pupils. This material differs from all other parts of his collection in that it was made and used by

Hunter for teaching and research work throughout his long, successful medical career. The collections comprise wet preparations of human, and some animal, tissues and organs, skeletal material, air-dried preparations and some animal taxidermy specimens.

The medical collections have a long and complex history reflecting the intricacies of the history of the University. The collections were considerably supplemented throughout the nineteenth century and into the late twentieth century with new specimens being added by University teaching and research staff. The post-Hunter material includes comparative (animal) anatomy specimens, fine nineteenth century wax models and specimens made using recent techniques such as corrosion and plastination. The Hunter anatomical collections were moved to the Department of Anatomy in 1901 and so left the direct supervision of the Hunterian. The collection was further divided in 1954 when the pathology (morbid anatomy) specimens were removed to the University Department of Pathology at the Glasgow Royal Infirmary in the centre of the city.

Maggie Reilly
Hunterian Museum
University of Glasgow
Glasgow G12 8QQ

Tel: 0141 330 4221
Email: mreilly@museum.gla.ac.uk
Web: www.hunterian.gla.ac.uk/

Prof A. P. Payne
Laboratory of Human Anatomy
Thomson Building
University of Glasgow
G12 8QQ

Tel: 0141 330 5871
Email: A. Payne@bio.gla.ac.uk

University of Glasgow Library, Special Collections
Glasgow University's Special Collections Department is one of the foremost resources in Scotland for academic research and teaching. Built up over a period of more than 500 years by purchase, gift and bequest, the collections now contain more than 200,000 manuscript items and around 200,000 printed works, including over 1,000 incunabula.

Probably the best known of the Library's rare book collections, the Hunterian Library contains some 10,000 printed books and 650 manuscripts and forms one of the finest eighteenth-century libraries to survive intact. It was assembled by Dr William Hunter (1718-83), anatomist, teacher of medicine, Physician Extraordinary to Queen Charlotte, and collector of coins, medals, paintings, shells, minerals, and anatomical and natural history specimens, as well as of books and manuscripts. Under the terms of Hunter's will, his library and other collections remained in London for several years after his death - for the use of his nephew, Dr Matthew Baillie (1761-1823) - and finally came to the University in 1807.

About one third of Hunter's books - not unnaturally - are to do with medicine, with a good balance struck between the great historical texts

(such as editions of Hippocrates, Galen, Vesalius, Harvey) and the writings of his own contemporaries (men like Smellie, the Monros, Albinus, Haller). Anatomy and obstetrics - the two fields in which Hunter made his fame and fortune - are particularly well represented, though an interest in other topics, e.g. naval medicine, the deficiency diseases, inoculation against smallpox, is also represented.

David Weston
Keeper of Special Collections
Glasgow University Library
Hillhead Street
Glasgow, G12 8QE

Tel: 0141 330 6767
Email: special@lib.gla.ac.uk
Web: http://special.lib.gla.ac.uk/

UNIVERSITY OF ST ANDREWS

The Bute Building

The Anatomy and Pathology Collection at the University of St Andrews is housed in the Bute Medical Building. Built in 1899 thanks to the benefaction of £7,000 from John Patrick Crichton-Stewart, 3rd Marquess of Bute, the Medical Building was designed to provide high quality accommodation for the teaching of medicine in St Andrews. A Museum Building was added to exhibit the University's Zoology Collection in 1911 and the Carnegie Building was added onto that in 1933. All are known now collectively as the 'Bute'. Medical students undertake pre-clinical medical studies at the Bute before finishing their training at the University of Manchester.

Anatomy and Pathology Collection

The University's Bull of Foundation allowed for a Faculty of Medicine, but for a long time there was little medical instruction at St Andrews. Instead, the main activity of the Professors was the operation of the system by which medical degrees were awarded on the basis of references. The collection at the University of St Andrews,

administered by Museum Collections and Special Collections, contains objects and archives which represent these changing methods in teaching for the past 500 years.

Medical and Surgical Instruments

The detailed analysis of this subject is well represented through archival material and models. The skill of the profession is also displayed through surgical instruments.

Teaching Collections

Teaching materials range from engravings of eighteenth century dissections to wax and latex models, to X-Rays and CAT Scans. There are also skeletal and preserved remains which are used in teaching, but not generally available for public viewing.

Museum Collections Unit,
University Library
University of St Andrews,
Fife KY16 9TR

Tel: 01334 462417/3946
Email: iac@st-andrews.ac.uk
Web: http://www.st-andrews.ac.uk/muscoll/

Special collections Department

The University Library contains approximately 100,000 volumes of rare and older books, acquired by purchase and gift, since its foundation in the fifteenth century. The libraries of the colleges of St Leonard, St Salvator and St Mary, founded before that of the University itself, formed the first collections of books within the institution, and these were incorporated into the main library in the 18th century. The University library itself was founded by royal gift in 1611-12, when King James VI and I and members of his family presented over 200 volumes to the University to mark the founding of the Common Library.

The Department of Special Collections is home to the Library's manuscripts and rare printed books, as well as its extensive photographic collections and the University muniments.

Department of Special Collections
St Andrews University Library
North Street
St Andrews
Fife KY16 9TR

Tel: 01334 462339
Email: speccoll@st-andrews.ac.uk
Web: http://specialcollections.st-and.ac.uk/

Chairs of Anatomy in Scotland

UNIVERSITY OF ABERDEEN

Marischal College

1839–1841	Allen Thomson
1841–1860	Allan Jardine Lizars
1860	Marischal and Kings Colleges join to form the University of Aberdeen
1860–1863	Allan Jardine Lizars

Regius Chairs of Anatomy

1863–1889	John Struthers
1889–1925	Robert Reid
1925–1938	Alexander Low
1938–1964	Robert Lockhart
1964–1977	David Sinclair
1977–1993	E. John Clegg
1993–	Unfilled

UNIVERSITY OF DUNDEE

(University College, Dundee until 1954; Queens College, Dundee 1954–1967)

Chair of Anatomy
(Cox Chair of Anatomy from 1955)

1888–1894	Andrew Melville Paterson
1894–1925	John Yule Mackay
1925–1958	David Rutherford Dow
1958–1967	R. E. Coupland
1968–1988	David Andrew Thomas Dick

Part-Time Professor

1988–1991	David Andrew Thomas Dick

Cox Chair of Anatomy and Cell Biology

1992–	Ellen Brigitte Lane

Personal Chair in Anatomy and Forensic Anatomy

2003–	Sue Black

UNIVERSITY OF EDINBURGH

1705–1716	Robert Elliot
1708–1720	Adam Drummond
1716–1720	John McGill
1720–1758	Alexander Monro
1754–1808	Alexander Monro secundus
1798–1846	Alexander Monro tertius
1846	John Goodsir
1867	Sir William Turner
1903	Daniel John Cunningham
1909	Arthur Robinson
1931	James Couper Brash
1954–1984	George John Romanes
1984	Matthew H Kaufman

UNIVERSITY OF GLASGOW

1718	Regius Chair of Anatomy and Botany founded The province was restricted to Anatomy in 1818, when the Chair of Botany was founded.
1720–1742	Thomas Brisbane, MD First Chair of Anatomy
1742	Robert Hamilton, MD who then became Chair of Medicine
1756–1757	Joseph Black, MD
1757–1781	Thomas Hamilton, MD
1781–1790	William Hamilton, MD
1790–1848	James Jeffray, MD
1848–1877	Allen Thomson, MA, MD, LLD, DCL, FRS
1877–1909	John Cleland, MA, MD, FRS
1909–1935	Thomas Hastie Bryce, MA, MD, FRS
1935–1944	Duncan MacCallum Blair, MB, DSc
1946	William James Hamilton
1948	George McCreath Wyburn
1973–1990	Raymond John Scothorne

Current Professor in Anatomy but not Regius chair Anthony P. Payne B.Sc. Ph.D

UNIVERSITY OF St ANDREWS

The Bute Chair was founded in 1901 by means of a bequest by John, 3rd Marquess of Bute.

1901–1914	James Musgrove
1914–1942	David Waterston
1946–1973	Robert Walmsley
1973–1990	David Brynmore Thomas

CONTRIBUTIONS

ARTISTS' DETAILS

FURTHER READING

Contributors

Iain Bamforth grew up in Glasgow where he studied medicine at the university, graduating in 1982. He has had a varied career, working as a general practitioner in the American Hospital of Paris and the Australian outback and as editor/translator for the World Health Organization. He is currently employed as a primary health care expert in a EU-funded community health project in the poorer parts of Sumatra and Papua. Active as a poet, critic, essayist and anthologist, his literary career encompasses four books of poetry, a literary history of modern medicine *The Body in the Library*, a study of medicine and modernity and a book of literary essays *The Good European*, to be published in 2006 by Carcanet. He lives with his family in Strasbourg.

Dr Sara Barnes is an independent researcher and writer in the arts. Formerly a lecturer in cultural theory and contemporary art practice, she now specialises in the culture of anatomical visualisation, particularly in recent art. In addition to her role as researcher for the *Anatomy Acts* exhibition and managing editor of the *Anatomy Acts* publication, recent research projects include the Hands-On (formerly Tacitus) project and Research and Practice, both at Edinburgh College of Art.

John Fleming. Following a Student Apprenticeship at EMI Ltd, John Fleming worked on radar and computer logic circuit development with John Drage and Godfrey Houndsfield. In the 1950s and early 1960s Fleming worked at Ferranti Ltd and Smiths Industries Ltd, Glasgow before moving in 1962 to work with Tom Brown and Professor Ian Donald (University of Glasgow) on medical ultrasound. Following Brown's departure Fleming was responsible for continuing development of medical ultrasound products including Diasonograph; the first B-Scan machine in commercial production. Fleming and Angus Hall established an Ultrasonic Technology Unit in Professor Donald's Dept of Midwifery. Fleming established the British Medical Ultrasound Society's Historical Collection in 1984, retiring in 2002 having formed substantial collections of hardware and documents. In 1995 he began working closely with Malcolm Nicolson. Fleming retired in 1997 but remains Honorary Research Associate at Glasgow University.
Further information at:
www.bmus.org/history_of_ultrasound.htm

Elizabeth Hallam is Senior Lecturer in Social Anthropology at the University of Aberdeen. She has researched and taught in the fields of anthropology and cultural history at the University of Kent and the University of Sussex. Her books include *Death, Memory and Material Culture* (with J. Hockey), *Beyond the Body: Death and Social Identity* (with J. Hockey and G. Howarth) and *Cultural Encounters: Representing Otherness* (edited with B. Street). She is currently writing *Anatomy Museum. The Body, Death and Display* for Reaktion Books. Her research and publications focus on the historical anthropology of the body; death and dying; visual and material cultures; histories of collecting and museums. She is also involved in collaborative museum, exhibition and digitisation projects.

Kathleen Jamie was born in the west of Scotland in 1962. Her poetry collections to date include *The Tree House* (Picador 2004), which won both the Forward prize, and the Scottish Book of the Year Award and *Jizzen* (Picador 1999) which won the Geoffey Faber Memorial Award. Her travel book about Northern Pakistan, *Among Muslims*, was published by Sort Of Books in 2002. A non-fiction book *Findings* appeared in 2005. A part-time Reader in Creative Writing at St Andrews University, Kathleen Jamie lives in Fife.

Dawn Kemp is Director of Heritage of the Royal College of Surgeons of Edinburgh which houses the oldest extant Pathology Museum in the UK (1832). She has worked in the cultural sector in Scotland for over 25 years and was previously curator at the National Museums of Scotland, Museum of Flight. She has curated several exhibitions relating to Scottish social and technological history including: *Views from Above* (NMS and tour, 2000); *The People's Album* (NMS/Various 2000); *Lanark 1910: Scotland's First Air Show* (NMS, 2002); *Audubon in Edinburgh* (RCSEd, 2003); *Sport, Surgery and the Well Being* (RCSEd 2005); *Scottish Women's Hospitals 1914-1919* (RCSEd 2005). She is currently working on the redisplay of the Surgeons' Hall Pathology Museum collections. She is a member of the Scottish Museums Council Human Remains Working Group and is a part-time doctoral student at the University of St Andrews researching the lay audiences of *Anatomy and Pathology Museums in Scotland 1800-1850.*

Roberta McGrath is associate lecturer in the theory and criticism of photography at Napier University, Edinburgh. A regular contributor to *Ten:8* photographic magazine in the 1980s, she has written widely on the sexual politics of representation and contributed to a number of anthologies including *Illuminations: Women Writing on Photography from the 1850s to the present*, Liz Heron and Val Williams, (eds), IB Tauris,1995, and *The Photography Reader*, Liz Wells (ed), Routledge, 2003. Her essays on visual representation in medicine and sexuality have appeared in *Ecstatic Antibodies: resisting the AIDS mythology*, Sunil Gupta and Tessa Boffin (eds), Rivers Oram, 1990, and *Pleasure Principles: Politics, Sexuality and Ethics*, Victoria Harwood et al (eds), Lawrence and Wishart, 1993. She is author of *Seeing her Sex: Medical archives and the female body*, Manchester University Press, 2002.

Professor Duncan Macmillan, MA, PhD, FRSA, FRSE, HRSA is an art historian and art critic. He is Professor Emeritus of the History of Scottish Art and former Curator of the Talbot Rice Gallery, the University of Edinburgh and art critic for *The Scotsman*. His book *Scottish Art 1460-1990* was Scottish Book of the Year 1990 and was updated and reissued in 2000 as *Scottish Art 1460-2000*. He is also the author of many other books and articles.

Malcolm Nicolson is a Reader at the Centre for the History of Medicine, University of Glasgow. He has published widely on the history of medicine in the eighteenth, nineteenth and twentieth centuries. The history of diagnosis is a particular research interest. He is currently preparing (with John Fleming) a book-length study of the development of diagnostic ultrasound in Scotland.

Dr **Andrew Patrizio** is a curator and writer specialising in contemporary art and science/art interactions. He is a Reader and Director of Research Development at Edinburgh College of Art. He was a curator at Glasgow Museums and at National Touring Exhibitions / Hayward Gallery, London in the 1990s, and has written two books on sculpture and numerous papers for journals, catalogues and conferences. He is a member of the Arts & Humanities Research Council's Peer Review College and on the Art & Design sub-panel for the 2008 Research Assessment Exercise. For more information go to www.eca.ac.uk

George Rousseau has been Professor of Eighteenth-Century Studies at UCLA and Regius Professor of English at King's College Aberdeen in Scotland. He is currently a member of the Faculty of Modern History at Oxford University and Co-Director of the Oxford University Centre for the History of Childhood. He was the holder of a Leverhulme Trust Award 1999-2001. His most recent books are *Framing and Imagining Disease in Cultural History* (2003), *Nervous Acts: Essays on Literature, Culture and Sensibility* (2004), and a biography of *Marguerite Yourcenar* (2004).

Jonathan Sawday is Professor of English Studies at the University of Strathclyde in Glasgow. He is the author of *The Body Emblazoned: Dissection and the Human Body in Renaissance Culture* (London and New York: Routledge, 1995) as well as numerous other publications on sixteenth and seventeenth century literature, culture, and science.

Dr **Steve Sturdy** is a lecturer in the Science Studies Unit, University of Edinburgh. He teaches and researches the history and sociology of medicine, particularly the relationship between medical science, practice and policy in nineteenth and twentieth century Britain. He edited *Medicine, Health and the Public Sphere in Britain, 1600-2000* (Routledge, 2002) and, with Roger Cooter and Mark Harrison, *War, Medicine and Modernity* (Sutton, 1998).

Artists' Details

CHRISTINE BORLAND

Born 1965. Lives and works in Kilcreggan,
 Argyll, Scotland.
Selected Solo and Group exhibitions since 1990

Major Exhibitions

2005
Repeat Pattern. Dick Institute Museum,
 Kilmarnock, Scotland.

2004
Conservatory. Contemporary Art Gallery of South
 Australia, Adelaid; touring to Anna Schwarz
 Gallery, Melbourne.
Simulated Patient. Lisson Gallery, London.

2003
An Hospital. Mount Stuart, Bute, Scotland.
Take All the Time You Need. Dunkers Kulturhus,
 Helsingborg, Sweden.

2002
Christine Borland. Contemporary Art Museum,
 Houston, Texas.
To be Set and Sown in The Garden. Permanent
 Sculpture Commission, Glasgow University,
 Glasgow.
Christine Borland, Survey. Presentation of 7
 Projects throughout 2002/03, Kunstverein
 Munich.
Significant Notes. Aarhus Kunstforening af 1847,
 Aarhus, Denmark.
Dragon Doll with Claire Barclay. Glasgow Print
 Studio, Glasgow.

2001
Nephila Mania. Fabric Workshop & Museum,
 Philadelphia.
Christine Borland. York University Art Gallery,
 Toronto.
Hoxa Sound. The Constant Moment. Site Specific
 Project, Orkney.
Christine Borland. Lisson Gallery, London.
Fallen Spirits. Anna Schwarz Gallery, Melbourne.

2000
Spirit Collection. Sean Kelly Gallery, New York.
Treasury of Human Inheritance. Galeria Toni
 Tapies/Editions T, Barcelona.
Christine Borland. Galerie Cent 8, Paris.

1999
*What Makes for the Fullness and Perfection of Life,
 for Beauty & Happiness is Good.*
*What Makes for Death, Disease, Imperfection,
 Suffering is Bad.*
Dundee Contemporary Arts, Dundee.
Christine Borland. Galerie Eigen & Art, Berlin.

1998
Christine Borland. De Appel, Amsterdam,
 Netherlands.
Museum für Gegenwartskunst, Zürich, Switzerland;
 Fundaçao Serralves, Porto, Portugal.
Christine Borland. Galerie Cent 8, Paris.
L'Homme Double. Project Room, Aarhus Kunst
 Museum, Aarhus, Denmark.

1997
Christine Borland. Galerie d'Ecole, FRAC
 Languedoc-Roussillon, Montpellier, France.

Christine Borland. Lisson Gallery, London.
The Dead Teach the Living. Skulpturen Projekte,
 Munster, Germany.

1996
From Life. Kunstwerke, Berlin.
Second Class Male, Second Class Female. Sean
 Kelly Gallery, New York.
Christine Borland. Galerie Eigen & Art, Berlin.

Selected Group Exhibitions

2005
Home Testing. Part of the Conference for Medical
 Humanities, The Knowledge Spa, Peninsula
 Medical School, Royal Cornwall Hospital Truro.

2004
*Designer Bodies: Towards the Posthuman
 Condition*. Stills Gallery, Edinburgh.
Wonderful: Visions of the Near Future. Arnolfini
 Gallery, Bristol; touring 2004-5.

2003
Liquid Sea. Museum of Contemporary Art, Sydney.
Beinal Da Maia 3. Forum da Maia, Maia,
 Portugal.
Arrangement: The Use of Flowers in Art. Rhodes &
 Mann, London.
Fresh. Contemporary British Artists in Print.
 Edinburgh Printmakers, Edinburgh.
Love Over Gold. Gallery of Modern Art, Glasgow.
From Dust to Dusk. Charlottenborg Exhibition
 Hall, Copenhagen.
Bloom–mutation, toxicity and the sublime. Govett-
 Brewster Art Gallery Contemporary Art
 Museum, New Plymouth, New Zealand

2002
Apparition: the Action of Appearing. Arnolfini
 Gallery, Bristol.
*The Gap Show, Young critical art from Great
 Britain*. Museum am Ostwall. Dortmund.
Mirroring Evil. Jewish Museum, New York.
Mendel, The Genius o f Genetics. Mendel
 Monastery, Brno, Czech Republic.
Happy Outsiders. Zacheta Gallery, Warsaw.
Iconoclash, Beyond the Image Wars. ZKM,
 Karlsruhe, Germany.
Remarks on Colour. Sean Kelly Gallery, New York.
*New, Recent Acquisitions of Contemporary British
 Art*. *Scottish* National Gallery of Modern Art,
 Edinburgh.
Medicate. Art Gallery & Museum, Royal Pump
 Rooms, Leamington Spa.
The Hygiene Show. The School of Hygiene &
 Tropical Medicine, London.

2001
Open Country – Scotland. Musee cantonal des
 Beux Arts de Lausanne, Lausanne.
Circles 4. Centre for Art & Media Technology,
 Karlsruhe.
Humid. Spike Island, Bristol; Melbourne Festival,
 Australian Centre for Contemporary Art,
 Melbourne; Auckland Art Gallery, Auckland.
Devoler. Institut d' Art contemporain,
 Villeurbanne, France.
Paradise(Lost). Ecole Superieure de'art, Perpignan,
 France.
G3. Casey Kaplan, New York.
Here & Now. Scottish Art 1990–2001. Aberdeen
 City Art Gallery & Museum, Aberdeen.
Working Drafts. Envisioning the Human Genome.
 TwoTen Gallery, The Welcome Trust, London.

Space. Glasgow Print Studio, Glasgow.
Gene(sis) Contemporary Art explores Human Genomics. Henry Art Gallery, Seattle; touring.
From Beuys to Hirst: Art Works at Deutsche Bank. Scottish National Museum of Modern Art, Edinburgh.

2000

Spectacular Bodies. Hayward Gallery, London.
Biennale de Lyon. Halle Tony Garnier, Lyon.
Paradise Now. Exit Art, New York.
Warning Shots. The Royal Armouries, Leeds.
A Shot in the Dark. Lisson Gallery, London.

1999

High Red Centre. CCA, Glasgow.
Sampled, The Use of Fabric in Sculpture. Henry Moore Institute, Leeds.
Rewind the Future. Chac Mool Contemporary Art in collaboration with Lisson Gallery, West Hollywood.

1998

Artranspennine '98. Tate Gallery Liverpool, Liverpool.
Manifesta 2. Casino de Luxembourg, Luxembourg.
In Your Face. The Andy Warhol Museum, Pittsburgh.
Nettwerk-Glasgow. Museet fur Samtidskunst, Oslo.
To be Real. Yerba Beuna Centre for the Arts, San Fransisco.
Close Echoes. City Gallery, Parague, travelled to Kunsthalle Krens, Germany.
Artists Editions. The Modern Institute, Glasgow.
New Art from Britain. Kunstraum, Innsbruck.
Here to Stay Arts Council Purchases of the 1990's.

1997

Life/Live. Centro Cultural de Belém, Lisbon.
Material Culture. Hayward Gallery, London.
Flexible. Museum für Gegenwartskunst, Zürich.
Turner Prize Exhibition. Tate Gallery, London.
Letter & Event. Apex Art, C.P., New York.
absence/presence. Kopavogur Art Museum, Iceland.
Wish you were here too. 83 Hill St, Glasgow.
Connections Implicities. Ecole Nationale Superiere des Beux Arts, Paris.
Pictura Britannica; Art from Britain. Museum of Contemporary Art, Sydney; Art Gallery of South Australia, Adelaide; City Gallery, Wellington, Australia.
Building Site. Architectural Association, London.

Selected Bibliography

Liquid Sea. Museum of Contemporary Art, Sydney, Australia, 2003
Apparition: the Action of Appearing Arnolfini Gallery, Bristol, England, 2002
Significant Notes Aarhus Kunstforening, Denmark, 2002
Bullet Proof Breath, Art Gallery of York University, Toronto, Canada, 2002
New, Recent Acquisitions of Contemporary British Art Scottish National Gallery of Modern Art, Edinburgh, Scotland, UK 2002
Mirroring Evil, Nazi Imagery/Recent Art The Jewish Museum, New York, USA, 2002
Mendel. The Genius of Genetics An exhibition at the Abbey of St Thomas, Brno, Czech, 2002
Happy Outsiders from London & Glasgow Galerie Sztuki, Warsaw, Poland, 2002

Paradise Now, Picturing the Genetic Revolution Exit Art, New York, The University of Michagan, The Tang Museum, Skidmore College, USA , 2001 *'Progressive Disorder* D.C.A. Dundee, Scotland & Bookworks, London, England, UK 2001*

Nothing Graham Gussin & Elle Carpenter 2001

Here & Now D.C.A. Dundee, Scotland, Scotland, UK 2001

Open Country - Scotland'Musee cantonal des Beux Arts de Lausanne, Switzerland, 2001

Humid Spike Island, Bristol, England and a separate publication by the Melbourne Festival at the Australian Centre for Contemporary Art, Melbourne, Australia, 2001

Christine Borland, The Dead Teach the Living De Appel, Amsterdam/Museum für *Gegenwartskunst,* Zurich ,Switzerland, Fundaçao Serralves, Porto, 2000 *'Spectacular Bodies* Hayward Gallery, London, England, UK 2000

Partage d'Exotismes Biennale de Lyon, Halle Tony Garnier, Lyon 2000

Warning Shots, The Royal Armouries, Leeds, England, UK, 2000

Artranspennine '98, Tate Gallery Liverpool, Liverpool, 1998

Manifesta 2, Casino de Luxembourg, Luxembourg, 1998

Nettwerk-Glasgow Museet fur Samtidskunst, Oslo, 1998

Close Echoes, City Gallery, Parague, travelled to Kunsthalle Krens, Germany, 1998

New Art from Britain, Kunstraum, Innsbruck, Innsbruck, Austria, 1998

Here to Stay, Arts Council Purchases of the 1990's, 1998

Sculpturen Projekte 3, Munster, Germany 1997

Christine Borland, FRAC Languedoc-Roussillon, Montpellier, France 1997

Letter & Event, Apex Art, New York, 1997

absence/presence Kopavogur Art Museum, Iceland 1997

Connections Implicities, Ecole Nationale Superiere des Beux Arts, Paris, France 1997

Pictura Britannica; Art from Britain Museum of Contemporary Art, Sydney, 1997

Flexible, Museum für Gegenwartskunst, Zürich, Switzerland, 1997

Life/Live, Centro Cultural de Belém, Lisbon, 1997

The Cauldron, The Henry Moore Scukpture Trust, Leeds, 1996

Sawn Off, Stockholm, Sweden, 1996

Material Culture, Hayward Gallery, London, 1996

'Nach Weimar', Kunstsammlung, Weimar, Germany 1996

More Time, Less History, Fundacio Serralves, Oporto, Portugal, 1996

Full House, Kunstmuseum, Wolfsburg, Germany, 1996

From Life, Tramway, Glasgow/Kunstwerke, Berlin, Germany 1996 * *'Christine Borland & Craig Richardson,* Chisenhale Gallery, London, England, 1993

Guilt by Association, Irish Museum of Modern Art, Dublin,1991

Self Conscious State 3rd Eye Centre, Glasgow, Scotland, 1990

JOEL FISHER
Born 1947. Lives and works in Newcastle and
 Paris.
Selected Solo and Group exhibitions since 1990

Solo exhibitions

2003
Isography, Artaffairs Gallery, Amsterdam.
Two Secrets, Hatton Gallery, Newcastle-upon-Tyne.

2001
European Ceramic Work Centrum (EKWC)
 's-Hertogenbosch, Holland.
Link, Rockefeller Apartments NYC, curated by
 Joyce Schwartz.

2000
George Frasier Gallery, University of Auckland,
 New Zealand.
United Nations, New York, sponsored by the
 French Association.

1999
Six Touchable Sculptures & A Suite of Drawings,
 Galerie Farideh Cadot, Paris.

1998
Punctuated Memory, Hubert Winter Gallery at
 Kontorhaus Berlin; Project Room, Stux Gallery,
 New York.

1997
Sculptures and wall projections, Stux Gallery,
 New York.
Mosaic Evolution, Art Affairs/Antoinette de Stigter,
 Amsterdam.

1996
Les Incunables: Chapitre 1-Premières sculptures,
 Galerie Farideh Cadot, Paris.

1995
Fingere, Galerie Rochefort, Montreal; The Red Mill
 Gallery, VSC Johnson, Vermont.

1994
Light, Lawrence Markey Gallery, New York; Galerie
 Hubert Winter, Vienna; Bellas Artes, Sante Fe.
Circle, Gallerie Farideh Cadot, Paris; Ben Shahn
 Gallery, William Patterson College, New Jersey.
 (Cat)

1993
Gallerij S-65, Aalst, Belgium.
Galerie Farideh Cadot, Paris.
As If or Other Than, Antoinette de Stigter,
 Amsterdam.

1992
C. Grimaldis Gallery, Baltimore; International Bird
 Museum, South Hampton, NY.

1991
Galeria Comicos/Luis Serpa, Lisbon.
Galerie Hubert Winter, Vienna.
Galerie Raymond Bollag, Zurich. (Cat)
Art Affairs/Antoinette De Stigter, Amsterdam.
Barbara Gross Gallerie, Munich. (Cat)
Forms of Attachment, Galerie Farideh Cadot,
 Paris. (Cat)

1990
New Sculptures, Galerie Farideh Cadot, Paris
Works from London 1979-82, Farideh Cadot
 Gallery, New York. (Cat)

Group exhibitions

2005

A Forest Rises: Ecology and Art, LipLim Art
Museum, Korea. (Cat)
Exposed! 2005 Outdoor Sculpture Show Stowe;
Vermont.

2004

Far from the Sea, October Foundation 1998-2003;
Vanderbilt University.

2003

Poetiche dello Spazio, Il Prisma Galleria d'Arte,
curated by Victor de Circasia.

2002

The Connecting Principle, University of Newcastle.
Drawing Invitational FAWC Fellows , Provincetown.

2001

From the Ashes, C.U.A.N.D.O. benefit, New York.
Form and Displacement, Gallery Korea New York.
Le Corp Mis a Nu, Donjon de Vez , France.
*Extra Art: A Survey of Artist's Ephemera 1960-
1999,* Vor-Sicht Rück-Sicht 8. Triennale
Kleinplastik Fellbach, Germany.

2000

The Eye of the Storm, Parco La Mandria, Turin.
Dream Machines, National Touring Exhibition (GB),
curated by Susan Hiller.
Double Debut, Willoughby Sharp Gallery, New
York.
Local Papers, curated by Fran Kornfeld,
Williamsburgh Art & Historical Center.
Interply, PILOT project room, Auckland.

1999

Flowers for the opening, Frontstore, Basel.
Exhibition Posters, Lawrence Markey Gallery,
New York.

1998

Acts of Faith, curated by Willoughby Sharp,
A Lubelski Gallery, New York.
Heroes and Heroine, curated by Willoughby
Sharp, New York.

1997

Odeurs…une odyssée, Passage de Retz, Paris.
*Frac Picardie Exhibition, VIII Biennale of Prints &
Drawings,* Taipei.
Irredeemable Skeletons, Shillam & Smith, London.
Habakuk & Co, a curtsy to Max Ernst, Art Affairs
Amsterdam; Farideh Cadot Gallery, Paris.
@ curated by Willoughby Sharp, Satellite, Long
Island City, New York.

1996

Contact Prints, Galeria Foksal, Warszawa
Schwere-los, Landesmuseum, Linz, Museum
Budapest. (Cat)
Graphite auf Papier, Thomas von Lintel Galerie,
Munich.
Dessins en Séries, La Maison de la Culture
d'Amiens FRAC, Picardie.
Blitz, Galerie Rochfort, Toronto.
Korrekturen/Jahrtausendwende Austellung, Krems,
Austria.
In Site, Tblinsi, Republic of Georgia.
Figure to Object, Karsten Schubert Gallery and
Frith Street Gallery, London. (Cat)
Sammlung Toni Gerber in Kunstmuseum Bern,
Bern. (Cat)

20th Century American Sculpture at The White House, Washington. DC. (Cat)

Transitions, Gallery Farideh Cadot, Paris. (Cat)

1995

Forme Uniche Della Continuita Nelle Spazio, Galeria Serpa, Lisbon.

Works on Paper, Todd Gallery, London; Galerij S 65, Aalst, Belgium.

1994

Lawrence Markey Gallery, New York; Grimaldis Gallery, Baltimore, Maryland.

Site Seeing, Bardamu Gallery, New York.

Chance, Choice and Irony, Todd Gallery, London.

Chance, Choice and Irony, John Hansard Gallery, Southampton. (Cat)

Across the River and into the Trees, curated by Collins & Milazzo, Rushmore Festival Woodbury, New York. (Cat)

5th Paper Biennale, Leopold Hoesch Museum, Duren, Germany. (Cat)

L'Art Americain, dans les Collections Publiques Francaise des Province, Musee de Toulon. (Cat)

1993

Andere Lander-andere Sitten, Nationalgalerie, Prague. (Cat)

Konkrete Kunst im Wandel, Galerie Heseler, Munich.

Jour Tranquilles a Clichy, organized by Alain Kirili, Paris.

Jour Tranquilles a Clichy Tennisport, New York.

Parceling Perception, Four Walls, New York.

Floor Show, Anders Tornberg Gallery, Lund.

Drawings by Sculptors, C. Grimaldis Gallery, Baltimore.

Hyper Cathexis, Stux Gallery, New York.

Tom Chimes, Joel Fisher, Bill Walton, Larry Becker Gallery, Philadelphia.

Concurrencies II, curated by Lucio Pozzi, William Patterson College, N.J.

Celebrating Art & Architecture, Federal Reserve Building, Washington DC.

1992

Process to Presence: Issues in Sculpture, Locks Gallery, Philadelphia.

In a Silent Way, Hoogstraten, Belgium.

All about paper, Galerij S65, Aalst, Belgium.

Singular and Plural, Drawings and prints 1945-1991, The Museum of Fine Arts, Houston.

Floor Show, Anders Tornberg Gallery, Lund.

Joel Fisher, Markus Raetz, Daniel Tremblay, Galerie Farideh Cadot, Paris.

1991

Ibsenhuset, Skien, Norway.

Plaster at Last, curated by Alain Kirili, New York Studio School, New York.

Oeuvres sur Papier, Farideh Cadot Gallery, Paris.

Kunst als Grenzebeschreitung: John Cage & die Moderne, Neue Pinatekm, Munich.

1990

Castelli, Fisher, Raetz, Rousse, Usle, Galerie Farideh Cadot, Paris.

Drawings by Sculptors, Baltimore Museum of Art, Baltimore.

Between Two Worlds, Credit Suisse exhibit, New York. (Cat)

Hand, Body, House: Approaches to Sculpture, Ben Shahn Galleries, Wayne, NJ. (Cat)

European Paper Artists, Glasgow Print Studio,
 Glasgow.
Works on Paper, Larry Becker Gallery, Philadelphia.

CLAUDE HEATH
Born 1964 London. Lives and works in London.
Selected Solo and Group exhibitions since 1990

Solo exhibitions

2005
Built in the Air/In Aere Aedificare Fruehsorge/
 Galerie fur Zeichnung, Berlin.

2003
Ben Nevis. Sleeper. Reiach & Hall, Edinburgh.

2002
Claude Heath. Kettle's Yard, Cambridge (Cat).

2001
Claude Heath. Paul Kasmin Gallery, New York.
Claude Heath. The Centre for Drawing at
 Wimbledon School of Art, London. (Cat).

2000
Art In Sacred Spaces. Christchurch, Isle of Dogs,
 London.

1999
Claude Heath Drawing from Sculpture. The Henry
 Moore Institute/Leeds City Art Gallery (Cat).

1998
The Pith and the Marrow. Hales Gallery, London.

1995
Claude Heath. Hales Gallery, London.

Group exhibitions

2005

Showcase CAS. City Art Centre and Talbot Rice Gallery, Edinburgh.

Work from the Print Studio, Cambridge. Broadbent Gallery, London.

Sue Arrowsmith and Claude Heath. Galerie Hollenbach, Ausstellungraum Zurich.

2004

Gegen den Strich/Another Line. Staatliche Kunsthalle Baden-Baden.

Sue Arrowsmith and Claude Heath. Galerie Hollenbach, Stuttgart.

Other Criteria. The Henry Moore Institute, Leeds.

Sculpture on Paper: Works from the Leeds Collection. The Study Galleries, Leeds City Art Gallery, The Henry Moore Institute. Selected by Claude Heath.

ARTfutures. 2004. Contemporary Art Society, London.

Facing. FLACC, Hasselt, Belgium.

Transmission: Speaking and Listening. Domo Baal Gallery, London, with Sheffield Hallam University, School of Cultural Studies

2003

Claude Heath and Marion Coutts. Kettle's Yard Gallery, University of Cambridge.

Pizza Express Prospects Drawing Prize. The Truman Brewery, London.

Drawing 100. The Drawing Room, London.

2002

Mapping The Process. Essor Gallery, London.

Head On: Art with the Brain In Mind. Science Museum, London.

2001

Paper Assets: Collecting Prints and Drawings 1996-2001. The British Museum, London.

Fall Show. G Fine Art, Washington.

Sages, Scientists, and Madmen. One In The Other, London.

The Jerwood Drawing Prize 2001. Cheltenham & Gloucester College, Princes Trust, London.

Summer 2001. Paul Kasmin Gallery, New York.

Systems: Past-Present-Future. TIAA/CREF, New York.

2000

Art In Sacred Spaces. Christchurch, Isle of Dogs, London.

Made Space. Touring exhibition; Pekao Gallery, Toronto, Canada; The Changing Room, Stirling, Scotland; Talbot Rice Gallery, Edinburgh, Scotland.

Claude Heath. Bury St. Edmunds Art Gallery.

1999

Drawings. Nicole Klagsbrun Gallery, New York, Gallerie Hollenbach, Stuttgart.

Claude Heath, Leo De Goede, DJ Simpson, Alexis Harding, Andrew Bick. Gallerie Hollenbach, Stuttgart.

The Great Hall. Bury St. Edmunds Art Gallery.

1998

From Within/D'all Interno. Juliet Gallery, Trieste, Italy.

Works on Paper. Duncan Cargill Gallery, London.

The Jerwood Painting Prize. The Jerwood Gallery, London.

The Whitechapel Open. Whitechapel Gallery, London.

Le Doux Dessin. Hasselt, Belgium.

1997

Antechamber. Whitechapel Art Gallery, London. (Cat)

Blueprint. De Appel Foundation, Amsterdam. (Cat)

Klarsehend. One In The Other, London.

1996

Young British Artists VI. The Saatchi Gallery, London. (Cat)

The Whitechapel Open. Whitechapel Gallery, London.

1995

To Whom It May Concern. Anna Bornholt Gallery, London.

Selected Bibliography

2003

William Furlong, 'Claude Heath' in *Sculpture in 20th-century Britain: A guide to Sculptors in the Leeds Collections*. The Henry Moore Institute.

Claude Heath, *Transmission: Speaking and Listening*, Sheffield Hallam University. Interview with audience.

2002

Angela Kingston and Ian Hunt (eds), *What is Drawing?* The Centre for Drawing, Wimbledon School of Art. 2001-2: Andrew Patrizio, 'Perspicuous by their absence; the drawings of Claude Heath'; Erika Naginski. 'Drawing things in, sketching things out'; 'Claude Heath. Interviewed by William Furlong.'

Mel Gooding. *Seeing Things.*, Kettle's Yard, University of Cambridge, catalogue, p.3-8.

Tom Lubbock, 'Don't Look Now', The Independent Review, The Independent, Tuesday 8 October.

2001

Alistair Hicks. *Art Works: British and German Contemporary Art 1960-2000*. Deutsche Bank.

Jan Koplos, 'Claude Heath at Paul Kasmin Gallery.' *Art In America*.

2000

Chris Noraika. 'Made Space.' Exhibition publication of Atopia Journal, Issue 0.99.

1999

The Saatchi Gallery. '*The Saatchi Decade*'.

Dorcas Taylor (ed), Claude Heath. 'Claude Heath Drawing From Sculpture.' The Henry Moore Institute.

Dorcas Taylor (ed), '*Leeds Sculpture Collections: Works On Paper, Concise Catalogue.*' The Henry Moore Institute.

1998

Regina Von Planta. 'Claude Heath at Hales Gallery'. Kunst-Bulletin, November issue.

Paolo Cecchetto and Marina Wallace. 'From Within/D'all Interno.' Juliet Gallery. Exhibition catalogue.

1997

James Hall. 'Young British Artists VI.' Artforum, January issue.

1995

Barry Barker. 'Out of Sight but not out of Mind.' Curators statement page for Hales Gallery exhibition.

Further Reading

N.B. other primary sources not listed in the catalogue of works can be found in *The Quick and the Dead*, 1997, see below

1 General

Arendts, B. and Thackara, D. (eds). 2003. *Experiment: conversations in art and science.* London: Wellcome Trust.

Baigrie, B. (ed). 1996. *Picturing Knowledge. Historical and philosophical problems concerning the use of art in science.* Toronto: University of Toronto Press.

Baird, D. 2004. *Thing knowledge: a philosophy of scientific instruments.* Berkeley & London: University of California Press.

Grob, Bart. 2000. *The World of Auzoux: Models of Man and Beast in Papier-Mâché.* Leiden: Museum Boerhaave.

Bynum, W. F. and Porter, R. (eds). 1993. *Medicine and the five senses.* Cambridge: Cambridge University Press

Carlino, A. 1995. *Know Thyself. Graphic Communication and Anatomical Knowledge in Early Modern Europe*, in RES Anthropology and Aesthetics, XXVII, Santa Monica, CA and Cambridge, Mass.

Carlino, A. 1999. *Books of the Body. Anatomical ritual and renaissance learning.* (trans. Tedeschl, J. and A. Chicago and London.

Cartwright, L. 1995. *Screening the Body: Tracing Medicine's Visual Culture.* Minneapolis and London: University of Minnesota Press.

Choulant, L. 1920. *History and Bibliography of Anatomic Illustration,* (trans. and ed. by Mortimer, F). Chicago: Chicago University Press.

Crary, J et al (eds.) 1989-1990. *Fragments for a History of the Human Body, Parts I, II, III.* New York: Zone Books.

Crary, J. 1990. *Techniques of the Observer.* Cambridge, Massachusetts: MIT Press.

Cunningham, A. (ed.) 1997. *The Anatomical Renaissance: The Resurrection of the Anatomical Projects of the Ancients.* Aldershot: Scolar Press.

Ede, S. ed. 2000. *Strange and Charmed. Science and the Contemporary Visual Arts.* London: Calouste Gulbenkian Foundation.

Elkins, J. 1986. 'Two conceptions of the human form: Bernard Siegfried Albinus and Andreas Vesalius', Artibus et Historiae, 14: 91-106.

Emery, A. E. H. and Emery M. L. H. 2006. *Surgical and Medical Treatment in Art.* London: Royal Society of Medicine.

Foucault, M. *The Birth of the Clinic: An Archaeology of Medical Perception.* London: Routledge.

Greenhalgh. T. and Hurwitz, B. (eds). *Narrative-Based Medicine. Dialogue and discourse in clinical practice.* London: B.M.J. Books.

Habermas, J. 1989. *The Structural Transformation of the Public Sphere. An Inquiry into a Category of Bourgeois Society*, trans. T. Burger. Cambridge: Polity Press.

Herrlinger, R. 1970. *The History of Medical Illustration,* London: Pitman Medical.

Hopwood, N. 2002. *Embryos in Wax. Models from the Ziegler Studio.* Cambridge: University of Cambridge.

Howes, D. 2005. *Empire of the Senses. The Sensual Cultural Reader.* Oxford: Berg.

Jordanova, L. 1989. *Sexual Visions: Images of gender in science and medicine between the 18th and 20th centuries.* Hemel Hempstead: Harvester Wheatsheaf.

Jordanova, L. 1999. *Nature Displayed: Gender, Science and Medicine 1760-1820.* New York: Longman.

Jordanova, L. 2000. *Defining Features. Scientific and Medical Portraits 1660–2000.*
London: Reaktion.

Kemp, M & Wallace, M. 2001. *Know Thyself. The Art and Science of the Human Body.* Berkeley: The University of California Press.

Kevles, B. H. 1997. *Naked to the Bone. Medical Imaging in the Twentieth Century.* New Brunswick, N.J.: Rutgers University Press.

Lawrence, C.J. (ed). 1992. *Medical theory, surgical practice: studies in the history of surgery.* London and New York: Routledge.

Lawrence, C. 2003. *Medicine in the Making of Modern Britain.* London: Routledge.

Le Minor, J-M. and Sick, H. 2005. *J. M. Bourgery & N. H. Jacob. Atlas of Human Anatomy and Surgery. The Complete Coloured Plates 1831-1854.* Taschen

Mayor, A. H. 1984. *Artists & Anatomists.* The Artist's Limited Edition in association with the Metropolitan Museum of Art.

McGrath R. 2002. *Seeing Her Sex: Medical Archives and the Female Body (The Critical Image).* Manchester: Manchester University Press.

Miller, J. 1978. *The Body in Question.* London: Jonathon Cape.

Nutton, V. and Porter, R. (eds). 1995. *The History of Medical Education in Britain.* Amsterdam: Editiuns Rodop, B.V.

Porter, R. 1997. *The Greatest Benefit to Mankind. A Medical History of Humanity from Antiquity to the Present.* London.

Poggesi, M, et al. 1999. *Encyclopedia Anatomica.* Cologne and London: Taschen.

Putnam, J. 2001. *Art and Artifact: The Museum as Medium.* London: Thames and Hudson.

Richardson, Ruth. 1987. *Death, Dissection and the Destitute.* London: Routledge

Roberts, K.B. and Tomlinson, J.D.W. 1992. *The Fabric of the Body: European traditions of anatomical illustration.* Oxford: Clarendon Press.

Sawday, J. 1995. *The Body Emblazoned. Dissection and the human body in Renaissance culture.* London: Routledge.

Scarry, E. 1985. *The Body in Pain. The Making and Unmaking of the World.* Oxford: Oxford University Press.

Shildrick, M. 1997. *Leaky Bodies and Boundaries: feminism, postmodernism and (bio)ethics.* London: Routledge.

Smith, P.H. 2004. *The Body of the Artisan: Art and Experience in the Scientific Revolution.* Chicago and London: The University of Chicago Press.

Stafford, B. M. 1991. *Body Criticism. Imaging the Unseen in Enlightenment Art and Medicine.* Cambridge Mass, London: MIT Press.

Stafford, B. M. 1996. *Good Looking Essays on the Virtue of Images.* Cambridge, Mass. and London: MIT Press.

Sturdy, S. (ed). 2002. *Medicine, Health and the Public Sphere in Britain 1600-2000.* London: Routledge.

Townsend, C. 1998. *Vile Bodies: Photography and the Crisis of Looking.* Munich: Prestel and Channel 4.

Granta. 1992. *The Body*. Granta(39).

Van Dijk, J. 2005. *The Transparent Body: A Cultural Analysis Of Medical Imaging (In Vivo:the Cultural Mediations of Biomedical Science)*. Washington D.C: University of Washington Press.

Von Hagens. G. and Whalley, A. 2001. *Body Worlds. The anatomical exhibition of real human bodies*. Heidelberg: Institut für Plastination.

2 General Scottish-related

Anderson, R.G.W. Simpson, A.D.C.1976. *Edinburgh & Medicine*. Edinburgh: The Royal Scottish Museum

Barzun, J. 1974. *Burke and Hare. The resurrection men*. New Jersey: The Scarescrow Press.

Bridie, J . 1931. *The Anatomist*. London: Constable.

Bynum, W.F. 1995. *Science and the Practice of Medicine in the Nineteenth Century*. Cambridge: Cambridge University Press..

Bynum, W. F. and Porter, R. (eds).1985. *William Hunter and the eighteenth-century medical world*. Cambridge: Cambridge University Press.

Campbell, R.A and Skinner, A.S (eds). 1992. *The Origins and Nature of the Scottish Enlightenment*. Edinburgh: John Donald.

Calder, J.F. 2001. *The History of Radiology in Scotland1896-2000*. Dunedin Academic Press.

Cathcart, C.W. 1893, 1898. *Descriptive catalogue of the anatomical and pathological specimens in the Museum of the Royal College of Surgeons of Edinburgh*. Vols 1 and 2. Edinburgh: James Thin.

Clarke, T.N., Morrison-Low, A.D. and Simpson, A.D.C. 1989. *Brass& Glass. Scientific Instrument Making Workshops in Scotland as illustrated by instruments from the Arthur Frank Collection at the Royal Museum of Scotland*. Edinburgh: National Museums of Scotland.

Comrie, J.D.1932.*History of Scottish Medicine*. 2 Vols, Oxford: Bailliere, Tindall and Cox.

Conrad, L.L et al. 1995. *The Western Medical Tradition 800BC – 1800AD*. Cambridge: Cambridge University Press.

Cope, Z. 1953. *William Cheselden 1688-1752*. Edinburgh: E & S Livingstone.

Craig, W .S. *History of the Royal College of Physicians*. Blackwell Scientific Publications

Cresswell, C.H. 1926. *The Royal College of Surgeons of Edinburgh: Historical Notes 1505 - 1905*. Edinburgh: Oliver and Boyd.

Devine, T.M., 1999. *The Scottish Nation 1700-2000* Edinburgh: Penguin.

Dingwall, H.M. 2003. *A History of Scottish Medicine*. Edinburgh: Edinburgh University Press.

Dingwall, H. 2005. *A Famous and Flourishing Society. The History of the Royal College of Surgeons of Edinburgh 1505-2005*. Edinburgh: Edinburgh University Press.

Geyer – Kordesch, J. and Macdonald, F. 1999. *Physicians and Surgeons in Glasgow. The History of the Royal College of Physicians and Surgeons of Glasgow, 1599-1958* Oxford: Hambledon Press.

Hamilton, D. 1981. *The Healers. A History of Medicine in Scotland*. Edinburgh: Canongate Press.

Herman, A. 2001. *The Scottish Enlightenment. The Scots' Invention of the Modern World*. London: Fourth Estate.

Hook, A. and Sher, R.B. 1985. *The Glasgow Enlightenment*. East Linton: Tuckwell Press.

Hull, A. and Geyer – Kordesch. 1999. *The Shaping of the Medical Profession. The History of the Royal College of Physicians and Surgeons of Glasgow, 1585 – 1999*. Oxford.

Jacyna, S. 1994. *Philosophic Whigs: Medicine, Science and Citizenship in Nineteenth-Century Edinburgh, 1789-1848*. Routledge.

Jordanova, L. 1995. 'The Representation of the Human Body: Art and medicine in the work of Charles Bell' in Ballen, B. (ed.). *Towards a Modern Art World*. New Haven & London: Yale University Press.

Kaufman, M.H. 1996. 'Monro Secundus and 18th Century lymphangiography' in *Proceedings of the Royal College of Physicians of Edinburgh*, 26.

Kaufman, M.H. 1997. 'In search of sources: observations on a watercolour painting of an anatomical subject' in *Proceedings of the Royal College of Physicians of Edinburgh*, 27.

Kaufman, M.H. 1997. 'Another look at Burke and Hare: The last day of Mary Paterson: a medical cover up?' in *Proceedings of the Royal College of Physicians of Edinburgh*, 27.

Kaufman, M.H. 1999. 'Observations on some of the plates used to illustrate the lymphatics section of Andrew Fyfe in *Compendium of the Anatomy of the Human Body, published in 1800*' in *Clinical Anatomy*, 12.

Kauffman, M. H. 2003. *Musket-Ball and Sabre Injuries. From the first half of the nineteenth century*. Edinburgh: Royal College of Surgeons of Edinburgh.

Kemp, M. 1975. *Dr William Hunter at the Royal Academy of Art*. Glasgow.

Knox, R. 1852. *Great Artists and Great Anatomists*. London: H Renshaw.

Moore W. 2005. *The Knife Man. The Extraordinary Life and Times of John Hunter, Father of Modern Surgery*. Random House.

McCullough, L.B. 1998. *John Gregory and the Invention of Professional Medical ethics and the Profession of Medicine* London.

MacQueen, J. (ed.) 1990. *Humanism in Renaissance Scotland*. Edinburgh: Edinburgh University Press.

Porter, R. and Teich, M. (Eds). 1981. *The Scottish enlightenment in its National Context*. London.

Rosner, L. 1991. *Medical Education in the Age of Improvement : Edinburgh Students and Apprentices, 1760-1826*. Edinburgh: University of Edinburgh Press.

Rousseau, G. S. 2004. *Nervous Acts. Essays on Literature, Culture and Sensibility*. New York: Palgrave.

Shennan, T. 1903. *Descriptive catalogue of the anatomical and pathological specimens in the Museum of the Royal College of Surgeons of Edinburgh*. Vol. 3. Edinburgh: Oliver & Boyd.

Summerly, P. 2001. 'The Macewen collection of clinical photographs (circa 1880-1918)' in *Journal of Audiovisual Media in Medicine*, 24.

Tansey, V. and Mekie, D.E.C. 2005/1982. *The Museum of the Royal College of Surgeons of Edinburgh*. Edinburgh: The Royal College of Surgeons of Edinburgh.

Thornton, J.L. 1982. *Jan van Rymsdyk: Medical artist of the eighteenth century*. Cambridge and New York: Oleander Press.

Willocks J. and Barr,W. 2004. *Ian Donald – A Memoir*. London: RCOG.

Withers W. J. and Wood P. 2002. *Science and Medicine in the Scottish Enlightenment*. East Linton: Tuckwell Press.

Yule,W. L. 1998. 'In search of a medical artist' in *The Lancet*, 352, 5 September, 1998.

3 Art, Medicine and Anatomy Exhibitions

Albano, C., Wallace, M. and Arnold, K. 2002. *Head On: Art With the Brain in Mind*. London: Artakt.

Arnold, K & and Kemp, M. 1995. *Materia Medica: A new cabinet of medicine and art*. London: Wellcome Institute for the History of Medicine.

Arnold, K., Hurwitz, B., McKee, F. and Richardson, R. 1997. *Doctor Death. Medicine at the end of life*. London: The Wellcome Institute for the History of Medicine.

Arnold, K., Olsen, D. (eds). 2003. *Medicine Man: the Forgotten Museum of Henry Wellcome*. London: British Museum.

Bogusch, G., Graf, R. and Schnalke, T. (eds) 2003. Auf Leben und Tod. Beiträge zur Diskussion um die Ausstellung 'Körperwelten' Darmstadt: Steinkopff.

Beardsley, L.E. 1995. *Body Doubles: Siamese Twins in Fact and Fiction*. Philadelphia: Mutter Museum.

Bevan, A. and Galloway, J. 2004. *Rosengarten*. Edinburgh, Glasgow, Platform Projects , Hunterian Art Gallery.

Bradburne, J. M., (ed). 2001. *Blood: Art, Power, Politics and Pathology*. Munich: Prestel Verlag.

Cazort, M., Kornell, M., and Roberts, K.B. 1996. *The Ingenious Machine of Nature: Four centuries of art and anatomy*. Ottawa: National Gallery of Canada.

Claire, Jean (ed.) (1993). *L'âme au corps: arts et sciences 1793-1993*. Galeries nationals du Grand Palais. Paris: Réunion des musées nationaux, Gallimard / Electa.

Eiblmayr, E. 1996. *Body as membrane*. Odense: Odense Kunsthalle.

Fusco, M. (ed) 2004. *Wonderful. Visions of the Near Future*, BKD Special Projects.

Hansen, J. and Porter, S. 1999. *The Physician's Art. Representations of art and medicine*. Durham, NC: Duke University Museum of Art.

Iles, C. and Roberts, R., (eds). 1997. *In Visible Light Photography and Classification in Art, Science and the Everyday*. Oxford: MOMA Oxford.

Jones, D. and Wang, S. 2002. *Working Drafts. Envisioning the human genome*. London: The Wellcome Trust.

Jones, D. and Arnold, K. 1999. *The New Anatomists*. London: The Wellcome Trust.

Karp, D et al. 1985. *Ars Medica. Art, Medicine and the Human Condition*. Philadelphia, Philadelphia: Museum of Art.

Kemp, M. and Wallace, M. 2000. *Spectacular Bodies, The Art and Science of the Human Body*. London: Hayward Gallery and University of California.

Kemp, S. 2004. *Future Face. Image, identity, innovation*. London: Profile Books & The Wellcome Trust.

Kennedy, B. P. 1992. *The Anatomy Lesson: Art and Medicine*. Dublin: National Gallery of Ireland.

Leighton, T. 2004. *9 MUTTER XX04*. Philadelphia: Mutter Museum.

Petherbridge, L. J. D. 1997. *The Quick and the Dead. Artists and Anatomy*. London: South Bank Centre.

Petherbridge, D., Ritschard, C., and Carlino, A. (1998). *Corps à vif*. Geneva: Musée d'Art et d'Historie.

Voogd, K. (ed). 1998. *Neuro-artonomy. art brain aesthetics anatomy*. Rotterdam, Neuro-atonomy.